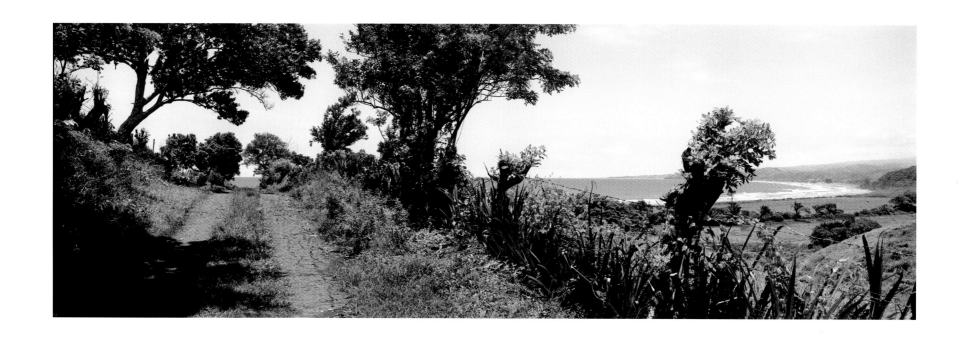

Number Nine: Charles and Elizabeth Prothro Texas Photography Series

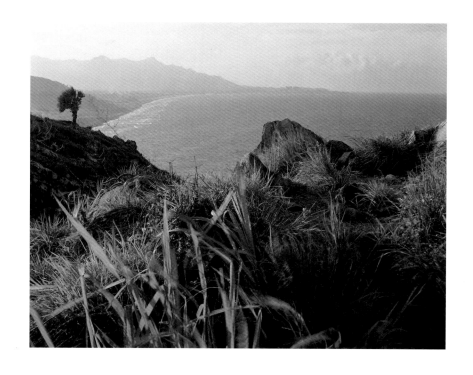

Traveling the Shore of the Spanish Sea

Traveling the Shore of the Spanish Sea

The Gulf Coast of Texas & Mexico

GEOFF WINNINGHAM

TEXAS A&M UNIVERSITY PRESS • COLLEGE STATION, TEXAS

LIBRARY OF CONGRESS CATALOGING-IN-PUBLICATION DATA

Winningham, Geoff.
Traveling the shore of the Spanish sea : the Gulf Coast of Texas and Mexico /
Geoff Winningham. — 1st ed.
p. cm. — (Charles and Elizabeth Prothro Texas Photography Series ; no. 9)
Includes bibliographical references and index.
ISBN-13: 978-1-60344-161-2 (cloth : alk. paper)
ISBN-10: 1-60344-161-1 (cloth : alk. paper)
1. Winningham, Geoff—Travel—Texas—Gulf Coast. 2. Winningham, Geoff—Travel—
Texas—Gulf Coast—Pictorial works. 3. Winningham, Geoff—Travel—Mexico—
Gulf Coast. 4. Winningham, Geoff—Travel—Mexico—Gulf Coast—Pictorial works.
5. Gulf Coast (Tex.)—Description and travel. 6. Gulf Coast (Tex.)—Description and
travel—Pictorial works. 7. Gulf Coast (Mexico)—Description and travel.
8. Gulf Coast (Mexico)—Description and travel—Pictorial works.
I. Title. II. Series: Charles and Elizabeth Prothro Texas Photography Series ; no. 9.
F392.G9W56 2010
917.64'10464—dc22
2009023278

Maps by Janice Freeman

CAPTIONS FOR FRONTMATTER PHOTOS
page i: Playa Escondida, Veracruz
page iii: Villa Rica, Veracruz
page iv: Lighthouse at Punta Mancha, Veracruz
page vii: Playa Escondida, Veracruz
page viii: Laguna Madre at Carvajal, Veracruz
pages xii–xiii: Playa Escondida, Veracruz
pages xiv–xv: White Ranch, Chambers County, Texas

*The author expresses his deepest appreciation
to Jim Jard and to
Bracewell & Giuliani LLP
for providing the early support
that made this book possible.*

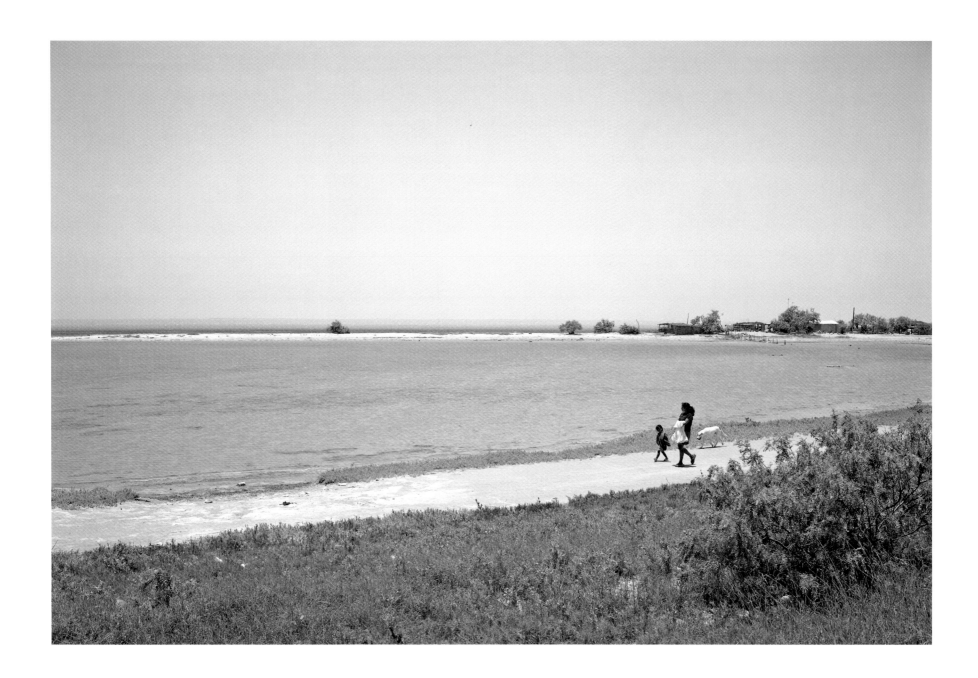

This book is for Janice,
my heart's traveling companion,
for the joy she has brought to our life together;
and for Max, our dear son.

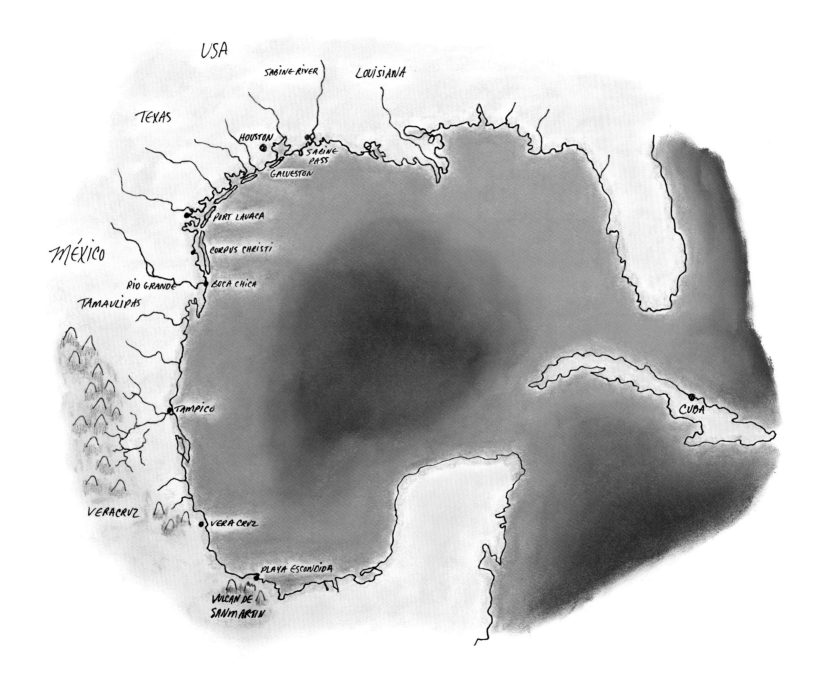

Table of Contents

Preface xiii

PART 1: Sabine Pass to Galveston Bay 1

PART 2: Galveston to Port Lavaca 43

PART 3: Indianola to Boca Chica 93

PART 4: Matamoros to Tampico 149

PART 5: Tampico Alto to La Antigua 199

PART 6: Veracruz to Playa Escondida 247

Acknowledgments 335

Bibliography 337

Index 339

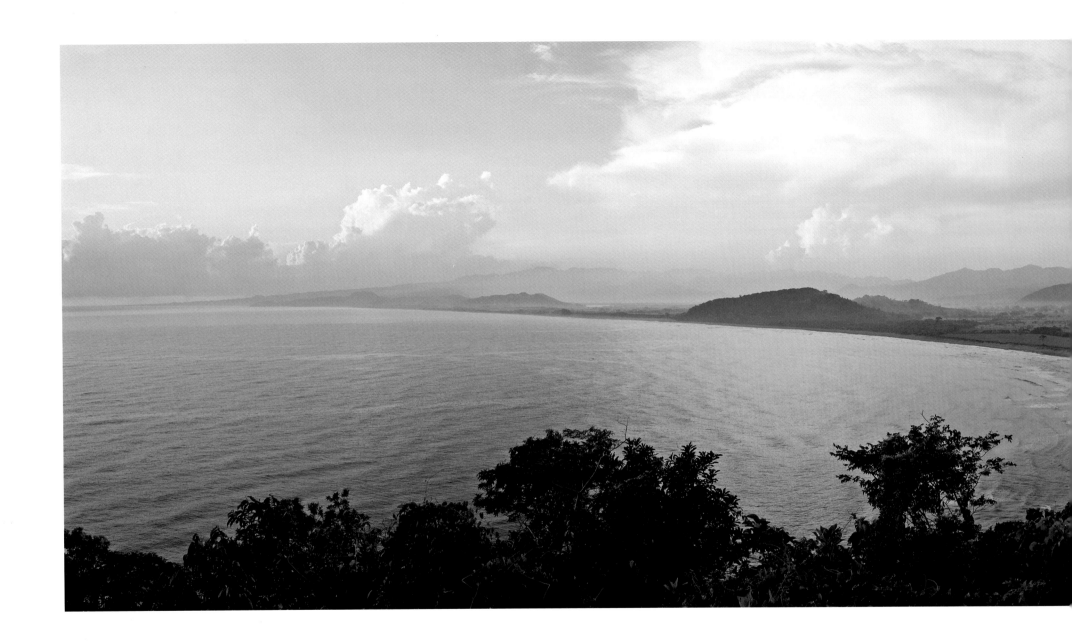

Preface

IN JANUARY OF 2003, I traveled for the first time to the southern Gulf Coast of Mexico. The blue waters, tropical forests, and rugged mountains overlooking the sea were as beautiful as any coastal landscape I had ever encountered. Yet I had never seen a single photograph nor heard anyone describe this part of the Mexican coast. A few months later, on the Texas coast near the Louisiana border, as I photographed the historic White Ranch, I was impressed by the perfect flatness of the horizon and the endless waves of salt grass. It occurred to me that these two areas could be the beginning and the end points of a landscape study that would also encompass the two cultures I was involved with, the United States and Mexico.

My original idea was a simple and straightforward one: to photograph the western shore of the Gulf of Mexico, including Texas and the Mexican states of Tamaulipas and Veracruz. From the beginning, there were three things that interested me. First, I wanted to make a visual record of the natural landscape of the coast at this point in time. As far as I knew, no one had photographed the landscape of this coastline—from the coastal plain of Texas to the mountains of southern Veracruz—in a continuous and comprehensive way, and I wanted to make a contemporary visual record of it.

Second, the history of the coast fascinated me, particularly the crucial role the Gulf of Mexico played in the discovery and exploration of the New World. Robert Weddle's *Spanish Sea,* along with a dozen other books on the history of the Gulf of Mexico, became my constant companions as I traveled and photographed.

In structuring my previous book, *Along Forgotten River,* I juxtaposed my contemporary photographs of the landscape along Buffalo Bayou with historical texts taken from the writings of the earliest travelers to see the same landscape. I was pleased with the result, so I began to look for a way to do a similar thing with the Gulf Coast, to let the rich history of the Gulf resonate with the contemporary photographs I was doing. I set out to find historical texts and documents related to the Gulf Coast and to weave them into a book along with my photographs.

My third interest was to take photographs of particular aspects of the

two cultures that have developed on the coast. I would photograph whatever I encountered along the coastal roadways, with particular attention to vernacular architecture, signage and other iconography, and the people I encountered as I traveled. Photographing along the coastal highways of the two countries, I decided, would offer a structured way of looking at and comparing the physical cultures of the United States and Mexico.

About a year into the project, I realized that what I was doing was photographing the coast of New Spain, five hundred years after the discovery of the New World. Two years ago, after four years of photography and many hours in the library, I finally gave up on the idea that the text of the book could be derived from historical sources. The first problem was that I simply couldn't find what I needed in historical sources. I wanted a text that worked well with the photographs while telling the history of the coast, but what had worked for the landscape along Buffalo Bayou would not work for the coast of New Spain. More importantly, as I traveled, I encountered people and heard stories that could not be captured in photographs; yet these stories begged to be told. I decided to write a narrative of my travels.

In over a thousand rolls and several hundred sheets of color film, I have photographed the Gulf Coast from Sabine Pass (at the Texas/Louisiana border) to the southern tip of Veracruz. For the sake of continuity, I have merged all of my travels along various parts of the coast—a hundred trips, at least—into one continuous narrative. The journey begins in Port Arthur, Texas and concludes, almost fifteen hundred miles down the coast, at the end of an old stone road through a rain forest, just outside of Monte Pio, Veracruz. As surely as Port Arthur presents a disturbing and cautionary tale for the twenty-first-century traveler, this ancient road, through a tropical landscape of indescribable natural beauty, is the closest thing I can imagine to the Garden of Eden.

During the last year or so of the project, as I returned to photograph again some of the most interesting spots along the coast, I found myself trying to come to terms with the disturbing changes I had observed over the course of this project. For this reason, in addition to describing what I saw along the coast, the people I met, the adventures I had, and the history that was always swirling around in my head—in addition to all that—a personal lament found its way into the story, a sense of loss for a landscape that is rapidly disappearing.

PART 1: *Sabine Pass to Galveston Bay*

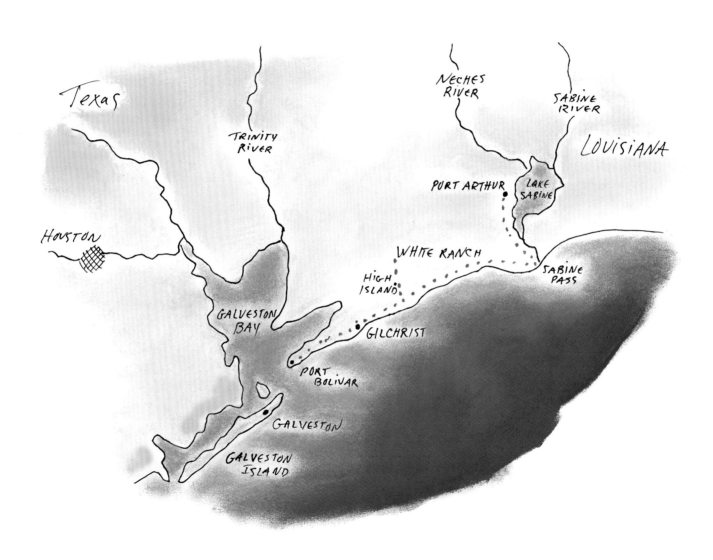

*I*T'S EARLY IN THE MORNING, the middle of May, and rain showers are starting to fall from a bright sky of broken clouds. I am driving north in heavy traffic, inching along the freeway that skirts the western side of downtown Houston. To my right, sunlight flashes between the buildings of the city skyline. Plumes of white vapor rise from the peaks of the tall buildings and trail off into the clouds, like smoke from a dozen campfires atop a distant mountain range.

I am looking for the exit to the east freeway, trying to keep my attention on the road, but the skyline of the city—refracted through the morning rain and sunlight—compels me to keep looking up and to my right.

The freeway bears east around the north side of the city, where another image catches my eye. The brown waters of Buffalo Bayou, swollen from the rains of the past few days, swirl below the roadway. On an overpass, just a hundred yards to my right, cars and trucks are circling the city, moving barely above the rushing water. Dense foliage and thick vines climb up from the water to the very edge of the city streets. Houston is going to make a magnificent set of ruins one day.

My reverie is broken by the sound of honking horns behind me. I flick the steering wheel and exit onto Interstate 10. As I do, an image of the city skyline appears for an instant in my outside mirror, my last glimpse of downtown Houston as I head east toward the Texas Gulf Coast.

I drive eastbound on the interstate highway, along with a growing number of tanker trucks and eighteen-wheelers. The urban landscape flashes by in a blur of signs and storefronts—Godfather Bail Bonds, Star of Hope Mission, Family Dollar Store—then, as the freeway takes me through the east side of Houston, the language of the signs changes from English to Spanish—Ostioneria Siete Mare, Bienvenidos BiRite, Iglesia Methodista, Una Nueva Vida. I pass Jacinto City and Galena Park, endless strip malls, billboards, service stations, and storefronts—U-Store-It, Assemblies of God, Slick Willie's Pool Hall, Golden River Chinese Buffet, Discount Mufflers, Jim Adler The Tough Lawyer, Taqueria Lopez, Royal Palace Cabaret—and an entire house passes me in the left lane, a one-story white home, loaded on a flatbed trailer, eastbound at seventy miles an hour.

Finally, the city begins to fall behind me, and a marshy landscape opens up on both sides of the highway. Beyond the Crosby-Lynchburg exit, industrial and maritime facilities line the freeway. To the south, I can see the eastern end of Buffalo Bayou winding through a maze of refineries, flowing toward the Port of Houston and Galveston Bay. Through heavy haze, the San Jacinto Monument stands like a huge stake driven into the banks of the bayou. It towers above the refineries and the docks, marking the site of the Battle of San Jacinto. It was there, early on the morning of April 15, 1836, that the army of the Republic of Texas, under General Sam Houston, surprised the Mexican forces under Santa Anna and won Texas' independence from Mexico.

Past Baytown, the landscape changes again. Tall pine trees line the access roads to the freeway, and rolling green prairies stretch all the way to the horizon. I cross Cedar Bayou and the Chambers County line. On the prairie to the south of the freeway, a subdivision has been plotted and homes are under construction. A sign advertises: "Lanai: Your Idea of Home."

Traffic has increased, and the big trucks have multiplied. An eighteen-wheeler pulls up, six inches to the left of me in the passing lane. A pickup

Dowling Park, Sabine Pass, Texas

truck fills my rearview mirror. The summer rainstorm is getting worse, but no one is slowing down.

As I pass Mont Belvieu, the only rise or fall in the road comes with the bridges over the rivers. Up and over the Old and Lost rivers, then the mighty Trinity River. Long views across the vast coastal marshes of southeast Texas. Around Wallisville and Turtle Bayou, the traffic begins to let up.

Small lakes dot the land on both sides of the freeway—Cotton Lake, Old River Lake, Lake Charlotte, Lost Lake—each with its own islands—Bird Island, Loat Island, and Mustang Island. I have crossed into Chambers County, and I am driving now more over water than land.

Packed away in the back seat of my truck I have a suitcase of clothes and personal items, four bags of camera equipment, about two hundred rolls and sheets of color film, two tripods, several boxes of books—mostly of Texas and Mexican history—notebooks and pencils, a tape recorder, and maps. I have lots of maps. I have road maps of Texas and three coastal states of Mexico: Tamaulipas, Veracruz, and Tabasco. I have topographical maps of the entire Gulf Coast, a road atlas of the USA, and another of Mexico. I have studied these maps for almost a year, planning this trip, dreaming of what I might find in the most remote places along my route.

My destination today is the Texas-Louisiana border, so I exit Interstate 10 onto Highway 73 and head east toward Port Arthur. Thirty minutes later, I cross a bridge over Taylor's Bayou. The rain has stopped now, and the sky has cleared. I stop my truck on the wide shoulder at the top of the bridge and get out for a good look at the landscape.

Below the bridge, Taylor's Bayou, a hundred yards wide, flows south, then takes a sharp turn to the east, passing through a wet, forbidding landscape of tall cane and dense brush. Today, after all the rain, there's hardly a spot of dry land in sight. It's all one huge, swampy marsh. Off to the south, refineries dot the horizon. Their shiny crack towers puff plumes of white vapor into the clear blue sky.

A single fishing boat is docked on the banks of the bayou about a mile away, and my mind turns to the unforgettable saga of François Simars de Bellisle, almost three hundred years ago, in these very same swamplands.

. . .

Bellisle set sail from France in 1719, a twenty-four-year-old officer on a French West Indies ship, bound for Louisiana. The ship's captain, upon entering the Gulf of Mexico, became lost, overshot the Mississippi River, and finally ran aground, probably near Galveston Bay. Bellisle and four companions were sent ashore in hopes of ascertaining their position or finding help. While the men were ashore, the ship floated free and sailed away, leaving the five Frenchmen stranded on the coast.

Carrying a couple of guns, but very little ammunition, the men walked up and down the coast, surviving at first on the game they were able to kill. Looking for landmarks, they walked north almost to the Sabine River—perhaps across the very land I was surveying at the moment—before they became mired in mud up to their necks and eventually turned back to the southwest. Winter came, the men ran out of ammunition, and one by one they died of starvation or exposure, until only Bellisle was left. Later, he would describe his survival in vivid detail. He scavenged oysters when he could find them; he boiled grass and consumed it. He even roasted and ate huge yellow worms "as long as a finger," which he collected from driftwood along the beach. Finally, he encountered a band of Atakapan Indians on a small island. They robbed him, stripped him of his clothes, beat him, and forced him to carry their burdens.

Through all this, for almost two years, Bellisle survived. He would later describe being dragged along by the Atakapans as they hunted deer and buffalo and dug for "wild potatoes." He provided a firsthand account of their cannibalism, describing how the Atakapans caught one of their enemy, skinned him, cut off his head and arms, and then "devoured him completely."

Finally, Bellisle was able to send out a note, a plea for help, with another tribe that came to the Atakapan camp. The note, addressed to "the first white man," passed from one tribe to another, and then, miraculously, was delivered to the French fort at Natchitoches, Louisiana. The French commander sent a party of Hasinais Indians, who rescued Bellisle from the Atakapans.

Bellisle eventually acquired a plantation near New Orleans and re-
mained in Louisiana until 1762. There he composed his *Relación,* in which
he recounted his wanderings and adventures on the Gulf Coast. He wrote:
"I must not forget the country I saw during this journey. . . . This is the
most beautiful country in the world."

• • •

A mile or two ahead, the Sabine River—the border of Texas and
Louisiana—flows south, past Port Arthur, where it merges briefly with
the Gulf Intracoastal Waterway, then on to Sabine Pass, where it empties
into the Gulf of Mexico. The Sabine River will be the northeastern bound-
ary of the coastline I will travel, the starting point from which I'll go south
and west along the Gulf. I will cover the entire Texas coast, six hundred and
twenty-four miles in all, then I will cross the Rio Grande and travel at least
an equal distance along the Mexican coast.

Right now, I want to start by making some photographs that describe
the landscape around me. I need a high vantage point, and right away I see
it. Directly in front of me, past the intersection with Highway 87, a bridge
rises in a high arch over the Sabine River.

The Gulfgate Bridge, it turns out, was not designed for foot traffic.
There is no pedestrian lane on either side, only about a foot and half of
space between the traffic lanes and the huge steel pipes that frame the out-
side of the bridge. As I hike up the incline, I slide along the steel pipes in
order to stay clear of the oncoming traffic. Near the top, at least a hundred
and fifty feet above the riverway, I set up my tripod and back against a steel
girder. Then I open the camera's shutter, throw the dark cloth over my head,
and rotate the camera in a counterclockwise direction, studying the land-
scape on the ground glass. Every direction, every angle, offers an interesting
view and good picture possibilities.

Clouds have returned to the sky, but the landscape glows with direct
sunlight near the southern horizon. The rest of the land is softly illuminated
under a canopy of white clouds. A residential neighborhood of simple, one-
story frame houses lies directly in front of me, just beyond the base of the

View to the northeast from Sabine Pass, Texas toward Louisiana

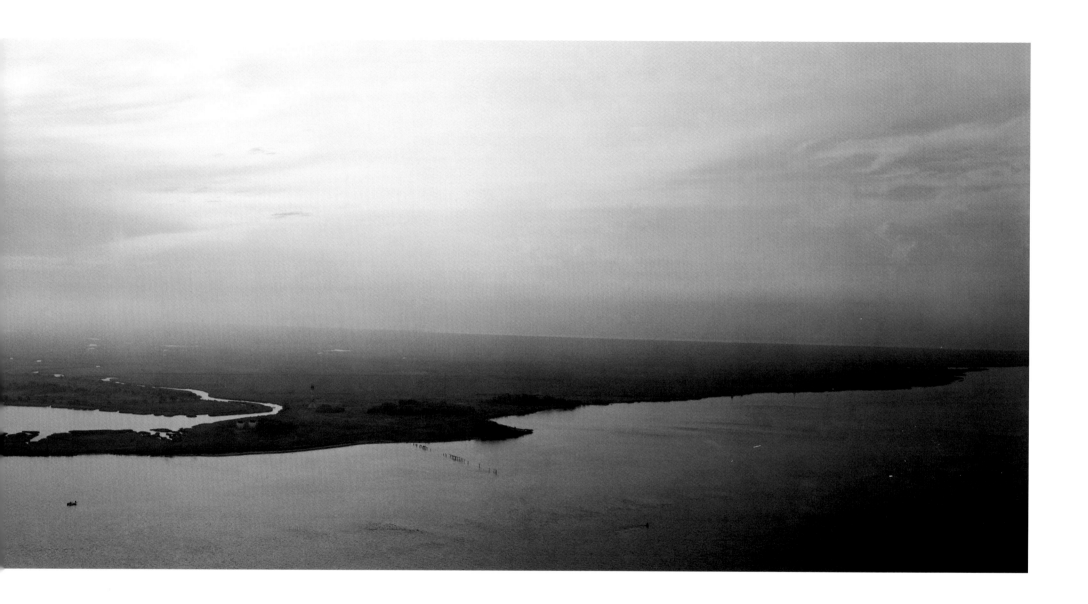

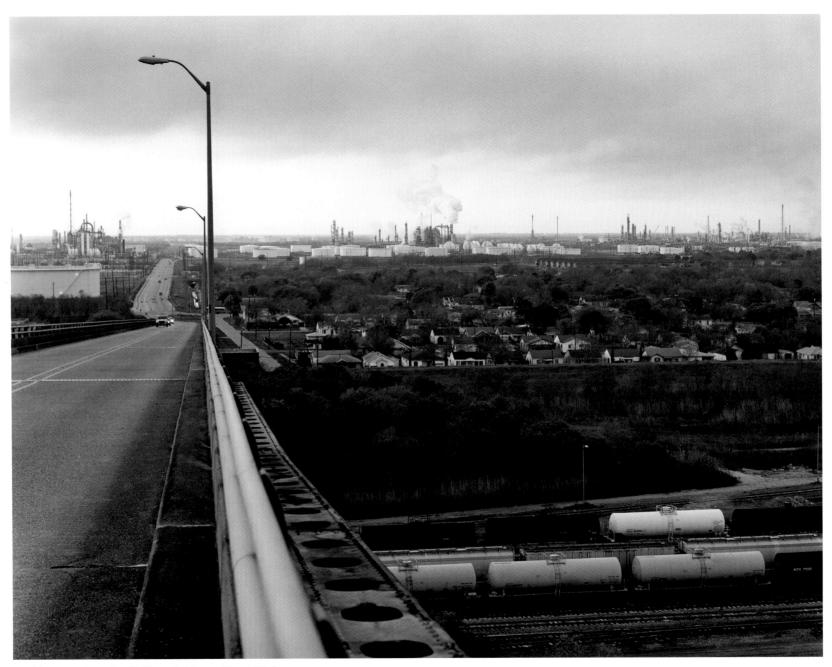

Looking west from the Gulfgate Bridge on Texas Highway 73

bridge. Oil refineries crowd the horizon line beyond the neighborhood. As the afternoon rush hour approaches, traffic on the bridge increases. Every ten seconds or so, a car or pickup truck speeds past me, and the bridge shakes.

I can identify the expanse of water over my right shoulder and behind me as Lake Sabine, so large it totally fills the landscape to the east. Downtown Port Arthur is directly to my right. Wharves and docks line the river—the Sabine-Neches Waterway, it's called at this point—which flows directly toward me from the north, under the bridge, then due south, bound for Sabine Pass and the Gulf of Mexico.

Enormous oceangoing barges, three hundred yards or more in length, glide down the waterway and pass under the bridge. One barge is so big it gives me a dizzying, disorienting sensation as it passes underneath. For a few seconds I have a sensation that the barge itself is still, anchored in the water, and the rest of the world, including the bridge, is moving past it, as though I can see and feel the earth's rotation. Then, as I look off into the distance and back at the barge, the sensation passes. The barge moves on downstream, under the bridge and south, past the railroad tracks and tanker cars, past the refineries, and off toward the Gulf Coast.

Down from the bridge and back at my truck, I decide to have a look at Port Arthur before I drive south to Sabine Pass. I have read much about the history of the place: what a great, thriving city it once was, how the discovery of oil at Spindletop had brought prosperity and notoriety. But I know nothing about Port Arthur today.

I turn right onto Reverend Ransom Howard Street and cruise through a black, lower-middle-class neighborhood. The Love Center Church of God in Christ, a handsome white frame building with a matching sign in front, advertises "Services Every Day of the Week." An African American gentleman in a white, open-collared shirt—perhaps the Reverend Ransom Howard himself—is just getting out of his shiny black Cadillac in the driveway beside the church. He waves at me as I drive past, as though I were a member of his congregation.

On the next corner, half a dozen cars sit parked around the West Side Food Store ("Milk—Ice—Lotto—Money Orders"), a sky-blue, shingled structure. Business seems to be brisk. The first dozen or so blocks of Seventh Street look good enough, but before I cross the railroad tracks, the appearance of the neighborhood changes abruptly. Two warehouses of the Port Iron & Supply Company sit roofless and ragged. Their sheet metal roofs have been ripped away, doubtless by the winds of last year's Hurricane Rita.

At Houston Avenue I find myself on the edge of downtown Port Arthur. I take a right turn and pass an entire block of handsome old brick buildings from the 1920s. They are all abandoned, though, most of them stripped of their doors, windows, and roofs. The Golden Light Social Club, at the corner of Fifth and Houston, is boarded and locked.

Proctor Street appears to be the main street of Port Arthur and offers a view straight through the middle of town. I can see for twenty blocks or more down the street, but there's not a single person or moving vehicle in sight. The Hotel Sabine stands about twelve stories high on the east side of Proctor, a plywood barricade surrounding the deserted building. On the opposite side of the street, the ornate old Port Arthur Savings Building, with carved stone columns and elegant brass handrails, is locked tight, its windows boarded. Grass grows two feet high in the cracks of its stone front steps.

Port Arthur looks like a ghost town.

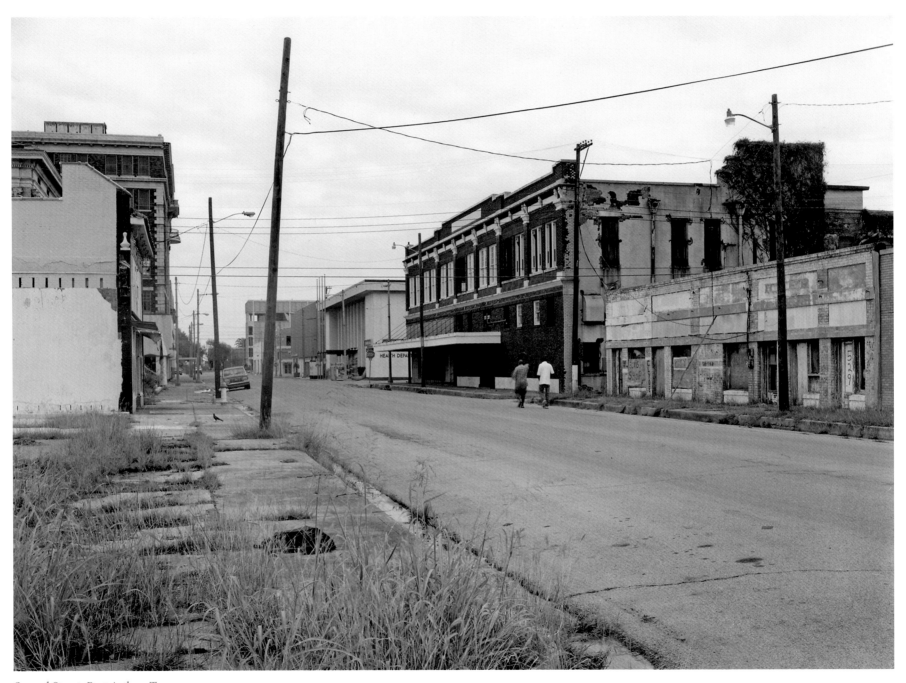

Second Street, Port Arthur, Texas

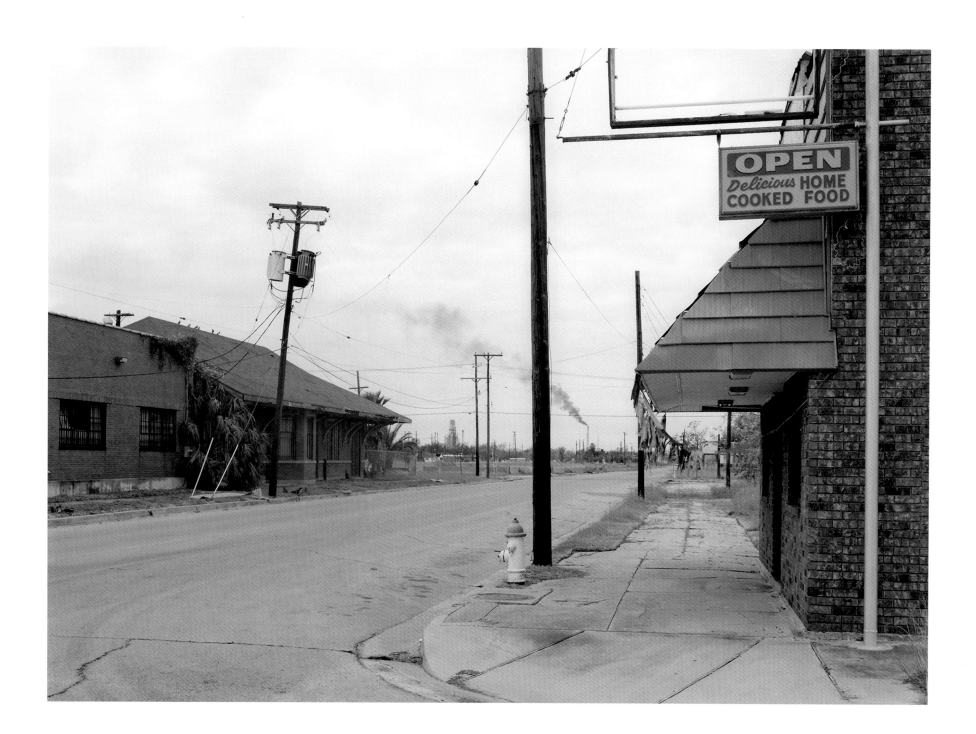

I notice a city bus coming toward me down Proctor Street. A moment later I see one man walking north along the sidewalk. I cruise slowly down Proctor, looking for more signs of life. EJ's Club is open and the Rescue Me Car Wash is in operation. Two young black men are polishing and vacuuming a Port Arthur police car.

Just down from EJ's, on the same side of the street, I discover what remains of the Regency Club, one of the legendary night clubs, as I recall, from Port Arthur's glory days. I remember hearing stories of headwaiters in white gloves, fine dining, elegant gambling facilities, and a world-famous brothel upstairs. The sign still hangs over the sidewalk, a red carpet in neon. But the neon sign is dark, and the doors to the Regency Club are chained shut.

I park my truck and walk north on Proctor. Past the abandoned Hotel Sabine, I arrive at the Museum of the Gulf Coast. There are cars in the parking lot, and the place seems to be open for visitors.

The receptionist, a gracious lady with a beehive hairdo and a rich East Texas accent, greets me as I step through the door: "Well, howdy there. Come on in and make yourself at home." She accepts my five dollar admission fee with a smile and points me to the first gallery. My attention, right away, is drawn to a mural covering the entire north wall of the museum, two stories high. A wall label describes how the one-hundred-and-twenty-five-foot "mural/diorama" was painted by Travis Keese and Melinda Dickinson. The mural blends, in one grand sweep, the history of the Gulf Coast, from the Paleozoic Age to the twentieth century. In the beginning, pterodactyls fly through the skies over an ancient ocean. At the far end of the mural, oil gushes forth at Spindletop as a crowd of people look on in wonder and astonishment. This is a mural with a clear message: petroleum is nature's gift to the people of the Gulf Coast.

I study the displays on the first floor and learn about estuaries, bayous, tides, and avian species of Texas. The intermingled histories of Texas and Mexico are sketched out in maps and narratives. There are old maps of the Gulf Coast, going all the way back to 1513, reproductions of them, at least, all framed and nicely labeled. But what really gets my attention is a portrait of the founder of Port Arthur, Arthur Stilwell, along with a narrative summary of his life.

Stilwell was a successful businessman, financier, and philanthropist, as well as a published writer of novels, poetry, and songs. He described himself as a "spiritualist," attributing both his successful business decisions and his creative writing to advice he received directly from the spiritual world. "Brownies" spoke to him, he attested, as he slept. In the 1890s, as he was laying out the Kansas City, Pittsburg and Gulf Railroad, Stilwell said he was advised by his spiritual voices to "locate your terminal city on the north shore of Lake Sabine . . . for Galveston will someday be destroyed." Stilwell did as the voices advised him and purchased 53,000 acres of land, right there on Lake Sabine.

Envisioning his future city as both a crucial port and tourist attraction, Stilwell had a twelve-foot deep channel dredged though Lake Sabine, connecting the town site with the gulf. Then he began construction of a huge, Victorian-style hotel on a bluff overlooking the lake. Surrounded by a park of rare, tropical plants, the seventy-room Sabine Hotel offered its guests a quarter-mile pleasure pier extending from its gardens out over the lake. The hotel, gardens, and pier were all lit at night by arc and incandescent lights.

Stilwell's vision of Port Arthur as a major port and a tourist attraction on the Gulf Coast was quickly realized, but short-lived. A storm swept in and flooded the town streets. Pigs, cattle, alligators, snakes, and local residents all swam for high ground, eventually making their way to the hotel. The hotel provided safe refuge for those who were able to make it there and survive the storm intact. Then the rebuilding of the town began, a story that was destined to be repeated, with minor variations, several times over the next century.

Still, despite the storms that swept over the area through the years, Port Arthur proved to be a progressive and growing city, particularly in the years from 1890 to 1920. But by the end of the nineteenth century, Stilwell had lost control of his enterprise to the promoter John W. Gates. In 1901, oil was discovered at the nearby Spindletop field, ushering in the modern age of petroleum and changing Port Arthur irreversibly. A sign posted on Highway 87, as you enter the city today, says it best: "Port Arthur: We Oil the World."

There are some old photos in the museum, describing the quality of life in Port Arthur during those progressive years. My favorite is a mural-sized print, about four by five feet, that shows the "main drag" of Port Arthur—

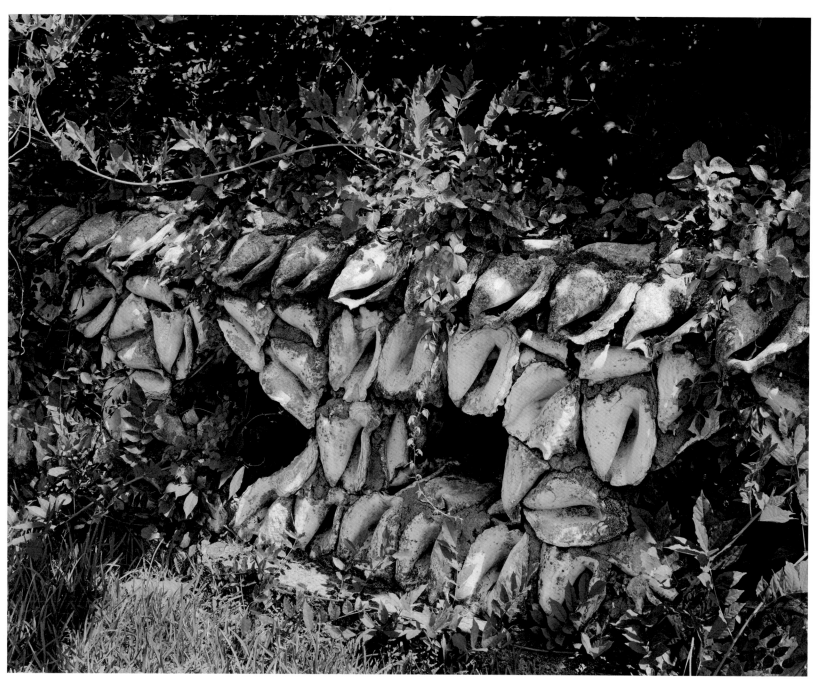

Shell wall, Edington Courts, Proctor Street, Port Arthur, Texas

today's Proctor Street—in 1897. Buggy tracks have grooved the center of the muddy street, a restaurant sits off to the right side, and several bonneted women are entering the Jefferson County Real Estate office on the left. A narrow footbridge has been improvised out of wooden planks, laid out from one side of the street to the other, offering pedestrian passage over the muddy street.

Another photograph, an eight-by-ten glossy print, "ca. 1910," shows a huge sperm whale—probably sixty or seventy feet long—dead on the beach at Port Arthur. All around it, a dozen men in business suits and ties study the carcass from various angles. I didn't even know there were sperm whales in the Gulf of Mexico.

A third picture, from about the same time period, shows two men—in shirt sleeves, neckties, and suspenders—standing on a city street in downtown Port Arthur. Between them, swinging from the window of an office building, hangs an enormous sawfish, perhaps twelve feet in length, a monstrous thing from the depths of the sea. One man holds a fishing pole; the other, a rifle.

As it turns out, very few visitors to the Museum of the Gulf Coast even pause on the first floor. Most proceed directly to the second floor to see what amounts to a shrine dedicated to Port Arthur's most famous citizen: Janis Joplin, the great blues singer, who was born and raised in Port Arthur. Her 1952 Porsche convertible—an "art car" of sorts, covered in hand-painted, psychedelic landscapes—sits in the place of honor on the second floor of the museum. I am studying one of the groovy landscapes painted on the side of the car when a museum guard approaches to inform me that bricks from Joplin's original home on Proctor Street are for sale in the gift shop. Each brick, he assures me, comes with a certificate of authenticity from the museum. When I don't jump at the offer, the guard introduces himself—B. J. Broussard is his name—and then asks if I have seen the "Rash'nberg room."

Robert Rauschenberg, one of the great American artists of the twentieth century and a sort of rock star in his own right, is another famous Port Arthur native. With Mr. Broussard's encouragement, I have a quick look at the twenty-five or so Rauschenberg paintings and collages in the museum collection. By now it's almost noon, and I have spent most of the morning in the museum. Back out on Proctor Street, I see that Coyo's Bar and Grill is opening for lunch. There's no need to wonder what's being served. A lady is spelling out the menu in red plastic letters on a sign out front: "Catfish, Red Beans, Rice. $3.99."

"Whatcha drinkin?" is the only question I need to answer as I place my order at Coyo's. Framed and hanging on the walls are football programs from Port Arthur Yellow Jackets games, dating back to the glory days of the 1940s, plus pictures of John Wayne, the Three Stooges, and Alice in Wonderland. As I eat lunch, I try to put together the story of Port Arthur: the visionary founding, the storms that set the town back, the prosperous times around the turn of the century, then Spindletop comes in, and Port Arthur becomes Oil Headquarters for the World. The Regency Club, the gambling and the nightclubs follow. Then what happened? Why does Proctor Street look like a graveyard? Where have all the good times gone?

Driving north along Proctor Street, I pass Lamar State College. The campus extends only two or three blocks to the east, where I can see the tops of tankers and tugboats, gliding along just beyond a levee. In the Lakeshore Historical Area, white antebellum homes, most of them beautifully restored, are gleaming in the early afternoon sunlight. I follow Lakeshore Drive as it parallels the levee, alongside the river. Tankers and tugboats glide by, past the Pompeiian Villa ("last remaining landmark of the 'Dream City'"), then past the old Masonic Temple and all the other reminders of Port Arthur's past.

Lakeshore Drive eventually makes a loop, returning me to Proctor Street, where a low wall, covered in wisteria vines, catches my eye. It's not a brick or stone wall; it's made of conch shell. I stop to photograph the old wall, and I have spent an hour poring over it, studying it from every angle. I'm still under my dark cloth, fully absorbed in the process, when a shrill voice comes from behind me.

"This was Shangri-La. You *know* that, don't you?"

I peek out from under my dark cloth to see a fellow, probably in his forties, dressed in blue jeans and a t-shirt, standing behind me.

"My name's Steve Vasquez, I live here. Who are *you?*"

I introduce myself, and Steve continues: "Everybody knows the story. The fairies told Stilwell that Galveston would be destroyed, to build his

fabulous city *here,* and he did. And they were right of course, the fairies. A few years later, the storm took out Galveston. Only the fairies didn't warn Stilwell about Spindletop, so here it comes and WHOOSH, the whole place is swimming in oil. So it's looking good for a while. All that oil brought us a lot of money, but look at where it's got us now. The air stinks. People are dying of cancer. Everybody that can has left town, and the only people with any money are the damn *lawyers,* who are getting rich suing the oil companies and refineries. So much for Shangri-La. Shangri-La is *history."*

I have a feeling that Steve could talk about this for a long time, but I have my picture of the shell wall now, and the mid-afternoon sunlight is looking better and better. So I decide to push on, promising to talk with Steve again later.

I turn around and start driving back south on Proctor Street, hoping to make it to Sabine Pass before dark. A secondhand store on the corner of Lake Charles Street catches my eye: "Mary's Corner. Buy Sell Trade." Used tables, chairs, old paintings, and a couple of wooden church pews are sitting out front on the sidewalk.

Mary Pierce is wearing blue jeans and a black sweatshirt with a message printed across the front of it: "When the going gets tough, the tough use duct tape." She is sweeping the driveway in front her store, a converted gas station, where she offers her collection of secondhand goods. Mary sees my camera and asks me what I'm taking pictures of.

I tell Mary that I'm looking for pictures that give you the essence of a place, like that shell wall I just photographed down the street, and photographs that give you the history of a place.

"Well, then, you better get over to Jerdy's Barber Shop," Mary says, "I gotta feelin you might like what Jerdy's done."

Mary stops sweeping and points across the street, where a dozen or more men are piling out of an old Dodge van and entering a big, ramshackle house on the corner.

"Mexicans," she says, "straight outa Mexico. On the way to New Orleans, most likely." Mary tells me that she has seen thousands of men and women come through town since Hurricane Katrina struck New Orleans a few months ago. They arrive almost every day, one or two vans full of people. They stay overnight in the old house across the street on the corner, but they leave in the morning before dawn. They try to stay off the interstate as much as they can, but they are on the way to New Orleans to work in the massive cleanup after the hurricane.

I listen for a sense of anger or prejudice in Mary's voice, but I hear none, so I ask her what she thinks of all these Mexicans coming through Port Arthur.

"Ain't nobody else gonna clean up that mess in New Orleans. The work's too hard. I mean, you got to admire those people. Me, I think we need 'em, and I know they need the work, so god bless 'em. That's what I say."

Leaving Mary's Place, I continue south, eager now to get on the highway to Sabine Pass. As I pass the museum and Coyo's, I decide to stop and take one last picture of the old Port Arthur Savings building. As I'm photographing, a man in a white jacket steps around the corner and calls to me: "Hey! You wanna SEE something?"

His question sounds like a proposition. Like he has adult movies to show me.

"See *what?"* I ask.

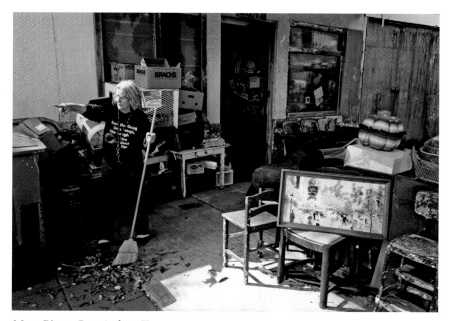

Mary Pierce, Port Arthur, Texas

"Well, why doncha just come around here and see for yourself. I'm Jerdy. Jerdy Fontenot. Come on." With that, he turns and starts back around the corner. I follow him with my view camera and tripod. Jerdy, who I have already guessed is the barber that Mary had mentioned to me, opens an old, wooden screen door and ushers me into his barbershop.

My first reaction to the tiny, one-room barbershop is one of simple shock. When the shock passes, my first clear thought is: I have found the *real* Rauschenberg of Port Arthur. The walls of Jerdy's barbershop are one continuous, mind-bending collage of thousands upon thousands of photographs, news clippings, calendars, and printed material of all kinds.

Two old-fashioned barber chairs sit in the center of the one-room shop, their leather seats patched and repatched many times over. Mirrors cover the wall opposite the entry, and six chairs, upholstered in red Naugahyde, rest against the wall to the right. Two fans hang from the ceiling, one over each barber chair.

Virtually every square inch of the four walls is covered. There are news clippings, wedding portraits, snapshots of fishermen with their catch. There are Playboy pinups, portraits of virtually everyone who made the news over the past sixty years. There's Willie Nelson, Erin Brockovich, Rudolf Valentino, and Andy Williams. Monica Lewinsky, Howard Hughes, Ingrid Bremen, Roy Hofheinz, Rosemary Clooney, and Hitler. And Janis Joplin. Lots of pictures of Janis Joplin.

"Oh, she used to come in here with her dad," Jerdy tells me. I lean over to have a close look at one of the pictures of Joplin, which has been collaged with a photograph of Jimi Hendrix. "You know a lot people just assume Janis Joplin left Port Arthur because she didn't like it here, but that's not why she left. You know why she left? I can show you why she left. See here . . ." Jerdy reaches for a well-worn issue of *Playboy,* flips it open to a marked page in an interview with the rock star and reads: "At fourteen I had no tits."

"See, she's tellin you right there what the problem was. She was an underdeveloped teenage girl, and of course she was self-conscious about it. So she left. Wasn't no problem with Port Arthur. No problem at all. Not long after that, after she died, the whole family moved away, and that was too bad. You know, parents can't take account for the way kids turn out."

I can't stop looking at the walls of Jerdy's barbershop. I scan from one image to another, marveling at the sheer randomness of it all. There's Betty Grable's legs next to a picture of the Brooklyn Bridge. The Port Arthur Lions Club Minstrels of 1950, parading down Proctor Street ("Five Shows This Week"). An original official program from the Grand Opening of the Astrodome ("Eighth Wonder of the World"), dated 1965, and an article from the Dallas *Tribune* showing the route of the JFK motorcade on the day of his assassination.

What finally holds my attention is a collection of about a dozen hand-colored postcards of Port Arthur from the 1930s: the Interurban Trolley and various notable buildings on Proctor Street, the opulent Newport Bar, and the Million Dollar Pleasure Pier.

"It was a GREAT town in those days, Port Arthur was," Jerdy says, gazing wistfully at his postcard collection.

"So what happened?" I ask.

"The do-gooders, I call 'em. That's what destroyed this town, and a great town it was. Do-gooders." Jerdy's voice rises with each word, and then he screams it out: "DO-GOODERS. That's what it was that brought this town down. Do-gooders tryin to make a *name* for theirselves," Jerdy points to a yellowed newspaper clipping on the wall. "It's all right there. You can read it for yourself."

The article on the wall recounts the saga of the James Commission. Appointed in 1957 and given powers by the Texas legislature to investigate alleged corruption, the commission sent undercover agents into Port Arthur. By the fall of 1960, state law enforcement officers were raiding brothels and gambling operations in the city. Televised hearings followed, and the local officials found themselves under fire for kickbacks and alleged mob connections. The county sheriff eventually resigned under pressure, and two competing grand juries fixed prominent citizens and their local business activities in Port Arthur squarely in their sights. State representative Tom James was trying to ride a campaign to clean up corruption in Port Arthur all the way to the office of attorney general. Waggoner Carr had done it with a campaign to clean up Galveston, and James appeared to be doing the same with Port Arthur.

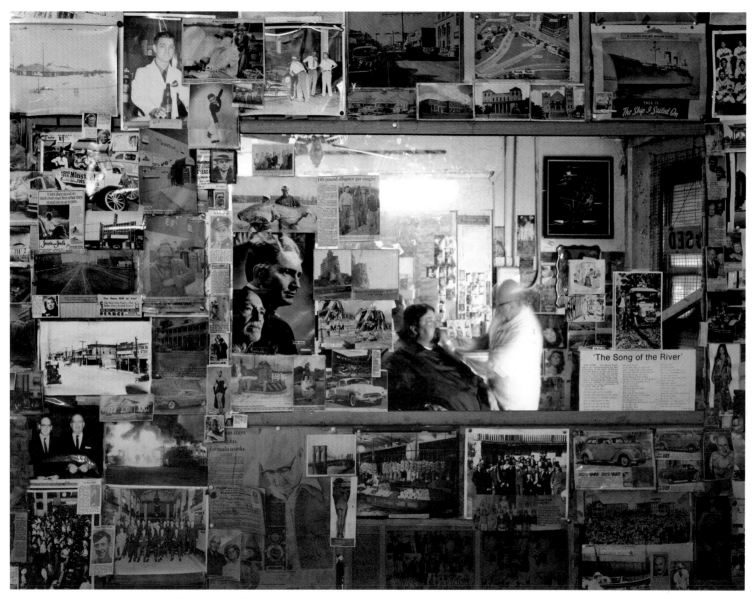

Jerdy's Barber Shop, Port Arthur, Texas (and following two pages)

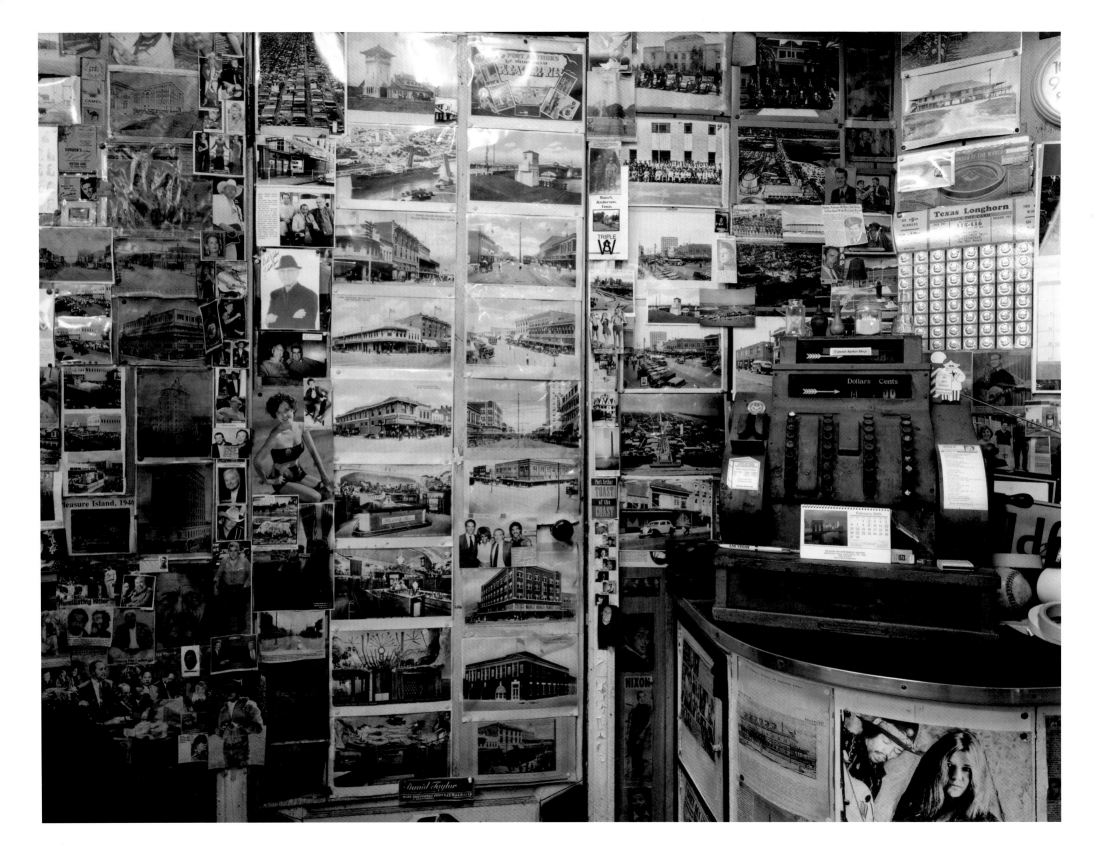

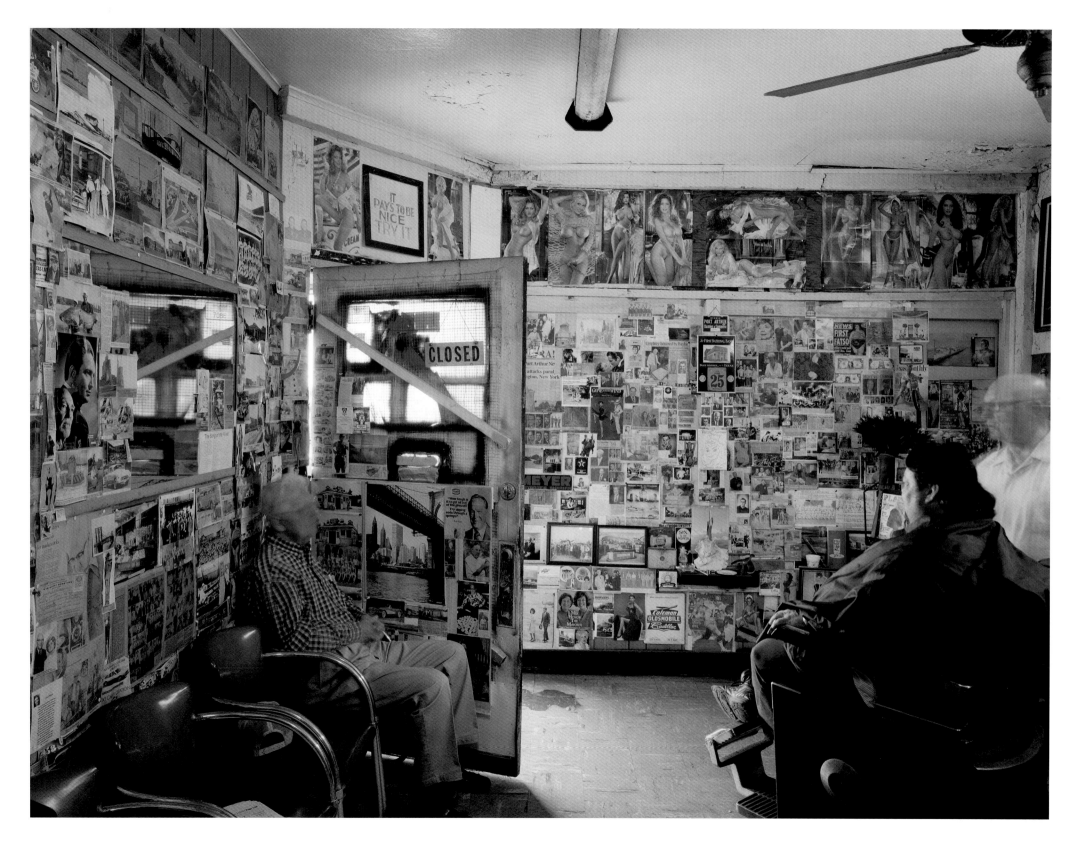

As I read the old newspaper piece, Jerdy seems to calm down a bit. Soon he's sitting in one of his barber chairs, looking out the door, and reminiscing.

"The world was comin to Port Arthur in those days 'cause it was an open city. You could find anything you wanted. You could gamble. You could party. You could have your choice of women. The only thing you couldn't find was a parking place downtown.

"Sailors from all over the world was waitin to get back to Port Arthur. This was what they lived for. And that's what the do gooders destroyed. Look outside now. Not one car, not one person in sight."

After I take a few pictures of his shop, I leave, promising Jerdy that I will return with copies of the photographs. I glance at my map, checking my route to Sabine Pass, and I notice my old friend, Interstate 10, a bold red line drawn due east out of Houston. If that line continued straight to the east, it would pass through Port Arthur, but it doesn't. Instead, it bears north, toward Beaumont, leaving Port Arthur out of its path by thirty miles. Perhaps as much as anything else, I'm thinking, that's what killed Port Arthur.

Back on Highway 87, I drive south toward Sabine Pass. The highway leads through the middle of a cluster of refineries: Premcor, Chevron Phillips, Valero. Tanker trucks are pulling into the highway every hundred yards or so. I have read that almost twenty percent of the country's refinery capacity is located right here between Port Arthur and Sabine Pass, and this afternoon the air has the foul, pungent smell of gas about it.

It's thirteen miles from the city limits of Port Arthur to Sabine Pass. The highway runs south along the Sabine Neches Waterway for a couple of miles, then the waterway turns due west, becoming the Gulf Intracoastal Waterway, and the Sabine River continues south to the coast. A highway bridge rises over the Intracoastal, offering a view across the marshy grasslands. The Intracoastal cuts a channel that will lead, ultimately, all the way to Brownsville.

Farther south, down Highway 87, the tall columns of offshore rigs rise in the distance. Construction sites for the huge, oceangoing rigs are located all along the waterway. The town of Sabine Pass strikes me as little more than an intersection, but in fact the place has an extensive and interesting history. First known as Sabine City, it was probably laid out in 1836. The company that founded the city included some notable men of the time, including Sam Houston. They expected the town to become a major seaport, rivaling Galveston. By 1847, Sabine City had a sawmill—the only one in the county—and a post office. Cattle and cotton were being shipped out of the port, and its future looked bright indeed. As the Civil War approached, two forts, Sabine and Griffin, were constructed to fight off the Union forces.

Then a series of events transpired that would shape the destiny of Sabine Pass. First, an outbreak of yellow fever broke out in 1862, dissuading the Union forces from occupying the town, but also causing many of the inhabitants to evacuate. The town had a moment of glory in 1863, when a small contingent of Confederate cannoneers, under the direction of the young Lt. Richard Dowling, turned back an attempted invasion of Texas by a flotilla of Union gunboats at the Battle of Sabine Pass. A monument to Dowling and his men still stands in the state historical park south of town. But that brief moment of glory faded with the devastation done by a series of hurricanes. The storm of 1886 leveled the town. Then, hurricanes in 1900 and 1915 blasted away what reconstruction had taken place.

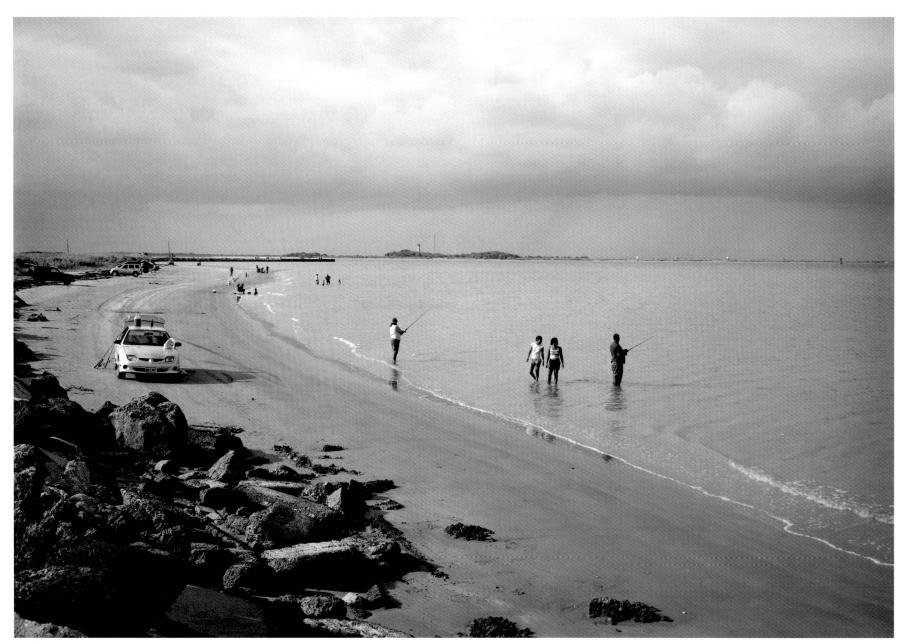

Beach at Sabine Pass, Texas

Sabine Pass after Hurricane Rita

The marine construction industry has somehow survived the wrath of these storms and—judging from all the rigs under construction there—appears to be thriving. There's some commercial fishing, but the place seems to be suspended in an uneasy truce with nature. Several shrimp boats lie marooned in the grass, deposited there, I assume, by the storm surge of Hurricane Rita. A pickup truck sits in four feet of water alongside the road, its hood agape, as though it's gasping for air.

I follow the road as far to the south as it goes; I want to see where the river joins the sea. The pavement ends just past the shipyards of Rowan Marine Services, where a drilling rig as big as a major office building is under construction. A dirt and gravel road continues, barely more than one lane wide, leading along the waterway and through the marshes. Every hundred yards or so, a pickup truck sits on the side of the road, where someone is fishing or crabbing. Finally, the gravel road ends at the Sabine Pilots' station.

From the end of the road I can see the old Sabine lighthouse several miles away. A single white egret stands in the shallow water of the pass, under a blue sky, with one white cloud floating overhead. I frame a picture looking toward the lighthouse, then I feel it's time to leave the Sabine River, the northern boundary of my journey, and start driving south. Back in the center of Sabine Pass, I turn left on coastal Highway 87.

The pavement ends twelve miles out of Sabine Pass, trailing off into a few broken shards of asphalt, then disappearing completely. I find myself driving across sand, dodging trash. A barbed-wire fence marks the perimeter of an expanse of grassland to my right. Thirty or so head of cattle are pressed up against the fence, and they have turned their heads toward my truck, curious as to what I am doing here past the end of the road. From previous trips to this part of the coast, I suspect these are Bill White's cattle and that I have arrived at the southeastern corner of the historic White Ranch.

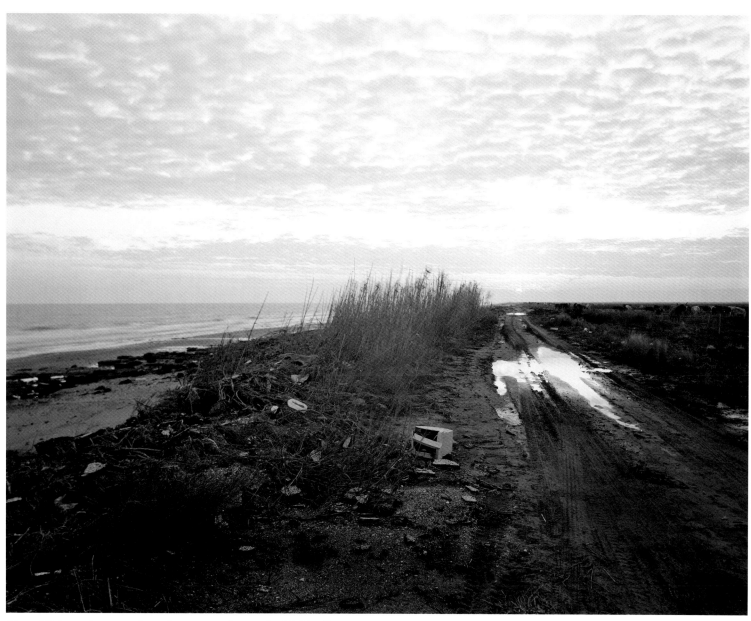

Texas Highway 87, approximately twenty miles south of Sabine Pass

White Ranch, Chambers County, Texas

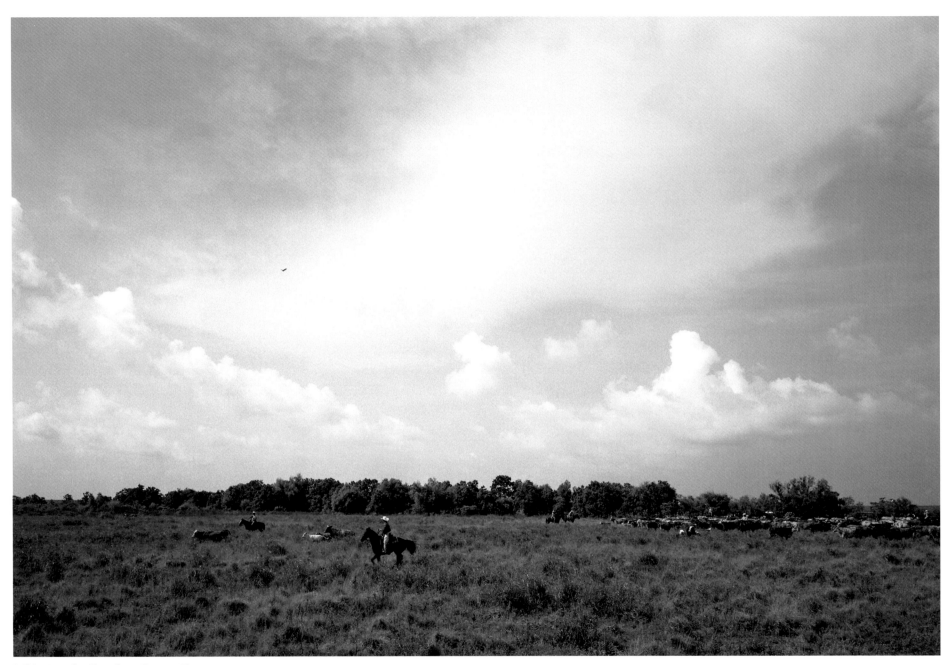

White Ranch, Chambers County, Texas

• • •

James Taylor White came to Texas from Louisiana with his new bride, Sara Cade White, probably in 1827, though some sources date his arrival as early as 1819. The Whites built their home on the salt grass prairie, right about where their covered wagons bogged down in the deep mud of what is now north central Chambers County. Taylor White is said to have owned half a dozen cattle when he married Sara, and she brought an equal number to the marriage. In the years after their arrival, the Whites' dozen "beeves," all of pure Spanish breed, multiplied at an astonishing rate. Soon Taylor White, who had founded the first cattle ranch in the state of Texas, also had the largest herd in the state. He was, truly, the first cattle king of Texas.

Little would be known of the early days of the White Ranch, however, if it were not for a few firsthand accounts of early travelers to Texas, notably that of David Carlton Hardee, a doctor from North Carolina and a friend of General Sam Houston, who came to Texas in 1838 and wrote a series of letters describing his experiences. Dr. Hardee arrived two years after the Battle of San Jacinto and about eleven years after Taylor White had started his ranch. While he was living in the historic old town of Liberty, Hardee kept hearing stories about Taylor White and his ranch, so he set out one day to find White and see his ranching operation for himself.

In one of his letters Hardee describes White's ranch as "the largest pasture on earth." He was particularly fascinated by the practice White had pioneered of "burning off the prairie" every spring, so as to bring a new growth of salt grass. Dr. Hardee also wrote one of the best early descriptions of the salt grass prairie land along the coast:

It is difficult for the imagination to conceive a more beautiful sight than an extensive prairie covered with new grass after a burn. The grass, when only six or eight inches high, is tender and delicate, and is moved in waves by the gentlest breeze. In the main, the surface is almost dead level.

Scattered here and there may be seen small lumps of trees, either pine or live oak. They look like small islands in a great lake of water. Now and then, a solitary tree may be seen in the distance, and through the hazy atmosphere, like a ship at sea, or a light-floating cloud upon the bosom of the ocean in peaceful slumber.

Hardee recounted how White's stock of cattle had grown to an estimated "eight thousand to ten thousand head" in just over a decade. The cattle were all of the Spanish breed, he noted—meaning longhorn cattle—for only this breed could live on the coarse, tough salt grass of the coastal prairie and endure the torturous mosquitoes.

Dr. Hardee suggested that Taylor White "at the time I visited him was the richest man in Texas." He not only owned the largest number of stock of any man in the Republic, but he also had thousands of dollars on deposit in the banks of New Orleans. White pioneered what eventually became known as the Opelousas Trail, by driving his cattle east, across the Sabine and Neches rivers, all the way to market in New Orleans.

White's ranch has been passed down through seven generations of family ownership. Today, the ranch is slightly smaller than it was at its peak size, four generations ago, when it covered 76,000 acres. Bill White, who consolidated ownership from other family members two decades ago, is the sole owner. With a crew of five to ten cowboys, almost all of them of Mexican descent, he runs a herd of about 20,000 cattle on the ranch today.

• • •

At his home in Stowall, Texas, a few miles north of the coast, I sit down with Bill to talk about his ranch, his cattle business, and the effects of Hurricane Rita, which ripped across the coastline a few months before. "We had to move all the cattle off the ranch to higher ground," he explains. "That's the first time since Carla, in sixty-one, that we had to do that. We had no serious damage. Forty miles up the coast, they took the full force of it. In Louisiana, in some places, they lost everything. It's still brackish out there, but when we get some rain, we'll be OK."

Bill's observations about the original James Taylor White and the early years of the ranch are candid and illuminating. "These people came from Louisiana, so they already knew what you could do with cattle on the coast.

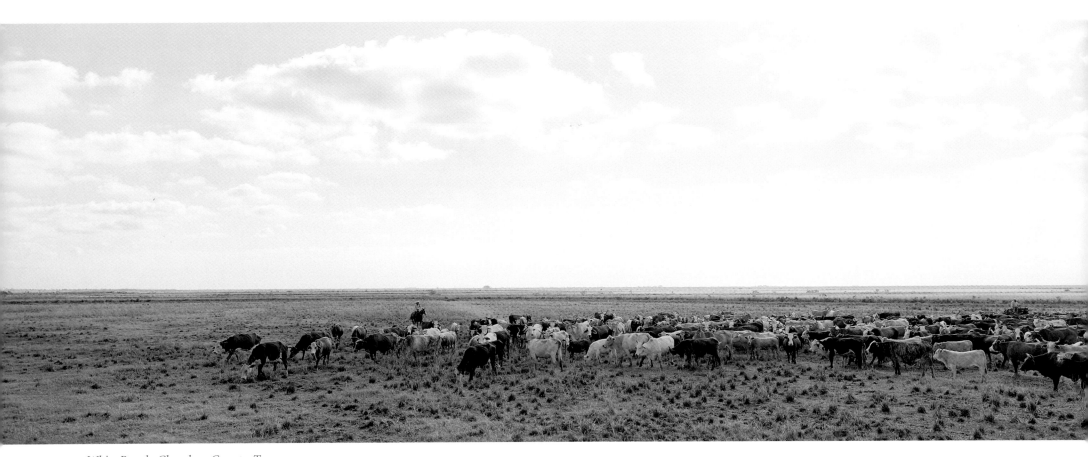

White Ranch, Chambers County, Texas

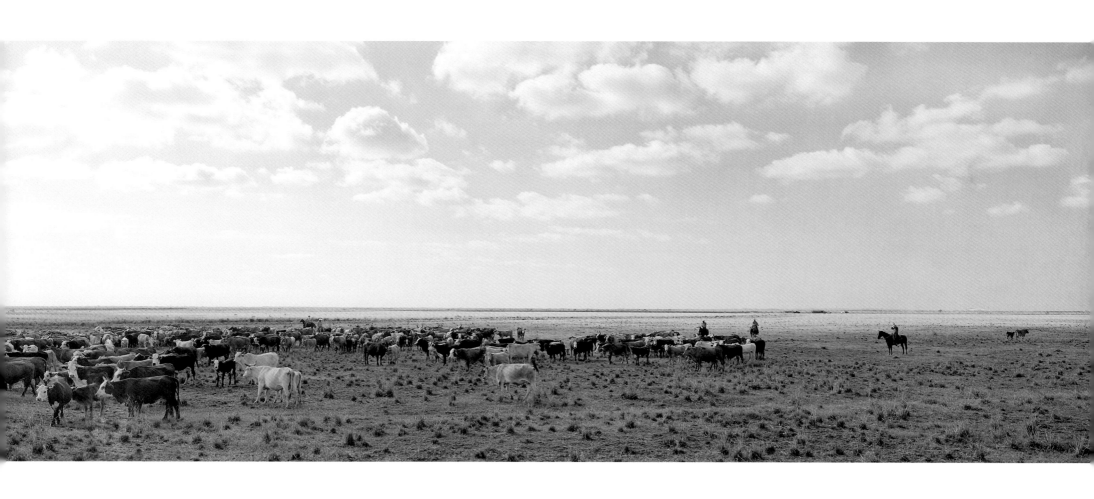

They also knew there was a market in New Orleans. And they knew what to do with the land when they got here. All they had to do was get out there and get it done. And they did, with the help of the slaves they brought along, which nobody much talks about.

"People make a big deal of how they came here with only twelve head of cattle, but the place was teeming with wild cattle, mostly from the mission in Wallisville. Wild cattle was all over the place. If you could go out there and get 'em, they was yours. And that's what they did. I understand some people estimate there was ten, maybe fifteen thousand head of cattle runnin' wild around here. And a few years after he arrived, that's about how many cattle old Taylor White had in his herd.

"By the 1830s, he was driving cattle to New Orleans. The rest of the cattle drives, the real famous ones, didn't happen, I'm told, until after the Civil War. And all the cowboys around here, back then, was black cowboys. There wasn't anything but black cowboys. The Mexican cowboys, like work for me, they're new."

· · ·

Half an hour later, I am back on the road, driving south on 124, crossing the Intracoastal Waterway and entering the town of High Island. The tiny community is situated on top of a salt dome, at an altitude of thirty-eight feet above sea level, that's about nine feet lower than it was a century ago, according to the U.S. Geodetic Survey, but it's still lofty enough to get High Island some recognition as "the highest point on the Gulf of Mexico from Mobile, Alabama to the Yucatán Peninsula."

High Island got its name, as one might imagine, because at times of hurricanes and flooding it can be totally surrounded by water, making it—if only briefly—a true island. And the place has quite an interesting history. The infamous pirate Jean Lafitte is said to have thrown parties in the grove of oak tress that once covered the spot. He's even rumored to have buried some treasure around High Island, but no one has come forward with any of the booty yet. History does record, however, boom times in High Island in the 1890s, and travelers can read about those times on historical markers in the town today. They tell of Sam Smith's mineral springs operations, and how people flocked here from all over the state to partake of their healing powers.

At the peak of the heyday in High Island, C. T. Cade built a "very large and ornate" hotel called the Sea View, where guests were treated to the "best food and finery," plus a mule-drawn rail car to take them back and forth to the beach. Cade also developed a twenty-eight mile railroad line from Port Bolivar, at the southern tip of the peninsula, to High Island. The hurricane of September 1900 put an end to that spurt of growth and prosperity, though. Its high winds and floodwaters devastated the area.

Bolivar Peninsula, near Gilchrist, Texas

Bolivar Peninsula near Crystal Beach, Texas

The Sea View Hotel building actually survived the storm and served as a sort of headquarters for oilmen who rushed to the region after the gusher at Spindletop in 1901. It even provided quarters for the men and horses of the "horse patrol," when they kept watch for enemy submarines before and during World War II. The old hotel was still standing after the war, just south of town, up among the sand dunes and oleanders, until fire, probably caused by a transient guest, leveled it.

As I drive south out of High Island, turning onto coastal Highway 87 toward the Bolivar Peninsula, I can see where the hotel must have stood. Today there's just a stretch of sandy landscape and some small dunes, fenced off from the highway, with a dozen or so oil pumps bobbing up and down in the distance, a reminder that time moves on and nothing built by man lasts for very long on this coastline.

Now I am on the Bolivar Peninsula, a narrow strip of land that runs twenty-seven miles southwest down the Texas coast, from High Island to Galveston Bay.

The U.S. Corps of Army Engineers actually refers to Bolivar Peninsula as "an offshore sandbar near the eastern end of a chain of barrier islands." Some folks call it the southwestern branch of the "Redneck Riviera." Whatever you choose to call it, Bolivar Peninsula doesn't look like any other place on the Texas coast. There are rickety wooden fishing piers where, for five bucks, you can park and walk out over the water to fish for red snapper or croaker. There are folksy bait camps, abandoned cattle pens, countless fireworks stands, and horses grazing in vacant lots.

A string of curious beach houses are under construction at the Audubon Village subdivision north of Gilchrist. These are strange-looking structures, tiny wood frame houses perched atop concrete piers, twenty feet above the ground. They look like birdhouses for people. A sign offers, "Beach Homes with Lot $99,000–199,000."

Gilchrist seems to have a more or less equal number of RV parks, bait shops, restaurants and churches. On the highway in the center of town, there's the First Baptist Church ("The Hugging Church"). One block south, the Gospel Lighthouse Church ("R U Saved?") sits nestled under three tall palm trees, with an equal number of large wooden crosses planted in the sandy soil out front. The Firehouse Restaurant and Bar promises "Home Cookin," so I decide to stop for dinner.

Crystal Beach, Texas

Gilchrist, Texas

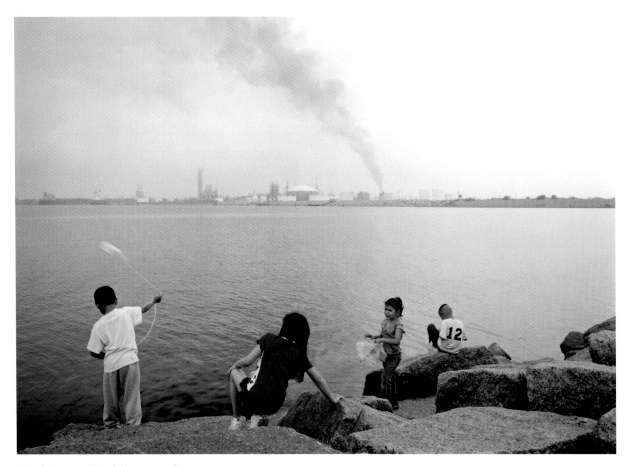

On the Texas City dike

Inside the Firehouse, the color motif is dark red on bright red. Red tabletops, red wood trim, even a red dance floor. The place has a comfortable, down-home atmosphere and a nice red bar. A chalkboard tells me that today's special is fried fish with french fries and hushpuppies. A waitress wearing a short t-shirt and a rhinestone in her navel takes my order. I opt for the special and ask what kind of fish it will be.

"It's gonna be whatever we *got,* honey. Most likely flounder, but don't worry, it's gonna be good. We got a new cook back there."

I agree to the fish, whatever it turns out to be, and inquire about the evening entertainment.

"We just got kary oke on Friday and Saturday nights. That's about as live as we get."

South of Gilchrist I find Rollover Pass, a quarter-mile long strait, opened by the Texas Game and Fish Commission in 1955 to connect the waters of the Gulf with East Bay. Rollover is one of the most popular fishing sites on the Texas Coast, and this afternoon there are a hundred or more fishermen working both sides of the pass. The tide is out, so there are sandy flats extending out on the bay side. The flats, too, are covered with fishermen. A historical marker sheds some light on the origin of the Rollover name. Early ship captains, in their efforts to avoid the customs agents at Galveston, would roll barrels of imported merchandise from the Gulf side of Bolivar Peninsula over to East Bay. From there, the merchandise would be transferred to the mainland without paying duties.

Fishing in the Houston Ship Channel

Farther down the road, I pass the Crystal Beach Liquor Store ("Ease off the throttle/Stop for a Bottle"), the Copacabana subdivision of beach homes, and half a dozen fireworks stands. The wooden ruins of the Seahorse, an abandoned drive-in restaurant, stand in the weeds on the north side of the highway. An old, dappled gray mare grazes in an open field alongside the property. There's not much left of the old drive-in except a rickety wooden frame, weathered and gray, half overgrown with weeds. The remains of the structure no longer stand up straight, but lean inland, from the battering of coastal winds. There's also a wooden sign with white letters, badly weathered, but still readable: "Take a Footlong Hotdog to the Beach."

From Crystal Beach it's only a few miles to Point Bolivar, one of the oldest ports on the entire Gulf Coast and the anchor at the southern tip of Bolivar Peninsula. Port Bolivar's history is intertwined with that of Old Fort Travis and the various railroad lines that have operated along the peninsula over the years. The most prominent landmark on the peninsula, the Bolivar Lighthouse, stands on the north side of the highway. Over a hundred feet tall, built of brick and sheathed in riveted cast-iron plates, it's an imposing structure. Rust and age have given the old lighthouse a uniform black patina. There's not much else to see in Port Bolivar, except a small grid of old streets behind the lighthouse, next to Galveston Bay and the ferry terminal. As I drive onto the ferry, the evening sun is dropping close to the horizon. Once the boat is fully loaded, we push off for the crossing to Galveston.

On the Bolivar Ferry to Galveston

PART 2: *Galveston to Port Lavaca*

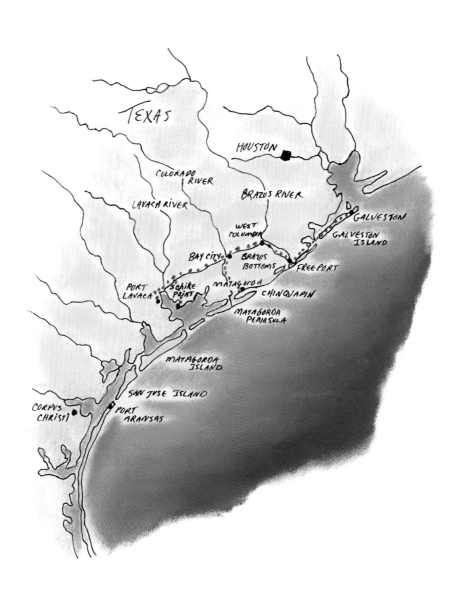

THE DECK of our six-hundred-ton ferry, the *Gibb Gilchrist,* is packed to the gills with a full load of cars, trucks, and mobile homes as it steams across Galveston Bay. Overhead, hundreds of noisy gulls soar, angle, and dive for the breadcrumbs and other tidbits tossed into the air by passengers. A crowd has gathered on the bow of the big ship to watch the school of dolphins that is swimming in front of us, leading our vessel through the choppy bay waters.

To the south, far out in the open waters of the Gulf, a line of ocean-going tankers and barges wait their turn to enter Galveston Bay and the ship channel to Houston. Just ahead and to the north the ruins of the SS *Selma,* an old tanker, protrude from the shallow waters in front of Pelican Island. The massive, four-hundred-foot concrete hull, barnacled and crumbling, suggests an ancient marine archaeological site.

Galveston Island comes into view, and the first features I can make out are the tall, dark profiles of three industrial cranes on the waterfront of the Port of Galveston. The three cranes, silhouetted against the afternoon sky, remind me of the observation made almost two centuries ago by the earliest explorers who saw this island. Near the middle of the island, there were—according to all accounts—three trees. Because the island was so utterly flat and otherwise featureless, these three trees stood out like beacons. In fact, no one who saw and wrote about Galveston Island prior to 1850 failed to mention the three trees. In 1836, Colonel W. F. Gray wrote that "there are only three trees on [Galveston Island]." A year later, an anonymous traveler wrote in his journal, "The whole island presents rather a dreary and forbidding aspect, with nothing to relieve the eye or diversify the prospect except three lone trees upon its southeastern side, about midway, and which stand as the only beacon to the mariner along this solitary and monotonous portion of the Gulf of Mexico."

Some observers specifically identify the trees as live oaks. In 1842 William Bollaert added more specific information about the trees. "Leaving the town of Galveston, and along the shore some fifteen miles," he wrote, "the 'Three trees' are arrived at, which forms a good landmark. What is known as the 'Three trees' is composed of a clump of some twenty trees, then a small grove, and lastly three trees."

Despite the many accounts of the three trees, it would be an entirely different feature of the island and its adjacent waters that would determine Galveston's important role in the early history of Texas. This feature was first noted in 1785 by Don José de Evia, the commander of a Spanish surveying expedition, as he sailed south from New Orleans, charged with mapping the coast of present-day Louisiana and Texas. Approaching Galveston Island, Evia observed that the currents of the surrounding bay appeared to make a natural harbor behind the barren island. Perhaps sensing the future importance of the island and its potential harbor, Evia named the island in honor of the viceroy of Mexico, Bernardo de Gálvez.

Before European explorers arrived, the island had been a favorite hunting and fishing grounds for the Karankawa Indians, who, according to H. Yoakum, in his 1855 *History of Texas,* had their own name for the island.

From the discovery of the island in 1686, by the colony of LaSalle, until 1816, it had remained unsettled. A few roving Carankawees occasionally resorted to the western end of the island for purpose of fishing, but there were no human habitations on it. . . . In the beginning of the year 1816, it was covered with long green grass, on which fed herds of deer. It also abounded in serpents, from which it was called, by the pirates of the gulf, Snake island.

By 1816, Louis Aury, the French pirate, had come to Galveston from Haiti and established a stronghold of rebels in support of the Mexican revolution against Spain. But Aury's hold on Galveston was short-lived. When he left the island in 1817 to accompany Gen. Javier Mina of Mexico on an expedition to the Santander River, another outlaw—none other than the infamous Jean Lafitte—set up his own pirating outpost on Galveston Island.

Lafitte's smuggling and pirating operations on Galveston lasted about four years, before he was run off the island by the U.S. government. Lafitte named his headquarters, located on the bay side of the island, Campeche. His men and their families lived in crude huts scattered around a two-story house that Lafitte built for himself. He painted the house red, called it Maison Rouge, and placed two cannons in front of it.

After Lafitte's departure, the Republic of Mexico briefly took over Galveston, and when Texas won its independence from Mexico in 1836, it

took control of the island. After the war, a fur trader and land speculator by the name of Michael Menard joined forces with other investors, purchased 4,605 acres at the Galveston harbor, and founded a town of the same name.

By the middle of the nineteenth century, Galveston was prospering, largely on the strength of its port. Galveston also became the transfer point for oceangoing ships and steamers coming into Galveston Bay, then up Buffalo Bayou to the growing city of Houston. A railroad link was built between Houston and Galveston, and the island city continued to grow. The Civil War brought Galveston's prosperity to a temporary end, when Union forces blockaded the port. After the war, however, the city's growth again accelerated. By 1870 Galveston was the largest city in the state, with a population of 13,818. It was also the grandest city in Texas. Architect Nicolas J. Clayton designed homes and commercial buildings that were among the finest of the time. The state medical school was awarded to Galveston; the Grand Opera House was built and world-class theatrical presentations were performed. By 1900 Galveston was a great city with a promising future.

Then Galveston's luck ran out. The low, flat island was hit by a hurricane with wind gusts of 120 miles per hour and a storm surge of fourteen and a half feet. An estimated six thousand people died in Galveston on the night of September 8, 1900, when the hurricane swept ashore with little warning. A third of the city was totally destroyed. A trolley line near the shore was uprooted, and the iron rails and wooden ties became a nightmarish scythe, ripping through homes before the churning waves of the storm carried them away. When daylight came and the bodies and the missing had been counted, the Galveston storm of 1900 was recognized as the most deadly natural event in history.

Perhaps the most astonishing thing about Galveston is that the city survived the hurricane. Fourteen years earlier, down the coast at Indianola, the entire population left in the wake of the hurricane that had leveled the city. Indianola simply vanished. In Galveston, about two thousand people moved away after the hurricane, but the rest stayed. They built a massive, seventeen-foot seawall along the Gulf, constructed a concrete bridge to the mainland, and even raised the elevation of the east end of the island by eight feet, pumping sand under homes and buildings. The population of the island stabilized and then began to grow.

But there were other factors, forces even greater than the storm, that kept Galveston from regaining its place as the most populous city and the most important port in Texas. The great Texas oil boom, starting with the gusher at Spindletop in 1901, began at the very the time that Galveston was struggling to recover from the storm. Refineries and storage facilities were built at safer inland locations, places like Port Arthur, Orange, and along the new Houston Ship Channel. Headquarters for the oil companies were established in Beaumont and Houston. As a result, Galveston had to reinvent itself. Drawing on its reputation for the finest beaches on the Texas coast, Galveston gained a reputation as a place of raucous, at times illegal, fun. Even the architectural heritage of the island, preserved in large measure due to the city's economic stagnation, ultimately proved to be an important asset and attraction.

On the Bolivar Ferry to Galveston

Galveston Bay and the Houston Ship Channel from the northeastern tip of Galveston Island

• • •

The Bolivar ferry docks on the northeastern tip of Galveston Island, where the streets of the city are lined with fragrant red, pink, and white oleanders. Right away, I'm drawn to the historical district. Over forty years ago I first saw Howard Barnstone's book, *The Galveston That Was*. The photographs in that book, by the great French photographer Henri Cartier-Bresson, opened my eyes to the combined documentary and pictorial power of photography. Cartier-Bresson's images of the shadowy streets, the ornate Victorian homes, and the elegant old commercial buildings of the Strand brought me to Galveston for the first time in the fall of 1964, following in the footsteps of a photographer I wanted to emulate.

Much has changed in the East End Historical District in the forty-odd years since I first photographed here. Many of the old homes along Post Office, Church, and Winnie streets have been restored. Freshly painted in bright color combinations, their porches decorated with blooming plants, they don't look anything like the falling-down, deserted homes I recall.

Still, the streets are shadowy and mysterious. Melancholy spirits hang in the humid air around the old houses, and I can't shake the feeling that Miss Havisham is in there somewhere, languishing in the shadows of her parlor and watching me as I frame my pictures.

Everywhere I look, the simplest actions speak of poetry. A boy wheels his bike around a street corner in the sunlight, then disappears into the deep shadows of overhanging oaks. An aged lady walks her dog past a magnificent oleander in full bloom. An oak tree, in a process that must have taken half a century, has absorbed an old fence, growing around the iron bars and swallowing them.

The magnificent architectural heritage of Galveston survived because the city's economic progress stalled. Whether it was the storm, the oil boom, or a combination of events that caused this once promising city to falter, that is what we have to thank for the survival of Galveston's architectural heritage. Had the city continued on its late nineteenth-century surge of growth, most, if not all, of this architecture would have been demolished to make room for the new.

I have an urge to see the Cartier-Bresson photographs again, and I won-

der if they are still available to be viewed in the Rosenberg Library. I am curious about another thing, as well: the "three trees," the grove of trees that the early travelers mentioned seeing on the island in the nineteenth century. Was there—could there *possibly* be—any remaining trace of them today? And if they are long gone, as I suspect they are, what stands in their place?

The Rosenberg Library, on 23rd Street and Winnie Avenue, was founded in 1871, making it the oldest public library in continuous operation in Texas. On the third floor of the library, the Galveston and Texas History Center is open to the public. Casey Greene, the head of Special Collections, is hanging an exhibition of prints and photographs in a third-floor gallery. A gray-haired, bespectacled man in his early sixties, Greene looks up from a framed print to greet me.

"Tell me, what can we do for you today?" he asks. His manner is crisp and efficient, but there's a twinkle in his eyes and a charm about him. I am not sure what I expected to find in a curator and historian, but it appears that I have found a man who takes pleasure in his work. I decide to save the Cartier-Bresson prints for another visit. Instead, I want to try to locate the legendary "three trees," so I recount for Greene some of the early accounts that I've read.

The wheels begin to turn in the curator's mind: "Hmmm . . . yes, of course I do recall the three trees. But you want to know exactly where they were, is that right? Wait here," he says over his shoulder. "Let me pull a couple of maps. I think we might be able to pinpoint that location."

Greene returns with several large documents. "This is William Bollaert's hand-drawn map of the island. Dated 1842. Bollaert, you recall, made a significant geographical account of the Republic of Texas, and he spent a good bit of time on the island. Here you will see his indication of the 'Three trees,' more or less in the middle of the island, slightly toward the bay side."

But can we relate Bollaert's mapping, done in 1842, to a current map of the island? Can we find exactly, or even approximately, where the three trees stood, according to today's streets, roads, and property lines. I have no sooner posed that question than Greene unrolls a second, bigger map onto the table. He runs his fingers across the map, studying its details as he speaks: "This is the Resurvey of 1901, done by R. W. Luttrell, a civil engineer, just after the big storm of 1900. It divides the island into four sections. Let's see here. Yes. Here it is. He refers to this site as Lafitte's Grove. But you see, it's about the same place that Bollaert placed the 'Three trees.' At some point

in time, I suspect, the three trees came to be called Lafitte's Grove. And I seem to recall that we have early photographs of Lafitte's Grove."

Greene is off again into the archives, and his enthusiasm for the task seems to be rising with each step. "Let me pull the vertical file," he says as he disappears into the stacks. "Just give me a minute."

Not much more than a minute passes before Greene returns. The vertical file has been pulled, and from the smile on his face, I can see that the search has been successful. He lays the file folder on the table, along with a pair of white cotton gloves. "You need to put these on," he says, as he pulls half a dozen photographs from the folder. "This is the original photograph, dated on the back, in pencil, 1894. Six years before the storm. About fifty years after Bollaert's map."

The photographs from the file are different prints of the same picture. One is an original print, and the other four are modern copies made from the original. The original is a beauty, an eight by ten contact print, doubtless from a glass plate. On the back of the print, in pencil, someone has written: "Galveston Island Three trees taken about 1894." The print is in beautiful condition, slightly faded to an overall brownish tone. The image is sharp and richly detailed. Undoubtedly made with a large, tripod-mounted view camera, the photograph records a group of about a dozen people, one or two families. They have gathered in the shade under a motte of live oak trees. The grass in the foreground is lit by full sunlight, and the people grouped under the trees are in deep shadow. Then, as now, it would have presented a challenge to show the people clearly, given the bright sunlight all around. But as I look closely at the print, I am amazed at what can be seen in the near darkness. A small child is nestled in the lap of an old woman, and to her left a boy leans against one of the trees. In the center of the group, a man plays a harp; another holds a violin. Two horses and a buggy can be made out behind the group.

I ask Greene for one more look at the map from the 1901 survey. "Do you think there could be anything left of the three trees today? Can we locate the site by today's streets?"

"Probably nothing left of them. I suspect the 1900 storm destroyed them, but I can't say for sure. I would say, from the map, that you're talking about somewhere near Stewart Road and Ten Mile Road. You could go out that way and ask around. You never know what you might find."

I thank Casey Greene for his time and expertise, then I start driving toward the west end of Galveston Island. From Broadway, I turn right onto Seawall Boulevard. New commercial developments have sprung up all along the seawall since I was last here, a few years ago. Opposite the beach, hotels, restaurants, and gift shops line the north side of the street. The old Hotel Galvez, dating to 1911—the "Queen of the Gulf" it was called back then— offers the last trace of any local style, its Victorian details reflecting those of the historical district. Most of the other hotels—Ramada, Best Western, Hilton, Comfort Inn—have the same names and the same architecture you would find anywhere in the country. As I drive past all this development, I wonder how much of it could survive a major hurricane.

Ten miles down the island, the seawall, and the levee end. The pavement drops down about fifteen feet, bears to the right, and Seawall Boulevard turns into FM 3005, the two-lane road that leads all the way to San Luis Pass. As the name of the road changes, so does the territory. Now, on the ocean side of the road, mile after mile of beach houses dot the landscape. At first they're clustered in groups of three and four—painted pastel hues of green, blue, pink, and lavender—then there are whole subdivisions: Beachside Village, Bermuda Beach, Sands of Kahala Beach, Jamaica Beach, and Indian Beach. On and on they go, with hardly a break between them. On my right, open pastureland extends for miles. Horses graze in an open pasture at the corner of 8 Mile Road, where I turn north.

At Stewart Road, I turn left and head southwest. Judging from what I saw on the 1901 survey map, the three trees were somewhere between here and 10 Mile Road. I pass the Lazy Oaks Bar and Grill, then arrive at a major subdivision on the bay side of the road, Laffite's Cove. I'm wondering about that curious spelling of the famous pirate's name when I turn into the subdivision and cruise down Carthaginian Way. The neat, carefully maintained homes have been built on man-made canals that extend all the way to East Bay. It's a weekday, and there are virtually no cars in the driveways. A few people are out gardening or mowing their lawn. A sign points the way to the subdivision's own nature preserve. All in all, Laffite's Cove presents an idyllic picture of a well-kept, friendly enclave of weekend homes. But I'm not any closer to finding the location of the three trees, so I stop to ask. A

Galveston beach and seawall

Civil War Monument, Broadway Avenue, Galveston

Mardi Gras reveler, Galveston seawall

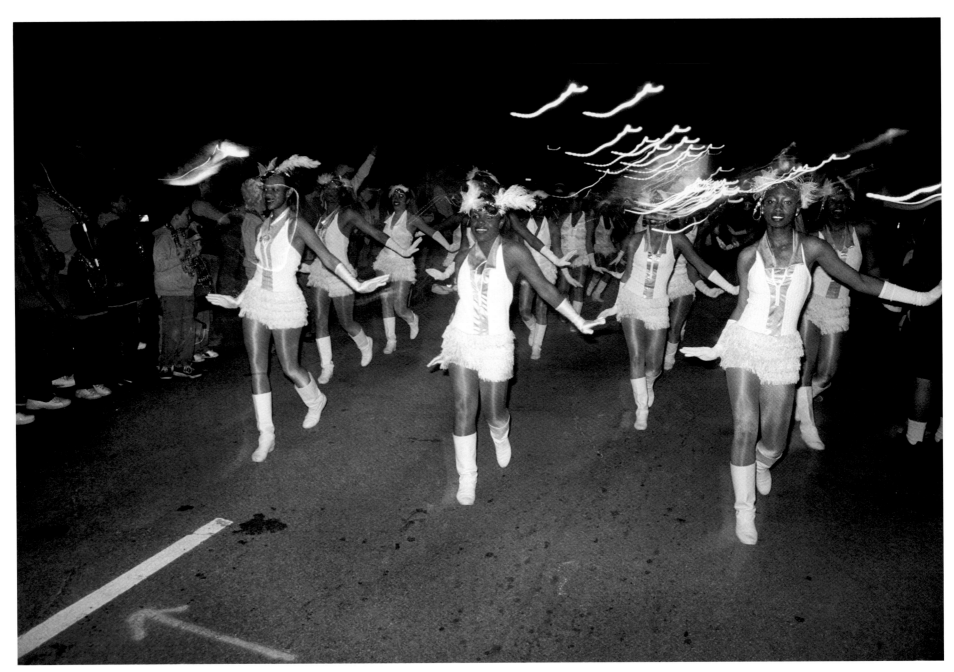

Knights of Momus Grand Parade, Galveston Mardi Gras

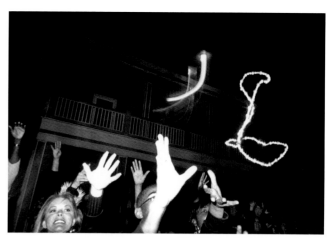
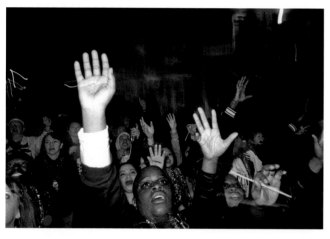
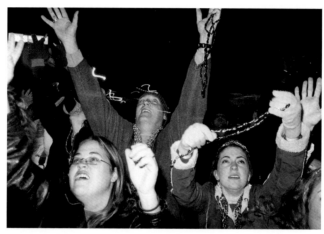
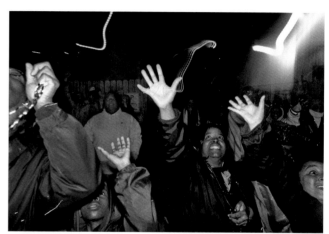
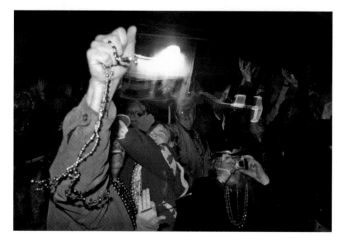
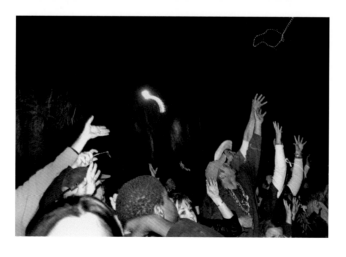
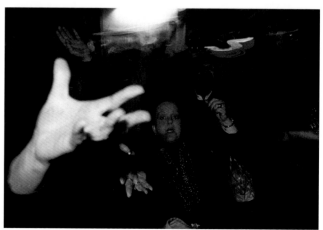

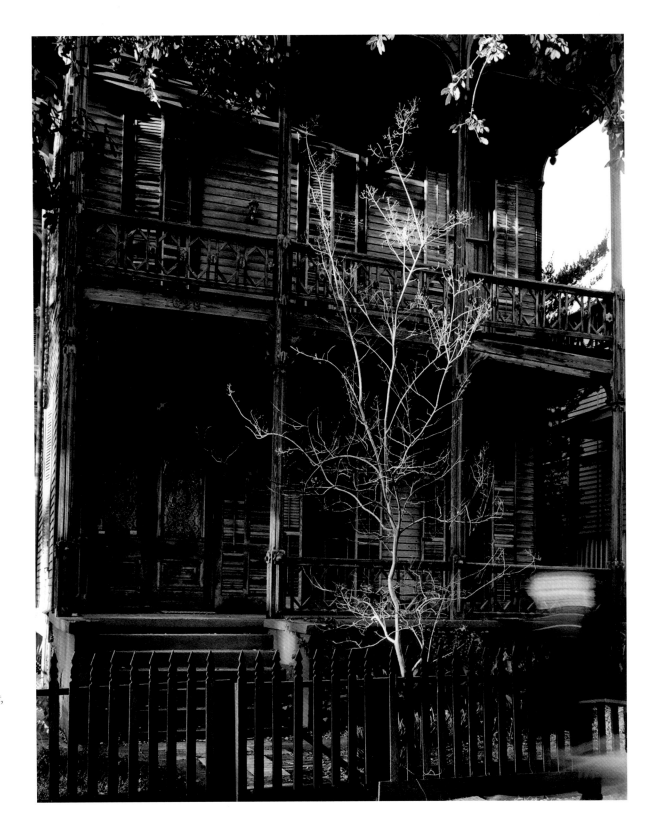

*Winnie Street, East
End Historical District,
Galveston*

heavyset man in his sixties, on a riding lawn mover, turns off his engine as I approach.

"I never heard of any spot called three trees," he tells me, "and I've been here for fifteen years. But there's one of those history markers over there on Stewart Road, opposite the entrance. It's real hard to see it when the grass is growed up around it, but it's there. Maybe it'll tell you something."

I failed to notice the marker when I made the turn into the subdivision, but now I can see it, just south of the road. I make my way through the tall grass until I'm close enough to read the inscription. The text on the marker identifies the place as Lafitte's Grove, where the pirate established a fort and settlement in 1817. This same place, according to the marker, is where the Battle of the Three Trees was fought in 1821, between Lafitte's men and the Karankawa Indians.

The maps I saw in the library suggest that Lafitte's Grove was located at or near the site of the three trees, and the historical marker refers to the battle fought on this site as the "Battle of the Three Trees." But there are no trees here now. All I have found is a marker and a big, dense thicket of brush behind it. I am guessing that the hurricane of 1900 uprooted the big trees and blew them away, six years after the family outing that was so beautifully rendered in the old photograph in the library.

Back in my truck, pulling away from the historical marker, I notice what is left of an old gate, twenty feet down the road from the marker. The gate is wide open and appears to be the entrance to what was once a private road onto someone's property. Grass and brush have grown up around the entrance, and there's water standing a few inches deep in the dirt road, but it's passable. My curiosity overpowers my apprehension, and I drive in.

Twenty yards down the old driveway, past all the grass and foliage that hides the place from the road, I find myself in a clearing, surrounded by a cluster of old buildings. To my right, closest to Stewart Road, a large house sits under two old oak trees. The structure is virtually covered in vines and brush. The entire house is elevated ten feet or so above ground level, and a wooden stairway leads up to the front porch. The steps and the porch—in fact, the entire house and roof—are rotted, splintered, and ready to collapse. Still, I can see into the house through the open front door, and there are remnants of curtains, carpets, and furniture inside. The whole property is a bit spooky. The house, as well as an adjacent barn and a shed, have obviously been vacant for many years, yet I sense that I have arrived here an instant after everyone has left.

I follow a path from the house to the north side of the property, where I face a tangled, dense grove of oak trees and brush. Judging from their massive trunks, three of the trees are quite old. These trees are not standing straight, but leaning to the north. Their trunks and huge limbs are growing almost parallel to the ground.

In driving onto the property and then following the path from the house, I have circled around to a position immediately behind the historical marker on Stewart Road. A mass of thick foliage and high grass separates the grove of leaning oaks from the historical marker, but they are less than a hundred feet apart. I make my way back from the trees toward the old house, just far enough that I can imagine myself in approximately the same place the photographer would have put his tripod down in 1894. In my imagination, I see the three trees, still growing straight, before the great storm hit. I see the families there, under the trees, and I see the baby, cuddled in the woman's lap, under the tree on the left side of the grove. I hear the sound of the harp and the violin. I hear the horses neigh and stamp at the ground.

These old oak trees must have taken terrible beatings over the years, perhaps as far back as the great storm of 1900, but certainly from the countless storms that have swept across Galveston Island in the years since then. There is no way of knowing if these are the same "three trees" that were noted by all the early explorers or if they are the same trees shown in the old photograph in the library. Yet, it seems entirely possible that these are those same trees.

Oak trees near Stewart Road, Galveston Island

• • •

At the southwestern tip of Galveston Island, a two-mile concrete causeway extends over San Luis Pass, leading back to the coastal mainland. On a Sunday afternoon, almost exactly a year ago, I came to this end of the island and found a memorable scene on the bay side of the highway. There was no paved road leading from the highway to the edge of the bay waters, so I had to drive across the sand until I arrived at a narrow stretch of beach where a number of people had parked their cars and trucks. Along the shore of West Bay, families were wading in the shallow waters and lounging on the beach.

Today, all of that natural landscape and beach that I found only a year ago is gone. In its place, a new development of luxury homes, Baywater Villas, covers the last half-mile of the bay shore of Galveston Island. Fifty three-story homes are built and ready for sale. At least fifty more are under construction. Hundreds of palm trees have been planted throughout the development. In the middle of three man-made lakes, fountains bubble and sparkle in the afternoon sunlight. Two Mexican gardeners, each on a riding mower, sit at the corner of Estuary and Tributary roads, taking a break and chatting. Arrows on a road sign point to the Kayak Launch, Primrose Drive, and the Sunset Vista. I decide to skip all three attractions and head back onto the highway.

The long, low causeway over San Luis Pass connects Galveston Island with the promontory known as Follett's Island. At one time, a small, sandy island—San Luis Island—stood in the pass. Over time, the changing tides and shifting sands of the pass have connected Follett's Island with San Luis Island. As I drive over the causeway, I look out over the turbulent waters of San Luis Pass. On both sides of the causeway, cars and trucks are parked on the beach. Children are playing in the surf, and fisherman have waded chest deep into the water.

Despite the idyllic coastal scene on the beaches below the causeway and the dramatic view across San Luis Pass, I can't get the Baywater Villas subdivision out of my head. Its manufactured lakes, bubbling fountains, and Sunset Vistas are disturbing. I wonder what this place must have looked like

five hundred years ago, when the first Europeans arrived on the Texas Gulf Coast. In fact, the first known landing was right here, and the story is so extraordinary it might be unbelievable, except that we have collaborating firsthand accounts from the few who survived that saga.

The story begins in 1527, when Pánfilo de Narvaez sailed from Cuba carrying a royal order to form a Spanish colony in "La Florida." Fourteen years earlier, Juan Ponce de Leon had discovered what he thought was an island north of Cuba. He returned a year later, attempting to establish a Spanish colony there, but his efforts failed and he died from an arrow wound inflicted by the native Indians. Thirteen years later, when Narvaez sailed, suspicion had grown that La Florida was not an island, but a peninsula of a vast mainland. Ten years earlier, Spanish explorers—Córdoba, Grijalva, then Cortés—had begun crossing from Cuba to the Yucatán Peninsula, pushing north and east, claiming for Spain all of the territory from the Yucatán to Cabo Rojo, south of today's Tampico. Narvaez's orders were seen by some as an effort to contain Cortés, by establishing a settlement that would put a northeastern boundary on Cortés's exploits.

The Narvaez expedition included five ships and four hundred people, including Álvar Núñez Cabeza de Vaca, who had been assigned as treasurer of the expedition. Their charge was to begin the colonization of all the land from today's Florida to the province of Panuco at the Rio de las Palmas, north of Cortés's northernmost settlement at Santisteban del Puerto.

Shortly, after landing on the western coast of Florida, Narvaez, a rash, vindictive, and brutal man, aroused the fury of the local Indians and doomed his expedition. He cut off the nose of an Indian chief, then cast the chief's mother to dogs. The Indians' determined efforts to expel the Spaniards, plus blunders by Narvaez at virtually every step, left the Spaniards reduced in numbers, separated from their ships, and stranded in the marshes of the Florida coast.

Recently planted palm trees, FM 3005, west Galveston Island

Narvaez and his surviving men—about 250 in number—improvised from whatever they could find around them and built five seagoing rafts. When the rafts were done, the men piled onto them and pushed off to sea. For over a month, with little water and a ration of a half a handful of maize per day, the men drifted west, hugging the coastline. As they passed the mouth of the Great River—today's Mississippi—powerful currents pushed all five rafts out to sea. Cabeza de Vaca, in command of one of the rafts, caught up with one of the other rafts, and together they made their way back to the coastline. They continued drifting for another four days, first along the coast of Louisiana and then among the barrier islands of the Texas coast.

Near death from hunger, thirst, and exposure, the Spaniards' hopes of survival had almost vanished, when waves threw them ashore on a deserted beach. After over a century of study, historians now generally agree that it was on San Luis Island, in the pass between Galveston and Follett's islands, that Cabeza de Vaca and his raft, holding about fifty Spaniards, were thrown ashore in November of 1528. Cabeza de Vaca's *Relación,* his letter of account to the Spanish court, written shortly after his eight-year ordeal, tells the story, starting on the day preceding their landfall:

At the end of these four days, a storm overtook us and caused us to lose the other raft, and because of the great mercy God had for us, we did not sink in spite of the foul weather. And with it being winter and the cold very great and so many days that we suffered hunger along with the blows that we received from the sea, the next day the people began to faint in such a manner that when the sun set all those who had come in my raft were fallen on top of one another in it, so close to death that few were conscious. And among all of them at this hour were not five men left standing. And when night came, only the helmsman and I were able to guide the raft. And two hours into the night, the helmsman told me that I should take charge of it, because he was in such condition that he thought he should die that very night . . .

Later, near dawn, it seemed to me that I was hearing the rise and fall of the sea because, since the coast was a shoal, the waves broke loudly. . . . And near land a wave took us that pitched the raft out of the water the distance of a horseshoe's throw, and with the great blow that its fall occasioned, almost all of the people who were nearly dead upon it regained consciousness. And since they saw themselves near land, they began to leave the raft walking, half crawling. And as they came on land to some bluffs, we made a fire and toasted some of the maize that we carried. And we found rainwater, and with the heat of the fire the men revived and began to regain strength. The day we arrived here was the sixth of the month of November [1528].

Cabeza de Vaca and his men named the island where they landed Malhado, Island of Misfortune. All but four of the men would die there, victims of starvation, the harsh elements, and the cannibalistic Karankawa Indians who found them. Cabeza de Vaca's *Relación* continues, offering a firsthand account of one of the earliest encounters between the explorers from the Old World and the native inhabitants of the New World:

I ordered [Lope de Ovieto] to look . . . and see if in this land there were any roads that could be followed. . . . And since it seemed to us that he delayed in returning, I sent two other Christians to look for him and find out what had happened to them . . . and they saw that three Indians with bows and arrows were following him, and calling to him, and he in turn was calling to them with gestures. And thus he arrived to where we were, and the Indians stayed back a little, seated on the same bank.

And half an hour later, another one hundred Indian archers arrived, and now, whether or not they were of great stature, our fear made them seem like giants. And they stopped near us, where the first three were. It was out of the question to think that anyone could defend himself, since it was difficult to find even six who could raise themselves from the ground. The inspector and I went to the Indians and called them, and they came up to us, and as best we could, we tried to assure them and reassure ourselves. And we gave them beads and belts and each one of them gave me an arrow,

La Florida

[Departed by raft Sept. 1528]

"La Junta de los Ríos"

"Region of the Four Rivers" [Nov. 1528 – mid 1536] "Region of the Prickly Pears"

[Fall 1535]

"Malhado"

Bay of Horses

Cabo de la Florida

Río Grande

SIERRA MADRE ORIENTAL

[Arrived April 1528] Bay of the Cross

[Arrived May 1536]

North Sea (Mar del Norte)

SIERRA MADRE OCCIDENTAL

San Miguel de Culiacán

Río de las Palmas

HAVANA

Río Panuco

Santisteban del Puerto

New Spain

México-Tenochtitlán

South Sea (Mar del Sur)

Map of Cabeza de Vaca's route, 1527–1536

which is a sign of friendship. And by gestures they told us that they would return in the morning and bring us food to eat.

. . . The next day at sunrise, which was the hour the Indians had said, they came to us as they had promised, and they brought us much fish and some roots that they eat, which are like nuts. . . . Since we found ourselves provided with fish and roots and water and the other things we requested, we resolved to embark again and continue on our journey.

But in their efforts to relaunch their raft, Cabeza de Vaca and his men met with yet another disaster:

At a distance of two crossbow shots out to sea, we were hit by such a huge wave that we were all soaked, and since we went naked and the cold was very great, we dropped the oars from our hands. And with a successive wave the sea overturned our raft. The inspector and two others clung to it in order to save themselves, but the result was quite the opposite, for the raft dragged them under and drowned them. Since the shoreline is very rugged, the sea, with a single thrust, threw all the others, who were in the waves and half drowned, onto the coast of the same island. . . . Those of us who escaped [were] naked as the day we were born and [we had] lost everything we had carried with us. . . . And since it was November and the cold very great, we, so thin that with little difficulty our bones could be counted, appeared like the figure of death itself.

. . . The Indians, on seeing the disaster that had befallen us and the disaster that was upon us with so much misfortune and misery, sat down among us. And with the great grief and pity they felt on seeing us in such a state, they all began to weep loudly and so sincerely that they could be heard a great distance away. And this lasted more than half an hour, and truly, to see that these men, so lacking in reason and so crude in the manner of brutes, grieved so much for us, increased in me and in others of our company even more the magnitude of our suffering . . .

The survivors had no idea how far they were from the Spanish outpost near the Rio de las Palmas. And certainly no Spanish authority could have known where they were. What follows is an epic story of survival. In his

BUC-EES bait and convenience store, Texas highway 332, Freeport, Texas

Relación, Cabeza de Vaca gives a detailed description of how the eighty or so men were quickly reduced—by starvation, exposure, and the harsh conditions—to fifteen, then only four. About all that Cabeza de Vaca and his three companions had left to sustain them at that point was their faith in God, which served them in the most unexpected way, as the Indians turned to them as healers:

Some Indians came to Castillo and said to him that they suffered a malady of the head, begging him to cure them. And after he had made the sign of the cross over them and commended them to God, at that point the Indians said that all the sickness had left them. And they went to their houses and brought many prickly pears and a piece of venison . . .

The next morning many Indians came there, and they brought five sick people who were crippled and very ill, and they came in search of Castillo, so that he could cure them. And each one of the sick people offered their bow and arrows. And he accepted them, and at sunset he made the sign of the cross over them and entrusted them to God our Lord and we all prayed in the best way we could that we might bring them health, since he saw that there was no other means by which to make those people help us so that we could leave so miserable a life. And he did it so mercifully that, come the morning, they all awoke so fit and healthy, and they went away so vigorously as if they had never had any malady whatsoever.

. . . some Indians of the Susolas came to us, and they begged Castillo to go and cure a wounded man and other sick people, and they said that among them there was one who was very near his end. Castillo was a very cautious physician, particularly when the cures were threatening and dangerous. And he believed that his sins would prevent the cures from turning out well every time. The Indians told me that I should go to cure them because they held me in esteem, and they remembered that I had cured them at the nutgathering grounds . . .

And thus I had to go with them, and Dorantes and Estevanico went with me. And when I arrived near their huts, I saw the sick man whom we were going to cure, who was dead, because there were many people around him weeping and his house was undone, which is the sign that the owner is dead.

And thus when I arrived, I found the Indian, his eyes rolled back in his head, and without any pulse, and with all the signs of death; so it seemed to me, and Dorantes said the same. I removed a mat that he had put on top of him, and with which he was covered. And as best I could, I beseeched our Lord to be served by giving health to that man and to all the others among them who were in need. And after having made the sign of the cross and blown on him many times, they brought me his bow and they gave it to me along with a basket of crushed prickly pears, which I gave to our Indians who had come with us. And having done this, we returned to our lodgings. And our Indians, to whom we had given the prickly pears, remained there, and at night time they returned to their houses and said that that one who had been dead and whom I had cured in their presence had arisen revived and walked about and eaten and spoken with them, and that as many as I had cured had become well and were without fever and very happy . . .

They beseeched us to remember them and to ask God to always keep them well, and we promised them that we would do so, and with this they departed the most contented people in the world, having given us all the best things they had.

The remainder of Cabeza de Vaca's *Relación* tells how the four survivors finally escaped the Indians and set off in search of a Spanish outpost. They eventually covered over two thousand miles of uncharted territory.

Traveling five days with very great hunger because there were no prickly pears nor any other fruit along the route, we arrived at a river where we put up our houses. And after setting them up, we went to look for the fruit of some trees. . . . And since through all this land there are no trails, I stopped to investigate it more fully; the people returned and I remained alone, and going to look for them, that night I got lost. And it pleased God that I found a tree

aflame, and warmed by its fire I endured the cold that night, and in the morning I gathered a load of firewood, and I took two fire-brands and again looked for the people. And I continued in this manner for five days, always with my lighted torch and a load of wood, so that if my fire died in a place there was no firewood . . . I would not remain without a light, because against the cold I had no other recourse since I went naked as I was born. And for the night I had this defense, that is, I went to the groves of the wood near the rivers, and stopped in them before sunset. And in the earth I dug a pit with the butt of a timber and in it I threw a great deal of fire-wood from the trees that grow in great quantity there. And I gathered much dry wood fallen from the trees, and around that pit I placed four fires like the points of a cross. And I made an effort and took care to rekindle the fire from time to time, and from the long grass that grows there I made some bundles to cover myself in that hole. And in this way I protected myself from the cold of night. And during one of them, the fire fell on the grass with which I was covered. And while I was sleeping in the pit the fire began to burn fiercely, and despite the great haste I made to get out, my hair nevertheless received the sign of the danger in which I had been.

In this entire time I did not eat a mouthful of food, nor did I find anything that I could eat, and since my feet were bare, they bled a great deal. And God took pity upon me, that in all this time the north wind did not blow, because otherwise it would have been impossible for me to survive. And at the end of five days I arrived at the bank of a river where I found my Indians, for they and the Christians had already taken me for dead, and they were convinced that some viper had bitten me . . . and they told me that until then, they had traveled with great hunger, that this was the reason they had not searched for me, that that night they gave me to eat some of the prickly pears they had. And the next day we departed from there and went to where we found many prickly pears with which all satisfied their great hunger. And we gave many thanks to our Lord because his succor never failed us.

In search of the Rio de las Palmas, today's Rio Soto Marina, the men walked from their landing point on San Luis Island all the way down today's Texas Gulf Coast, across the Rio Grande, to the present-day Rio San Fernando in northern Mexico. Then, not knowing that they were less than a hundred miles from the Rio de las Palmas, the four Spaniards turned inland, probably in an effort to avoid the hostile Indians of the coast.

The exact course of the Spaniards' cross-country journey is unknown, but clearly they crossed the entire present-day country of Mexico, traveling first in a northwesterly arc, through the eastern range of the Sierra Madre Mountains, then along a southwesterly route, across the Sonoran desert, until they finally arrived at the Spanish outpost at Culiacán, near the Pacific Ocean. The year of their arrival was 1536, eight years after their rafts were thrown ashore on San Luis Island.

Cabeza de Vaca's *Relación* includes remarkable observations about the land the survivors crossed, the flora and fauna they saw, and the physiognomy and habits of the Indian tribes they encountered. For this reason, Cabeza de Vaca is regarded as the first geographer, the first historian, and the first ethnographer in Texas. As if those were not enough distinctions for the castaway Spaniard, he is also credited as having made the first surgical procedure in Texas, when he successfully removed an arrow from the chest of an Indian.

· · ·

Across the causeway over San Luis Pass, I drive onto Follett's Island. There are beach houses in small developments on both sides of the highway, and the Bright Light Bait House is open. Pickup trucks fill the parking lot. West Bay glistens like a strip of silver lying on the horizon to the north of the highway. To the south of the road, the gulf waters come to within fifty feet of the road. There's nothing ahead of me but open road and a string of telephone poles, all leaning to the southwest, pointing the way to Freeport.

At Surfside Beach, the blue-gray silhouettes of massive industrial plants appear ahead on the horizon. A few moments later, I turn north

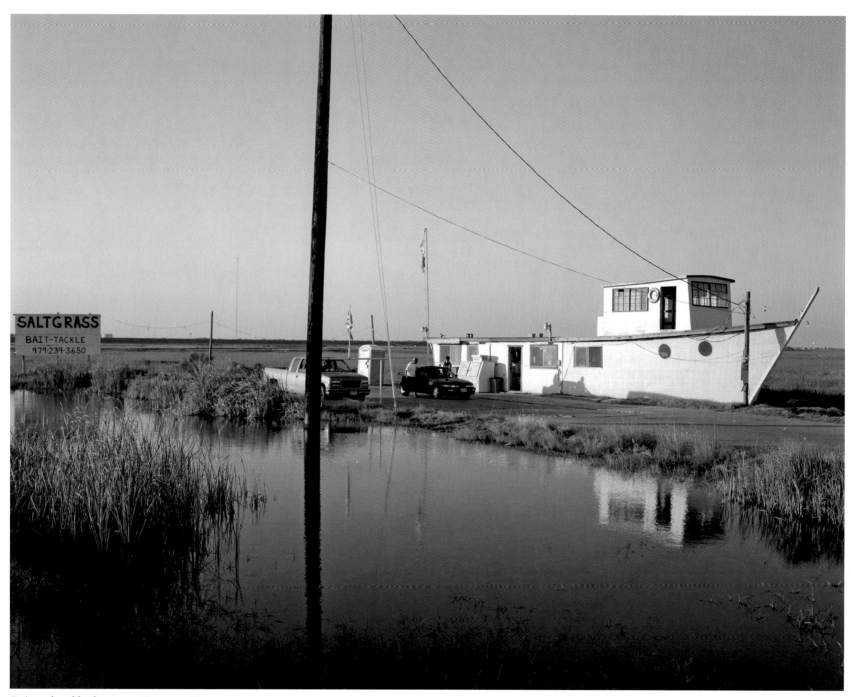

Bait and tackle shop, near Freeport, Texas

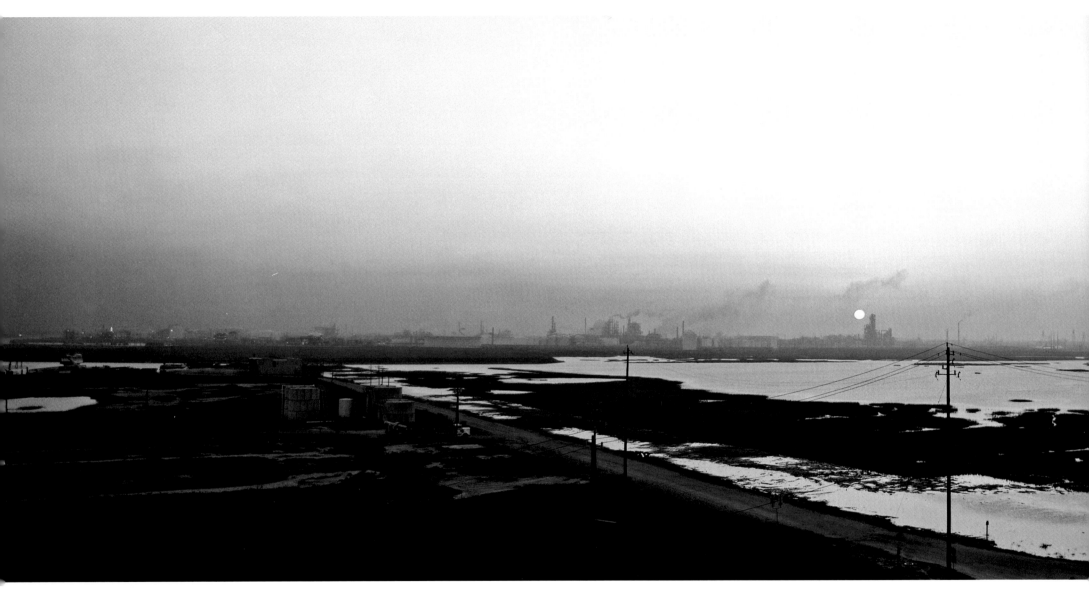

View toward Freeport from the Intracoastal Waterway bridge, Texas Highway 332

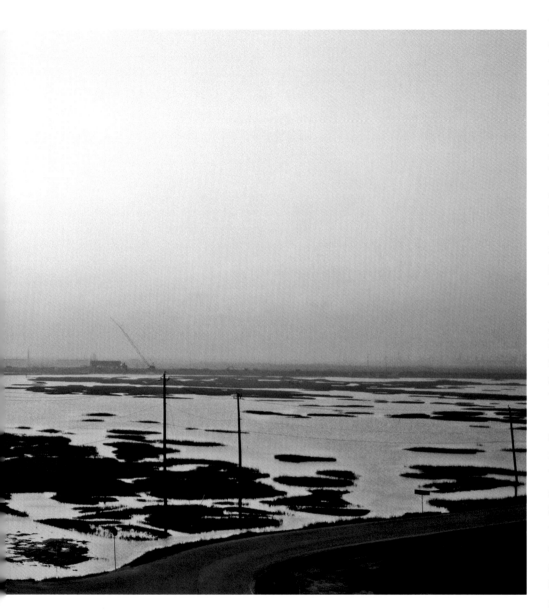

on Highway 332 and climb a long, low-arching concrete bridge over the Intracoastal Waterway. The view from the top of the bridge offers a three-hundred-sixty-degree panorama of industrial development. Hundreds of round, white storage tanks stand along the waterway below me. The towering stacks of chemical plants send puffs of white vapor into the sky. Dow Chemical, I recall, selected Freeport back in 1940, as the site of its Gulf Coast operations. One of the first plants that Dow built in Freeport extracted magnesium from seawater, which was critically important to the Allies. As Dow grew with each massive new plant it built in Freeport, a severe shortage of housing for the workers developed. So the company built an entirely new city and named it Lake Jackson. By 1944, Dow was shipping chemicals by marine vessels to ports all over the globe, and the Brazosport industrial area, as it came to be known, was on the world map.

As impressive as the industrial and chemical complex of Brazosport appears from the top of the Intracoastal bridge, what awaits the traveler coming down from the bridge is, in its own way, equally impressive: BUC EES, a whopper of a convenience store, road food emporium, beach style shop, and bait shop, all rolled into one postmodern, credit-card-friendly package. What *would* Cabeza de Vaca have thought of this place?

Today is the Thursday before Labor Day weekend, and the parking lot at BUC-EES is full of cars and pickup trucks. There are quite a few fishermen dropping in, most of them wear camouflage gimme caps and t-shirts with words of brotherly wisdom or warning. A sign over the parking lot advertises the BUC-EES Bait Buffet. You can pick from "Shrimp, Ballyhoo, Squid, Ribbonfish, Chum, Shad, Sardines . . ." The list goes on. Inside, there's every snack food known to Western civilization, plus cappuccino, dark roast coffee, and a variety of flavored brews. At the road food dispensary, I detect a cajun twist to the menu. There are gizzards, a large order for $2.99. Sausage on a stick costs $1.99. And Meat Pie ("La. Special') is also $1.99. For those with a less adventurous palate, there's fried chicken, french fries, and fried egg rolls. I'm thinking of Cabeza de Vaca's month-long ration of "half a handful of maize" each day, and I wonder not so much how he survived, as how *these* folks do, today, on the fried foods that BUC-EES is serving up.

Back on the highway, I follow the signs south to Quintana Beach. Then I head west, crossing over a high bridge spanning the Brazos River. Shrimp boats are docked along both sides of the river. This is Freeport, but the center of the town is virtually deserted. A few cars are parked here and there, but there's not one person is sight, a striking contrast to all the bustle and activity back at BUC-EES. East of the center of town, I find a neighborhood of narrow streets, small homes, and simple churches; many of the humble buildings are classics of American vernacular architecture. Walker Evans might have invented this place.

The neighborhood is ethnically mixed. On the corner of East Sixth Street and Spruce, a black man pushes a lawn mower across his front yard. Four pickup trucks are parked down the street in front of another home, where a dozen Hispanic men are gathered in the side yard around a barbecue pit. On East Sixth Street, a man sits on the front steps of a tiny, white frame building. A hand-painted sign across the front of the building reads "Gutierrz Barber Shop." It's a beautiful little building, with a square front facade and a sloped, shingle roof. The Hispanic fellow sitting on the steps eyes me as I drive by, so I stop, get out, and introduce myself, continuing to admire the little building as we speak.

"Are you Señor Gutiérrez?" I ask, as he stands, smiling.

"Ambrosio Gutiérrez. Call me Butch."

"Butch?" I ask.

"Really, it's Bocho. You know. It's Bocho, that's what we call Ambrosio, for short, in Spanish. But you call me Butch. That's English for Bocho. Butch."

"I sure like your barber shop, Butch . . . man, it's strange calling you Butch. I'm gonna call you Bocho, that OK?"

"Oh yeah."

"How long have you been cutting hair here?"

"Oh, man. I was *raised* here. Back when this place was *alive*. You know, it's kinda ghost town now. So many people, when they get a good job, they *leave* here and get a house in Lake Jackson or somewhere. But I was *raised* here." There was a beautiful, distinctive way that Bocho said "*raised,*" with his voice rising and drawing out the word for emphasis. A very Mexican inflection, and very expressive.

"What do you call this neighborhood?"

"This here is the *east* side." (The same beautiful rising of the voice on the word east.) "Not so many people live here now and mostly its old people that's still here. I remember when this place was *alive,* man. This place, what's my shop now, this place was my *momma's* café, back when I was a kid. We had a jukebox and we was open twenty-four hours, never close. My sister and me we help my mother in the café. My sister would be helpin' her cook. I didn't learn to really cook till I was older. Now I'm a helluva cook. I can cook anything you want. Chili. Bake a cake. You name it. That's my hobby. But back then I was justa kid and I would be sweepin' the floor and cleanin' up the place for my momma.

"Righta cross the street, back then, we had *night* clubs in those days. This was a *fun* place, I tell you what. Now when those clubs close up, maybe midnight, maybe two in the morning, here they come, all wantin' a hamburger, maybe some *chili,* and some coffee. Yessir, and it was *all* kinds. Whites and blacks and *Spanish,* you name it, we had em all. We did a helluva business early in the mornin' down here. Now it's a *ghost* town down here."

I'm curious about Bocho's choice of words in referring to the "Spanish" people, so I ask him: "If there were Spanish people—you call them Spanish—but we're talking about Mexicans aren't we, how did they come to be here? Do you know?"

"Yeah, well, Spanish is what I *call* em, cause a course they *are* Spanish. You know what I mean. Spanish. Not whites or blacks. *Spanish.* Like me. Well, hell, I don't know where anybody come from. But the Spanish has been here as long as I can remember and I'm seventy-eight years old. Some of em was left over from the *dump* people, I know that. That goes back to before Dow was even here.

"The dump people? Who were they?"

"Come in here. I show you something."

Bocho leads me up the steps and into his immaculate, one-room barbershop. Behind his barber's chair, taped to the wall beside the mirror, is a clipping from *The Facts,* the Freeport newspaper. The article, dated September 14, 1997, describes how Hispanic workers were brought to Freeport in 1912 to provide labor for the newly arrived Freeport Sulphur Company. The workers were not allowed to live in the main community of

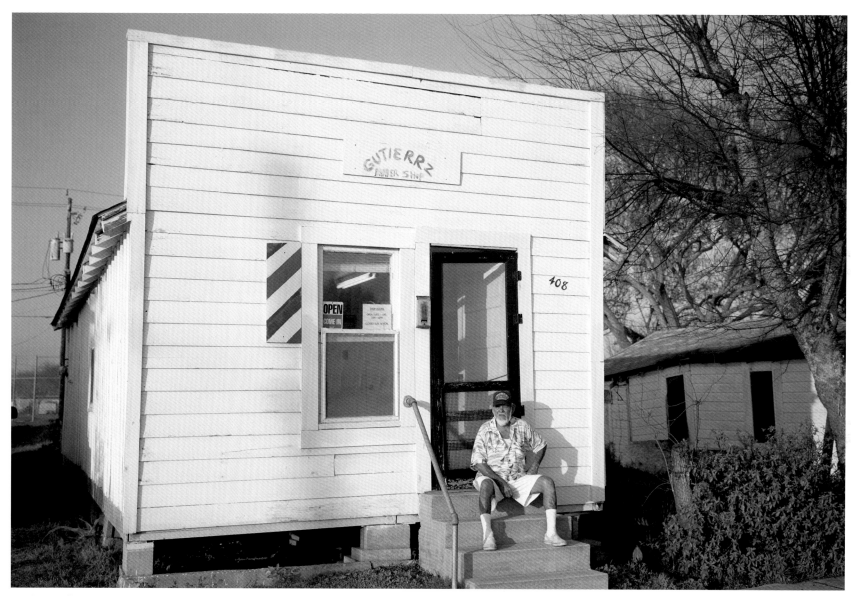

Ambrosio "Bocho" Gutierrez, Freeport, Texas

Freeport, but instead were relegated to shacks built along the city dump. Hence, "dump people."

"That was *here*," Bocho said, pointing to the floor. "Then they finally tore down those shacks and built some nice homes and businesses. Like my momma's café. This barbershop is the last of them businesses that's left. All the rest is homes and churches. And most of the homes, nobody's livin' in em."

"So what keeps you here?" I ask, as Bocho settles into his barber chair.

"Well, I still got a pretty good business here. You know, I cut *every*body's hair. I cut the men and I cut the women's hair, too. I do it all. And I cook for people. Just yesterday I cooked a pot a chili for fifty people. A wedding. I do good, and I like it here. Hell, we get a mayor that's talkin bout puttin' in a big *marina* over there, how that's gonna bring jobs and hotels and restaurants and everything. I tell you how smart he is. Last week he got run over by his own lawn mower. *Twice.* He fell down, it run him over, and he roll over and let it run over him again. *Twice.* I ain't all that smart, but I'm gonna get out a the damn way after a lawn mower runs over me one time. Hell if it's gonna get me *twice.* And he the same guy, the mayor, he's tellin' us that we gotta get behind this marina deal. *Hell,* any idiot can tell you there ain't enough people in this town with *yachts* to make a marina work, and you gotta have *yachts* to make a marina work. I'm gonna keep on cuttin' hair and cookin, but I ain't countin' on no marina. Not me."

I leave Bocho with his five o'clock appointment, a young Hispanic man who walks into the shop with a full head of black hair, baggy blue jeans worn low around his hips, and a purple t-shirt that reads "She Looked Good Last Night." I promise to bring Bocho a photograph of his shop and ask him for directions to the mouth of the Brazos River.

"Just turn south on the highway out there and you'll come to Quintana Beach. Then go right, just drive along the beach. Watch out for all the driftwood and be sure the tide's not up too high. You can usually drive the two miles or so down to the river without no trouble. That's the only way to get there. There ain't no road to it other than the beach."

Quintana Beach. I am reminded of Quintana, the historic gulf port that once thrived on the west side of the Brazos River at the gulf, and Velasco, its sister city, four miles upriver on the east side. Both towns were named

for Mexican generals, both played critical roles in the history of early Texas—Old Velasco has been referred to as the Boston Harbor of the Texas Revolution—and both towns became famous vacation spots, favored by the wealthy plantation families of the region. In the 1830s, Velasco even had a seminary for young ladies and a private school for young men. There were comfortable hotels for patrons of a nearby racetrack, extensive wharves, and a customhouse.

Both towns have disappeared from the map. Quintana and Velasco fell victim to the double blows of social progress and that great enemy of coastal cities: hurricanes. With the ruin of the plantation system after the Civil War, both Velasco and Quintana rapidly declined. Then the hurricane of 1875 swept through, causing extensive damage. Both towns were still struggling to recover from that hurricane when another blew through in 1900, the same storm that destroyed Galveston. It stripped the coastline of Brazoria County bare and totally wrecked both towns. Quintana never recovered. Most of its surviving residents gave up and moved inland. Velasco slowly rebuilt, endured ups and downs of poverty and prosperity, and was finally incorporated with Freeport in the 1950s.

The Brazos River has its own important role in Texas history, all the way back to the earliest Spanish and French explorers. The various names applied to the river can be confusing, in part reflecting the confusion that afflicted early explorers when it came to all the rivers along the Gulf Coast. The earliest known name for the river, given by the Caddo Indians, was the Tokonohono. French explorers renamed the river Maligne. But there is so much evidence that both the French and the Spanish confused the Brazos and the Colorado rivers through the early eighteenth century that it's hard to say which river they were naming. In early Spanish accounts, the full name of the river is Los Brazos de Dios, "The Arms of God," and there are a number of legends regarding the origin of that name. One legend tells of the Coronado expedition, near death from thirst, being led to the stream by Indians, who drank from the river, lived, and so named it. Another legend tells of a Spanish ship, its sailors parched with thirst, lost, and unable to find land, when one of the crew found a muddy streak in the water. They followed the streak's current, found the river, drank from it, and lived.

The Brazos is the longest river in Texas and the one with the greatest

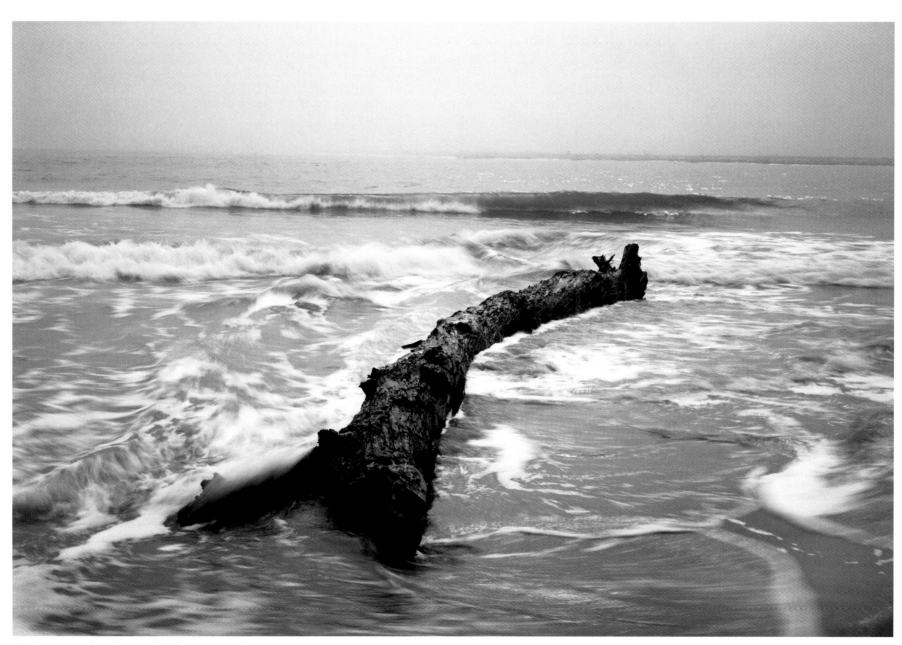

Quintana Beach at the mouth of the Brazos River

discharge. As I approach the mouth of the river, driving south along the sands of Quintana Beach, the amount of driftwood in the surf begins to build. Here and there, entire trees, roots and all, lie in the shallow waters of the surf. Black-faced gulls, white egrets, and flocks of gray pelicans perch on the giant tree trunks or bob nearby in the surf. When I reach the actual mouth of the river, which I estimate to be about a hundred and fifty yards across, I can see a substantial sandbar a short distance out in the water. This is a big river, with an impressive discharge into the sea, but so shallow are the waters at its mouth that entry into it from the gulf would be impossible for anything but the smallest boats.

The scene here at the mouth of the Brazos is wild, even a bit scary. There's not a person or a single vehicle in sight. A stiff wind is blowing from the south, and white-capped waves are crashing over the sandbar. The powerful force of the river can be seen in the huge, uprooted trees scattered along the riverbanks.

I walk along the beach, looking across the mouth of the river to its southern banks, where even more driftwood and uprooted tress are piled in the sand. An old, beat-up Chrysler van approaches from up the beach. The van—with a badly cracked windshield, faded blue paint, and rusted bumpers—comes to a stop about a hundred yards to the south of me. Two people, an older man and a young woman, emerge from the front seats. I watch as they help an older lady exit the van from the back seat. The man opens the hatchback door. Three dogs jump out and run toward the surf. The older lady walks in my direction with the dogs tagging alongside her. All four are smiling.

"I sure would like to see that pitcher you just took. I bet it's a real Hallmark moment. Ain't it beautiful out here?" she asks. The dogs are at my feet, smiling up at me, sniffing at my tripod.

"It *is* beautiful here," I reply. Though I'm thinking to myself, it's not *everybody's* idea of beautiful. A rough beauty, perhaps. All the uprooted trees, ripped from the banks of the river, carried here to the edge of the sea. Piles of driftwood everywhere, with an assortment of plastic bottles and an old shoe or two thrown in. No, it's not the majestic beauty of Big Sur or the lovely shores of Cape Cod. Then I notice that the lady is wearing a white cotton beach hat that fully covers her head, and when she leans over to pet the dogs, I notice that she has no hair on her head. I put that with her pale complexion and the fact that she appears unnaturally thin under her t-shirt and faded blue jeans. She's not well, I figure. Very ill, perhaps. But she's enjoying herself here at the mouth of the Brazos.

"You like this place?" she asks.

"I do. There's a primitive beauty about it. What about you?"

"I just love it. He brings me here almost every day. Sometimes early in the morning, when the sun is rising. Other times like today, late, when the sun is going down. It's always different. But it's always relaxing. I don't know what I would do if I couldn't come here. It makes me feel so peaceful." She gives me a little smile and a wave, then she and the dogs continue down the beach.

The sun is almost down now, and the tide is coming in. I figure that I better drive back to the highway while I still can. Thinking about disappearing towns, like Quintana and Velasco, has me considering the history of this part of Texas as I consult my road map. I decide to find a motel and spend the night in Freeport, then get up in the morning and drive a few miles north to West Columbia. Columbia was the site of the first capital of the Republic of Texas. I'll have a look at the town before I continue south toward Matagorda.

• • •

I am reading, from a handmade album on display in the Columbia Historical Museum, the firsthand account of an ex-slave named Ned Thompson. In the album, Thompson recounts how he and his wife were rounded up in his African village, forced onto a slave ship, and brought across the Atlantic Ocean to Texas. They were unloaded, according to Thompson's account, on the Brazos River at Columbia, Texas, and theirs was the last load of slaves to arrive in North America.

"Well, I shu-ah hope you'll sign my guest book befoah you leave." The soft voice and honey-sweet accent causes me to turn away from the album I've been reading to find a tiny, silver-haired lady, elegantly dressed, facing me with a gracious smile.

"I would love to sign your guest book. Are you the museum director?"

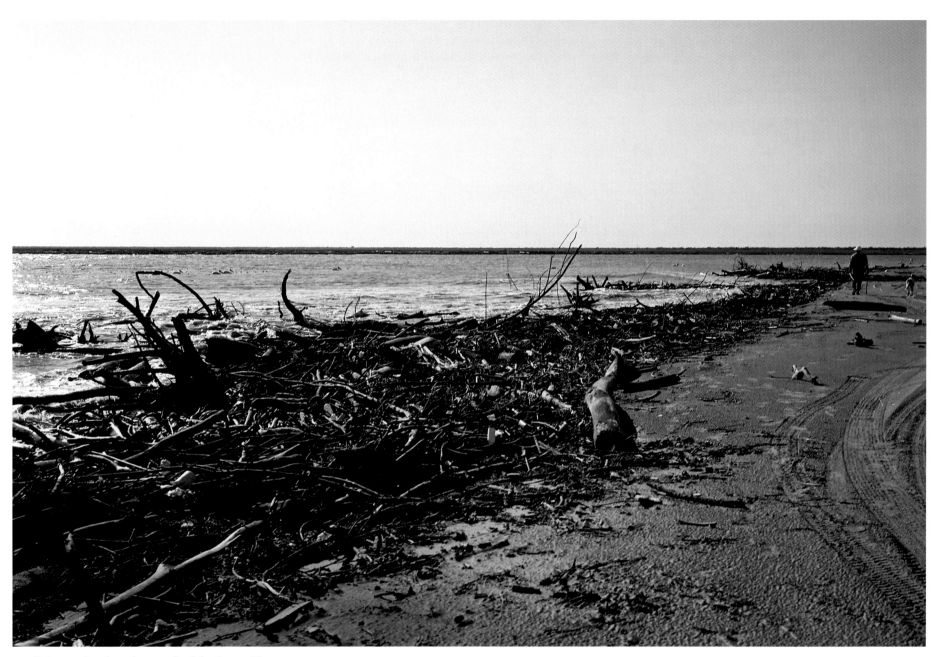

Quintana Beach at the mouth of the Brazos River

"I am Emma Womack. I am the *founder* of this museum."

Mrs. Womack explains to me that when her husband died, she needed something to do, and she had always loved history. She persuaded the owners of this building to let her make a history museum of it. "All these wonderful things," she tells me, started flowing in, since everybody in town seemed to have something they wanted to give to the museum. There was already a museum in Angleton, she explains, but people wanted their things to stay here in West Columbia, "where they belong."

"Angleton is the county seat?" I ask.

"Oh, yes. But it has no history. No history at all, compared to Columbia. But then few places do. History is all around us here in Columbia, so it was just fitting and proper that the museum be here. Now, you must understand, we don't *own* anything here. It's all on loan. But I suspect it will be on loan forever. Isn't that wonderful?"

With Emma Womack at my side, I went right back to the photograph and story of Ned Thompson and his wife. "Do you have favorite things in the museum?" I ask. "Things you especially like to show."

"No. I don't let myself have favorites. I just don't let myself do that. Here, look at this. Did you see this?" Emma Womack points to a red brick sitting on a low shelf beside a photograph of Ned Thompson and his wife. Beside the brick is a handwritten note on a small, white card: "Brick Made by Slaves."

"How did the museum come to have the brick?"

"I can't recall. But I'm sure it's a genuine slave brick. Look at how rough and irregular it is. Not at all like today's factory-made bricks. Isn't that wonderful?"

Well, yes, I'm thinking, it *is* wonderful. And, certainly, I am not one to get picky about the provenance of any particular object. I am more fascinated, though, with a tiny lady's purse, labeled "From about Civil War Time," displayed right next to the slave brick. The black silk purse measures no bigger than two inches across, and I am wondering what could have been small enough to carry in the purse.

My musings on slave bricks and tiny silk purses are interrupted by the sound of sirens. "Oh my, here comes the parade," Emma Womack says, moving toward the front window of the museum. "This is the San Jacinto

Festival, you know, and the parade has all the beautiful girls who are candidates for the Belle of the Brazos. Here they come, now."

Here they come, indeed. Right through the middle of town, down Brazos Avenue, in front of the museum, past Scott's BBQ and Chesney's Jewelry store, past Tom's Barber Shop, with two sheriff's cruisers out front, sirens wailing, followed by the honor guard, the Texas flag and Old Glory, then the Marching Roustabout band and drill team. This year's Man and Woman of the Year, unidentified by name, but recognized by all, wave to the crowd from the back seat of a new Chrysler Crossfire convertible. Then, what everyone has come to see: the ten lovely candidates for the Belle of the Brazos. One by one they pass, each in a new or fashionably antique vehicle—a 2007 Mustang or a 1957 Thunderbird—each in a classic southern ball gown of brilliant color, each shading themselves with an umbrella of matching color. I excuse myself from Emma Womack's company, promising to return to the Columbia Historical Museum soon. I want to see the rest of the parade from the street. Perhaps I'll even catch the crowning of this year's Belle of the Brazos.

• • •

Highway 36 takes me south out of Columbia toward Brazoria. In the morning sunlight, the landscape comes alive in a thousand shades of green. This area, roughly from Freeport to Matagorda, stretching fifty miles or so north from the Gulf, is known as the Columbia Bottomlands. The soil is dark, rich, and thick. Forests of oak and pecan trees line the wetlands of a dozen rivers and streams that crisscross the area. The Brazos, Colorado, and San Bernard rivers, Caney and Jones creeks, along with numerous bayous, are the basis of the fertility of the region. In the spring of the year, there is no more beautiful region of the Texas Gulf Coast than the Columbia Bottomlands.

I notice again, as I have on previous trips to this region, that there are a lot of African Americans living around Brazoria and that this area is economically depressed. Ramshackle old houses and falling-down sheds line the highway. Big O's Country and Soul Cooking appears to have been out of business for years. The Handy Way Store and Exxon dealership are

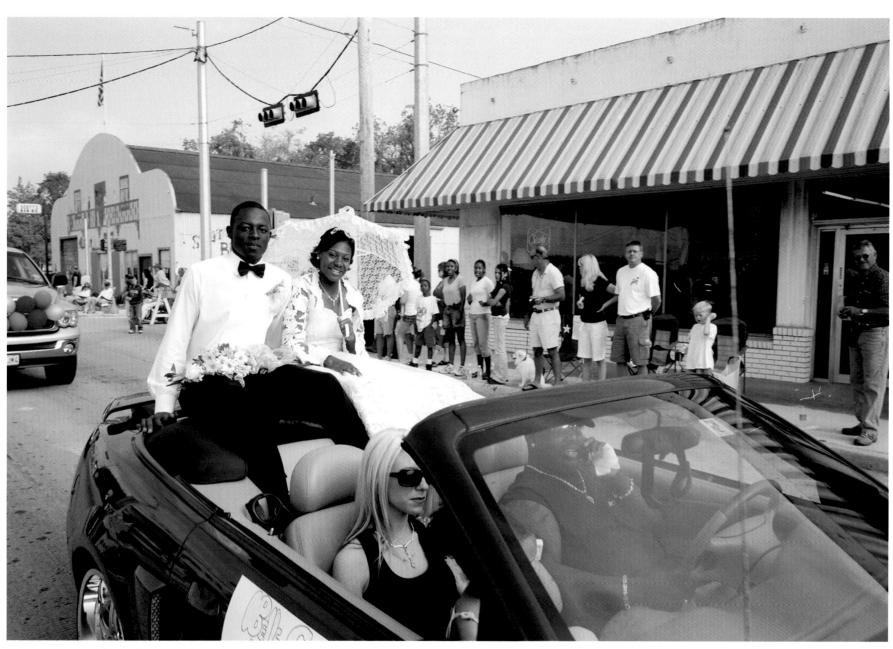

San Jacinto Festival Parade, West Columbia, Texas

On Texas Highway 521, near Brazoria, Texas

closed, and the old sign out front still advertises regular gas at a dollar and nine cents a gallon. On the other side of Brazoria, I turn southwest onto Highway 521, toward Wadsworth and Matagorda. Highway 521 is the closest thing to a coastal highway through this region, paralleling the shoreline, ten to fifteen miles inland. Just out of Brazoria, I cross a high, arching bridge above the San Bernard River. On the other side of the bridge, the Rose of the River Hair Salon sits on the right side of the road, followed by Mertie's This 'N That store, the Magnolia Baptist Church, and the Bag-A-Bag drive-in grocery. A historical marker under some trees on the north side of the highway identifies the property as the site of the Levi Jordan plantation, built from 1848 to 1851 by slave labor.

Behind the marker, a barbed wire fence with No Trespassing signs protects a wooded piece of property. Nestled in a grove of trees at the back of the property, I can see an old plantation home that is undergoing renovation.

I am struck by the appearance of the homes and lots along the road as

I continue west on Highway 521. The entire area looks like a disaster zone. The homes are falling apart, their roofs are caving in, and the yards are all littered with trash. But these homes are not abandoned; people are living in them. Abandoned cars, rusted tractors, and old appliances are scattered across the front yards and in adjacent fields. One front yard, totally covered in junk, looks like it was the site of a major explosion. Nailed to the front fence, a hand-painted sign reads: "Nothing for Sale. Don't Ask."

As I continue driving west on Highway 521, tiny creeks and streams cut through the land and cross under the highway, a new one every mile. I cross over Linnville Bayou, then Caney Creek. At the crossroads with FM 457 a sign points south to Sargent Beach. I turn there, looking for a place that will give me open access to photograph some of this beautiful landscape.

A few miles down FM 457, I notice a driveway leading off to the right. There are no signs and no mailbox. I drive in and follow the road, which leads into a grove of pecan trees. A wooden bridge passes over Caney Creek, and on the other side I see cattle grazing and several low buildings. A metal gate, chained and locked, prevents access to the farm itself, but to my right, a landscape of high grass, wildflowers, and towering oak trees runs along the north side of Caney Creek.

I take out my medium format camera, a Fuji rangefinder, light enough to carry for a long distance through all the high grass, but big enough in terms of film size to render intricately detailed landscape. I stuff five rolls of film in my pocket and start walking along the banks of the creek. The next time I look at my watch, it's seven o'clock, and I have been lost in the pleasures of exploring and taking pictures for over three hours. I have five rolls of exposed film and high hopes for the pictures.

• • •

I take Highway 457 north, turn west on Highway 35, and soon I am driving into Bay City. In the center of town, there's an old-fashioned square—with a jewelry store, a florist, an ice cream parlor, and a range of other small retail stores—surrounding a modern courthouse. A tall limestone monument stands in front of the courthouse, gleaming in the afternoon sunlight.

West of Texas FM 457, along Caney Creek (and following two pages)

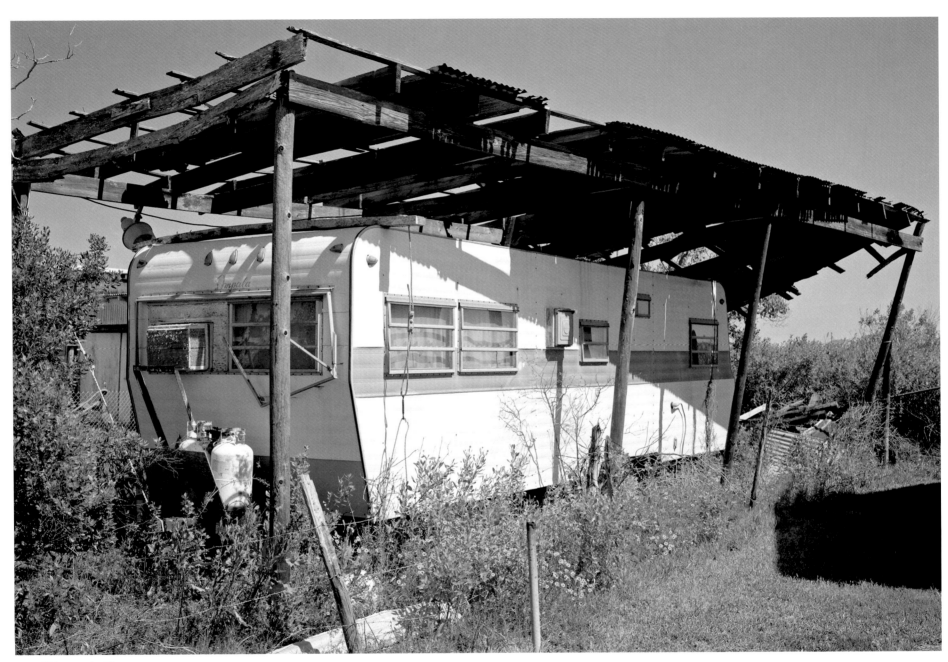

Chinquapin, Texas

Schicke Point, Matagorda County, Texas

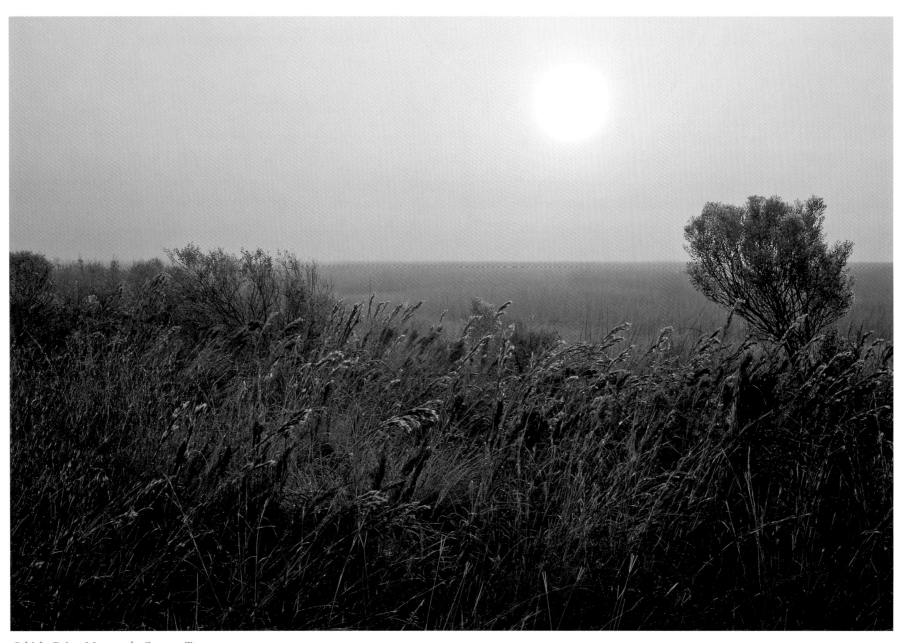

Schicke Point, Matagorda County, Texas

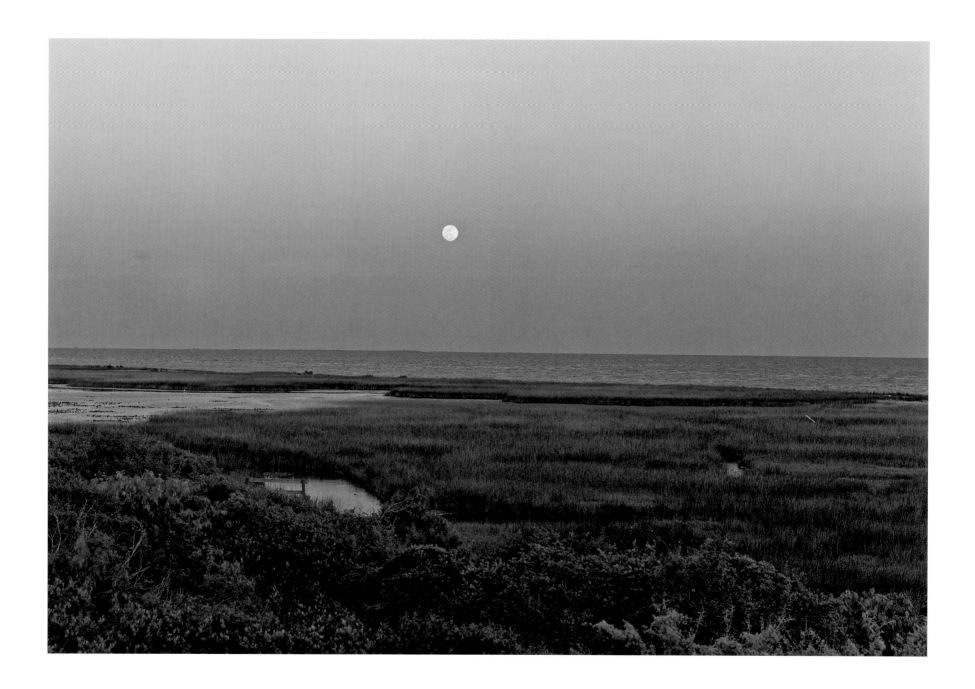

At the top of the monument, a confederate soldier, rifle at his side, casts his gaze toward the south. Across the street, a handsome one-story classical building, an old bank building, I suspect, houses the Matagorda County Museum.

I am standing on the steps of the museum, reading the hours of operation and realizing that the museum is closed today, when the front door opens and a lady asks: "Would you like to come in? We're closed to the public today, but we're here, and you're welcome to come in and look around." After we have introduced ourselves, Sarah Higgins, the director, gives me a private tour of the museum.

The museum is small, but immaculate, and it's loaded with objects of local history. Ms. Higgins takes me to two of her most prized pieces in the museum collection. First, she shows me a large, intricately detailed, hand-drawn map of Matagorda County from 1839. "This map was done by a man named James Selkirk. He was a surveyor, an artist, and one of the pioneer daguerreotypists in Texas," Higgins explains. "When we found it, it was in terrible condition, but we had it restored. Notice how it identifies all the land grants of the original settlers in the county area. And notice that all the names on the west side are Hispanic, while all the names on the east side are Anglo. I'm not sure what that tells us, but there they are." I am more interested in the physical beauty of the map. Pieced together like an old quilt, yellowed with age, and with Mr. Selkirk's elegant calligraphy in blue ink, now faded with time, this is an object I could study and admire for hours.

"This is one of the actual cannons from LaSalle's ship, *La Belle*," Higgins continues, as she ushers me across the room. "You know, the *La Belle* was found in shallow water, right out there in Matagorda Bay. Just fifteen years ago. It sank in 1768 and laid there in the sand and mud under the water for over two hundred years. The state undertook the excavation of the ship, a five-year project, and when it was done, we got one of the cannons." The cannon doesn't interest me. It has been restored and polished to the point that it has no sense of age. It looks like a new replica of an old cannon. I prefer the ragged beauty of the map.

But what really catches my eye is a display depicting a Karankawa Indian family. It's a strange little diorama, with three mannequin-like figures—poppa, momma, and little kid Karankawa—all set on a little patch of sand.

Behind them, a painted mural provides a backdrop of gulf water, blue sky, and various birds in flight. The text in front of the display tells us that the Karankawa were a nomadic people who adapted to the harsh environment of the Gulf Coast and survived there from somewhere around 5000 BC until the middle of the nineteenth century. Cabeza de Vaca's encounter with the Karankawas, when he and his men were washed ashore in 1528, is the earliest known European contact with them, and Cabeza de Vaca was the only early European known to have survived an encounter with the tribe.

"A Texas Ranger," the text reads, "once described the Karankawas as 'the most savage looking human beings I ever saw.' The men—tall, heavily tattooed with cane piercing their nipples and chins—smeared themselves with alligator grease and mud to ward off mosquitoes. Their smell made early settlers sick to their stomachs."

"You know, there was a journal discovered not too long ago," Sara Higgins began. "A journal written by one of the earliest settlers in the Austin Colony. I think there had been some serious question about whether the Karankawas were actually cannibals, as some accounts had described. Well, in this journal, the man described how he came back to his homestead and found his family, his wife and children, hung up on a fence, dead. The Karakawa had strung up the man's family and killed them for the fun of it. No other reason. Then they took the man with them. Well, after some time, other settlers found the bodies of the family, and they set out to look for the man, the father of the family. When they finally caught up with the band of Karankawas who had taken him, they had the man on a leash, dragging him along with them, cutting off chunks of his flesh and eating it as they went. The settlers went back and told Austin what they had seen, and he sent a band of men to track down the Karankawa band and free the man. He lived for a short while, but eventually he died of gangrene."

. . .

Highway 35 crosses Lavaca Bay on a new, divided causeway connecting the industrial area of Port Comfort with the city of Port Lavaca. Over the causeway, the four-lane highway is lined with new motels, restaurants, and a Walmart Supercenter, but there's no sign of a city along

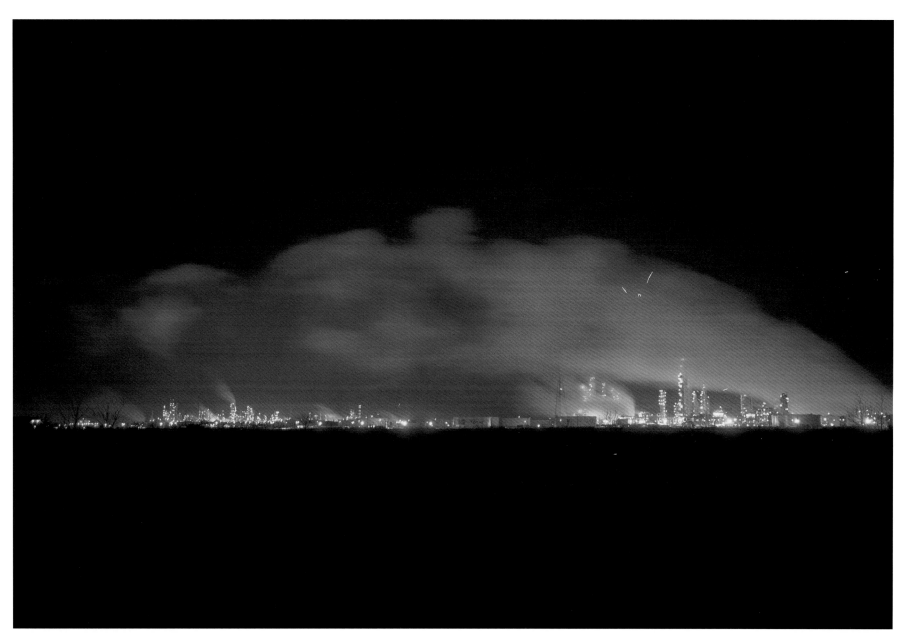

Oil refinery at night, Port Comfort, Texas

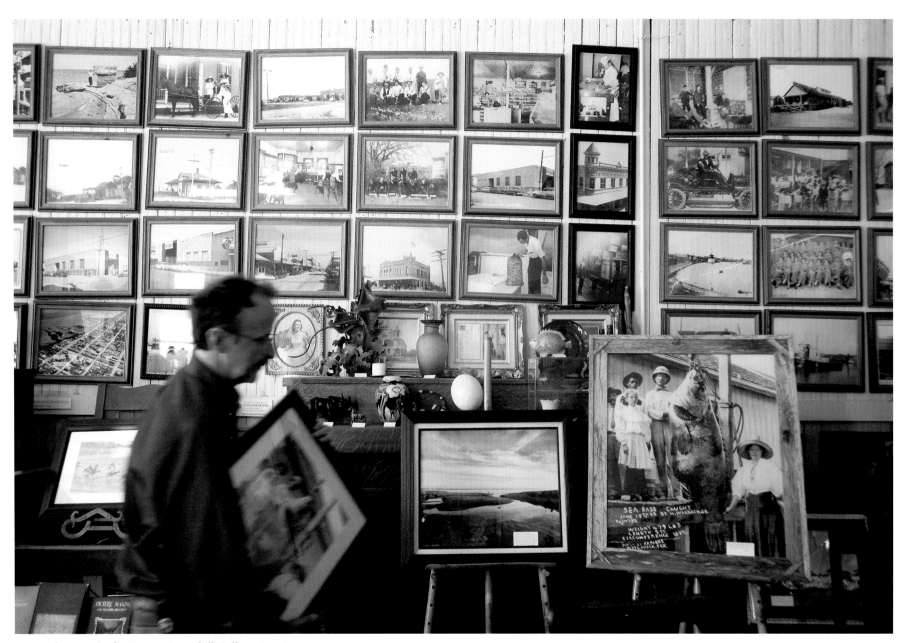

Dean Johnstone in the Roseate Spoonbill Gallery, Port Lavaca

this stretch of the road. I turn left at the first stoplight and drive south on Commerce Street, following the shoreline of Lavaca Bay. After two miles I find East Main Street and turn right. I am looking for a little gallery called The Roseate Spoonbill, and I locate it two blocks down Main Street, in the middle of a charming strip of restored old buildings.

It's about twelve noon on a weekday when I park in front of the gallery. I notice that Rita's Do-or-Dye Beauty Shop is open across the street, and the Green Iguana Grill is serving lunch next door. The windows of the Roseate Spoonbill are full of framed maps and photographs. Inside, hundreds of framed historical photographs cover the walls of the gallery. Tables placed around the gallery hold books, portfolios, and memorabilia. A short, bespectacled man, about forty years old, enters the gallery from a back room carrying a framed picture. I introduce myself, and learn that this is Dean Johnstone, owner of the gallery and an accomplished photographer. I am curious to know where he finds all the historical photographs on display.

"Most of these are made from photo postcards," Dean explains. "We go to postcard shows, and there are dealers, each with thousands upon thousands of old postcards. We look for the ones that are actual photo prints, real photographs that were printed as postcards. And we look for the postcard photos that came from around here, from Port Lavaca and this region. We scan them, restore them, and make high quality digital prints from them."

The superb quality of the digital reproductions is impressive. I have looked at a lot of old photographs, and I have a good eye for originals, but Dean's prints are so good they could fool me.

My attention turns to a wonderful old photograph that Dean has restored and framed. The picture shows an enormous fish hanging on a wharf between a small group of people, a classic of the "fishing photo" genre. The picture is boldly captioned in hand-printed lettering on the lower left corner. "Sea Bass Caught June 15th 09 By H. Warrack Jr. and Wife. Weight 479 lbs Length 8 feet Circumference 6 ft. Photo by P. P. Parks Port Lavaca Tex." The mammoth fish is framed dead center in the picture. To the left of the fish are four people. A tall, slim, Anglo man, H. Warrack Jr, no doubt—a bit of a dandy in his round, wide-brim fishing hat, white shirt, and bow tie. A pretty little girl in pigtails stands next to the proud

fisherman, perhaps his daughter, called in for the occasion of the picture. Behind the girl, a young black man looks on, wearing a skeptical expression, as well as a bystander, who must have sneaked into the picture. Finally, on the other side of the hanging fish, with one hand on its pectoral fin, stands a fashionably dressed woman. She stares directly into the camera's lens.

"This picture comes from a very interesting old card," Dean explains. "See here. Two words have been scratched out from the caption. Right here after 'Caught June 15th 09 by H. Warrack Jr and Wife,' it used to say 'and Joe.' But see how the 'and Joe' has been scratched out. Apparently old man Warrack decided that Joe wasn't gonna get any credit for his part in catching that fish. Well, there's another version of this card. I've seen it several times. And in that version the 'and Wife' part of the caption is scratched out, too. And, if you can believe this, the woman is blacked out, too. He just took her out of the picture, along with her name in the caption. I guess he eventually decided to take all the credit for catching that fish himself. You might say that he was Photoshopping before Photoshop."

On the way out of Port Lavaca, I pass a sign pointing to the Historical Cemetery. I decide to stroll through the graveyard and look for old tombstones. On the east side of the cemetery, I discover a tombstone like nothing I've seen before. The pink *cantera* stone has been carved, primitively but beautifully, into a big fish. With its head at the bottom and its tail at the top, the figure of the fish rests against a large cross, also carved from the same piece of stone. Two small stones on the ground in front of the monument give the names of the two people buried here: Jose Reyes Cuellar (1949–1975) and Domingo Cuellar (1943–1953).

Were they fishermen? What is the story of this unique tombstone? And why did one of them die so young? On the way out of the cemetery, I notice four black men sitting in a driveway across from the entry gates, watching me with obvious curiosity. I stop and ask them if they know the Cuellars and where they live.

"They's lots a Cuellars. But one Cuellar family that I know lives over on Lavaca Street. You go two blocks over to Lavaca, turn right, go down and you'll see the house down on the left. Got a big anchor in the front yard. And a cross. Don't know his first name, but he's a shrimper."

Gravestone for Jose Reyes and Domingo Cuellar, Port Lavaca Historical Cemetery

I find the house right away. It's hard to miss, with a fifteen-foot cross in the front yard, covered in tiny white Christmas lights, and a dense growth of blue wildflowers all around it. I knock on the front door, and a Hispanic woman in her sixties answers. I ask her if this is the family of Jose and Domingo Cuellar, who are buried by the beautiful stone carving of the fish.

"Oh, lordy, yes. That's my husband's brothers. Let me get him for you."

A short, sturdy man appears from the back of the house, pulling on a shirt as he walks. He's older than the woman, perhaps seventy-five. His face is weathered and wrinkled, but he's got bright eyes and a warm smile: "Serefino Cuellar. Mucho gusto."

"Those my brothers, Mingo and Joe, that are buried there. Mingo he died when he was just boy. He drown right here. Joe, he drown too, in Galveston, on his boat. We don't know how he drown, but he drown, too."

"So did you have the tombstone carved for their graves?"

"No, that was my brother, Frank. He was very close with Joe. They always worked together, fishing I mean. And Frank don't want Joe to have just a cross or a Jesus like everybody else. He says Joe needs a fish, so he goes and gets a fish made for the grave. He got it in Mexico. A placed called China, little town in Nuevo Leon."

Serefino settles into the couch now, looking comfortable with me. He seems to enjoy telling his family story. "We all come here from Karnes County. My daddy, he was from Linares, in Mexico, but my momma was from Runge, in Karnes County. When we was just kids, we could farm about anything. Rice. Pick cotton. Chop cotton. Cane. You name it. We could do it. Then we move here in forty-three, and my daddy starts shrimpin' and ahsterin'."

"Ahsterin'?"

"Yeah, there was ahsters all over this bay back then. Now you hadn't got many ahsters, but back then you did. None of us care much for school. Only thing I learn in school is how to play hooky. I went shrimpin' and ahsterin' instead. By the time I was fifteen I was makin' good money. I didn't need schoolin to know that I could make more money fishin' than I could make farmin'. I even had a *convertible* car when I was fifteen. A *convertible* car like that guy on TV. What's his name? Columbo. I had me a *convertible* car with a real long trunk like Columbo. You remember him?"

"Sure. I remember Columbo. You like it here in Port Lavaca?"

"Oh yeah. My kids all movin' to Austin, but I like it here. You know what I like?"

"What's that?"

"When I need to go to the store and get some bread and milk, you know how long it takes me? Ten minutes. That's all. And nobody gonna be honkin' at me or gettin' in my way. Ten minutes. That's all. That's why I like it here."

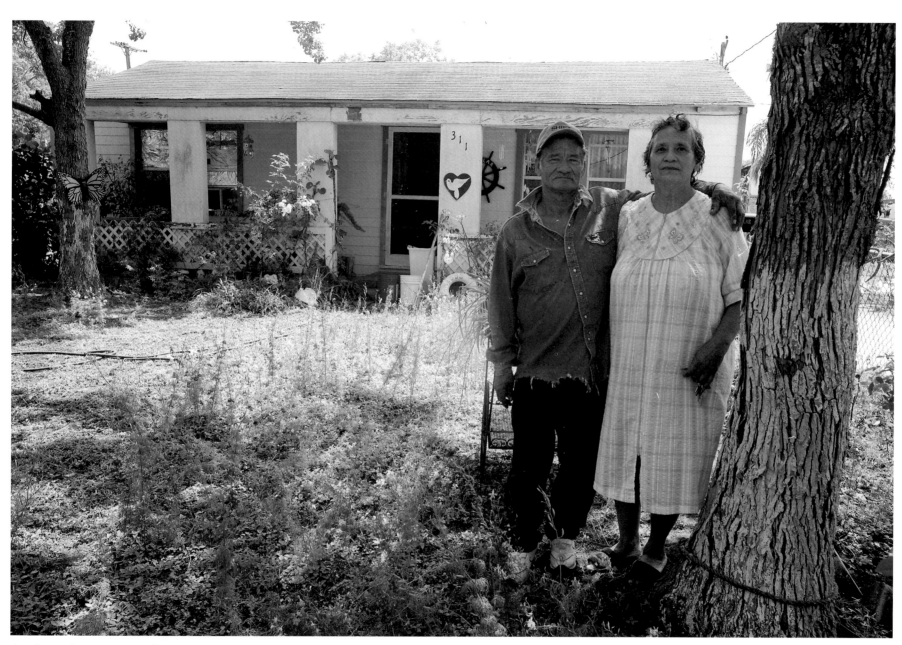

Serefino and Margarita Cuellar, Port Lavaca, Texas

PART 3: *Indianola to Boca Chica*

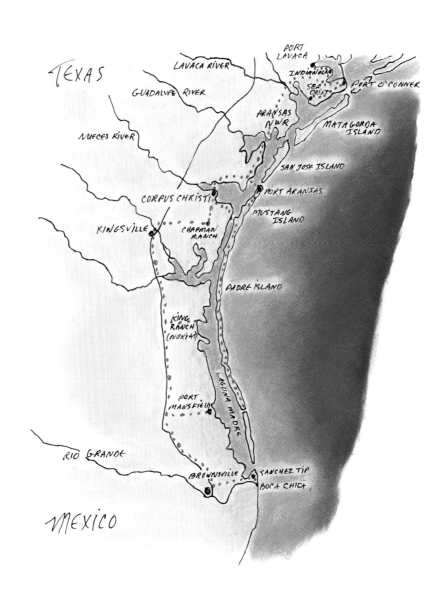

TWELVE MILES SOUTH of Port Lavaca, a small sign on the side of Highway 316 points the way to Indianola. The narrow road winds for several miles through grassy coastal plains before it arrives on the shore of Matagorda Bay. Then it turns south and parallels the beach, fifteen or twenty yards away from the lapping waves. A string of relatively new, well-kept trailers and beach homes, set among swaying palms and pastel-colored oleanders, lines the right side of the road.

Founded in 1848 as Indian Point, this stretch of beach was the primary landing place for German immigrants bound for western Texas. Indian Point thrived during the Mexican War, eventually rivaling even Galveston as the principal port of the Texas coast. In 1849, the name of the growing town was changed to Indianola, and it continued to grow, expanding three miles down the beach, all the way to Powderhorn Bayou. Indianola replaced Lavaca as the county seat of Calhoun County, and Charles Morgan chose the growing port as the Matagorda Bay terminus for his New York–based steamship line. By 1853, when the city was incorporated, the population had reached 5,000, four newspapers were being published there, and Indianola was known as "The Dream City on the Gulf." It seemed to be only a matter of time before it overtook Galveston, both in population and in the volume of business done on its wharves.

The first hurricane struck in 1875, pounding Indianola and killing over two hundred people. Despite the death and devastation wrought by that storm, those who survived began to rebuild the city. Then, on August 20, 1886, another hurricane ripped across Matagorda Bay and again laid waste to the city. What the second storm did not destroy, the ensuing fire did, and the site of Indianola was abandoned soon thereafter.

But Indianola, I discover, is starting to find new life. As I drive down the gravel road, the number of beach houses and trailer homes continues to grow. At the end of the road, there's a new bait shop and boat ramp. Don and Kerry Hanselka, along with Kerry's wife Brenda, operate the Indianola Fishing Marina, complete with a lighted pier, cabins for rent, and a wall covered with color snapshots that prove how good the fishing can be. Next to the color snapshots, Don has framed two aerial photographs of the Indianola site. One was taken in 1961, just prior to Hurricane Carla;

the other was taken immediately after the storm. The second picture offers powerful evidence of the total devastation wrought by that storm. Nothing, absolutely nothing, is left standing in the wake of the storm. The sandy strip of land looks like a lunar landscape set on the edge of the bay waters.

Outside the marina, Alfred Chapa operates a taco stand. As he fixes me a barbeque taco, Alfred talks up the town: "Yeah, I started this year. I just come down just on weekends, but I do a real good business. The place is really growing. People like to come here to kayak and fish. Lots of people are building houses here. It's only gonna get better, and I'm in on the ground floor. Everybody already knows me. They know my tortillas are homemade. And they ain't nothing else to eat here but junk food and candy."

As I head back up the road, out of the new community of Indianola, I can't get that aerial photograph out of my mind. I have never seen anything like the total destruction brought by Carla, the most recent in the long line of major hurricanes that have swept through this part of the coast. The photograph serves as an urgent reminder that the end of anything on the Gulf is just a hurricane away. And yet, what's happening in Indianola today is a reminder that memories tend to be short, and that people always return to the pleasures of the coast.

The southern part of Calhoun County forms a broad peninsula, bound on the east by Matagorda Bay and on the west by San Antonio Bay. Leaving Indianola, I drive fifteen miles of flat highway, from the eastern to the western shore of the peninsula, and arrive in the little town of Seadrift. The only thing I know about Seadrift is that it was named for the all the debris that landed there from Indianola after the 1886 hurricane. The storm essentially ripped Indianola to pieces, swept it across the peninsula, and deposited it on the opposite shore.

Most of the little town sits on the coastal side of Highway 185, so I drive into that side of town. The streets are narrow, barely wide enough in some places for two cars to pass. The town is laid out in a rectangular grid, and the east–west streets are numbered, making it easy to find your way around. It's late May and the oleanders are blooming, adding splashes of pink and red to the bright green of the spring landscape and filling the air with fragrance. Most of the homes are simple wood structures that have taken a beating from the elements over the years. Along one street, however, I count

a dozen or so very different homes. These are two- or even three-story brick houses that look like they belong in a new, upscale suburb of Houston, except for one detail: they each have a stone figure of a virgin prominently displayed in the front yard. Most of the homes have a Honda out front, and some sort of wire traps or cages lie stacked in the driveways. Now I get it: these are the homes of Vietnamese fishermen.

As I cruise slowly down Broadway Street, I spot four Asian men sitting under a tree next to one of the homes. They seem to be taking it easy, just talking, and they are all watching as I drive along their street. I decide to join the conversation and see if I can learn something about Seadrift.

All four men stand to greet me as I walk up. They bow, shake my hand, and offer me a chair. One man goes into the house and returns with a can of Sprite for me. They are being very hospitable, but I sense that they are uneasy, probably curious about why I stopped. There's an initial period of silence, with the four men looking off into the distance toward nothing in particular. I ask them how the fishing is going this year.

"No fish. We crab," replies the oldest man, who's sitting immediately next to me.

"How's the crabbing?" I ask.

"No crab."

"You shrimp?" I ask.

"No shrimp. We crab," he says, nodding his head. "But no crab. This year no crab, no shrimp."

Silence.

I'm not sure I understand what he is trying to tell me, so I have a sip of the Sprite, then dive back into the conversation. "You go out in your boat and catch crab. But right now there aren't any crabs out there? That right?"

The old man turns toward me, shaking his head again as he speaks, "No crab. No crab last year. No crab this year. No crab next year, go work in plant."

"What plant?"

"UN-yon car-buy."

"Union Carbide plant?"

"Ya. UN-yon car-buy."

I ask the men why there are no fish, or shrimp, or crabs in the bay, and

Site of Indianola, Texas on Matagorda Bay

they shake their heads. Maybe there are chemicals in the water, maybe the chemicals come from the Union Carbide plant, but they don't know.

One of younger fellows turns to me and speaks in clear, unaccented English: "We don't really know what's going on. But there are virtually no crabs this year or last year in the bay. Hardly any shrimp, either. We know that there was mercury dumped in the water in past years by one of the big chemical plants over in Port Comfort. Maybe that's part of the problem, maybe not. We don't know."

I want to see the rest of the town, so I thank the men for the Sprite and their hospitality. A couple of blocks down Broadway, I hit Main Street and take a right turn. There's not much: the El Comal Mexican Restaurant, a tiny café, a hardware store, and the post office. I decide to drop in and see if I can meet the postmaster of Seadrift. The population of the town seems like a good place to start the conversation.

"Thirteen hundred and fifty-two," the postmistress tells me; she's a tall, attractive lady, probably in her fifties. "That was the last census. Twelve hundred and ninety-nine before that, so we are growing. Not too fast, but we *are* growing. If you want to know more about the town, you should go over and talk to my husband, Pat Hathcock. He knows a lot more than I do about the town, and he would enjoy talking with you."

Pat Hathcock has lived in Seadrift for about twelve years. He describes himself as "semiretired," but he writes a weekly column and a blog for the *Victoria Advocate,* where he used to work full time as a reporter. We sit on his front porch on Fourth Street, and he recounts for me some of the history of the town.

"Seadrift was known as a fishing and shipping point all the way back to the middle of the nineteenth century. Then, about 1910 or 1911, it had its own little boom time. A real estate promoter, I think his name was Powers, came up with this idea to make Seadrift the fig capital of the cosmos. His deal was that if you bought a town lot, you got five acres outside of town for growing figs, which he claimed grew like crazy, for some unknown reason, all around Seadrift. Well, I guess it was a good scheme, because the town grew real fast. They even had passenger train service to Seadrift in the nineteen teens. Then a big hurricane came through in 1919, and that pretty much put an end to everything. All that's left of that big fig promotion is a lot of very confusing land titles.

"I like the place a lot. I like living in a real, working fishing village. But real estate prices are going up fast. The city folks from Houston and Austin seem to be discovering Seadrift. But it's nothing like Port O'Connor, where things have just gone plain crazy in the last couple of years. Condos and gated communities. A flood of tourists every weekend. I guess that may happen in Seadrift next, but not yet."

Port O'Connor is situated on the eastern tip of the peninsula, at the end of Highway 185, nineteen miles due east of Seadrift. The place was laid out in 1909 and named for Thomas M. O'Connor, owner of the 70,000-acre Alligator Head Ranch. By 1914 the town had become a major fishing and seafood processing center, a fig and citrus growing community, and a summer resort with facilities for tourists who arrived on the St. Louis, Brownsville and Mexico Railway. In 1939, the Gulf Intracoastal Waterway reached Port O'Connor, linking it with New Orleans and Corpus Christi. Hurricanes swept through in 1919, 1942, and 1945, damaging the town, but it was Hurricane Carla, in 1961, that almost put an end to the place.

Along the bayfront, on the south side of Port O'Connor, a row of new beach homes faces the water. It's a Friday afternoon, the weekend has arrived, and most of the homes are occupied. Big, late-model pickup trucks sit in the driveways, most of them towing trailers and fishing boats. On the shore across from the homes, the sandy soil has been leveled and a huge wooden sign has been erected to advertise the LaSalle Addition. According to the sign, five of the thirteen lots are already sold. Just a few blocks away, at Second Street and Maple, an entire community, the Caracol, is being developed. Canals have been dug, bringing the bay waters right to the edge of every new home that will be built in this "gated, master-planned, waterfront community." It's the same sort of development I saw underway on the southeastern tip of Galveston Island.

As I explore the streets of Port O'Connor, I find that here, like Seadrift, the narrow streets are laid out on a rectangular grid. Many of the homes are new or recently remodeled, but there's nothing especially fancy or expensive. Port O'Connor is still an unpretentious beach community, though the Caracol and the LaSalle Addition promise to change all that. As I cruise down Ninth Street, I notice a tiny house set back a hundred feet or so from the road. There's a wonderful mailbox out front, decorated with carved wooden figures of seagulls, fish, and a pelican. The little house is painted bright blue-green with white trim. A table with a bright red tablecloth sits on the front porch, and a man in a white t-shirt is working on a lawnmower in the driveway. Two little dogs run out, barking and greeting me as I step out of my truck. I introduce myself to the man, Joe Ramos, who tells me that he is seventy-seven years old, born and raised in Port Arthur. Judging from his bronze complexion, he could be Hispanic, but his facial features don't remind me of anything I've seen in Mexico, so I ask him if his parents were born here.

"Well, you see, my mother's mother was a Mayo Indian. They still got them in Mexico, where she was from. They still got them down there. So she was half Mayo, and my daddy was half Apache through his mother. When he went to Mexico, he got with my mother, and he come back here to live with her."

Port O'Connor, Texas

I ask Joe how his parents got here, thinking of how difficult it would be for a young couple today to immigrate to this country from Mexico.

"Well, now, that's a *real* story. You see, my daddy convince my mother and her family that they should all come here to live. But how they gonna get here? Well, they build a big barge, a big *flat* bottom barge, and they put everything they have in that barge. And then they start pullin' that barge up the beach, *pullin'* it along, followin' the coast."

"They pulled the barge all the way up here from Mexico?"

"Yes sir, they *did*. They would pull that barge all day, my daddy and my momma and her daddy and momma, along with her two sisters. They would pull all day and stop at night and sleep on the beach. Momma, long as she lived, she would tell me you don't know what work is. *That* was work, *pullin'* that barge."

"So how did they decide to stop here at Port O'Connor?"

"I reckon they got *tired* a pullin' that barge. And they got to the pass here, Pass Cavallo, and they come in, and they unload the barge, and they settle here. Only they didn't call it Port O'Connor then. It was called Alligator Head Town. Lots later, some *rich* fellas come in here and built stuff and start callin' it Port O'Connor. That's how it got the name Port O'Connor."

Joe tells me that he can't say exactly what year that was when his parents came here, maybe 1920 or 1925, but he was born in 1930, and he went to school up to the seventh grade.

"Then I stopped goin' because we were poor and I needed to help out my family. My daddy made me a wheelbarrow out of wood and I'd go out to pick up driftwood on the beach, so my momma would have wood for the fire. My daddy took up fishin' because anywhere you went there was plenty fish. Plenty flounder. Plenty oyster. Plenty shrimp. Plenty crabs, too.

"We would flounder at night, my daddy and me. We would go floun-derin' all the way up to the lighthouse at Matagorda Island, then we would flounder back, carryin' that light and giggin' them flounder. *Big* ones. We would get back with two, three hundred pounds a flounder. Take em over to Mr. Clark at his fish house and try to sell 'em. Mr. Clark, he would say, 'Oh, Mr. Ramos, what I gonna do with all that flounder. I can't give you but eight cents a pound.'"

Joe tells me how he and his wife built this house after Carla took their first home. They built the first house, right here, mainly to get out of town.

"Out of town? I thought you said you lived in Port O'Connor all your life?"

"That's what I mean. But we wanted to get out of town. You see, back when we got married there was maybe a hundred people livin' over there in what they call *town*. That's Main Street now, that area is. Maybe forty of the people in town was Spanish like us. And my wife and me, we both wanted to be out of town. Out on our own. You know. Have some quiet and no-body watchin' us all the time. There wasn't nothin' then but trees and grass out here. I mean *tall* grass and *big* ol' trees. So I hire this guy to clear it. I had him clear a place for the house and then I had him clear a place right over there where my kids could play baseball. Now they tryin' to run me off."

"Run you off? Who's trying to run you off?"

"The city people and the real estate people. They been comin' round lookin' at my property and tellin me I have to pay my back taxes, but I'm over sixty-five and I know I don't have to pay taxes. They want me to sell and get outa here, that's what they want. So they can build a new fancy house here, sell to some tourist, and raise the taxes. But if I sell, where am I goin'? I got no place to go. So I'm stayin' right here. I was born and raised all my life here."

On the way out of Port O'Connor, I stop for gas at the new service sta-tion and convenience store. As I'm filling my tank, a family pulls up to the pump next to me. A young man, no more than thirty years old, is driv-ing a black Hummer and pulling a brand new, forty-foot fishing boat. The whole rig, Hummer and boat trailer together, measure about sixty feet long. Three kids jump out of the Hummer and run for the store, while the young man—wearing a Dallas Cowboys t-shirt, shorts, and fancy sneakers—slips his credit card into the pump. As I drive away, I remember Joe Ramos's story. I visualize his family arriving here, almost ninety years ago, pulling the barge loaded with all their earthly belongings through Pass Cavallo, coming ashore to start a life at Alligator Head Town. Today, it's the fam-ily in the Hummer that's arriving, pulling their new fishing boat into Port O'Connor for the weekend.

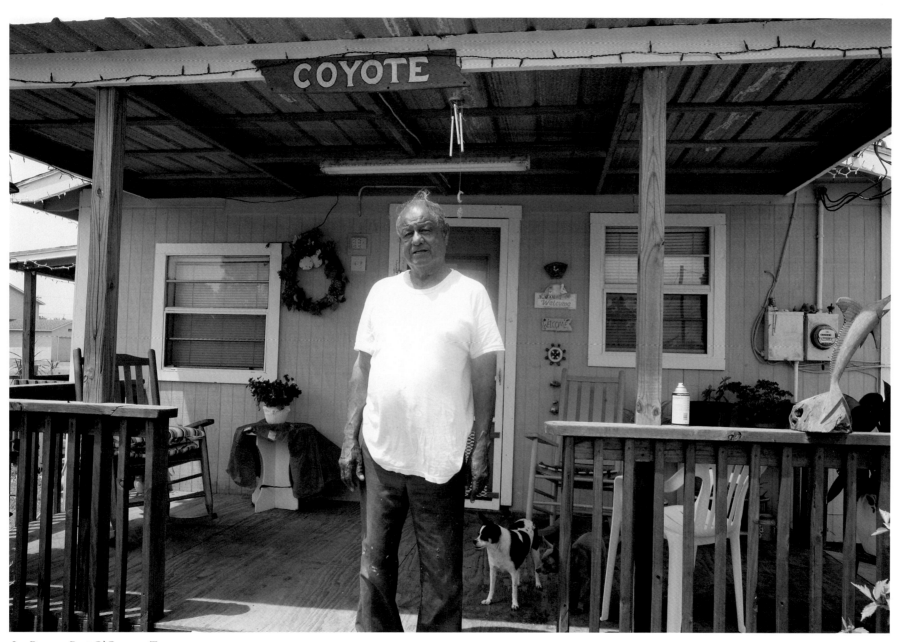

Joe Ramos, Port O'Connor, Texas

I retrace my route, driving west, back through Seadrift, and then I turn north to reconnect with Highway 35, which will take me on my continuing journey along the Coastal Bend of Texas. Just a few miles farther down 35, I turn due south on Farm Road 2040. The land here is as flat as the Texas Panhandle, and there's something extraordinarily beautiful about this flatness. For one thing, the sky seems bigger, more majestic and soaring. On a clear day you can see for miles across the fields of grain, corn, and cotton. Looking straight ahead, down the blacktop highway in front of me, the road seems to go on forever. A few white clouds drift overhead in the sky, carried north by the coastal winds. I see what appears to be a dot, a tiny dark shape, far down the highway ahead of me. As I drive and watch, with my eyes glued on the shape ahead, the dot gets a little bigger. Soon I'm able to make out the shape of an approaching pickup truck, closing fast on me. As it passes me—with a sudden whoosh—I catch a glimpse of a hand lifting from the steering wheel. That was a wave. I barely saw it, but I'm sure he waved to me. Farther down the road, another truck and another wave. This time I return the friendly gesture, lifting my own right hand and nodding as the truck passes.

Ten miles south of the little community of Austwell, I arrive at the Aransas National Wildlife Refuge, perhaps the most beautiful and most diverse of all the wildlife refuges of the Gulf Coast. The Aransas refuge covers 115,000 acres, including parts of Matagorda Island and San Antonio Bay, plus a peninsula of grasslands, oak thickets, freshwater ponds, and marshlands. As I approach the reserve, I recall the experience recounted by Frederick Law Olmsted in *A Journey through Texas*. Olmsted, who would eventually gain fame as a writer and a landscape architect, was only thirty years old when he passed through Texas on his saddle trip from the southwestern frontier in 1852. He wrote:

Our road led us through a bleak open prairie, on whose rolls stood no house, and scarce a tree, for fifteen miles. At our right, to the north, was a range of distant hills, from which orchards of live-oak occasionally stretched to within a moderate distance of us.

While riding slowly, we saw some white objects on a hill before us.

We could not make them out distinctly, and resorted to the spy-glass. "Sheep," said one. "Cattle," said the other. As we rode on, we slowly approached. "Yes, sheep," said one. "Decidedly not sheep," said the other. Suddenly, one of the objects raises a long neck and head. "Llamas—or alpacas." "More like birds, I think." Then all the objects raise heads, and begin to walk away, on two legs. "What! Ostriches? Yes, ostriches, or something unknown to my eye." We were now within four or five hundred yards of them. Suddenly, they raised wings, stretched out their necks, and ran over the prairie, but presently left ground, and flew away. They were very large white birds, with black-edged wings, and very long necks and legs. They must have been a species of crane, very much magnified by a refraction of the atmosphere.

What Olmsted saw were whooping cranes, and today Aransas Wildlife Refuge provides the winter habitat for the only wild flock of whooping cranes in the world. No one knows how many whooping cranes might have existed in 1852, but by 1941 there were only fifteen. Even then, no one knew where the whooping cranes spent the summer months, only that they left the Aransas area and flew north. Franklin Roosevelt, who liked to fish for tarpon in nearby Rockport, was persuaded in 1937 to establish the Aransas Wildlife Refuge, and serious preservation efforts began to protect the giant cranes. Today, there are well over two hundred whooping cranes nesting in the tidal marshes of Aransas each year from late October to the middle of April. There will be no whooping cranes now, in late May, but I drive directly to the forty-foot observation platform at the south end of the refuge, just to have a panoramic view across their habitat.

Aransas National Wildlife Reserve, Refugio County, Texas (and following two pages)

The Aransas reserve is known not only for the whooping cranes but also for an exotic array of wildlife, including alligator, javelina, bobcats, and a great variety of snakes. As I hike I keep my eyes down, fixed on the trail in front of me, making plenty of noise as I go. I've never had a snakebite, and I don't want to get one now. As for the javelina and bobcat, I'm trusting that they want to avoid me as much as I can do without them.

Dagger Point Trail winds up from the parking area, through a heavy growth of brush, live oak, and redbay. I recognize the redbay from its aroma and its deep green, waxy leaves. About three hundred yards up the trail, I find an offshoot from the main path, leading down to the shore of the bay. This is Dagger Point, a short, narrow promontory, covered in bluestem grass and strewn with driftwood.

• • •

A line of narrow sand islands extends from the Matagorda Peninsula south to the Rio Grande. After the Matagorda Peninsula, there is Matagorda Island, San Jose Island, Mustang Island, and then Padre Island, the longest barrier island in the world.

The first permanent settler on Mustang Island was an Englishman, Robert Ainsworth Mercer, who built a cabin in 1855 on the northern tip of the island, at a site then known as Sand Point. Mercer began to import sheep and cattle and eventually built an extensive ranching operation. After the Civil War, Mustang Island began a slow, steady growth. In 1880 William and Ed Mercer built the first store on the island. By then the place was known as Ropesville, and eight years later the community had its own post office. In 1896, in acknowledgment of the growing recreational fishing industry, the name was changed to Tarpon. Finally, in 1911, the community adopted the name Port Aransas. National attention was focused on the place in the 1930s, when FDR came on a series of fishing expeditions. Since World War II, Port Aransas has continued to grow, with a population today of well over three thousand.

The south jetty at Port Aransas is by far the longest jetty on the Texas coast. Constructed of huge granite blocks and poured concrete, it reaches almost half a mile into the sea. It is also one of the premier destinations

South Jetty at dawn, Port Aransas, Texas

New residential development, Mustang Island

for fishermen from all across Texas. This morning, twenty to thirty pickup trucks, a dozen RVs, and several tents sit in the predawn darkness at the base of the jetty. There is not a trace of sunlight yet, and the only sound is that of the waves crashing against the seawall.

Already, a few fishermen have found their places on either side of the jetty. As the sky begins to brighten, signaling the arrival of dawn, the first trace of light is cast across the water of the channel. A faint sheen of light begins to illuminate the dark, turbulent waters. A few pelicans bob on the surface, and the dorsal fins of a school of porpoise rise and fall through the swells. The silhouettes of fishermen can be seen now, their poles held high against the sky.

Many more fishermen are arriving. They are coming alone or in groups: a grandpa and granddaughter, couples young and old, and a Mexican family of fourteen. They carry their gear and poles, nets and buckets, and, the latest thing, their Bubbie Boy aerators.

The sun slips out from behind a cloud, barely above the dark line of the horizon. For a few seconds, the sun is a perfect orange disc, a piece of magic. A few minutes later the disc seems to catch fire, sending a trail of golden light sparkling across the water. Several hundred fishermen have found their places now on this cool, perfect summer morning.

· · ·

A stiff southeasterly wind is blowing across Corpus Christi Bay. White-capped waves ripple across the shallow bay waters, and a solitary fisherman is perched on a rock, a hundred yards or so out in the surf. As I approach, driving up the long, arching bridge on Highway 35 over the bay, the skyline of Corpus Christi appears on the opposite shore, soft and hazy, two miles in the distance.

With a population of over 300,000, Corpus Christi is by far the largest city on the South Texas coast. But history tells us that it was a city that had a hard time getting started. Despite its excellent location, at the mouth of the Nueces River and on the western shore of the bay, the Spanish more or less ignored the area until the 1680s. But when word got back to Mexico that the French had established a colony somewhere around Matagorda Bay, Spanish authorities sent an expedition in 1689, under Alonso de León, to check on the rumored French settlement. Still, the Corpus Christi Bay area remained unexplored. It wasn't until 1747, when Joaquín de Orobio y Basterra, took an expedition down the Nueces River and reported on his findings, that José de Escandón, the Spanish governor of the region, proposed founding a settlement at the mouth of the Nueces. Fifty families, along with a squadron of soldiers and two priests, were sent to colonize the area. But a prolonged drought and lack of sufficient provisions caused them to fail in their efforts to establish the settlement. Three more settlement efforts failed. One, in 1787, never got out of the planning stages. Two other efforts, both in the 1830s, failed due to the Pastry War and then the outbreak of the Texas Revolution.

The area remained uninhabited until 1839, when Henry Lawrence Kinney and his partner, William P. Aubrey, set up a trading post on Corpus Christi Bay. By the middle of the 1840s, the community, already known as Corpus Christi, was a small village. One traveler, an Englishman, described the place as consisting of "Colonel Kinney's fortified house, about a half dozen stores, and a grog shop or two."

In 1852 the entrepreneurial Kinney put together a state fair, reportedly the first in Texas, in his efforts to put Corpus Christi on the map. But the

fair was a failure and did little to advance the town's visibility. By the middle of the 1880s, however, Corpus Christi began a period of growth and prosperity that would extend into the twentieth century. City streets were paved. Three banks and a customhouse were established. A variety of factories, several hotels, and a number of churches sprang up. The city grew as a shipping center, and in 1890 the New York promoter Elihu H. Ropes announced plans to build a deepwater seaport that would make Corpus Christi the "Chicago of the Southwest." The plan failed, but the idea was planted. Storm and sanitary sewers were constructed, a modern water system was installed, and a new city hall and municipal building were constructed.

Then, all the progress came to a halt. On September 14, 1919, a powerful hurricane struck the city. Most of the central business district and the entire North Beach area were destroyed. Almost four hundred people died in the storm. But rather than give up and move away, civic and business leaders fought to overcome the terrible economic losses, and seven years later to the day, Corpus Christi celebrated the opening of its deepwater port. By 1930 modern office buildings lined the shorefront of Corpus Christi, oil was discovered in the county, and the town's population surged. Today, Corpus is the center of a large petroleum and petrochemical industry. The port of Corpus Christi is lined with oil wells, refineries, and pipelines. The city and nearby Aransas Pass are at the center of a major seafood processing industry, and a Naval Air Station adds to the economy. There's even a lively cultural life, with two major museums, a symphony orchestra, and a small theater.

As soon as I drive across the bay bridge, one left turn puts me in downtown Corpus Christi, searching for the beachfront. A few more turns, and I'm on Shoreline Boulevard, looking out across Corpus Christi Bay and up at the tall buildings on the city side of the boulevard. Downtown Corpus Christi is built right up to the water, with major banks and hotels directly across the street from the bayfront. Farther down, three t-shaped jetties offer pedestrian access to the city's new marina. It's a Saturday morning, and there are a number of tourists walking the seawall and cruising along in little pedal cars.

Corpus Christi Bay and the skyline of the city from Indian Point

At the corner of Shoreline and Peoples Street, across from the Bank of America Building, I notice a crowd gathered under a white gazebo on the seawall. I think I can make out a monument within the structure, a figure of a person. I'm curious to see what kind of monument is drawing so many people, so I park and cross the street to join the crowd.

A life-sized, bronze figure of a woman stands on a circular base, leaning with her back against a tiled column. Her head is turned to the left and slightly down. She appears to be contemplating an object that she holds against her left thigh. Her right hand rests on her right leg, with that foot raised and placed flat against the column behind her. This is not a monument to motherhood or to some political heroine. This is a hot Latin babe, with tight-fitting pants tucked into cowboy boots, a short jacket open at the front, and a studded bustier showing underneath. Even in bronze, this is a sexy statue. Her hair flows down and around the right side of her head, falls across her shoulder, and lands, in a curly tuft, on her right breast. As I move around to the right, I can see that the object in her left hand is a microphone. She wears earrings in the shape of tiny guitars. The young woman is Selena, the Latin Madonna, the queen of Tejano music, and the quiet crowd gazes at her in adoration.

Her full name, as the plaque on the monument tells, was Selena Quintanilla-Perez. She died in 1995, four days short of her twenty-fourth birthday. I can remember Selena's death, how the president of her fan club shot her. And I can remember the enormous outpouring of grief from Hispanics, both in the United States and Mexico. But I don't really know much about her career, and I can't even name one of her hit songs. Selena and her Tejano music are a phenomenon that appeals to an audience younger than I.

I watch as the crowd moves around the bronze monument, studying the figure from every angle. From time to time, a child or a teenager ducks under the steel guardrail and jumps onto the pedestal beside her for a photograph. As I move around to her right side, I notice that the bronze surface on the right side of her shapely derriere has a shinier surface than the rest of the figure. I'm guessing that it has been polished over time by the rubbing and patting of thousands of adoring hands.

For half an hour I watch as people pass by the Selena monument. Most stay for five to ten minutes. They read the inscription, study every detail of the star's likeness, and then take photographs of each other beside the monument. Most of the people cross themselves as they leave. For a few moments, there's a break in the stream of people, and the gazebo is empty. For the first time I can see the brick floor of the monument, which is covered in handwritten names, short poems, and testimonials. From near and far, they have come and left their marks: Marissa from San Antonio was here, as was Rolando from Monterey, Oscar from Waxahatchie. The Family Cantreras from Marion, Indiana; Ruby and Sergio from Caldwell, Idaho. Most of the messages are short, but touching: "I love you. Marlene Duckworth." "Each day I love you / Each day I miss you / Always will, Daniella." "Familia Cordero will never forget you." "Te recuerden en los angeles." The handwritten inscriptions cover the entire floor, five hundred names and notes, I estimate. They also cover the wall and the white columns of the gazebo. It's impossible not to be moved by the sheer number of messages that have been left. Moreover, most of the notes are dated, and none of them is more than ten days old. Many coats of paint, I suspect, and many hours of sanding on the floor, have erased layer upon layer of inscriptions.

As the flow of adoring fans resumes, I notice that Selena's appeal clearly crosses ethnic lines. There are African American families, young Anglo couples, even a few eastern Indians. Some of them bring bouquets of flowers to place at Selena's feet. A few of them weep and speak to Selena in whispered tones.

Monument to Selena Quintanilla-Perez, Corpus Christi

Gravestone, Old Bayview Cemetery, Corpus Christi

• • •

The Old Bayview Cemetery sits on high ground in the heart of downtown Corpus Christi, perhaps forty feet above sea level, between Interstate 37 and the old Union Pacific Railroad tracks. The cemetery is located in the part of downtown that locals call "the Cut," and it's a scary neighborhood. As I enter the cemetery from the gate on West Broadway, three cars pull to the curb at the opposite corner and the drivers appear to be negotiating with several men who have approached them in the street. From the gate, a grassy slope rises past a number of old, twisted mesquite trees. It's a blustery morning, and heavy gray clouds fill the skies. A light sprinkle has started, and brisk winds are gusting from the bay. Black, shiny grackles fly from tree to tree, eyeing me as I climb the slope toward the center of the cemetery.

Bayview is not a large cemetery by any standards, about a hundred fifty square yards. There are about a hundred tombstones and most of them date from the nineteenth century. No two of the old stones are alike, and their inscriptions and images are beautifully carved: kneeling angels, lambs in repose, clusters of roses. Most of the gravestones, like the mesquite trees scattered among them, lean to the northwest, as though bent by a century of wind from the sea. Other stones have fallen over and lie flat or have sunken partially into the ground. Still others have dropped, broken, and lay scattered in pieces in the grass. Some of the gravestones have lines of poetry carved into them, but they are so cracked and overgrown by the grass that I can only read a word or two.

With the wind gusting from the bay and cold rain beginning to fall, with drug deals being negotiated on the street outside and grackles watching my every move within the grounds, the Old Bayview Cemetery is a fascinating but slightly unnerving place this morning. On my way back to the gate, one tombstone catches my attention. A thin marble slab on a rectangular base, roughly two feet high, the monument leans sharply forward. I have to kneel and lower my head to ground level in order to look up at the face of the tombstone and read its inscription. Fragments of dried grass, tiny brambles, and chunks of soil cling to the carved inscription. The slight irregularlity of the lettering suggests that the carving was done completely by hand. With all the lichen and debris on the stone, I struggle to read the Spanish inscription:

> *En memoria*
> *de la que en vida*
> *fue Maria de Jesus Juarez*

"In memory of that which was the life of María de Jesus Juarez"

> *nació en Rio Verde, Sdo. de*
> *San Luis Potosí México el*
> *día 4 de enero 1850*
> *fallecio en Corpus Christi*
> *el día 24 de octubre 1906*

"Born in Rio Verde, state of San Luis Potosí, Mexico on the 4th of January, 1850, expired in Corpus Christi on the 24th of October, 1906"

> *lo afliguida hija*
> *Juanita M. de Reyes*
> *dedica este recuerdo*
> *a la memoria*
> *su alma en gloria y en paz*
> *descansa*

"Her grieving daughter Juanita M. de Reyes dedicates this monument to her memory. Her soul rests in glory and in peace."

Who was María de Jesus Juarez, this Mexican woman who came from Rio Verde to Corpus Christi, where she died at the age of fifty-six and was buried among the elite citizens of the city? Why did she die so young? And where is the grave of her husband or her daughter? And now that I think of it, why is hers the only Hispanic name on any of the gravestones in Bayview Cemetery?

• • •

Leaving downtown Corpus Christi, I head south down Shoreline Drive, past the seawall and the two t-shaped jetties of the marina. Then I turn west on Louisiana Avenue to find the home of Jeanne Adams, a Corpus Christi native who, I have been told, can give me an insider's view of some of the latest developments in Corpus Christi politics.

"Well, let me tell you what we just did," Jeanne says. "We ran those Landry people right out of town. They wanted to destroy our beautiful bayfront, but they finally gave up, thank God, and left us alone." We're talking in Jeanne's home, but I can hardly keep my eyes off the authentic Mexican folk art in the room. There are Mexican masks, folk paintings, Talavera pottery, and a library of books on Mexican history and culture. "We're still kind of shocked," she tells me, "that we were actually able to do it, but we won the battle for our bayfront. They had been saying, 'You just give us those t-heads, give us a 99-year lease on them, and we'll take it from there. We'll turn that shorefront into a moneymaker for everybody.' Of course, they wanted to do exactly the same thing they have already done in Kemah and in Houston. They wanted to turn our bayfront into a carnival, with gorilla heads to walk through and volcanoes belching flames. But we managed to place a majority of our people on the city council, and then we said to the Landry people, 'No thank you. We like our unobstructed view of the bay, just like it is. It's beautiful, it's Corpus Christi, and we want to keep it that way. No gorillas, no volcanoes, no thank you. Good-bye.' So they just left, and we still have our beautiful bayfront and our public beaches. Now they're after the island, too."

"The island?"

"Padre Island. Mustang Island. The whole thing."

"But isn't Padre Island a National Seashore? Isn't it protected from development?"

"Much of Padre is a National Seashore, but not all of it. And look what's happening to Mustang Island and Port Aransas. There is so little thought going into the development at that end of the island. What will be left of the beauty of that place in another generation? Very little or nothing at

all, I suspect, unless we persuade everyone to slow down and think about what we really want to do. Even Padre Island is not safe, even the National Seashore. They're already drilling there for oil, and there's constant pressure to develop it on the north end. We won one little battle to keep our bayfront here in Corpus, but where will it go from here?"

My conversation with Jeanne Adams turns to the subject of the Old Bayview Cemetery. I couldn't get the image of the beautiful old tombstone of María de Jesus Juarez out of my mind, along with the questions of who she was and how she came to be buried there.

"She was probably someone's maid," Jeanne observed. "A loyal, dearly loved maid who worked for a white family. I can't think of any other way that a Mexican woman would be buried there."

"You mean a Mexican wouldn't be buried in an white cemetery?"

"*Good Lord, no.* Corpus Christi is a bicultural city, always has been. That's the first thing you have to know about Corpus in order to understand it. But, as much as I hate to say it, that old disease, racial superiority, has always been with us. Heavens, when I was in school, if you were heard speaking Spanish on the playground, you would get sent to the principal's office."

"For speaking Spanish?"

"Yes. This has always been a segregated and—I hate to say it—a bigoted town. The prejudice has always been here, the sense that 'we are better than them.' I wonder if that will ever change. Good Lord, I love the Mexican people and their culture. When I was younger and could get around better, I used to travel to Mexico every chance I got. We have so much to learn from the Mexican people, yet there are still, to this very day, people who don't want their kids to learn Spanish in school and don't want their children to play with Mexican kids. What else can you call it except racial prejudice?"

As Jeanne and I talk, my eye is drawn to one of the many pieces of Mexican folk art that fill her home. An ex-voto painting, in rich blue and green colors, about twelve by eighteen inches, hangs in a bookshelf behind her. I stand and move closer to have a good look at the piece that has caught my eye.

The beautiful little painting is a classic ex-voto: a devotional image on a flat piece of tin, including a short, handwritten text along the bottom, a

El 3. de noviembre de 1898, caminaba Tiburcio C... para la feria del Santuario; mas habiendo perdido el camino ... on de no alcanzar ya dicha feria, por lo que resolvió caminar para Veracruz. En el rumbo que seguía habia nesesariamente que pasar el rio de Cota... el cual estaba crecido y habiendo dejado las canoas muy lejos, en el vado llamado "Paso Limon" tubo de atravesar y estando á la mitad del rio se vió á punto de ahogarse, mas invocando á Nuestro Padre Jesus ... as tres caidas, en el acto fué milagrosamente salvado.
En memoria de e... hecho, y para conocimiento de la bondad de dicha Ymagen, se dedica el presente. ... Octubre de 1899.

Ex-voto painting from Veracruz, Mexico (Collection of Jeanne Adams, Corpus Christi)

tribute to the saint who was responsible for the miracle. Like all ex-votos, it is essentially an illustrated testimony to a miraculous event that occurred in someone's life. The essence of the story in this case is obvious, even in a quick glance at the piece: a man was saved from drowning in a river. The blue waters of the river are shown rushing diagonally across the plate, from the upper right to the lower left, through a rural landscape of rich, green foliage and jagged rocks. In the center of the image, a man, still in the water up to his chest, hangs desperately onto a single tree on the side of the river. Perhaps the most remarkable thing about this simple, otherwise primitive painting is the depiction of the man's body, still submerged up to his chest in the river. The maker of the painting has rendered the water in the river with a curious, almost magical transparency, revealing the man's body underneath the surface. Then he has written by hand across the bottom of the metal plate the story of his near-death experience: on November 3, 1898, Tiburcio Carrillo, on his way to a fair in Veracruz, tried to cross a river, was swept away by the current, and nearly drowned. His Holy Father Jesus, by a miracle, appeared and saved him. Jesus has been painted into the blue sky above the river, a cross held over his left shoulder, his right hand on a bible, and his knees covered in blood.

The painting renders the event simply and powerfully. The colors are rich and vibrant, and the piece is all the more beautiful for a century of wear and tear. Bent and dented, with rusted edges and scarred corners, the paint has peeled away at several points across the surface, revealing tarnished metal below.

I have seen and admired a lot of Mexican ex-voto paintings over the years, but this is certainly the most beautiful and the most moving one I have ever seen. Perhaps it is especially moving to me, in part, because the frightening event that happened to Tiburcio Carrillo occurred in Veracruz, which is precisely where I am headed.

· · ·

Corpus Christi residents, like Jeanne Adams, speak of "going out to the island." When they do, they may be talking about going anywhere from Port Aransas, on the northeast tip of Mustang Island, down to Padre Island.

Padre alone is 130 miles long, extending from the southern boundary of Mustang Island all the way south to Port Isabel.

Despite its impressive length, some people think that "island" is too grand a term for Padre; that it is, in fact, nothing but an enormous sand bar. Roughly half desert and half grass flats, Padre is a long, skinny finger of an island, no more than three miles wide at any point. The island is separated from the mainland by the Laguna Madre. The high rate of evaporation and the relative lack of mixing with any fresh water make the Laguna extremely salty. Much of the lake, particularly on the northern end, is filled with grass flats, vast underwater fields of grass, which serve as spawning grounds for a wide variety of fish, clams, and snails.

Geologically, Padre Island and the Laguna Madre are not very old. Based on radiocarbon dating of shells, geologists estimate that they may be as young as 3,000 years. Over that period of time, waves and currents of the gulf have created the island and the laguna through a slow, steady process of erosion and deposition. When hurricanes sweep across the island, as they often do, they cause extensive reconfiguration. The entire profile of the beach can be changed, miles of sand dunes can disappear, and smaller lakes can be created within the island. Channels and passes between the Laguna and the Gulf can fill in and disappear. In fact, today Mustang and Padre islands are one continuous sand barrier, due to the fact that Corpus Christi Pass, the natural channel that once separated the two islands, has filled in, leaving only hard-packed sand and scattered tidal pools. Hurricanes can also cause the newly formed beaches to be covered with all sorts of debris, much of it from the depths of the ocean. Hurricane Carla left the beaches of Padre Island covered with huge, old shells, rock fragments, chunks of coral, even a large elephant tooth from the Pleistocene Ice Age.

The first inhabitants of Padre were likely Indians of the archaic period, living on the island from 3000 to 1000 BC, and they were followed by the Karankawa, as well as the Coahuiltecan people of the Rockport culture, who came to the island seasonally until the middle of the nineteenth century. Padre Island first appeared on a map in 1519, when Alonzo Álvarez de Pineda charted the Gulf Coast from Florida to Tampico. Pineda was searching for the Strait of Anian, the rumored water passage to India. He never found the nonexistent strait, but along the way he charted and named the

Sand dune, Padre Island

Sand and grass, Padre Island

made in the New World. In addition, the small fleet was heavily laden with the Spanish Crown's revenue from its enterprises. A fierce Gulf storm came upon the fleet. One ship made it to Havana, but the other three were driven back across the Gulf and finally broke apart on the shore of Padre Island. There have been countless shipwrecks on Padre since then, but that first recorded tragedy, and the gruesome ordeal that followed, as the survivors were slowly and relentlessly savaged by the Karankawas, established Padre Island as the graveyard of the Gulf.

For over two and a half centuries after the Spanish shipwrecks of 1554, history took little notice of Padre Island. Then, sometime between 1800 and 1805, a Mexican priest by the name of José Nicolás Ballí applied to the Crown for a grant to the unclaimed strip of sandy land off the coast. Ballí was from a wealthy family of Spanish colonists who had settled in the Rio Grande Valley just before the turn of the nineteenth century. The young priest is said to have inherited both his mother's deep religious faith and her facility for accumulating worldly wealth. When the Crown agreed to Ballí's request and granted the island to him, the priest turned it into a profitable cattle ranch. After the Mexican Revolution, through great efforts, Ballí convinced the Mexican government to reconfirm his title to Padre Island. But he died the same year, 1828, leaving title to Padre Island with his heirs. At that point in history, things started picking up on the island, and a fascinating series of events and American landowners followed.

When the Texas Revolution broke out in 1836, South Texas became a sort of no-man's land. Then, with the annexation of Texas by the United States in 1845, a major dispute ensued over the location of the border between the new Republic of Texas and Mexico. The question was whether the border was at the Nueces River, as Mexico asserted, or farther south at the Rio Grande, as Texas claimed. The United States took the position that the border of their land was the Rio Grande, and even ordered Gen. Zachary Taylor to move his army into the disputed area as a show of power. The region under dispute included Padre Island. Taylor and his troops established a fort and supply base at Port Isabel, on the mainland just opposite the southern tip of Padre. Port Isabel, Brownsville, and Corpus Christi all began to experience an economic boom based on the wartime activity. In 1848, the Treaty of Guadalupe Hidalgo established the border of Texas and Mexico

Bay of Corpus Christi, the Isla Blanca (now Padre Island), and even ventured ashore at the mouth of the Rio Grande.

The first Europeans known to have landed on Padre Island did so not by choice, but as the result of a horrific tragedy. Four Spanish ships left Veracruz in April of 1554, bound for Madrid, via Havana. The ships carried over four hundred people, mostly Spanish merchants, noblemen, and their families, who were sailing home to Spain along with the fortunes they had

at the Rio Grande, and Padre Island became a part of the United States.

By 1844, the last of the Ballí heirs had left the island, and in 1847 John Singer, an adventurous American who was attracted to the booming shipping trade in Port Isabel, wrecked his schooner on the southern shore of Padre Island. Stranded there with his wife and son, Singer decided he liked the place so much he decided to stay. He built a home, a blacksmith shop, and corrals at the location of Padre Ballí's old ranch headquarters, and over the years he amassed a huge ranching operation. But his successful ranching business was short-lived. The Confederates forced the Singers off the island in 1861, due to their Union sympathies.

While the Civil War raged, confusion reigned on the ranching lands of South Texas, including Padre Island. Unattended cattle herds grew in numbers, and it was a profitable time for those who knew how to exploit the open range. Then the true successor to the Padre Island cattle heritage of Ballí and Singer, Patrick Dunn, arrived on the scene. He was already a successful rancher on the mainland when, with the advent of barbed wire fencing, he saw the days of the free open range coming to an end. Dunn looked at Padre Island, saw the natural fences of the Laguna Madre and the Gulf of Mexico, and began to acquire land there. By 1926, Dunn—who by then was known as the Duke of Padre—owned virtually the entire island.

By the late 1930s, the first efforts to establish a state park on Padre Island were underway. A causeway from Corpus Christi to the north end of Padre was completed in 1950, and just a few years later, a bridge and causeway were built from Port Isabel to south Padre. These causeways brought tourists to the beaches, and soon developers began to build hotels and condominiums on both ends of the island.

In 1954, the National Park Service completed a survey of the approximately 3,700 miles of America's coastline, noting that only six and a half percent of the coastline was reserved for public use. Padre Island was one of three coastal areas that it recommended be taken into the National Park System. In 1962, the Padre Island National Seashore became a reality, preserving the natural beauty and solitude of an eighty-mile stretch of the island, from its northern boundary all the way down to the man-made Mansfield Channel.

• • •

I have visited Padre Island half a dozen times over the years, but I have never driven more than a mile or two of the island. Today I hope to drive all the way down to the Mansfield Channel, a sixty-seven-mile journey that I expect to take at least eight hours, maybe twelve, depending on the beach conditions and weather along the way. My truck is equipped with four-wheel drive and has a clearance of over ten inches. I have a towrope, a commercial jack, and a shovel on board. Still, I've read of vehicles hitting soft sand and sinking up to their headlights. I've been told of people shredding tires and destroying their suspensions after hitting debris buried in the

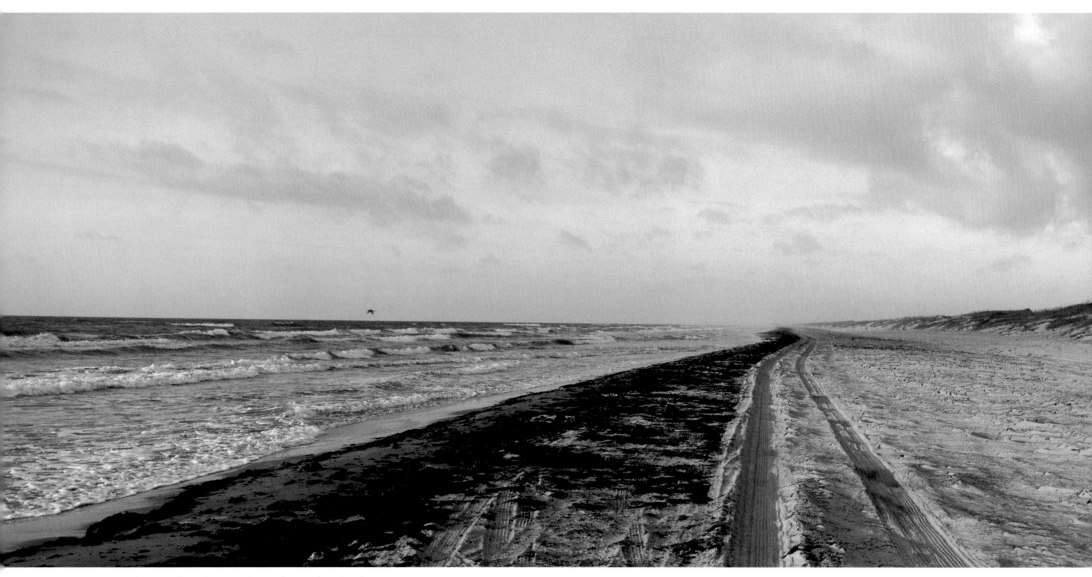

Looking south at the 10-Mile marker, Padre Island

sand. There is no cell phone coverage after the first few miles and only an occasional patrol by the Park Service. I have brought along an ice chest full of bottled water, an assortment of snacks, bread, and canned soups. I also have an air mattress and a blanket, since I plan to spend at least one night as far down the island as I can drive.

When I arrive at the large pavilion that houses the visitor's center and the Park Rangers' station, the latest water and beach conditions are posted on a blackboard. Beach conditions for today are listed as "Extremely Poor." The problem, according to the Park Ranger on duty, is seaweed on the beach. One man ran over a steel beam buried under the seaweed yesterday. It cost him his front suspension plus five hundred dollars for a wrecker to get him back from the thirty-mile marker. Also, the shell is really soft in some spots. "It's really bad just past the Little Shell area," he tells me. "If you don't know how to handle it, that shell will eatcha up. If you got four-wheel drive, you oughta be OK down to the ten-mile marker, but if I was you I'd turn around after that."

I decide to take the ranger's advice. I'm all geared up for an adventure, but I don't want to destroy my truck or get sucked into a quagmire of sand and shell. Out on the beach, I turn left to drive south down the island. It's very early morning, the sky is clear and the sunlight is raking across the beach. I follow the deep tracks of other vehicles along the right side of the beach, well away from the surf and the seaweed to my left. To my right, about a hundred yards from the surf, a line of low sand dunes extends as far as I can see. In the first ten miles, I pass fifty or sixty cars and trucks parked on the beach. Everyone waves as I pass.

At the ten-mile marker, I notice that the sand is getting deeper. It's time to turn around, but I'm not sure how to do it. I'm afraid that if I venture out of the tracks into the open sand and try to turn, I'll get stuck. So I keep going. I slow down and shift into four-wheel low gear. There's a steady growl from the drive train as the truck gets serious about pulling through the sand. I'm starting to think this could be fun. Keep your eye on the sand in front of you, I'm reminding myself. Watch out for objects half hidden under the sand, and keep your foot in it. Whatever you do, don't slow down.

At fifteen miles, there are no more camping families, only a fisherman

or two every mile or so. For the first time, I begin to sense the solitude of the island. Just past the twenty-five mile marker, I encounter more fine shell than sand, and I can tell that my tires are deep into it. This must be Little Shell, and the next ten miles are supposed to be the most treacherous driving. The sky has clouded over, and now a light rain has begun to fall. There's not one vehicle or a single person in sight, and I'm beginning to find the solitude a bit threatening. A hundred yards ahead of me, I see what looks like a large cross, made of driftwood, planted in the sand. I wonder if that's some sort of warning, so I stop to think about the situation.

I'm about to take the risk of trying to turn around in the deep shell, when I see a white Chevy Suburban coming toward me. It's bobbing and swaying side to side, as it makes its way through the shell. When he finally pulls up alongside me, I learn that the young driver works for the Audubon Society. He's been surveying the birds on the island. I ask him if he thinks I can make it to the channel.

"You oughta be able to get through," he tells me. "From here down to Big Shell is the hard part. Just keep it in four-wheel low and, whatever you do, don't let up off the gas. Watch out for the logs and driftwood, because there's lots of it. Just steer around it."

"Is anybody down there? I mean, is it safe?"

"I only went to thirty, and I saw a few fishermen. I don't know what you'll find after that. But if you do find anybody, I'd say leave them alone. If they've gone that far down the island, they're probably not looking to make any new friends. Fifty or sixty miles, if you find anybody down there, they're likely to be treasure hunters, and I'd sure stay away from them. Good luck. I hope the rain lets up for you."

Pushing away visions of sinking into a sand pit, never to be heard from again, I take off. There's not much to follow now, in terms of tracks. I'm on my own, plowing through the shell at a steady ten miles per hour. This area of Padre Island, from Little Shell to Big Shell, lies at the point of convergence of two major currents in the Gulf. One of these currents sweeps up the Mexican coast, and the other bears down from the northeast. They converge here in the middle of Padre Island, casting onto the beach a vast assortment of objects, natural and man-made. At the thirty-mile marker, I'm dodging logs, whole palm trees, plastic chairs, grounded buoys, oil drums,

soggy mattresses, and plastic bottles by the hundreds. I have to remind myself to keep my eyes on the sand in front of me, for the temptation is to study the curious collection of objects around me.

Then, somewhere right before the forty-mile marker, and just before three o'clock in the afternoon, the deep shell gives way to the flat, hard surface of sand and scattered seaweed. At the same time, the sky begins to clear overhead, the sun bursts out, and the surf is alive with birds and sunlight. I'm zipping along the swash line at 25 miles per hour, birds scattering and screeching all around me. Yahoo! I've made it through. Even the water appears different now: a brilliant, bright green color close to shore and deep emerald out along the horizon.

As I pass the 40-mile marker, I can see a very large object on the beach ahead of me. It's some sort of huge tank, perhaps twelve feet in diameter and twenty feet long that has washed ashore. It lies at the swash line, partially sunken in the sand, waves lapping around it. With scratches gouged all across its surface and its paint faded to a range of deep hues, it looks like Cy Twombly's gift to the Texas Gulf Coast, a complex, colorful piece of art completed by the primal forces of the sea.

The next fifteen miles, I pass five more huge buoys that have broken their mooring somewhere out in the gulf and washed ashore. A couple of them are as big as a small truck. I am reminded of one account of how pirates and plunderers would lure ships to crash on Padre Island. On dark nights, they would hang a lantern from the end of a long pole, which they would strap to the leg of a donkey. Then, they would lead the donkey in a circle, causing the lantern to bob up and down. A ship's captain, out at sea, would notice the faraway light, bobbing like a buoy, and head for it, thinking he had spotted a safe harbor. He would run his ship aground on the remote beach and fall into the hands of the plunderers.

It's almost seven o'clock when I arrive at the granite jetty of Mansfield

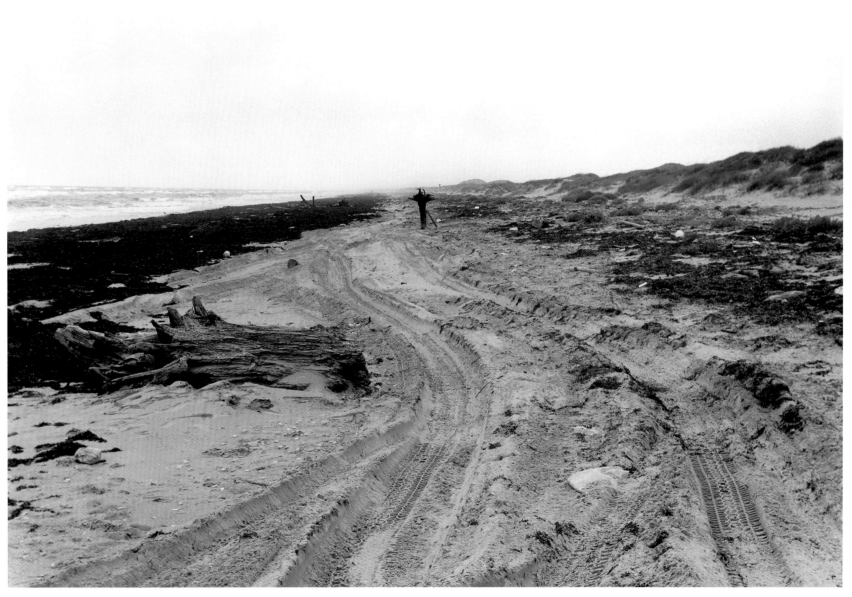

Entering Little Shell Beach, Padre Island

Near the 40-mile marker, Padre Island

Channel. I climb up onto the dunes adjacent to the jetty and walk for about a quarter of a mile along the channel. I have read that illegals, coming up the coast from Mexico, have to swim across the deep, turbulent waters of the channel clinging to inner tubes. I can only imagine how frightening the experience must be, plunging into the water at night and making the two-hundred-yard swim with nothing but an inner tube to keep you afloat.

The thought of darkness reminds me that I need to get ready for the night, so I fall back on my old Boy Scout skills. I collect stones from the jetty and make a pit for a fire. Then I scour the dunes for dry wood to burn. Like a good scout, I have brought charcoal lighter, so with a quick dousing of the driftwood and a single match I have a roaring fire. I stretch a tarp from the top of my truck to the beach, holding it in place with a couple of stakes. Finally, I inflate my air mattress, slide it under the tarp, and cover it with my blanket.

The air is cooling off, and there is virtually no wind to blow the sand around, so I'm thinking it should be a nice night to sleep on the beach. After eating a can of chicken noodle soup, warmed over the fire and straight from the can, I climb onto the air mattress and settle in with my blanket. I close my eyes, and all I can see in my mind's eye are birds. Gulls frolicking in the surf, screeching and soaring as I drive out of Big Shell. Pelicans soaring past, low over the sand dunes. Sunshine sparkling on the beach. It has been a beautiful, adventurous day.

Then I notice how dark and quiet it is here on the beach. There's no moon tonight and not a star in the sky. There's no sound except that of the surf. I'm tempted to turn on the radio in the truck, but I'm afraid of running down the battery. I lie down and try to sleep, but it's no use.

So what's keeping me awake? Well, it's the story of the Spanish shipwrecks, *that's* what's keeping me awake. The story starts to replay in my mind, in all its gruesome detail: four Spanish ships, 1554, commercial goods, four hundred persons, gold and silver worth 1.5 million pesos, a terrible storm. My mind fleshes out the story: Three of the four ships ran aground on Padre and smashed to pieces. The three hundred or so survivors, including men, women and children, decided to abandon the wrecked ships and walk to the nearest Spanish settlement at Pánuco, near today's Tampico.

They thought the walk would take them a couple of days, but they seriously underestimated the distance. They walked for a week down the island in the blistering sun, scrounging what bits of food and water they could from the harsh environment.

Then the local Indians found them. At first the Indians offered the Spaniards food, and stood by watching as they ate. Then they attacked them. The Spaniards had a couple of crossbows, and with these were able to hold off the Indians' initial attack. But as they continued their fateful march toward Pánuco, the Indians followed them. Each day, with their bows and arrows, they would pick off a few Spaniards. Finally, they reached the Rio Grande, but they lost their crossbows in the crossing.

On the other side of the river, two of the Spaniards were captured by

the Indian band, who forced them to strip naked, then released them. The rest of the castaway Spaniards, grasping for hope in an increasingly hopeless situation, decided that perhaps the Indians only wanted their clothes. So they all stripped naked, threw their clothes on the beach, and continued their march. To save them the embarrassment of being seen by the men, the women were sent ahead. One report tells how some of the women dropped dead of shame.

When the women and children reached the Rio de las Palmas, almost two hundred miles south of the site of the shipwrecks, but still over a hundred miles from Pánuco, the Indians attacked in earnest. By the time the men arrived, all of the women and children had been killed. Still, the men crossed the river and walked on. For twenty days the remaining Spanish men walked, and each day the Indians killed a few more, until none of the Spaniards remained. In the end, there were two survivors. The first was a man who wisely turned back to the wrecked ships before the attack began. He was rescued a few days later by a salvage fleet. The second was a priest, Fray Marcos de Mena, who took seven arrows on the south side of the Rio de las Palmas and was left for dead. He somehow survived, dragged himself to the settlement at Pánuco, praying all the way, and lived to tell the lurid story.

Around midnight, with the ghosts of the Spanish castaways all around me on the dark beach, I decide to move. I take down my tarp, stow my air mattress in the back of the truck, start the engine and take off, half expecting to run into a band of flesh-eating Indians in the dark. I drive for two and a half hours, until I see lights ahead on the beach. Three pickup trucks are parked side by side near the dunes. There's a fire going and a tent is pitched. I can see half a dozen long fishing rods leaning against one of the trucks. I drive a hundred yards past the little fishing camp, stop, turn off the engine, and recline my seat. I simply needed some company. I close my eyes and sleep until dawn.

The next morning, the sun is shining and the return trip up Padre

Dawn at the 50-mile marker, Padre Island

Island goes without a hitch. As I pass through Big Shell, maneuvering easily around the tree trunks and battered buoys on the beach, I wonder how much of the difficulty of my trip down the island the day before was the product of nothing but fear of the unknown. I drive through Corpus Christi and turn south on Highway 286. A few miles out of the city, the highway stretches out in front of me in a straight line, as far as I can see, through endless fields of crops. This is the quintessential coastal plain, the flattest landscape I've seen since the Texas Panhandle. In the fields along the highway, green sprouts have emerged in long rows from the rich, brown soil. Is that cotton? Or corn? I'm ashamed of my ignorance of such things, a situation that I vow to remedy, starting now.

Highway 286 ends at a stop sign at its intersection with Farm Road 70. A highway sign tells me I'm in Chapman Ranch, but there's nothing here except the stop sign and one curious building. It's a long, concrete structure on the right side of the highway. At first glance, the building appears to be unoccupied, but then I see a sign midway down the long bunkerlike building: "U.S. Post Office Chapman Ranch Texas."

Inside, the walls of the tiny post office are covered with old photographs and newspaper articles about Chapman Ranch, which I learn was a huge operation during the 1920s and 30s, the first mechanized cotton operation in Texas.

A short, gray-haired lady, probably in her early sixties, pokes her head out of the postal service window and asks if she can help me. I ask if she can tell me what's growing out there in the field across the highway.

"It's grain, honey. Milo. Where are *you* from?"

"I'm originally from Tennessee, but I've been in Texas almost all of my life. And you?"

"I'm Dorothy Kaufman, and I'm the postmistress here. I been here fourteen years, originally from Massachusetts, and before I came here I didn't have a clue about farming or crops or anything. Right now, this is my favorite time of year, cause it's all *green* and nice. Every morning I go by these fields and I can see things growing, a little bit every day. It just *smells* good here this time of year. By the way, I bet you didn't know that you're standing in the first shopping mall in Nueces County?"

"Is that right? I wouldn't have guessed it."

"It's true. This whole building, starting at that end, was a gas station, restaurant, bank, post office, car dealership, and saddle shop. I think there was a dentist here, too. And a general store. All in one building. This was a mall before anybody knew what a mall was. That was back when the ranch was going big guns. Guys were paid in script. Canyon Ranch script. This was quite an operation. Mechanized. We sold cotton seed all over the world."

I ask if the Chapman Ranch is still in operation, and Dorothy explains that it has been "downsized" a lot over the years, but that it's making a comeback in a new way: suburban development. Corpus Christi, she explains, is running out of room, and this is the only way it can grow. Chapman Ranch already has two new suburbs in development, and it seems certain that there will be many more to come. I ask Dorothy how she feels about that. What about all those crops she loves so much? What will happen to the fields of crops, if the place becomes one big suburban development?

"Well, that's just progress, or what you call progress. Nothin's gonna stop progress. You just gotta go with it. Don't ya think? I'm looking at the good side of it. I'm gonna be able to fix up my post office. More people means more money, and more money means I can really fix this place up. I'm gonna put down carpet and get new lights, and I'm getting more old pictures to put on the wall."

"You're going to make this into a little museum, aren't you?"

"Well, you can say that if you want. To me, it's just going to be the best post office you'll ever see. When people want to get together and talk, when they want to show people what Chapman Ranch used to be, this is where they'll come."

Dorothy Kaufman, Postmistress, Chapman Ranch, Texas

• • •

Highway 70 comes out of Chapman Ranch headed due west. After twenty-two miles, it intersects with Highway 77, thirty miles south of Corpus Christi. There is no coastal highway south from Corpus to the border. Highway 77 is the closest road to the coast, except the private roads on the ranches of Kleberg and Kenedy counties, until you get to Raymondville in the South Texas Valley. I turn south on Highway 77 and find myself on the outskirts of Kingsville. The Wild Horse Desert Mall sits on the west side of the highway.

A number of nineteenth-century accounts of this part of Texas describe a vast desert between Corpus Christi and the Valley, even though Spanish and French accounts from the two prior centuries do not mention a desert here. Perhaps the earliest of these accounts of a desert come from William Kennedy, writing in 1839:

> A few miles south of the Los Almos [River], commences the barren sandy ridge, distinguished by the name of the Wild Horse Desert, which extends nearly one hundred miles inland. It is so utterly arid and sterile that it is unfrequented even by reptiles and insects, and the traveler rarely encounters a living thing in traversing its desolate surface.

Kennedy thus described the heart of South Texas as a desert. His description was echoed in accounts of numerous other nineteenth-century writers. The question is whether these other writers ever visited the region or simply picked up what Kennedy had written. Not all who traveled this region in those days saw it as a desert. In his 1846 account, William McClintock wrote:

> Crossing the mustang, or wild horse desert, either from the Nueces or the bay, the country is almost as level as the ocean: which it strikingly resembles; when clothed with the tall grass, which is ever fanned by the bland southern breeze. Excepting a motte or small chaparel of them bushes at long intervals, it is destitute of timber . . . when within 60 or 70 miles of the Rio Grande, the country be-

comes more broken, mottes more frequent with here and there a low sand hill . . .

All things considered, the most memorable account of this area that I recall reading is that of James K. Holland, written 1848, when he was traveling south from near the Kleberg-Kenedy county line:

> Nothing but grass and not much of that—Still Perairie . . . traveled twelve miles and stoped to dinner in a live oak grove and found another old horse . . . thence on thr. watery Perairie low country—10 miles to camp *Sand Fort* 22 miles today . . . little grass . . . passed an embankment of white sand an area of about 50 acres—it was indeed a curiosity—grand gloomy—and interesting—the sand was valley of the Sierra Diablo.

Other accounts mentioned herds of wild mustangs, deer, and antelope in great numbers, and broad prairie lands with impressive pasturage. The most reasonable conclusion is that this area was not a true desert, but a vast expanse of flat and open land. Perhaps there were a few sand hills and certainly there were wild horses, but the name Wild Horse Desert seems to be more of an effort to romanticize the place than an accurate description. Even today, it makes a catchy name for a little mall along the highway.

The territory south of Corpus Christi toward the Valley is King Ranch country. The historic ranch, which covers 825,000 acres across six counties, has four distinct and separate divisions: Santa Gertrudis, Laurelis, Norias, and El Sauz. The town of Kingsville is situated in the heart of the ranch.

The King Ranch traces its origins to 1853, when Richard King acquired a Spanish land grant of 15,500 acres on Santa Gertrudis Creek, in what is now Nueces County. King, who had made vast profits running steamboats on the Rio Grande, purchased a second land grant a year later, the Garza Santa Gertrudis grant of 53,000 acres. Operating with partners Gideon Lewis and later Mifflin Kenedy, King continued to acquire vast tracts of acreage through the late nineteenth century.

The ranch's world-famous cattle operations began when King imported longhorn cattle from Mexico, along with a number of Mexican *vaqueros,*

On the Laguna Madre, King Ranch, Norias Division, Kleberg County

Corralling cattle, King Ranch, Santa Gertrudis Division, King County

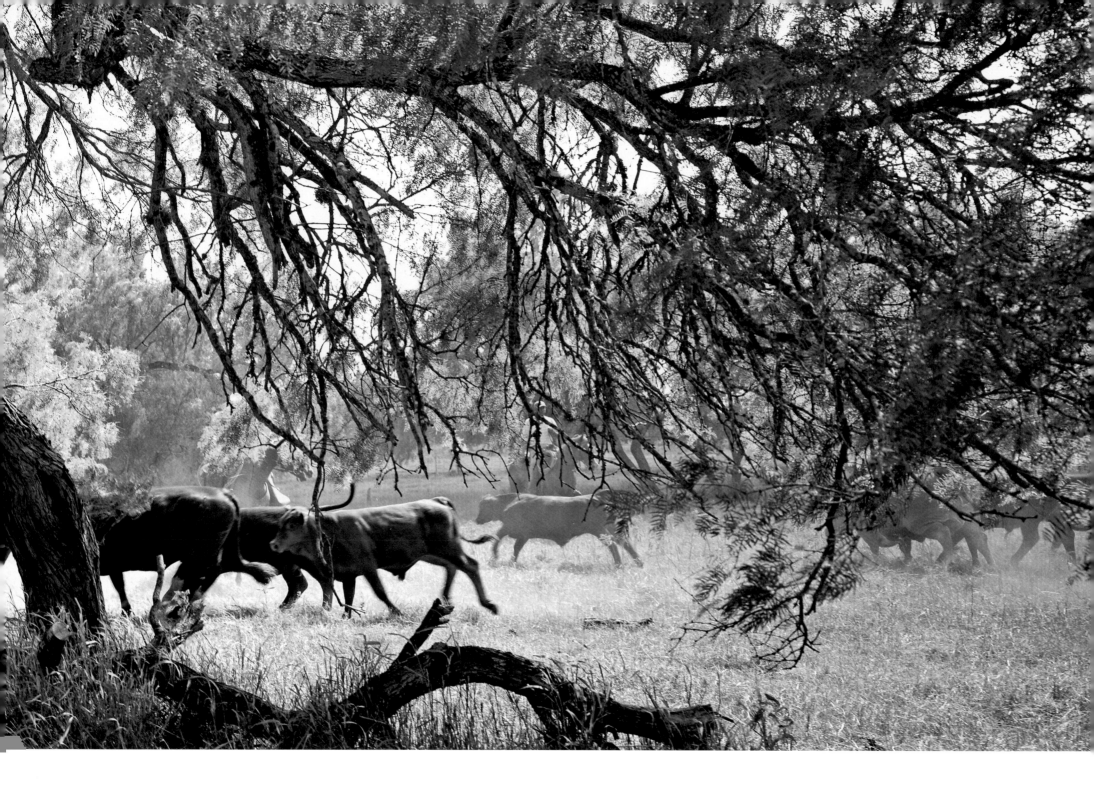

King Ranch, Norias Division, Kleberg County

who he hired as ranch hands. One story tells how King rescued an entire Mexican village when it was struck by an extended drought. All the village inhabitants were brought to the King Ranch, where they became known as *kineños*, "King's men."

King eventually crossbred the original longhorns with Brahmans and shorthorn cattle to produce the Santa Gertrudis breed. In the twentieth century, cattle ranching operations were expanded to Pennsylvania, then to Cuba and Argentina. The ranch ventured into horse breeding and racing, oil and gas production, and timber. Today, the King Ranch is a widely diversified corporation, headquartered in Houston.

After dozens of phone calls to the corporate headquarters, letters of support and recommendation, and finally a brief but strict letter of agreement, the King Ranch agreed to give me access to the ranch for the purpose of making a few photographs. I am to be attended at all times by an employee in the security division of the ranch.

At dawn on a clear summer morning, Joey Clements is waiting for me, parked in his white, heavy-duty Ford pickup truck at the main gate to the Norias Ranch. Norias is the southeastern division of the King Ranch. Most of its 162,000 acres are between Highway 77 and the Laguna Madre, north of Raymondville and south of Sarita, Texas. I leave my truck at the gate and join Joey in his truck. Soon we are headed along ranch roads through beautiful grasslands dotted with oak mottes. My first request is to see the shoreline of the Laguna Madre.

The spot Joey takes me to on the laguna is much like the coastline along Matagorda Bay. The only distinguishing feature is the abundance of rotting seaweed on the beach, a seasonal phenomenon that puts quite a stench in the air. Joey suggests that we try another place, a "surprise," something I would never expect, so we head north and east across the ranch. As we drive, I begin to learn a bit about Joey and his work. He's only been working for the King Ranch a few years, and in most respects it's a dream of a job. He loves being out on the land, and he's obviously proud to be a part of the history and tradition of the King Ranch. But he was not prepared for some of the difficult, soul-searching situations he has encountered. First, Joey tells me that the stream of illegal aliens coming across the ranch seems to be endless. On average, he and the rest of the security force detain thirty or forty people a day on the Norias Ranch alone. His job, as a deputy law enforcement officer, is to detain the illegals and call the Border Patrol, who will come and take them into custody. Some days, his work is straightforward and relatively easy. Other times, it can be gut wrenching. Joey tells me how he detained one group of illegals, including a woman with a newborn baby. As he was waiting for the border patrol to arrive and take the group into custody, the woman pushed her baby into his arms and begged Joey to take him. "She said I could send her to jail or back to Mexico, but she was on her knees, pushing the baby at me, begging me to let her baby stay in this country."

I ask Joey how he handled that, and he said that he turned all of them, including the baby, over to the Border Patrol. What else could he do? Besides, he told me, no matter what you hear, these are not people we want in our country. Most of them bring drugs and crime to our country, and they ought to be Mexico's problem, not ours. I'm looking at Joey, listening to what he's saying, and thinking about that woman with the baby, when Joey points to a huge sand dune rising out of a grassy field off the side of the road.

Could this be the "Sand Fort," the "Sierra Diablo" described by James K. Holland in 1848? I get out of the truck and climb the dune. There are at least fifty, maybe a hundred acres of sand, with dunes as high as forty or fifty feet. It looks as though someone transplanted a chunk of Padre Island into the grasslands of the Norias Ranch.

• • •

I head toward Brownsville and the international bridge into Mexico, driving east out of Harlingen on the expressway and wondering if it's possible to drive to the mouth of the Rio Grande on the U.S. side. I want to see where the river joins the sea. I look at my road map, and it shows a secondary highway coming out of Brownsville, ending at Boca Chica. There appears to be no town there, only a beach by that name that ends at the mouth of the river. So I exit the freeway and drive east on Highway 4. Within a few miles, the four-lane highway narrows to two lanes, and a succession of small homes and businesses gives way to the country. The black-

Fruit stand, Texas Highway 100, near Rancho Viejo

Laguna Madre at Port Mansfield

top road I'm following is lined with acacia, cactus, mesquite, and joshua trees. In ten minutes, I have left the expressway, passed completely out of the city, and arrived in a remote stretch of desert landscape.

Beyond the roadside cactus and foliage, the salt flats extend for miles. Beyond the flats, to the northeast, I can make out the skyline of South Padre Island, perhaps twenty miles away. The cluster of tall hotels rise out of the flats like a mirage, standing on the hazy horizon line like a toy city placed there by a child. The luminous green of the acacia, ruffled by the morning breeze, the buzz of locusts, the distant vision of the tall buildings, and the slow motion passing of white clouds over the salt flats, all give a sense of otherworldliness to the place.

Another mile down Highway 4, I can see the gulf out on the horizon, so I figure that I'm getting closer to Boca Chica. The highway bears to the right, and a smaller road forks off to the left. A simple wood structure, probably once a gas station, sits in the center of the fork. The store has a fresh coat of white paint, and a yellow sign out front announces "Sanchez Tip." Four men are sitting in the shade in front of the store. I look at my road map again, trying to figure out which fork in the road to take for Boca Chica, but I can't even find Sanchez Tip, so I decide to ask directions.

As I approach, one of the men stands up to greet me. He's Hispanic, about forty or forty-five, bronze skin and black hair that's starting to gray, and handsome with kind eyes and a warm handshake. I tell him I'm trying to find Boca Chica, but I think I'm lost because I can't find Sanchez Tip on my map.

"We're not on the map yet. But I can tell you that if you just stay on that road, just bear right, it'll take you to Boca Chica." I notice that the man is wearing a yellow shirt, the same color yellow as the Sanchez Tip sign. I ask if he is the owner of the store.

"Yes sir, I am now. I'm Homer Sanchez."

The store is neat and clean. Homer introduces me to his wife, Rosie, who is at the cash register. There are bait and tackle for sale, plus coolers full of water, soft drinks, and beer, along with a minimal selection of food and snacks. Homer tells me that the store has been here for seventy years, and that he has been trying to buy it since he was seventeen, but the old Polish man who owned it wouldn't sell. Then he died. Homer quit his job as a physical therapist, cashed in his 401K, and sunk all his money into the place. I ask him why he wanted the store for all those years.

"It's more than the store," Homer says. "This is a *place* with history and a meaning. It has been a big part of my life, as long as I can remember. When I was a kid, my father used to bring me fishing here. This store, it was here then. The Polish man I told you about, he owned it, and we'd come in here to get bait. My whole family, we would come here for three or four days at Easter. We would camp out and fish. This was where we came as a family. So, I told Rosie, I'm gonna buy the place and name it for my father. I'm gonna name it Sanchez Tip. And I'm gonna get it on the map before I die. Right after I bought the place, I started mailing letters and packages here, addressing them to Sanchez Tip. And they come through now. The post office, they already know where Sanchez Tip is."

I ask Tony where his parents were from. His father's family, he explains, had land around the Soto la Marina area, but they got evicted when oil was found there. So they moved up close to Matamoros, on the other side of the border, a little place called Santa Teresa. And his mother was born in Lyford, Texas.

"How did they meet?"

"Well, my father told me that story many times. How they met at a wedding near Santa Teresa. It was one of those Mexican weddings, a country wedding, that went on for days. And my mother had come down from Lyford for the wedding. And they met at that wedding. My dad was seventeen and my mom, I think she was thirteen. Poppa would tell me, 'When I met your mom I was wearing your aunt Chavela's shoes, the kind you put a penny in, and they were so tight they hurt my feet something terrible, but that's what I had to wear. And we were so poor that I was wearing underwear made from a flour sack. So, we're in the middle of this field, dancing together at this wedding, and I feel something in my pants. I thought it was some kind of animal had crawled up my pants leg. But it was just my flour sack underwear, all balled up down one leg of my pants."

I ask Homer if his dad is still alive.

"No," he tells me, " he died two years ago. He was a good man, a very

Weathered sign, Texas Highway 4, near Boca Chica Beach

Sand flats and skyline of South Padre Island, Texas Highway 4

proud man. We were poor, but we were a real family, a strong family. My mother, she's still alive."

"Did she work, too?"

"Oh, my friend, we all worked. From the time I was seven years old, I was picking tomato and pickle out of the field, and so was my two sisters. The whole family, all five of us, then later my kid brother, too. Nobody wants to be a migrant worker family, but sometimes that's where the best money is, so that's what you do. And we were the best, the very best at it, especially picking tomatoes. Nobody could keep up with us. They would give us a *vesana*, a section of maybe fifteen rows of tomatoes, and here we'd go. By the time the others were half way up their *vesana*, we'd done one *vesana* and were halfway down the other. Poppa would never let us rest, not even one hand. If I'm holding the bushel over here with one hand and picking with the other, poppa would say, *'Mijo, esta descansado su mano?'* 'Are you resting one hand?' *'Los dos manos, mijo.'* 'Use both hands, my son.' And we would really pick up a lot of money picking tomatoes."

"So you worked picking fruit and vegetables here in the valley?"

A tall, lanky guy, one of the fellows who was sitting out front with Homer when I arrived, walks into the store. A little Chihuahua follows him, right at his heels.

"This is Frank," Homer says. "He stays in the trailer out there and helps me out with the store."

"How'd you get here?" I ask Frank.

"I got lost. Did Homer tell you, bout the four illegals that come through last night?"

"No. He didn't tell me about any illegals. You get a lot of them coming through here, I guess, so close to the river."

"No. None, hardly any at all," Homer explains. "This place is watched by so many agencies. You not only got the Border Patrol and the sheriff, but you got the Parks and Wildlife, the DEA, the Coast Guard. They're all watching. And they don't miss a thing. So if any illegals do show up, they generally catch 'em in about ten minutes. It's kinda scary. I don't know how they know what they know, but they know everything that's happening. But what Frank's talking about is early last night four young men walked up. No car, no truck, no nothing. Just four guys that come walking up from

the direction of the river. They want to know how long it takes to walk to Houston. They're looking at the lights of South Padre over there behind us and asking if that's Houston and if they can they walk there before daylight?"

'Houston?' I said to 'em. "That's not Houston. That's South Padre, man. The coyote had dropped 'em off and told 'em they could walk to Houston by daybreak. They took off anyway, and it wasn't five minutes before the Border Patrol was here. 'Where'd they go?' they're asking me. I got no stomach for that. I want no part of it. What it takes for people to leave their family and look for work in another country, most people have no idea. No idea at all.

"Property is starting to sell around here," Homer adds. "I betcha ten years from now you won't be able to find a lot for sale. Property values are going up and places are moving. We're hoping the place is not going to become another South Padre. Whatever it turns out to be, it's gonna be called Sanchez Tip, right Frank?"

"Looks that way."

• • •

Less than a mile from Homer's store, I drive south on Boca Chica Beach in loose, dry sand. It's the middle of the day, the sun is bearing down hard, and there's not another vehicle or person in sight. After about five miles on the beach bears to the right, and I get my first look at the mouth of the legendary Rio Grande. It's not what I expected. A triangular sand bar forms a sort of delta at the mouth of the river. The water across the bar is only a few inches deep, and about two dozen men are wading through it, fishing. Some of them face the surf, with tall poles that stand in a row against the sky. Others have ventured across the bar and are walking at the edge of the water on the U.S. side, in front of me. Across the river, at least a hundred people are out on the beach—Playa Bagdad, it's called over there—sunbathing, casting small nets, and lounging in the shallow water. All of them turn to look at me, as I stop my truck on the beach.

I see the potential for a great picture here, but everyone is wondering who the hell I am and what I'm up to. Every eye is on me as I get out of my

Homer Sanchez at Sanchez Tip

truck and walk toward the water. Am I the Border Patrol in an unmarked vehicle or an undercover DEA agent posing as a tourist? I can see the questions on their faces, particularly those who have crossed to the U.S. side, who are less than fifty feet from me. With their heads down, they pretend to work at their nets, while they wait to see what I will do.

I feel like an intruder on this peaceful scene. Everyone on the sand bar has stopped fishing and has turned to stare at me. Even from across the river, the crowd watches my every move, wondering what I will do next. I wave to the guys on the sandbar and smile. Nobody waves back.

Well, I figure, I have to get out there and talk to them. I have to break the ice. In my mind's eye, I am already beginning to frame the picture. It should be a panoramic view, taken from the shallow water of the surf, looking straight up the river, with the sun behind me and to my right, and the line of fishermen scattered across the foreground. Playa Bagdad, with people all over the beach, will fill the left side of my frame, and Boca Chica will be on the right, with a few fishermen working that side of the river. In one picture I can encompass both countries, with the river in the middle. This picture is worth working for.

I go around to the far side of my truck, take off my shoes and change to a t-shirt and swimsuit. Then I grab my big panoramic camera, already loaded with a new roll of film. That will give me four shots, and that's all I need.

When I step out from behind the truck, the big camera is hanging from my neck. As I walk toward the water, the tension seems to ratchet up. I can just hear their thoughts: Now the gringo has a camera, and he's coming out here in the water. What the hell is *this* about?

I know from many years of experience that all you can do in a situation like this is smile, be pleasant, don't look sneaky, make eye contact, and try to break the ice in any way you can. *"Es una buena foto,"* I say to the fellow closest to me. He was casting a net in the water next to the beach when I drove up. Since then, he has stood, holding his net, glaring at me. I point to all the people on the sandbar, *"El río, los pescadores, una buena foto."* The fellow looks at me like an uninvited guest who has just shown up at his party. I smile at him and keep walking into the river.

The water appears to be ankle deep all the way across the sandbar to the beach straight ahead of me and to the surf, off to my left. Several men stand on the sandbar, less than thirty feet in front of me. They have stopped fishing, and they watch me as I approach. The water is so shallow it barely covers their feet. I'm going to walk across the sandbar, all the way to the surf, about a hundred yards away, and there I will talk to the fishermen as I frame the picture.

My first two steps into the river confirm what I expect: warm, shallow water and a sandy bottom. But I'm not thinking of the water. I'm thinking of the picture I'm going to take, so I take the strap off my neck and shift the big camera into my right hand. I preset my focus at twenty feet, the shutter at 1/125th, and the aperture at f22.

With my next step or two, I feel something different. Not sand on the bottom, but silt, and it's slippery. Then, to my surprise, I feel a trace of a current, moving toward the sea. Suddenly, faster than I can react, the slippery bottom drops off to nothing, and the current, now swift and powerful, takes me.

It all happens in a split second. First, no footing, just fast-moving water. Then it's deep, and I'm up to my neck. I struggle to keep my camera from going under. I push it straight up over my head, and they're all watching me as I go down, taken by the current. I'm under water, can't feel the bottom, nothing, and then I feel my camera, over my head, go under water. My glasses are swept off my face. Nothing but water, powerful water, pulling me toward the sea.

An instant later, I walk out of the stream and back onto the beach.

What happened? That's what I'm asking myself as I stand there on the sand, soaked from head to foot, including my camera. Even without my glasses, I can see everyone laughing. It occurs to me that I have just provided quite a comic spectacle. The gringo with the big camera walks straight into the deep water, drops like a rock, then scrambles out, *sin lentes*. Guys are rolling around on the beach, howling with laughter. One of the fishermen from the sandbar has rescued my cap from the water, and brings it to me with a smile. I broke the ice.

Then I begin to realize how dangerous my little spectacle actually was. I could have drowned in the powerful currents that had taken me. I look at the river and the sandbar, and I can see what I had missed before. The river has cut a deep, narrow channel alongside the sandbar as it travels the

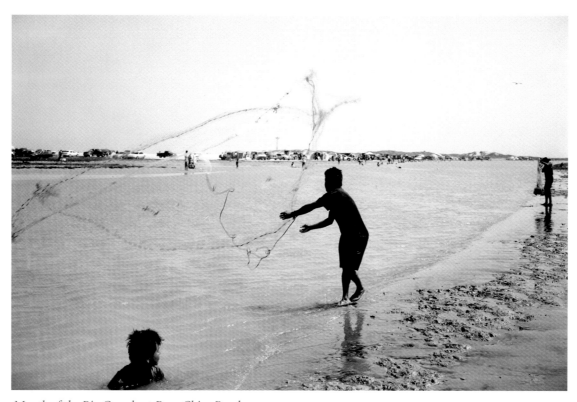

Mouth of the Rio Grande at Boca Chica Beach

Mouth of the Rio Grande at Boca Chica Beach

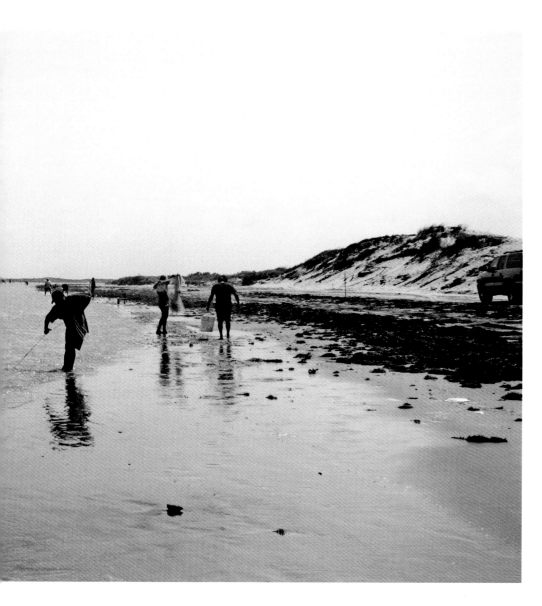

last hundred yards to the sea. The water is so silty that even now I could not tell how wide or how deep that channel was, but I'm guessing that it was at least eight feet across. And it must be at least ten feet deep, because I was completely submerged, including my camera, held high over my head. And I never felt the bottom, yet I somehow walked out. How *did* I get out? I couldn't say. One second I was over my head, at the mercy of the river's powerful current. Then, miraculously, I was out.

With another camera and my spare pair of glasses, I take a few pictures, but my heart's not in it. As I drive back up Boca Chica Beach, I can only wonder at the strange event I had experienced. Strangest of all, perhaps, is the fact that I never felt the slightest bit of fear. Perhaps that's because it all happened so fast. But most of all I cannot understand how I got out of the deep currents of water in that channel. I recall no struggle, no grasping for a way out, no effort at all, really. It seems as though I was simply taken out of the water, as gently and cleanly as I was put into it.

The more I think about it, the more my brief immersion in the waters of the Rio Grande seem like some sort of impromptu baptism. Or a warning of some kind from the other side of the border. Any way I look at it, the river has gotten my attention and started me thinking about what lies ahead.

Still, for the life of me, I can't figure out how I got out of that river.

PART 4: *Matamoros to Tampico*

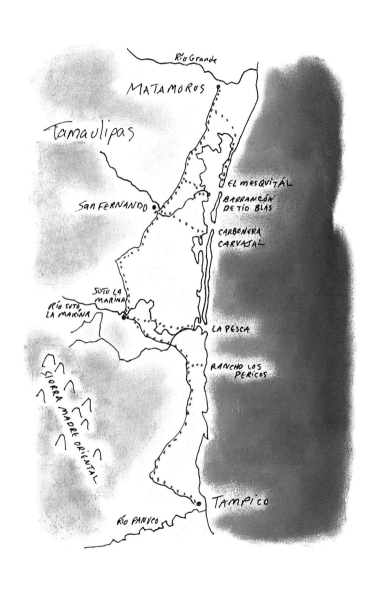

THE THREE southbound lanes of U.S. Highway 77 end abruptly in a row of tollbooths and a maze of chain link fences. A few hundred yards ahead, the shallow, murky waters of the Rio Grande flow through a landscape covered in tall grass and scattered trash. I pay the two dollar twenty-five cent toll and drive across the International Bridge into Mexico.

I have driven into Mexico over a hundred times in the past thirty years, and I know the rules for foreigners entering the country. To be more precise, I know all the rules that Mexican officials have revealed to me, up to now. The one thing repeated travels to Mexico have taught me is that as soon I think I know what to expect from Mexican border officials, I will be proven wrong. At any time, on any crossing of the border, officials in customs or immigration may ignore all precedents and invoke a previously unrevealed rule.

For this reason—for the sheer uncertainty of what lies ahead—I have never taken the drive across the bridge into Mexico without some urge to turn around and go back. So, as I drive the mile or so across the bridge, I am trying to reassure myself. I already have a valid Mexican entry visa and an entry permit for my truck, so I don't have to deal with immigration officials. I just have to pass through *aduana,* Mexican customs. Right away, I have to choose between two traffic lanes: one lane is for those who have something to declare and pay duty on, the other is for those with nothing to declare. The problem is that anyone who is traveling into Mexico for any period of time almost certainly is carrying with them goods that are in violation of one rule or another. Technically, a mere fifty dollars is the total value of merchandise allowed per person. I have that much in toothpaste, shampoo, and bottled water. Then there are exceptions, things that you are specifically allowed to bring, beyond the fifty-dollar allowance, such as: one camera (I have four) and twelve rolls of film (I have about two hundred). In the end, it's entirely up to the officers on duty, how closely they choose to examine the contents of your vehicle, and what they will allow. What if they find the coffee pot I am bringing, or the six halogen light bulbs, or the four boxes of books and notes from my travels? If I tell the truth, that I am working, another can of worms could open up. My visa does not allow me to work in Mexico, only to travel as a tourist or to reside there on a part-time basis. Doing any kind of work in Mexico could, if it were brought to the attention of officials, land me in the immigration office, hoping for a sympathetic official. There's no time to think about that now. I choose the Nothing to Declare lane and push a button on the entry gate. Bingo! I get the green light, which means I can pass without inspection. Two customs officers smile and wave at me as I drive past.

At the first red light, vendors surround my truck, pushing windshield wiper blades, road maps, mangoes, Chicklets, hubcaps, and gearshift knobs. It's free enterprise, Mexican style, and it's an impressive, if slightly intimidating, sight. As I wait for the red light to turn green, one young man taps at my window, holding up a bottle of soapy water. I nod in his direction, and a split second later he has mounted the hood of my truck. Then, balanced spread-eagle across the windshield he splashes soapy water across the glass and starts to work with a tiny squeegee. In one fluid, sweeping motion—up, across, down, and back across, like a magician waving a wand—he clears all the soap and water from the glass. The traffic light turns green as he jumps off the hood. It's a perfect job, done in a matter of seconds. Not one bug or bubble remains on the glass, and the windshield sparkles like new. The guy probably averages less than a peso per windshield, but I give him five. Thanks to him, I'm beginning to feel at home in Mexico already.

In Matamoros, I'm on the equivalent of a six-lane boulevard and have to summon my Mexican driving reflexes. The lanes, if they exist at all, are unmarked, so I'm swept along in a sixty-mile-an-hour, southbound free-for-all. Driving here is not for the faint of heart or for those who love too much the rules of the road. Cars, pickup trucks, city buses, and growling eighteen-wheelers jockey for an opening to pass bicycle-powered taco stands and sputtering motor scooters. Mexicans drive aggressively and with a spirit of improvisation. The general rule seems to be: "If You Think You Can Do It, Go Ahead." When a space opens between two vehicles, even for a split second, someone jumps into it. Road rage is nonexistent; instead, Mexican drivers appear to exhibit the opposite of road rage: respect for any driver who can find a way to get ahead of the rest, so long as he doesn't disrupt the flow of traffic.

Red lights mean, "Stop, If You Need To." When there is no cross traffic, drivers simply ignore red lights. Pedestrians have no right-of-way whatso-

ever and move into the street at grave peril to life and limb. Mexican drivers love their signal lights and use them creatively, sometimes to the utter confusion of other drivers. A flashing left blinker light, I have learned, can mean anything from "I'm about to turn left," to "You can pass me on the left," or even "I am staying in this lane and I'm going straight ahead." Only another Mexican can possibly know what a blinking left signal means, and surely even they must wonder at times. In the midst of all this, the police routinely cruise around with all their emergency lights flashing, which can stir panic in the uninitiated foreign driver who assumes that someone is being pursued.

The one overarching, absolute rule of driving in Mexico is this: Keep the Police Out of It. If you have an accident, try to settle with other driver or pedestrian and get the hell out of there before the police get a whiff of the incident. The police will insist on taking all parties to headquarters, talk about big fines, and then look for a payoff, the legendary Mexican *mordita*. It's a sad tradition, but a true one, and it is probably the single fact that has done the most to discourage foreigners from driving in Mexico.

Today, my goal is to find my way through Matamoros and onto Mexican Highway 180. This major coastal road will take me south, parallel to the Gulf, through the Mexican states of Tamaulipas, Veracruz, and Tabasco, all the way to the Yucatán Peninsula, should I decide to travel that far. At this point, I am not sure how far south I will travel, though I feel certain that I will travel at least as far as the city of Veracruz, six hundred miles south of the border. For the first three hundred miles, along the way to Tampico, Highway 180 never passes within sight of the coastline. At least a dozen smaller roads, some paved and others not, take off from 180 and lead east to one coastal village or another. These are the roads I will be taking, one by one, as I work my way down the northern Mexican coast.

The streets of Matamoros offer a mixture of the old and the new Mexico. After an endless string of shoddy wooden shacks and dilapidated old buildings, the Plaza Hidalgo appears on my left, with a modern Super Gigante department store, an HEB grocery store, McDonalds, and an Office Depot. Then, with hardly a break, junkyards and improvised auto parts stores line the roadway, along with grilled chicken stands and open-air *fruterias*. There are specialists in muffler and shock absorber repair, knife

Windshield washer in the streets of Matamoros, Tamaulipas

sharpeners and flat tire fixers, barbers, foot doctors, and dentists. Wherever you look, there is a scattering of trash, and a layer of dust on everything. Still, unless you value tidiness and cleanliness above all else, there's an undeniable energy, even *beauty,* about the streets of this typical Mexican border town. The neatness and order of the United States can seem downright boring in comparison. Here, the urgency, the improvisation, the very *art* of survival presents itself at every turn.

About five kilometers out of town, I notice a taco stand where half a dozen buses stand idling on the east side of the road; I stop to inquire. As I suspected, this is the first road to the coast, the road to El Mesquitál, so I turn east onto the two-lane, blacktop highway, where I immediately encounter a military checkpoint. All Mexican highways have these check-

Matamoros, Tamaulipas

On the road to El Mesquitál, Tamaulipas

points, which are set up to check for guns and drugs. In Mexico, getting caught carrying illegal drugs or a gun on the highway without a license will land you directly in prison, so there's an air of seriousness when you encounter one of these checkpoints. This is an especially grim and professional-looking band of soldiers, dressed in all black, with bulletproof vests and heavy-duty guns. The secondary coastal roads are also drug-smuggling roads, but I must not fit the profile of a drug runner, because I am waved through without so much as a question.

The road to El Mesquitál travels sixty-six kilometers, from Highway 180 to the coast. For the first half of that distance, I pass a succession of flat, cultivated fields, with an occasional farmhouse set back from the highway. One sign points the way to a Pentecostal church; another advertises cheese for sale. A gray dapple mare, tied to a tree on the side of the road, grazes in the high grass. About thirty kilometers down the road, everything changes. The cultivated fields give way to vast, sandy flats. Tall sand dunes rise at intervals, closing in on the highway from both sides. This road resembles the road leading to Boca Chica, on the other side of the border, except that the dunes are much bigger, and they cover most of the highway at some points.

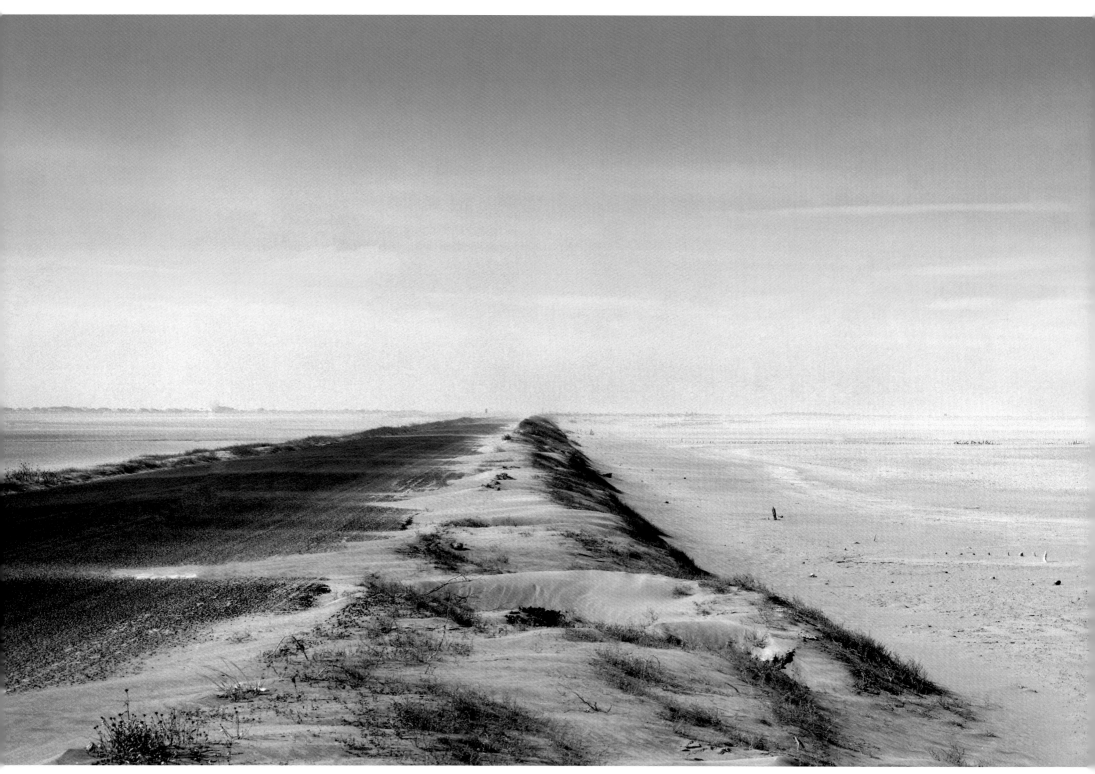

The road to El Mesquitál, Tamaulipas

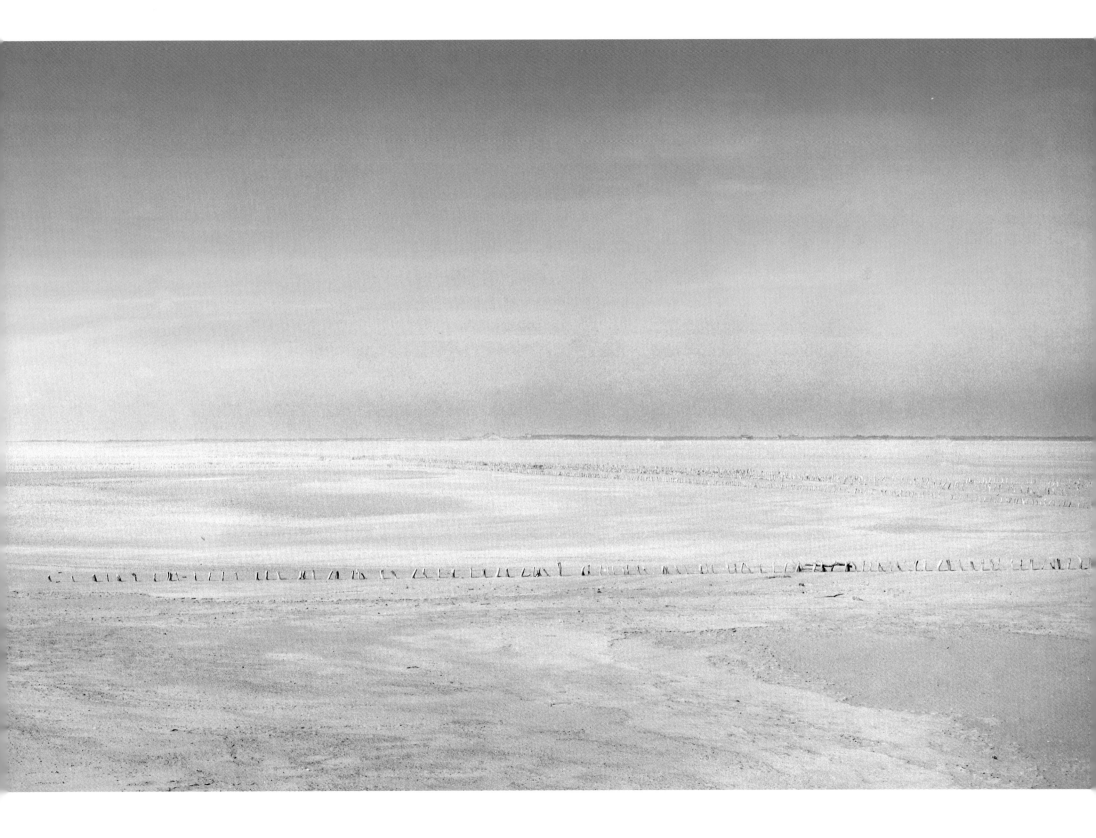

Passing through the tiny hamlet of La Salinera, I notice shallow lakebeds with small canals leading into them. There are vividly painted shanties along the road, and across one vast, low lakebed I can make out some sort of white pyramids, shimmering through the summer heat waves. At a tiny cemetery filled with brightly colored flowers and wooden crosses, I stop and get out for a closer look at the landscape. I am puzzled by the white pyramids and the lakebed itself, which shines like polished silver in the afternoon sunlight. At that moment, a man and a young boy appear. The man introduces himself as Amádo, the caretaker of the cemetery, and I ask him why the *laguna* looks like silver.

Amádo explains that what I thought was a shallow lake is in fact a *salinera*, where salt is collected. Channels are dug from the *laguna*, and they allow saltwater to flow into the *salinera*. The sun causes the water to evaporate, leaving a thick layer of salt. The salt is collected, piled into pyramids, and eventually trucked off to market. This particular *salinera* has been operating, Amádo tells me, for over fifty years. The silverlike surface I noticed on the lakebed is dry salt, ready to be collected. I ask Amádo how they collect the salt, and he bends over, making a shoveling motion. I wonder how long it would take to shovel all the salt from that lake bed, three or four hundred acres at least, and what grueling work it would be in the intense heat and humidity.

"*Sí. Muy difícil,*" Amádo says. "*Pero no hay otro trabajo. Es la vida aquí.*" Tough work, indeed. But there is no other work. That is the life around here.

The rest of the way to El Mesquitál, the landscape looks about the same: an endless expanse of drifting sand and shining *salineras*. As I approach the town, dozens of children in blue and white uniforms are walking along the side of the road, headed home from school. The town is a cluster of makeshift dwellings, constructed of recycled plywood, sheets of cardboard, or tarpaper tacked onto wood framing. Poverty was evident in the simple homes and makeshift businesses of Matamoros, but this is something else: extreme poverty, grinding poverty, like nothing I have seen anywhere in the United States. It's so hot the town dogs are not even barking as I pass through. They remain asleep under the fenders of old pickup trucks or in the shade of an occasional, scraggly mesquite tree. The only sign of life I can see, other than the students walking home from school, is one sway-back horse, sad and hungry looking, struggling toward me on the side of the road. I find it impossible not to compare El Mesquitál, the first coastal town south of the border, to South Padre Island, the last coastal community of the United States. South Padre struck me as glitzy, overdeveloped, and soulless, but El Mesquitál makes South Padre look like heaven on earth.

The road ends at two little restaurants on the Laguna Madre, both closed, and a few wooden shacks with fishing boats out front. I turn around and start back to Highway 180. On the edge of the town, over the last speed bump, or *tope*, as they call them in Mexico, I notice a man standing in front of a tiny home on left side of the road. As I drive past, the man is walking toward the road, waving to me. So I stop my truck, get out, and walk over to see what the fellow has to say.

La Salinera, Tamaulipas

"My name is Arturo," he says, with a broad, beaming smile across his face. "Wha you fron?" Arturo tells me that he lived in Houston for twenty-two years, and I ask him why he left.

"Oh, they always give me trouble there. I don't have papers, you know, and they always give me trouble. So I come here."

As we talk, I look around. His one-room house consists of a plywood frame covered in tarpaper. His sandy yard is littered with trash, including an old TV set, half buried in the sand. I try to imagine how one would adapt to living in El Mesquitál after twenty-two years in Houston.

"You like it here?" I ask.

"Oh yeah. I *like* it here. It's *quiet* here, and they leave me alone. You know, they don't give me no *problem* here. And sometimes the fishin' is *good*. Sometimes. You want some fish? I give you good price. We got good fillet right now, and we got some big shrimp, too. You want some?"

"No. Thanks, but I'm traveling. No way to keep the fish cold. You miss anything about Houston?"

"Oh yeah. Mostly I miss the pastries. They don't got no good pastry here."

"You miss the pastries in Houston?"

"Yeah. Mostly I miss the bear claws. And the eclairs. You know, *chocolate* eclairs. You like the eclairs?"

"I like eclairs."

"Me, too. But I miss the bear claws a lot too, and the Dunkin Donuts and all the pastries. They don't *got* any good donuts here. I don't know why. Out here we mostly eat the fish and shrimp. That's what we got. But we don't have the good pastries."

I promise to bring Arturo some pastries the next time I come to El Mesquitál.

"OK, I'm gonna be waitin for you," he says, still smiling, as I get back in my truck.

Arturo of El Mesquitál, Tamaulipas

• • •

Back on Highway 180, I'm driving south, looking for the next road to the coast. This is sorghum country. All along the highway, the bright, reddish-brown crop covers the countryside. Huge warehouses for the harvested grain sit back off the road. Made of a corrugated metal skin on steel framing, some of the *sorgo bodegas* are as large a giant airplane hangar. A hurricane that ripped through the area last August destroyed most of the *bodegas*, peeling the metal skin right off the steel frames. A few of the damaged buildings can still be seen, their corrugated skin ripped away. It appears that most of the big farms are privately owned. I pass Rancho Brasileño, Rancho Los Clemencias, and a dozen other impressive spreads. Others farms along the road are *ejidos*, or communal farms, created by the social revolution of 1910.

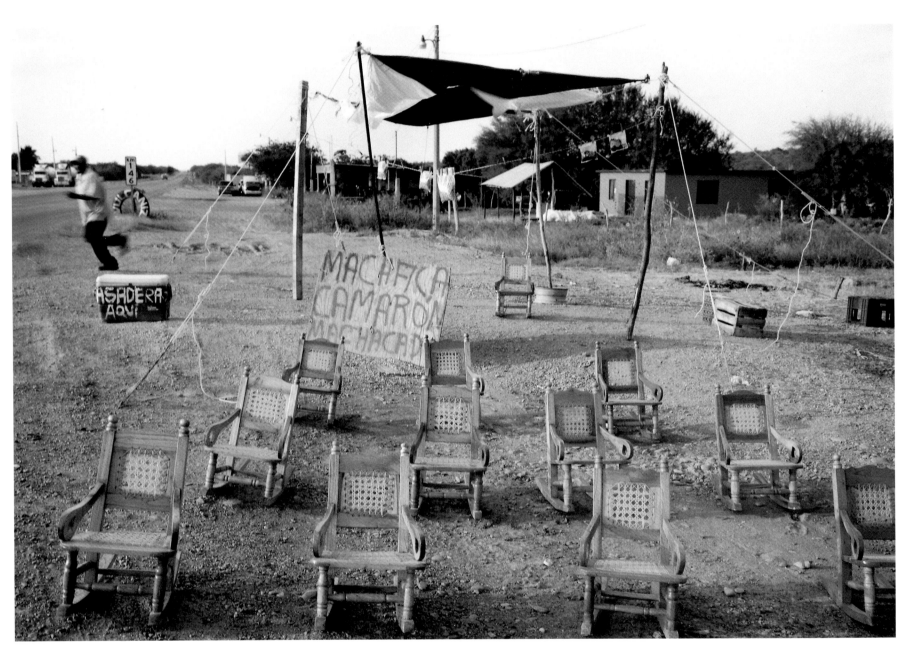

On Mexico Highway 180, near San Fernando, Tamaulipas

The landscape along this stretch of Highway 180 resembles that along Highway 77, as it passes through the South Texas Valley. But there are details along the road that would only be found in Mexico. Less than a hundred yards off the road, a tiny cemetery sits in the middle of a recently plowed field. I'm sure that must be the graveyard for the little *ranchito,* and they plow around the old wooden grave markers each time they turn the soil. An old gray horse stands alone and still on the side of a cornfield. White clouds rush through the blue sky overhead, their shadows moving across the cornfield and over the old horse. The very pulse of life can be felt in the air here. Colors seem more intense. Age, death, and beauty are everywhere.

Two years ago, as I was driving along this same highway, I decided to turn off onto a side road and drive to the coast. I'm not sure why I chose that particular road, except that my map showed a town and I liked the name, Guadalupe Victoria. The map placed the town at the end of the road, right on the banks of the Laguna Madre, but I never found Guadalupe Victoria. So far as I could tell, it doesn't exist. All I found at the location shown on the map were the remnants of a few abandoned shacks on a bluff overlooking the *laguna.* But I did find another town on the road that day. I never got the name of the place, but it was a fishing village on the Laguna Madre, north of where Guadalupe Victoria should have been. I met three fishermen by the beach in that town: two young men, Saul and Pedro, both in their early twenties, and an older man by the name of Baldesár. They invited me to go out fishing with them, and we spent the entire afternoon on the *laguna.* As they worked, Saul and Pedro, both unmarried, wanted to know what kind of jobs there were in Houston and what they paid. Baldesár, married with three children, had spent time in California but showed no interest in going back to the states. I was particularly struck by Baldesár's regal bearing, his quiet confidence, and his majestic good looks.

He was big, over six feet tall and weighing well over two hundred pounds. With beautiful bronze skin and jet black hair, I thought he could pass for a Hawaiian prince. Baldesár agreed to let me photograph him, and I did a close portrait, framing his head and shoulders against the sky. Later, at home, when I processed the film, I thought the picture was a stunning portrait, and I made large color print with the intention of giving it to Baldesár when I could return to the town.

I have the portrait of Baldesár with me now, packed in a box in the back of my truck, and I am looking forward to giving it to him as a gift. I find the same road toward the coast, south of the little town of Alfredo Bonfil, and thirty minutes later I've located Baldesár's *pueblito* again. On the way into the town, I have to drive around a small crowd that has gathered in the middle of the road, staring down into a gaping sinkhole. Two horses, tied to a tree right next to the sinkhole, are grazing in a cemetery of wooden crosses and faded paper flowers As I drive into town, a motley group of dogs trots along behind my truck, and children stare at me from their doorways.

The soil here is a combination of dirt and sand, a curious light gray color, almost white, and the water of the *laguna* is the same color. There are no trees—I'm guessing they were blown away by Hurricane Emily last year—and there's little vegetation of any kind. I pass four churches on the way into town: a small Catholic chapel and three big Pentecostal temples. The heat and humidity are intense, and few people are moving on the streets. I follow the main road, which eventually takes a sharp right turn toward the *laguna,* and ends between a cluster of little wooden houses and a concrete, fortlike structure, all on a bluff high above the lake. The bluff, doubtless created by erosion from decades of storms and hurricanes, hangs about fifty feet above the water.

There is no wall, no sign, and no warning of any kind. Had I arrived in the town at night, I could easily have driven right off the bluff and into the *laguna.* The big sinkhole is still in my mind, and can't help but wonder if

this entire side of town could crumble into the water without warning. The view from the bluff is strangely beautiful and totally unlike anything I have seen at any other point on the coast. I can see out for miles across the pale, shallow waters of the lake. A hundred yards out, people are walking in the lake, ankle deep in the water, probably searching for crabs. I step to the very edge of the bluff and look straight down. A number of small boats have been pulled up on the narrow beach, and pelicans are perched on them. Then I glance back at the town. It's a small place, but I estimate that there must be least two thousand inhabitants. I look again at my roadmap, but I find no indication of this town, either there or in my *Guia Roji.*

As I step away from my truck, a gust of wind blows across the bluff. Several white gulls, gliding on the wind, rise up from the *laguna,* pass a few feet in front of me, then drift toward the concrete structure. There, twenty or so men are sitting on the steps and hanging out the windows, shirtless, beer bottles in hand. The beat of Latin music pulses from inside the building, but the men have stopped socializing to stare at me, the stranger in town.

To my right, in the nearest house, a family of four sits on their porch. They, too, are watching me closely. I walk over to greet them and ask the name of this little town that doesn't appear on my maps.

A dark, handsome man in his mid-forties greets me. His name is Arturo Ortiz Murillo and the name of the town is El Barrancón del Tío Blas.

The Ravine of Uncle Blas. A strange but fitting name for the place. Arturo gestures to a chair, and I sit. We talk about his town and his family. Arturo has two brothers in Houston, both with good jobs, he says. His wife, Felicitas, supervises their two children, Arturo and Umberto, as they do their homework. Arturo says they have lived here for fourteen years. He and Felicitas came from Valle Hermosa after they married, because Felicitas wanted to live by the sea, and he liked to fish. It's easier than farming, he says, and it pays better. They have survived countless storms and three major hurricanes, which he recounts by name—Carolina, Gilberto, and Emily—as though they were celebrities who passed through town. Each storm, he tells me, takes at least a meter or two of land from the bluff. I wonder how much longer they plan to live here, since his house is no more than ten meters from the edge of the cliff. The last storm, Emily, was the worst. It came across the bar, Felicitas says, screaming like an animal. Most people had been persuaded to leave the town, but they had decided to stay. When she heard the storm coming, she grabbed the two children and they ran to take shelter in the concrete building. Arturo tried to drag his fishing boat up from the beach to save it, but he had to abandon it when the wind lifted him and threatened to blow him away. The storm tore apart every house in town. And when it was over, every boat was gone. Nothing was left standing except the concrete storm structure. And to make matters worse, there was no way to make money, because every fishing boat had been destroyed. They lived in the concrete structure for a month, along with many other families, as they slowly reconstructed their house and built a new fishing boat.

I ask Arturo why, with all these terrible storms, they choose to live here.

"The fishing is so good here," he says. "Better than any place else. And it's home now. This is our home. The kids love it." Then he made a grand, sweeping gesture toward the Laguna. *"Qué bonito, no?"*

Looking out from Arturo and Felicita's house, out across the milky colored water of the Laguna Madre, I *can* see a certain beauty in it all: the open expanse of sky and water, the birds, and the fresh sea breezes. But I can also see the trash piled on the beach below, and the hundreds of plastic bags and other debris scattered across the dry landscape, hanging in the scraggly bushes over the *laguna.* And I can see the steep drop-off to the beach, the end of the high bluff, which is creeping closer to Arturo and Felicita's house with each storm.

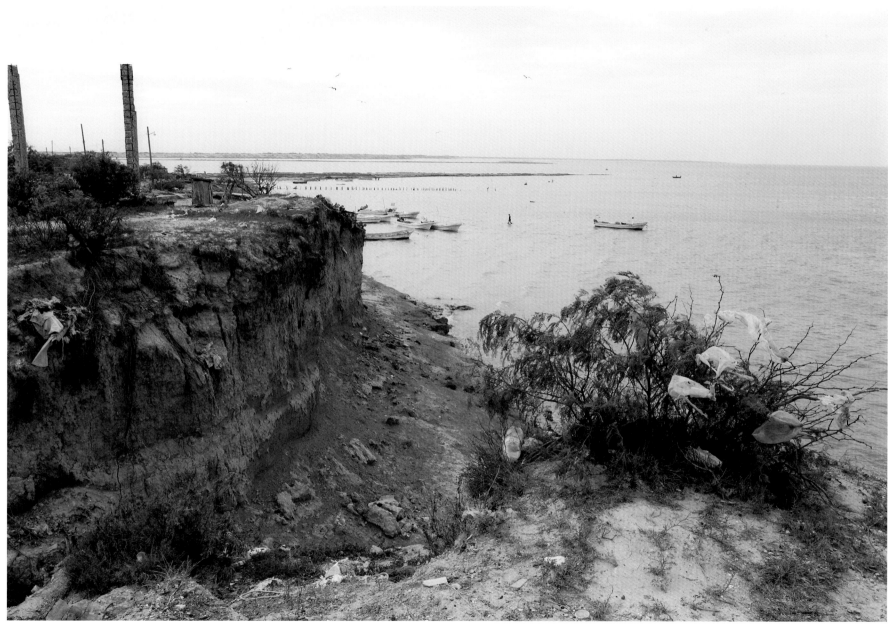

Laguna Madre at El Barrancón del Tío Blas

El Barrancón del Tío Blas

It's getting to be late in the afternoon, and I want to find Baldesár to give him the color portrait I had taken of him two years ago. By now, a couple of the drunks from the concrete shelter have wandered over to peer into my truck. One of these guys, a short fellow with a high pitched voice, wearing nothing but a ragged swim suit, watches as I open the truck, bring out the box with the portrait of Baldesár, and open it.

I recount to the fellow how I took the picture two years ago and am bringing the print as a gift. Bruno, as he calls himself, seems to recognize Baldesár and motions me to follow him. We walk down toward the beach, past several fishermen unloading their boats, and then up toward a row of simple wooden houses. Bruno points to one, a one-room house, made of plywood and painted bright yellow. I approach the door, a little reluctant to

knock, but not sure why. Surely Baldesár would remember me and would love the portrait of himself. I give a couple of sharp raps on the door, and a dog starts barking inside the house. The door opens and a lady holding a young child on her shoulder looks out at me.

"Esposa de Baldesár," Bruno whispers from behind me. This is Baldesár's wife. I ask the lady if Baldesár is home. I have a gift for him. The lady stares back at me, dumbfounded.

The lady does not appear to be in a welcoming mood, so I figure that if I just show her the beautiful print, she'll either call Baldesár or tell me where he is. As I open the box, I glance back at Bruno. He looks as though he has turned to stone, and he's staring straight at Baldesár's wife.

I turn the open box toward the woman so that she can see the print. Baldesár's regal face looks out at her in full color with a beaming smile. The wife makes a guttural noise, something between a cough, a groan, and a gasp. Without a word and without looking at me, she grabs the box with the print in it and closes the door. Confused, I turn to Bruno, who has walked away and joined a small crowd of men gathered on the beach. Among the men, I spot Saul, one of the two younger fellows who had gone out in the boat with us two years ago. I ask him what's going on, where is Baldesár? "I brought him a gift, a picture, but his wife took it without a word."

Saul looks at Bruno, and they exchange a few words, spoken too quickly for me to understand, then Saul motions for me to walk up the hill with him. Bruno comes along, walking on the other side of me.

"Baldesár is dead. He died last summer," Saul says.

"What happened? How did he die?" I ask. "Was it an accident?"

"Yes. Sort of. Yes." Saul and Bruno exchange glances. Something strange, something unmentionable, happened to Baldesár. I'm sure of that. They are undecided how much to tell me. After all, they don't really know who I am or why I'm here. My first guess is that Baldesár got involved in illegal drug trafficking, and it turned out badly.

"One night last summer, Baldesár gave himself an injection," Saul says, still walking, looking down at the ground as he speaks, "and it killed him."

"An injection of what?" I ask. An overdose of heroin or amphetamine, I'm thinking.

"I'm not sure the name, but it's what they give the bulls when they want them to—you know—to breed. He injected himself too much of it and it killed him. That's why his wife won't come out of the house or talk to you."

• • •

I've taken a room in the Rancho Viejo, a small hotel on highway 180, north of San Fernando, but I'm having difficulty sleeping. All I can think of is Baldesár's death. I assume that he was not with his wife on the night he died, but I can't decide whether it's more likely—after injecting himself with a bovine aphrodisiac—that he died in fits of passion or in horrific pain. Nor can I decide whether my portrait of him brought any solace to anyone, or simply reopened old wounds. Either way, his death must have provided all the lurid gossip that the good people of El Barrancón del Tío Blas could handle.

The next morning I'm out early, cruising the streets of San Fernando, the first city down the coast from Matamoros. I'm looking for breakfast. There are taco stands on every other corner, and the *gorditas* look pretty tempting. But I have *huevos rancheros* on my mind, so I need a regular restaurant. I find Restaurante Las Palmas right smack in the middle of San Fernando, at the intersection of Calle San Lorenzo, where you turn to drive out to the coast. I've already made the turn when I look back and see the telltale sign of a good restaurant: the parking lot is jammed with pickup trucks. Big ones. New, shiny Ford Lobos and muscular Dodge Rams.

Inside, Las Palmas has a single dining room, a comfortable size, about twenty by forty feet, with a kitchen off to the right side. I can see the cooks at work over a wood-burning stove, and the smell of fresh corn tortillas leaves no doubt that this is the place I'm looking for. There are half a dozen small tables spread about the center of the dining room, and one very long table, placed along the end of the room to my left as I enter. The long table is filled with *caballeros* having coffee. I count fourteen at the long table, eleven men and three youngsters. Right away, I have a sense that I know this crowd. Not the individuals, but the fraternity, for I have seen its chapters in small towns and cities across my own country. I have seen them since I was a child, when my father would take me with him for coffee in the com-

pany of men at the café in the New Southern Hotel in Jackson, Tennessee. This is the fraternity of Important Men Having Coffee, the San Fernando, Tamaulipas chapter. The *caballeros* at the main table here in Las Palmas are big men, ranchers, men of substance and responsibility. They wear wide-brimmed, white *sombreros* and white or light blue shirts with pearl snaps, and they are conferring on important matters, as men do, over coffee and eggs, without the women.

I take a seat at one of the small tables, place my order, and then settle in for a good look at this fine piece of Mexican culture that I have stumbled upon. A shoeshine man is making the rounds. He works so silently and unobtrusively, polishing boots from one end of the big table to the other, that I could have missed him. The *caballeros* all have the newest cell phones hanging in holsterlike cases from their belts. A couple of them are talking on their phones while, right beside them, their sons are bent over, absorbed in the electronic combat of video games. I try to blend, to be unnoticed as I observe, but either my bright blue Life Is Good cap or my notepad and road map call attention to me.

One of the *caballeros* toward the center of the table raises his hand, as though invoking the gods, and offers me the grand bon appétit of Mexico: *"Provecho, mi amigo, provecho."* I thank the man and wish him the same. That opens the conversation. They all want to know where I'm from, where I'm headed, and—most of all—if there is anything that I need. Several men speak perfect, unaccented English. One offers to trade his *sombrero* for my cap. I agree, but he backs out on the deal, provoking a lot of noisy jests from his fellow *caballeros*. Once they've heard what I'm doing, they agree that on no account should I fail to see La Pesca, the best town on the north Mexico coast. Skip the others, they say. If you've seen El Mesquitál and El Barrancón, then you've seen them all, except for La Pesca. There's great fishing at La Pesca, they tell me, in the Gulf, in the nearby lakes, and in the river. Then, in a couple of minutes, all the *caballeros* have bid me *"Adiós, vaya bien"* and they are gone, off to work in their big pickup trucks. The fraternity meeting at Las Palmas stands adjourned at nine o'clock sharp, and I am back on the road.

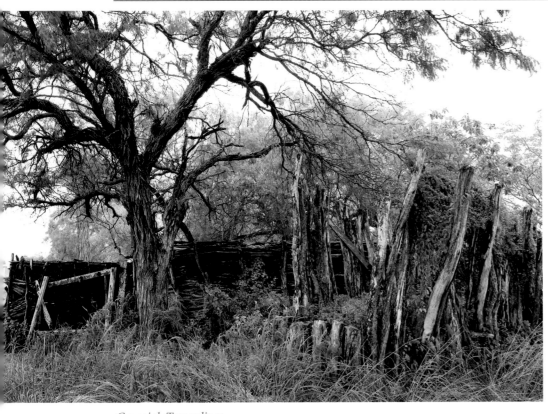

Carvajal, Tamaulipas

• • •

Notwithstanding the advice of my *caballero* friends, I decide that I should drive the sixty kilometers to see Carbonera, the coastal village east of San Fernando. One problem I have found in over forty years of photography is that no one can really tell you where you are more likely to find good subjects, and therefore, good pictures. In fact, if someone tells me a certain place is beautiful and full of good picture possibilities, I tend to avoid that place. If there is one thing that every good photographer is looking for it's surprise. It's more difficult, I find, to make surprising pictures

of "picturesque" subjects than it is of—for lack of a better word—*ordinary* things, everyday things. So I am off to Carbonera, which sounds like a very ordinary place.

After about an hour of driving through flat, coastal plains, I arrive at the coast. The highway ends in front of a little lighthouse, where a pot-holed, blacktop road veers off to the north, running along the beach. A line of wooden shacks parallels the road on my left, and fishing boats sit out on the beach to my right. After driving a mile or so, with an increasing smell of rotten fish in the air, amid even more grinding poverty than I saw in El Mesquitál or El Barrancón—and no sense of a town, really—I am ready to concede that the *caballeros* at the restaurant had it right. I should have skipped this sad place. It's poor, it's dirty, and it stinks.

Back at the little lighthouse, however, I notice that there's another road that heads south, and my *Guía Roji* shows the tiny town of Carvajal a few miles down that road. The homes and the landscape along the road to Carvajal look a great deal better than those on the road to Carbonera. The houses are more substantial and better kept; the grass is greener and there's more of it. The road leads along a particularly pretty stretch of the Laguna Madre, with white sand beaches and turquoise water.

On the way back to the lighthouse, I pass a scene that brings me to a screeching stop. Off to the left side of the road, a man is pushing a power lawn mower across a big, dusty, vacant lot. There is very little grass growing on the lot, but there is trash everywhere, particularly the lightweight plastic bags that seem to comprise so much of Mexico's trash. The guy appears to be mowing his trash. I stop my truck, grab a camera, and begin shooting pictures. After I've shot a few frames, the man shuts off his lawn mower and walks over to me. I decide to explain, on my terms, before he asks why I'm photographing. I explain that I'm traveling the coast, photographing the landscape along the way. The fellow wipes his brow, eyeing me with suspicion. I notice that the brown cap he's wearing has a red flame embroidered on the front of it.

"I could use a Coke," he says. "Why don't you go over to that store and get us both a Coke?"

I cross the street and buy two large Coca Colas. By the time I return, the man with the lawn mower has been joined by another fellow, a young

Rev. Juan Garcia, Carvajal, Tamaulipas

American wearing an identical brown cap with the same red flame on it. Both men seem to be studying me with a mixture of curiosity and concern. I'm hoping they're not getting ready to complain about my photographing without permission.

"Where are you from, my son?" asks the older man.

"Houston, Texas," I reply, wondering what the "my son" thing is about.

He asks if I am traveling alone, and I reply that I am.

"You know, you don't have to travel alone. Your home can be here. You will have a family and the Lord will provide for you here."

For the first time I notice the sign in front of the house next to the vacant lot. "Iglesia la Luz del Mundo. Juan Garcia, Pastor." The sign has the same red flame painted on it.

"Are you Juan Garcia, the pastor?" I ask.

The young man answers for the pastor, unfolding a color brochure as he speaks. "He is the pastor, and this is our church, Iglesia la Luz del Mundo. We are ministering all over the world today, in thirty-eight countries. Here is a picture of our central church in Guadalajara. Look at this. It's eighty meters high. It holds over five *hundred* people. We have fifty churches in Puebla, ninety in Veracruz, forty here in Tamaulipas. And we have more every year. You are welcome here."

The pastor is sipping his Coke, sweating, and eyeing me with either grave concern or suspicion. I can't tell which. Then he asks, "Do you have a church, my son?"

I reply that I was brought up in the Methodist Church.

The pastor finishes his Coke and tosses the empty plastic bottle over his shoulder onto the dusty lot. The young man has opened a small book, which turns out to be a hymnal. "Why don't you stay for our service tonight at seven?" he asks me. "We sing hymns in both languages. If you know the music of the Methodist Church, then you will recognize many of our hymns."

I decline, telling them I need to be on my way, that I am due in La Pesca this afternoon. I promise to return with some pictures one day soon. As I drive away, it occurs to me that twice in the last two days I have promised someone that I will return. One will be waiting for me to return with pastries, and the other will be waiting for my soul.

• • •

South of San Fernando the landscape along highway 180 changes dramatically. I have driven a hundred and fifty miles south from the border, all through flat, coastal plain. Now I am entering rugged hill country, where steep ridges and sharp ravines alternate with rolling pastureland and cattle graze among mesquite and cactus. Mountains rise in the distance. To the northwest, far beyond the rolling hills, the peaks of the Sierra Oriental mountain range come into view. To the east, steep hills block my view of the coastline. Tall, spiky yuccas grow on both sides of the road. Where the highway passes through the community of La Union, dozens of simple wooden stands line the roadway, and vendors sell dried shrimp, *nopales,* and *tacos.*

Highways 180 and 101 have been one and the same road up to this point. Now, twenty miles south of San Fernando, the two roads split. Highway 101 bears to the right and heads inland toward Ciudad Victoria, while 180 bears left, still on a course parallel to the coast, bound for the town of Soto

la Marina. The landscape along the highway turns more lush and green with every mile. North of Soto la Marina, I take a left, following the sign to La Pesca. The first stretch of the road weaves through a low valley, mostly rangeland with a few sorghum fields. Then the highway climbs steeply through a narrow mountain range, topping out at the tiny community of Vista Hermosa. There I get a long, beautiful view of the lowlands, the *laguna,* and the coastline below. A sharp descent follows, and I'm crossing marshlands in the approach to La Pesca. Finally, I can see the mighty Río Soto la Marina, half a mile south of the highway. At this point, a few miles from its mouth on the Gulf, the river must be at least three hundred yards wide. It's southern bank, too distant to make out in detail, appears to be covered in dense jungle leading up into the mountains I have just crossed. To the north of the road, the Laguna Almagre extends for perhaps ten miles toward the sea. On its still waters, shimmering in the afternoon sun, I can see a few little fishing boats working the shoreline. It's no wonder La Pesca is known as a fisherman's paradise.

Along the last few kilometers into town, I pass the manicured grounds of a number of new hotels and resorts—the Villa la Pesca, the Palma Real Inn, the Hotel la Marina del Río—intermixed with fancy *quintas,* country homes right on the river, probably owned by wealthy families from Monterrey or other inland cities. The town is disappointing, to say the least. The main street is wide, but only about eight blocks long, as dusty and trash-strewn as all the other coastal towns I've seen. There are taco stands, as always, on every other block. Most of the buildings facing the street are low, concrete structures in the quintessential unfinished Mexican style, with rebar sticking out of the roof. There are a few *mariscos* markets, half a dozen not-too-promising restaurants, a *farmacia,* and a couple of shops selling swimsuits, bait, and tackle. There is virtually no activity in the street. No cars, no pedestrians, no one entering or leaving the shops or restaurants, but there are men sitting in the shade, in groups of three or four, waiting, I suppose, for something to happen.

Nothing tempts me to stop, so I drive straight through the town of La Pesca and out to have a look at the Gulf. The road ends at a rock jetty. There's a white lighthouse at the mouth of the river, and a long, well-groomed beach, but the place is totally deserted today. Even the jetty is empty. There's not a single fisherman in sight as I walk along the rocks, looking first out to sea and then back up the river. Seabirds are fishing in the shallow, powerful flow of water at the mouth of the river. Looking for some sort of human activity and finding none, I start back into town. Along the way, I cross a bridge over a wide canal coming off the river. Both sides of the canal are lined with docks and fishing gear, and I can see people unloading boats. A dirt road leads from the highway down to the canal.

La Pesca, Tamaulipas

Monument, Colonia Miguel de la Madrid Hurtado, La Pesca, Tamaulipas

A sign at the start of the dirt road identifies the canal community as the Colonia Miguel de la Madrid Hurtado. I park by the sign, put a camera over my shoulder, and start walking. The first thing I notice is a monument, a huge, larger-than-life bust—in concrete, best as I can tell—a monument, presumably, to some notable La Pescan politician. There is no name or other information on the monument, which has been seriously damaged by either gunshots or other projectiles. Cracks in the concrete surface of the face reveal a mushy white foam underneath the politician's head. The damage to the surface does little, however, to distract from the politician's facial expression, which manages to suggest—somehow, all at once—arrogance, confusion, inebriation, idiocy, and power. I contemplate this curious monument for several minutes, then, unable to decide if it is a masterpiece or a folly, I continue down the dirt road along the canal, past a succession of shaky wooden ramps and precarious docks. It's late afternoon by now, and fishing boats rest on the banks of the canal. I notice a girl, perhaps ten years old, fishing from a makeshift jetty made of old tires and shell gravel. With both hands, she holds a 7 Up bottle coiled with string. The plastic bottle is her reel, and the string extends into the cloudy water of the canal, where her attention is focused. The girl turns to look at me as I pass, then she looks toward a little house beside the tire she's standing on, then back at me again.

As I pass that house, a Mexican woman steps out and greets me with a smile and an invitation. Her father wants to talk with me. She ushers me through the little house—a sort of boathouse, with nets and floats and other gear hanging all about on the walls—onto a porch over the canal. The girl I saw fishing from the banks is sitting a few yards to my left now, and an elderly man rests on a wooden bench to my right, along with three little kids. The man whispers something to the three children, and they approach me, one by one, with their heads bowed and their hands extended. I shake their hands, they mumble something that I can't understand, and then they're gone, whisked away by the woman who greeted me. I am left alone with the old man on the porch, and he motions for me to sit down beside him. We talk for a good while, and he seems particularly interested in exactly where I'm from, whether I'm married and how many children I have. He wants to know what kind of work I do. His name is Feliciano, and that was his daughter who invited me in. All the kids, including the girl fishing, are his *nietos y nietas,* his grandchildren. I ask Feliciano where he was born and how he came to La Pesca.

"Soy de Michoacán," he tells me. He came to La Pesca because in those days the fishing here was so good. "Chingos *de pescado, y ostiones* gordos," he says, his voice rising in emphasis. But, there are not so many fish now, and the oysters aren't so fat. It's hard to feed your family, no matter how many hours you work every day. That's why the children's father left for the United States, six years ago, to look for work. They haven't heard from him in over four years now. They assume he is dead, but, *"quién sabe?"* who knows? All the time we're talking, I'm watching the girl as she fishes. Feliciano tells me that her name is Erica, and she's twelve years old, a wonderful child. Always minds. Works hard. It occurs to me that she has left that line in the water for quite some time without pulling it in or recasting, as though her mind is not on fishing.

Feliciano asks me to step inside the little house, where he offers me a chair. He sits down, puts both hands behind his head, and stretches himself out straight in the chair. I'm beginning to think that he's looking kind of nervous, when he asks the question: would I be willing to take Erica back to the United States to live with me and my family?

"Cómo?" I ask. Surely I didn't understand the question correctly.

But Feliciano continues. This is not an easy thing to ask, he explains, because we love her very much, but this would be best for her. She could have a *good* life there. And she could help you in many ways. She could wash your clothes and clean your house. She can already do that and she's only twelve years old. Think of how much she can help you as she gets older.

The old man sat in the chair with his arms behind his head, with his feet stuck out straight in front of him, rocking back and forth as he talked, without looking at me, and I for a moment I thought he would begin to cry.

"Señor," I said, "I couldn't possibly take the girl. I couldn't cross the border with her. It's against the law, and they are watching the border very carefully now. Besides, I already have children, five children, and that's a lot of kids."

Now Feliciano stops rocking. He sits up straight in the chair, looking me in the eye as he speaks. "You do not know how many ways she could help you. Please, señor, please consider what I ask. When she is a little older, then you could decide whether to keep her with you or let her go out on her own. Her mother and I both ask you to do this, for the child's good. *Please.*"

Again I decline, but for a moment the father in me takes over and I try, as best I can, to consider whether it might be possible to do what this man asks of me, to take his granddaughter and give her a home in the United States. Now I can understand the look in *her* eyes. As she had watched me approach her home, she must have suspected what was going to happen, the request that her grandfather would make of me. This has probably happened before, perhaps many times, and likely she was sizing me up, even before I knew what would be asked of me.

I don't want to see the girl as I leave, so after I say goodbye to Feliciano, I walk straight to my truck without looking back, past the foolish, absurd-looking monument to the Mexican politician with the cracks and the holes in his head. I get in my truck and drive right through La Pesca, back to Highway 180. I am trying to think ahead, to anticipate the pleasures of the big city of Tampico. But I can't stop thinking about little Erica. I had gone looking for some human interaction in La Pesca, and I had gotten more than I could bear to think about.

Girl fishing, Colonia Miguel de la Madrid Hurtado, La Pesca, Tamaulipas

On Mexico Highway 180, south of San Fernando, Tamaulipas

Tropic of Cancer monument, Mexico Highway 180

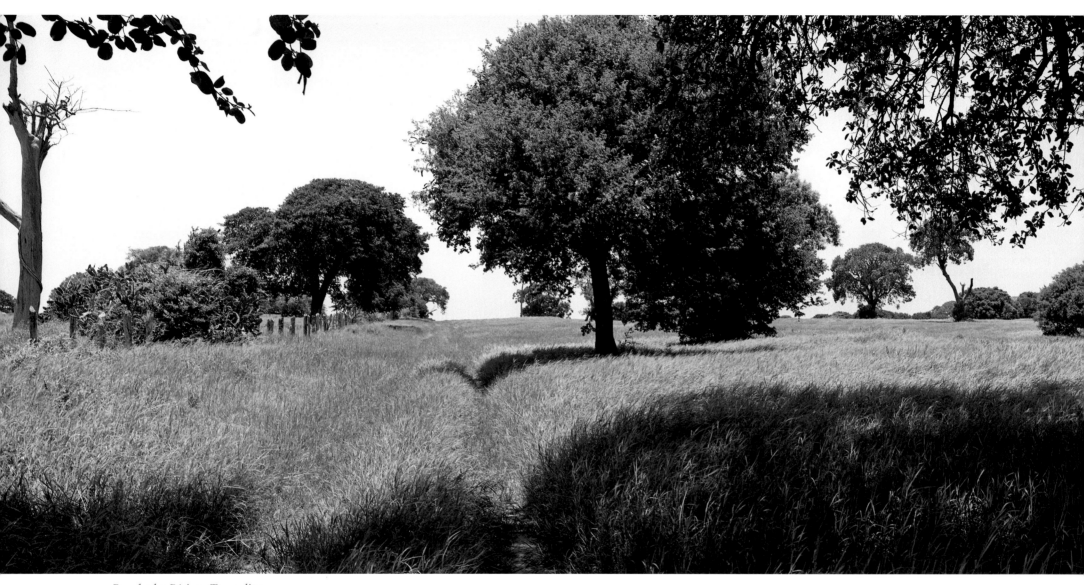

Rancho los Péricos, Tamaulipas

• • •

As it enters Tampico from the north, 180 passes through an industrial sector and grows into a divided, four-lane highway. Then there are six lanes, eight, and finally ten. A commercial landscape rises on both sides of the road, and I'm swept along, or so it seems, by a river of traffic feeding into the city. Towering palm trees line the center esplanade, as the road rises and falls, curves right then left, and finally winds its way into what looks like, well . . . southern California. This could be San Diego. The place looks sparkling clean, prosperous, and sunny. Actually it's more than sunny; it's blazing *hot*.

Bennigans, Dominos Pizza, Kentucky Fried Chicken, and Burger King join their Mexican relatives Sanborn's, Oxxo, and Pollo Felix along the roadside, and I cannot resist. After a week of mostly beans, rice, eggs, and tortillas, I want a *cheeseburger*. Nothing else will do. And it doesn't have to be some fancy gourmet burger, just give me a Whopper with cheese.

Inside the Burger King, I could be anywhere in the United States of America, except that the signs are all in Spanish. One hardly needs to be able to read, though, to be tempted. A brilliant, full-color poster over the counter shows today's special in all its juicy glory: "El Nuevo Texas Super Doble Whopper." Clearly, the "supersize" concept has arrived in Mexico, and judging from the bounteous burger on the poster—laden with three meat patties, triple cheese, and accompanied by a "Grandísimo Orden de Papas Fritas"—an epidemic of obesity will surely follow.

I sit down, feeling virtuous in my choice of a simple original Whopper with cheese, and my mind turns to the history of this region. I have with me my favorite book on the early history of the Gulf of Mexico, Robert Weddle's *Spanish Sea*, so I read as I eat, immersing myself, as I have many times before, in the chapters that deal with the exploration of the north and central Mexican coasts and with the earliest settlements along the Río Pánuco.

In the summer of 1519, the Spanish conquistador Hernán Cortés had established his camp and gathered his forces roughly two hundred miles south of Tampico, in what is today the state of Veracruz. Cortés was preparing for a march of conquest on the Aztec Empire in the central valley of Mexico. Montezuma, the Aztec ruler, had been warned of Cortés's arrival on the coast. Indian sentries had seen the Spaniards arrive in their "floating castles," and the news had been sent by runners to Montezuma in the Aztec capital of Tenochtitlán. When runners reported to the ruler that the chief of the intruders was fair-skinned and bearded, Montezuma's fears were confirmed; the ancient god Quetzalquatl had returned to claim his domain. The return had been predicted by legend for generations and confirmed by recent omens. Cortés had, in fact, no clear authority from the Spanish Crown to conquer and settle this New World. He had sailed from Cuba in February of that year, landed on the island we call Cozumel, then rounded the Yucatán and worked his way up the Gulf coast of Mexico. He had come ashore and established the first European settlement in the New World at Villa Rica, north of today's Veracruz city. Now he was determined to conquer the entire land in the name of Spain. Tens of thousands of Totonac warriors had joined forces with Cortés, and the march on the Aztec capital was eminent.

Totally unknown to Cortés, an expedition of four Spanish vessels under the command to Alonso Álvarez Pineda, had been sent by Francisco Garay, the governor of Jamaica, to reconnoiter and map the vast expanse of coastline between today's Florida and the northern limits of Spanish exploration on the Mexican Gulf Coast at that date. Pineda and his men, working their way west from the Florida peninsula, became the first Europeans to see the Mississippi River, the entire coast of Texas, the Rio Grande, and the coast of northern Mexico. Pineda would report that he found "very good land" suitable for settlement, rivers that yielded "fine gold," and affectionate native people waiting to be converted to the Catholic faith. He had encountered "giants," he said, men over seven feet tall, and others who were "dwarfs." Beyond his instructions to reconnoiter and map the coastline, Pineda had been told to search between Ponce de Leon's discoveries and the limits of Spanish exploration of the central coast of Mexico for the strait—thought surely to exist—that would connect the Gulf of Mexico with the "South Sea," the Pacific Ocean, recently discovered by Balboa. In his search for that strait, Pineda ventured far down the Mexican coast. He anchored briefly in the mouth of a great river—the Río Pánuco, we now know—and was given a friendly reception by the natives. His men observed populous villages of straw huts on the shores of the Pánuco at the precise location of today's Tampico. Then they pulled anchor and ventured farther south along the coast, still looking for the strait to the Pacific. Pineda's little fleet finally encountered Cortés's forces near Villa Rica. Cortés, the supreme conqueror, ever suspicious and on his guard, would permit no intruder on his domain, whatever their true intentions might be.

Pineda, wisely cautious of Cortés, kept his ship at anchor, but several of his men went ashore and were promptly captured by Cortés. Under questioning, the men revealed that Pineda had anchored in a river mouth north of there and had been given a friendly reception. That was more than Cortés could tolerate. Most likely, he was thinking beyond his ultimate conquest of the Aztec capital and wanted no restrictions on the northerly reaches of his future empire. Six of Pineda's men were taken by Cortés, and the fleet departed in haste, returning to the Río Pánuco. This time Pineda sailed up the river six leagues (about twenty miles), observing Indian villages all along the way. After remaining on the river forty days, careening his ships, Pineda returned to Jamaica to make his report to Governor Garay.

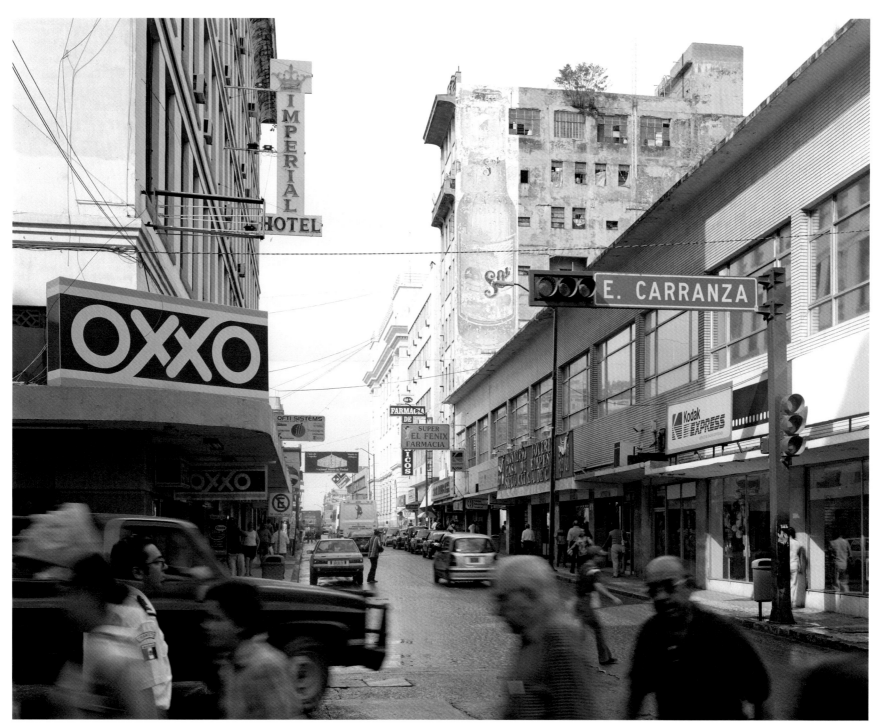

Colonia Centro Histórico, Tampico

Pineda had made significant discoveries. He had proved that Florida was not an island, as previously believed. He had found the continent's greatest river. But even more important, he had proven that the entire coast was a contiguous mainland. As part of his report, Pineda submitted a map, a sketch really, of the Gulf as he had seen it. The "Pineda map" is the earliest known map of the Gulf of Mexico, and it depicts with surprising accuracy of proportion the coastline all the way from the Florida peninsula to today's Cabo Rojo, roughly fifty miles south of the Río Pánuco. The royal officials in Spain, learning of the successes of Pineda's expedition, were so pleased that they favored Garay's plan of sending a colonizing expedition to the coastal territory around the Río Pánuco. Garay declared that the land recently discovered by Pineda "is called the province of Amichel, and is so named." In 1520, as Cortés was overthrowing the Aztec capital of Tenochtitlan, Garay was granted the title of *adelantado* and given the authority to settle Amichel.

Garay did not waste time. By the time the royal *cédula* had been issued, granting Garay the authority to settle, he had already sent Pineda back to the Río Pánuco with a heavily armed expedition. He also assembled another expedition, under the command of Diego Camargo, to find Pineda's settlement on the Pánuco and lend support. Shortly after Camargo arrived, for reasons unknown, the previously friendly Huasteca Indians became hostile and turned against the Spaniards in a fury. Pineda and all his men died in the Indian attacks. Most of Carmago's men and all his horses were killed. Carmago himself, badly wounded, escaped the Pánuco along with sixty of his men, but died within days. The rest of the men sailed south, their vessels damaged and leaking badly. Eventually, the ships sank or were beached and the survivors joined Cortés's forces at Villa Rica. Garay, in Jamaica, had no news of the disaster. At intervals, he sent a series of expeditions carrying provisions and armaments for the settlement. Each expedition, in the end, landed in the hands of Cortés, reinforcing the conqueror, who was rapidly expanding his domain of conquest north toward the Pánuco.

The Pineda and Camargo expeditions, including their encounters with Cortés, form the first chapter in the early history of the Río Pánuco. With that chapter—plus the Whopper and fries—under my belt, I'm ready to see the Río Pánuco and Tampico, the heart of Garay's Amichel, as they are today.

Avenida Hidalgo takes me south toward the *centro histórico* and the river. Once I have driven out of the fancy new commercial district on the north side of town, Avenida Hidalgo is lined with a mixture of old and new, residential and commercial buildings. The lanes are narrow, and the traffic is swift and unnerving, with buses jockeying for position, jumping from lane to lane. Hidalgo ends at the northeastern corner of the *centro histórico*, and I bear left onto Calle V. Carranza, headed downhill toward the river. There, the streets and the architecture of old Tampico bear a striking resemblance to Havana. Ornate old balconies hang over the sidewalks. The streets are jammed with people. Traffic moves slowly but steadily, with the help of tenacious policemen at every corner. As I wait for a traffic light to turn, something on the top floor of an old commercial building ahead catches my eye: a tree growing out of a window, a hundred feet above the city streets. A right turn takes me into the central market. I find it difficult to keep my eye on the road and keep moving, as I pass block after block of open stalls. There are fresh crabs tied in bundles, fruit stands with stacks of beautiful mangoes, giant avocadoes, and used hardware. A left turn takes me along a dingy block where prostitutes sit, half in, half out of each doorway, their legs crossed, staring straight ahead.

A left and then a right turn puts me on Altamira. I'm headed downhill, so I figure this will take me to the river, the historic Río Pánuco. Now I'm in a neighborhood of industrial parts stores and heavy-duty nightclubs. Painted women stand alone on the street corners. I pass over railroad tracks and enter the Colonia Elita Perez. This must be the oldest part of town. It could not be much more dilapidated, more forlorn, or more beautiful.

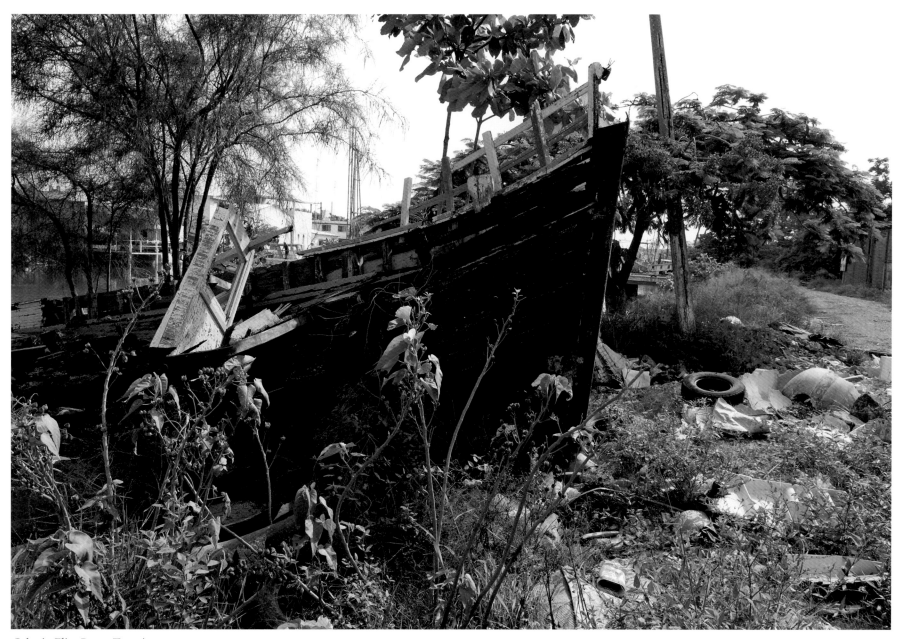

Colonia Elita Perez, Tampico

Colonia Elita Perez, Tampico

A canal leading off the Pánuco, a few hundred yards to the east, parallels the street I'm on. The street has no pavement to speak of, only a scattering of rocks over packed dirt. It must have rained earlier in the day, since large, shallow pools of water stand in the road. The canal is lined with old magnolia trees. Straight ahead, next to the charred hull of an old shrimp boat, a jacaranda stands in full bloom, its bright orange blossoms hang wet and heavy. Crumbling, abandoned warehouses are everywhere. Discarded sofas and mattresses lay about. On an old brick wall by the canal someone has sprayed "Jesus te ama." Two ornate concrete benches, looking at least a hundred years old, sit beneath an ancient magnolia tree. This was once a pretty place, I'm sure. Today, the only people around, other than this wandering photographer, who's pulling out his big camera, are a few fishermen. They are drifting in the canal, two to a boat, checking their crab traps. One boat drifts near the bank of the canal; I walk over to have a closer look.

Enrique Moreno and his son, perhaps ten years old, also named Enrique, have come to the side of the canal to pick up more fish heads from their bait bucket. I ask them if I can take some photographs as they go about the task, and the father consents. He asks the same questions I always get: Where you from? Do you have a family? Are you on vacation? Are you alone? That seems to be the hardest thing for anyone to understand, that I would be traveling alone. They never probe or express more than a polite amount of curiosity, but it's in the tone of voice. *"Eres SOLO?"* Enrique, the father, carefully baits each of his traps with a fresh fish head and asks me about work in the states. Isn't there a lot of work there? And the money is good, right? *"Es duro también allá?"* Yes, I answer, work is hard there, too. Work is hard everywhere. *"Pero, allá, todos son iguales, verdad?"* I pause before I answer that one: Everyone is equal there? For a second, I think of all the grief and controversy over illegal immigrants now in the states, how some of it must be in the news in Mexico, and I wonder if he could be asking the question with a little twist of sarcasm. Then I think of all the progress in civil rights during my lifetime.

"Sí. Todos son iguales, allá," I reply, wondering exactly what he makes of that concept. *"Cuánto vale los jaibas?"* I ask, shifting the conversation back to life in Tampico. Enrique tells me that the big crabs bring fifty pesos per dozen. And he can get thirty or thirty-five pesos for a dozen of the smaller

ones. He sells them to restaurants in Ciudad Madero, the big, working-class city adjacent to Tampico on its north side. Looking at the murky waters of the canals, I resolve not to eat in Ciudad Madero. Not seafood, anyway. As I leave, Enrique invites me to come back and photograph again. He's here every day, he tells me. He comes at five in the morning and fishes until dawn. After breakfast he comes back at ten and fishes until he fills his buckets. Then he goes to Ciudad Madero to sell his day's catch. Come anytime, he says, *"Le esperamos."* We'll be waiting for you.

Snug in my hotel bed that night, I pull out *Spanish Sea* again. The next chapter in the history of the Río Pánuco and the Tampico region takes the reader back to Jamaica. It's June of 1523, and Governor Francisco de Garay is sailing with a huge armada of vessels—eleven ships in all, carrying 600 men, 150 horsemen, plus artillery—all under the command of Juan de Grijalva, the very man who had first discovered the coast of New Spain in 1518, a year before Cortés sailed. Garay, holding a royal *cédula* from the Spanish court authorizing him to colonize the region around the mouth of the Río Pánuco, will tolerate no further interference from Hernan Cortés. Word had come to Garay that Cortés, having conquered the Aztec empire two years earlier, had pushed the boundaries of his domain north, all the way to the Río Pánuco, where he had established his own settlement, Santisteban del Puerto, a few miles inland from the coast.

Garay now had the royal authority to settle there, and Cortés was exceeding his legal rights. As Garay sailed, he reveled in the name he had chosen for the place: Victoria Garayana. His first mistake was misjudgment of the winds and currents of the Gulf, which caused his fleet to land about ninety miles north of the Río Pánuco, at the river known today as the Soto la Marina. (The same river that I had seen a few days ago at La Pesca.) So beautiful was the land along the river that Garay decided initially to settle there. In the end, though, he let himself be overruled by his officers, who were determined to settle, as they had been promised, on the Río Pánuco. That would prove to be a deadly mistake.

Garay decided to take the horses ashore, where he and a number of his men would make an overland march to the Pánuco. Grijalva would take the ships down the coast, and the two contingents would meet on the Pánuco. The overland march was a nightmarish push through marshlands and bogs,

a time of severe hunger and hardship. One of his men would later write: "We have come to the land of misery where there is no order whatsoever but everlasting toil and all the calamities that treat us so cruelly: hunger, the heat, malignant mosquitoes, foul bedbugs, vicious bats, arrows, vines that encircle, mudholes and swamps that swallow us." Eight horses were swept away in a surging river. The men slogged away, seemingly forever, through a nightmare of tidal sloughs and swarms of mosquitoes. These were the first Europeans to cross the mainland of the northern Gulf Coast of Mexico, and the experience was horrific. If any good came of that march through the marshes, wetlands, and woods, it was the observation of a number of New World creatures never before encountered. One was described as "a quadruped a little larger than a cat, with the face of a wolf, silver colored, scaly. . . . A sluggish creature, it folded itself up like a hedgehog or a tortoise upon seeing a man at a distance and allowed itself to be caught." An armadillo.

When Garay and his men finally arrived at the Pánuco, the ships had not arrived. The soldiers, near starvation after their overland march, set about to find food for themselves and their horses in the nearby countryside and Indian villages. When nothing was found, Garay suspected that Cortés had stripped the country of sustenance in order to demoralize them. But Garay's misfortunes were only beginning. First, the fleet arrived with news that four ships had been lost in a storm. Then Garay was summoned to appear in Santisteban to account for his sallies through the countryside, stirring up the natives, and bringing unrest to the land. Garay ignored every summons to appear in Santisteban, lying low instead and keeping his ships safe at anchor off the coast. Then unimaginably bad news arrived for the governor. The royal *cédula* awarded to him for the colonization of the land he called Victoria Garayana had been revoked. Cortes's proxies and secretary had successfully lobbied before the Crown in Spain for the revocation of Garay's *cédula*. A new royal *cédula* had been issued, and it named Cortés governor and captain-general of New Spain. Garay was brought to Santisteban, presented with the document, and made to hold it, kiss it, place it atop his head, and swear to abide by it.

Cortés, as gracious in victory as he was ruthless in battle, had Garay brought to the newly named Mexico City, where Cortés granted him rights to colonize along the Río de las Palmas. Meanwhile, back on the Pánuco, the natives had gotten more restless than ever. Deciding that it was time for all the intruders to leave their land, the Huastecas were reported to have killed and eaten 250 to 500 Spaniards. Cortés promptly dispatched an army under one of his trusted generals, Gonzalo de Sandoval, to put down the uprising. As Garay and Cortés celebrated midnight mass together in Mexico on Christmas Eve of 1524, Sandoval, having captured the Huasteca chiefs responsible for the uprising, had them burned alive, with their sons as witnesses. Thus ended the second chapter in the history of the Río Pánuco region, with the end of Garay's dream of Victoria Garayana and Spanish conquest of the Huastecas.

• • •

The next morning I'm on my way to the beach. Driving northeast on Avenida Álvaro Obregón, I'm soon out of the *centro histórico* and lost amid a massive complex of Pemex refineries. The air is absolutely foul with the smell of gas, and I am finding no signs pointing the way to the beach. An official white Pemex truck pulls out in front of me. His bumper sticker reads "Solo dios sabe a donde va" (Only god knows where he's going). I figure that I might as well follow him, and by good fortune he leads me right to Playa Miramar. The *palapas* stretch for miles along the clean, white sand. By any standards, it's a beauty of a beach. I turn right and pass one grand, new hotel after another. An open-air bar on the beach side of the road advertises a wet t-shirt contest tonight, sponsored by Corona beer. The sign is in English. I've heard that Canadians flock to the hotels of Miramar Beach by the thousands in the high season, November through March, when the Canadian winters are brutal.

Playa Miramar, Tampico

On the Río Pánuco, Tampico

The beach road ends at the Río Pánuco, where the *malecón,* or jetty, begins. This is by far the longest jetty I've ever seen, extending fifteen hundred meters—almost a full mile—out into the Gulf, with a two-lane road paved down the center. I drive up onto the jetty and head out to sea, with the Río Pánuco on my right. Two hundred yards away, across the river, another jetty extends along the south bank. Together the two jetties provide a protected entry into the mouth of the river for oceangoing freighters and pleasure boats alike. Both sides of the *malecón* are lined with fishermen. Some are working with lines, casting by hand. Some are in the water, working with snorkle, mask, and speargun, while others are throwing nets.

At the end of the *malecón,* the water is deep and clear. Pods of dolphins pass about twenty yards from the tip of the jetty. One fisherman stands alone, poised on a granite rock, looking out to sea. He wears sunglasses, a t-shirt, cut-off jeans, and running shoes. He holds a casting net, and he scans the water without moving, his eyes cutting left, then right. One of his buddies, farther down the *malecón,* shouts to him and points at the water. I can see the dark shape, just under the surface, moving toward the man with the net. He crouches and moves side to side, like a tennis player ready to receive a serve. The fish moves closer. When it's directly in front of the man, maybe eight yards out, the man jumps to the next rock, then the next, and throws the net. I marvel at his athleticism and his nerve. One slip on the wet rocks and he could be badly hurt on the jagged granite. The friend who gave him the signal helps him haul in the net with the four-foot mahi still fighting.

I could watch them stalk fish on the *malecón* all day, but I want to follow the river back to the *centro histórico.* Who knows what I might find along the way? I'm thinking of the villages of thatched huts that Pineda found along the Río Pánuco almost five hundred years ago, and I wonder what's there now. Leaving the *malecón,* I find a narrow, sandy road running parallel to the river. There's a succession of small businesses, mostly fish vendors, whose walls block access to the river, then an open lot with a tall monument in the center: El Virgin de los Pescadores. A dark, carved stone figure of the Virgin stands atop a tall granite base. She wears a crown of fish, and it's impressive, tall and elegant, but it's hard to imagine who would ever see it here. Perhaps, I realize, the monument is not for landlubbers or tourists like me, but for fisherman, as they pass down the river and head out to sea.

I drive the sandy road a little farther and find an access road that leads right to the edge of the river. At the end of the road, a grassy field forms the bank. A single horse grazes there, and beyond him a dozen pelicans sit on the remnants of an old wooden dock. This looks as close to the original landscape of the river as I'm likely to find. At least there is an echo of the natural landscape in the lush grass, the horse, and the birds. I get out my 4 x 5 view camera and tripod to take a picture, but a soldier approaches from a wooden shack on the left side of the field. He's wagging his finger, as if to say no pictures allowed. I look a little puzzled, but I keep working with the camera, hoping to get one picture before I have to leave. Then the soldier points to the ground where I'm standing. The problem is that I am standing on government property. I pull the tripod back a few feet, and he's happy. I'm glad he's happy, since he has a very big rifle over his shoulder and he looks like the kind of guy that might enjoy using it on me.

The soldier watches my every move as I put a film holder in the camera and pull the slide. Before I release the shutter, I wait for the horse to move to the right position in the frame. Minutes go by. I'm holding the shutter release and watching the horse. The soldier is staring at me intently, both hands on his rifle. Who is going to run out of patience first: me, with the horse; or the soldier, with me? Finally, the horse steps forward one foot, swishes his tail, and turns his head, all at once. That's what I was waiting for. I click the shutter release, return the slide in the film holder, and fold up the tripod.

Less than a mile down the road, I find another empty field on the river. This one serves as a parking lot and a point of departure for passenger boats ferrying people across the river to Chachalacos. There must be a restaurant or two over there, well known to the locals, because kids are handing out menus to people as they board the boats. My attention is drawn away from the boats by the sharp sounds of someone pounding on metal. Five or six young men are gathered more or less in a circle. Two of them are on their knees, hitting big chunks of scrap metal with heavy hammers and steel chisels. The rest of the men are standing and watching, or bringing more chunks of metal from a nearby boat. Camera in hand, I step closer to have a good look at what's going on. The scrap metal, now that I can see it better, consists of pieces of industrial pipe, some as big as twelve inches in diameter. Valves and elbows are connected to some of the pieces of pipe, and the men with the mallets and chisels are separating the pipes from the other parts, pounding at them with all their strength. The sound goes on and on—CHANG, CHANG, CHANG—as the hammers strike the chisels and the chisels rip at the pipe. It's hot now, and sweat drips from the foreheads of the men at work. I'm standing in the circle of young men, watching the work in progress, when one of the fellows speaks to me.

We go through the familiar questions and answers: I'm from Houston, traveling the coast, and yes, I'm traveling alone. His name is Steven, and he learned his English in the states. When I ask him why they are banging on the scrap metal, he explains that they have found this big load of old pipe and valves on the bottom of the river. They are separating the parts and removing the old gaskets. They'll clean off the barnacles, separate the metals into different types, and sell it all as scrap. They can get forty pesos per kilo for cast iron and seventy pesos per kilo for copper.

"In Nay-Par-NUS one day was *nieve*," Steven says to me. "*Todo nieve. todo blanco.* In Nay-Par-NUS."

"*Mande?*" I ask. I didn't understand him, and I'm not even sure which language he's using, English or Spanish.

"In Nay-Par-NUS, one day, *nieve* was all over. How you say *nieve?*"

"*Nieve*. Snow? You talking about snow?" I ask. Now the guys have stopped hammering at the pipe, and they're looking at Steven, wondering what he's saying about snow.

"Yeah, snow. Everwhere was *snow*, man. *Todo blanco*, man, I mean *todo*. Everthing was white in the snow. And man, it was really cold. In Nay-Par-NUS."

The Mexican guys are looking at Steven in total confusion. A place that's all white, totally covered in snow. And freezing cold. Could that possibly be true? Could such a place exist? As for me, I'm wondering where the hell is Nay-Par-NUS.

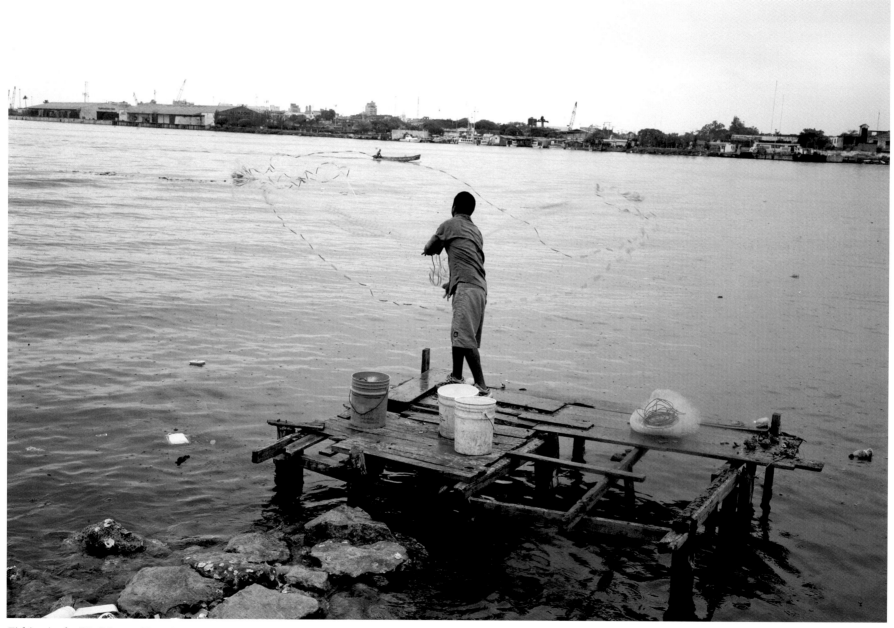

Fishing in the Río Pánuco, Tampico

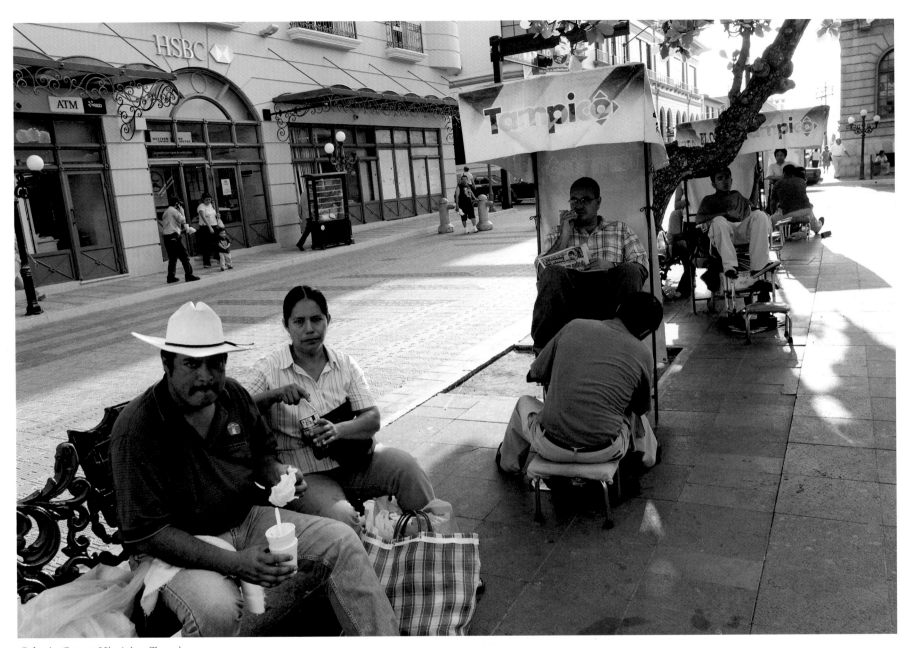

Colonia Centro Histórico, Tampico

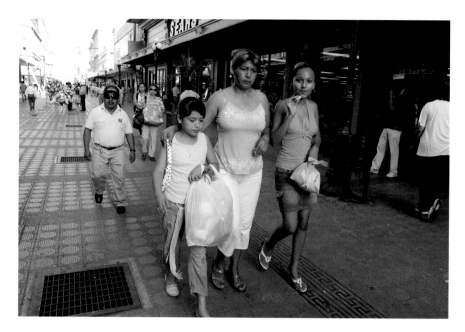
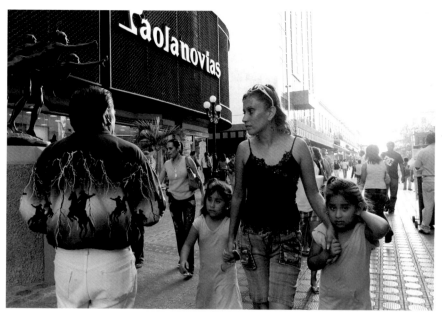
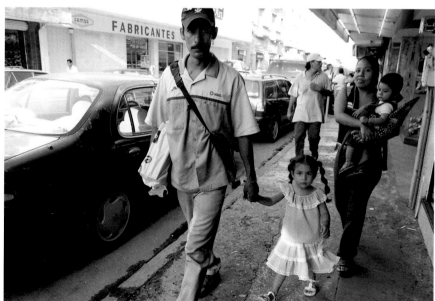

Plaza de las Armas, Colonia Centro Histórico, Tampico

"Nay-Par-NUS," Steven says, running out of patience with me. "You know, Nay-Par-NUS. Vir-HEN-Ya."

Newport News, Virginia. Now I get it. It was snowing and cold as hell in Newport News, Virginia, when Steven was there.

"Todo blanco en NayParNUS," Steven repeats, nodding his head over and over, smiling. Like he's found a mantra. *"Todo blanco en NayParNUS."* All the Mexican guys shake their heads in disbelief. Then they mimic Steven, repeating the mantra themselves as they go back to work—*"Todo blanco en NayParNUS"*—CHANG, CHANG, CHANG—sweating and banging at the scrap metal. I wave to the guys and walk to my truck. As I turn on my air conditioner and drive away, I wonder who would believe such a thing, if they hadn't seen it for themselves: *Todo blanco en NayParNUS.*

By five o'clock in the afternoon I have made it all the way from the *malecón* back to the *centro histórico.* I park my car and start walking up Avenida Salvador Díaz Mirón, looking for the Plaza de las Armas, the central plaza of Tampico. It's Friday afternoon and the streets are flooded with people. Díaz Mirón has been permanently closed off to traffic in the three blocks approaching the plaza, turning the street into a pedestrian walkway, a promenade leading to the *jardin.* A marimba band plays; there are vendors selling balloons, men blowing giant bubbles, and food for sale all along the promenade. This is a real city experience, something I have seldom seen in the states, a shared urban space and a communal life. Then I arrive at the plaza itself, with its giant pink kiosk in the center of the *jardin.* What a great spectacle it is, with people sitting and climbing all over the kiosk, lovers and loners, vendors and bird feeders, tourists, nuns, and shoe-shine men. It's a glorious scene, alive in the late afternoon light, with the bright notes of the marimba music drifting over the square, with pigeons fluttering all about, and toddlers in pursuit. What would Francisco de Garay think if he could be here now? His dream of Victoria Garayana was never realized, but Tampico is alive and full of energy.

PART 5: *Tampico Alto to La Antigua*

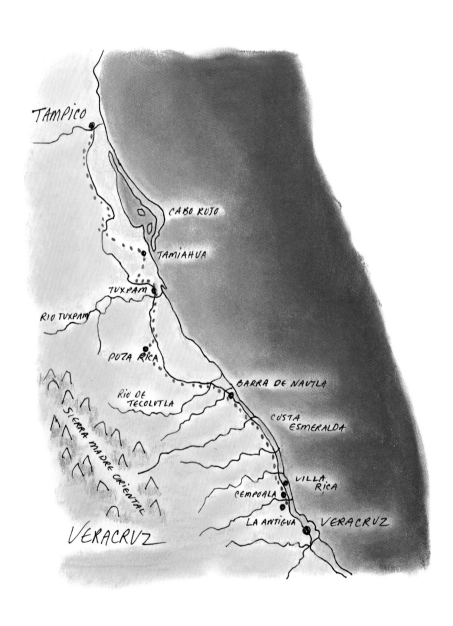

THE NEXT MORNING I am on my way out of Tampico, headed south toward Veracruz. From the top of the Puente Tampico, the new, modern bridge that arches over the Río Pánuco, I catch a brief, dramatic view down the river and out to sea. I even spot the *malecón,* where I photographed yesterday, a man-made, stone peninsula jutting out into the Gulf. The view is so grand and so intriguing I decide to park and return to the top of the bridge on foot.

It's a long, hot climb up the bridge, even at nine o'clock in the morning, but the view from the top is worth the effort. Over three hundred feet above the water, I have a panoramic view of both the northern and southern shores of the river. Half a mile down the northern shore, a mammoth offshore rig lies on its side, under construction. Hundreds of welders swarm over the massive rig, like ants on a pile of twigs. Immediately below me, in the back streets of Ciudad Madero, a horse-drawn cart has pulled up to a tiny junkyard with a load of scrap metal. The horse stands patiently as two men unload the scrap and toss it into a pile in the yard. Four blocks from the junkyard, two children push a wooden cart down the street, going from house to house, collecting mangoes from the yards.

To my right, the southern shore of the river marks the beginning of the state of Veracruz. From the bridge I also have a clear view of the Gulf Coast, as it extends south from the mouth of the river. As far as I can see in that direction, the earth is covered in a lush, green blanket of tropical foliage. That's where I am headed today: the coast of Veracruz. As I contemplate that landscape in the distance, I think of an earlier traveler who ventured there and wrote about it. Born in Scotland, Francis Calderón de la Barca came to Mexico in 1839. She was the wife of Don Angel Calderón, the first Spanish minister to come to Mexico after the revolution of 1810 established Mexico's independence from Spain. To give some perspective, the Calderóns arrived three hundred years after Cortés had ravaged the native Huastecas and established the first settlement in the area. The Calderóns remained in Mexico for three years. They traveled to virtually every part of the country and enjoyed all aspects of Mexican life. Fanny, as she was known, possessed an insatiable curiosity and boundless energy. She visited and wrote about monasteries and prisons, rodeos and bull-fights, elegant casinos and the finest resorts of Cuernavaca. The Calderóns traveled by horseback, by buggy, and on foot, often transporting their beds en route. Fanny made it her business to meet lepers who lived in horrid conditions in the streets of Mexico. She described, for example, exploring the river and the wooded shores south of Tampico, the same area I can see from the bridge today, and she noted some curious customs of the people who lived in that area:

> We have been hearing a curious circumstance connected with poisonous reptiles, which I have learned for the first time. Here, and all along the coast, the people are in the habit of inoculating themselves with the poison of the rattlesnake, which renders them safe from the bite of all venomous animals. The person to be inoculated is pricked with the tooth of a serpent, on the tongue, in both arms and on various parts of the body; and the venom introduced into the wounds. An eruption comes out, which lasts a few days.
>
> Ever after, these persons can handle the most venomous snakes with impunity; can make them come by calling them, have great pleasure in fondling them; and the bite of the person is poisonous!

Back in my truck, I pay the toll for the bridge (twenty-eight pesos) and I'm driving Highway 180 again, headed south into the state of Veracruz. There's not much to see in the first community, Tampico Alto, except a few vendors selling pineapples and honey along the highway. Then the landscape comes alive in myriad shades of green. Tropical foliage and flowering trees edge right up to the roadside. Handsome ranch houses sit on the hillsides overlooking pastures dotted with palm trees, jacarandas, and what the locals call *mulattos,* or gumbo limbo trees. Along one stretch of the highway, near the *pueblito* of La Crema, I sense a curious blend of Europe and the American Deep South, as Swiss cattle graze under trees dripping with Spanish moss. At points, the countryside opens into beautiful green valleys. To the northwest, like a mirage, the hazy, blue shape of Cerro Azul, a volcanic mountain, hangs like a painted backdrop. The farther south I drive, the steeper and more impressive the mountains become. The cultivated hillsides often lead to a mountaintop crowned with a dense crop of foliage, as though the

mountains have been given a down-home, short-on-the-sides haircut, with just a sprig left on the top. I recall Fanny Calderon's description of the vast, endless tropical forests along coastal roads she traveled here a hundred and sixty years ago. Those crowns of foliage on the mountaintops, I'm guessing, are what remains of the tropical forests she observed. I also see areas of serious erosion, due to the clearing of the forests, I suspect. As beautiful as Veracruz is, I wonder if there aren't serious troubles ahead, as the last remnants of the tropical forests are cleared to make space for even more cultivated crops.

Soon, I find myself approaching Naranjos, the first city south of Tampico and the center of a major orange-growing region. Along the highway through town, pickup trucks are parked, loaded with oranges. Their drivers sit in the shade alongside their trucks with scales hanging nearby. A kilo of fresh oranges sells for six pesos here, less than a third of what you would pay in a market in central Mexico.

South of Naranjos a secondary road bears off highway 180 to the southeast, toward Tamiahua and the coast. I have just made the turn when I see three figures on the side of the road in the shade of a tree: a man, a woman, and a young girl. They look like a family, and they're all carrying bags or packages of some kind. My guess is that they live in the country, they have come to town to shop, and they are looking for a ride back home. I pull to the side of the road and motion for them to get in. The woman, who I judge to be thirty years old, thanks me for stopping as she slides into the seat behind me. The daughter, about eight or ten years old, slips in next to her, and the father follows. He is a bit older than the woman, maybe forty, and he's nicely dressed in dark pants and a white shirt. I am struck by how neat and well-groomed all three of them appear. I ask the man where they are going, and he replies that they are on their way home, about ten kilometers down the road.

As I drive, in my rearview mirror I can see the girl in the center of the back seat. She is looking all around the truck and talking with her mother in whispers. She raises one hand above her head, toward the vent in the roof of the truck, and then wrinkles her brow. She leans toward her father and whispers something in his ear. I hear his softly spoken reply: *"La clima. Es la clima."* Air conditioning. It's the air conditioning.

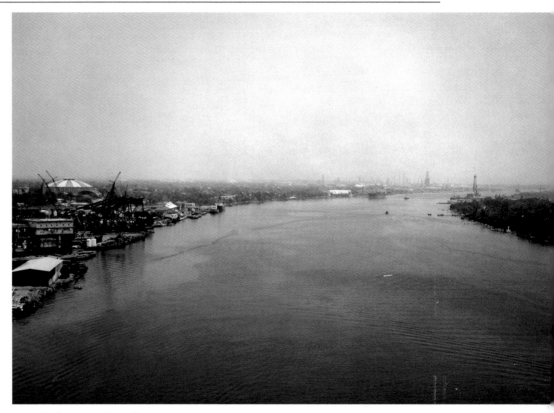

View looking east from the Puente Tampico

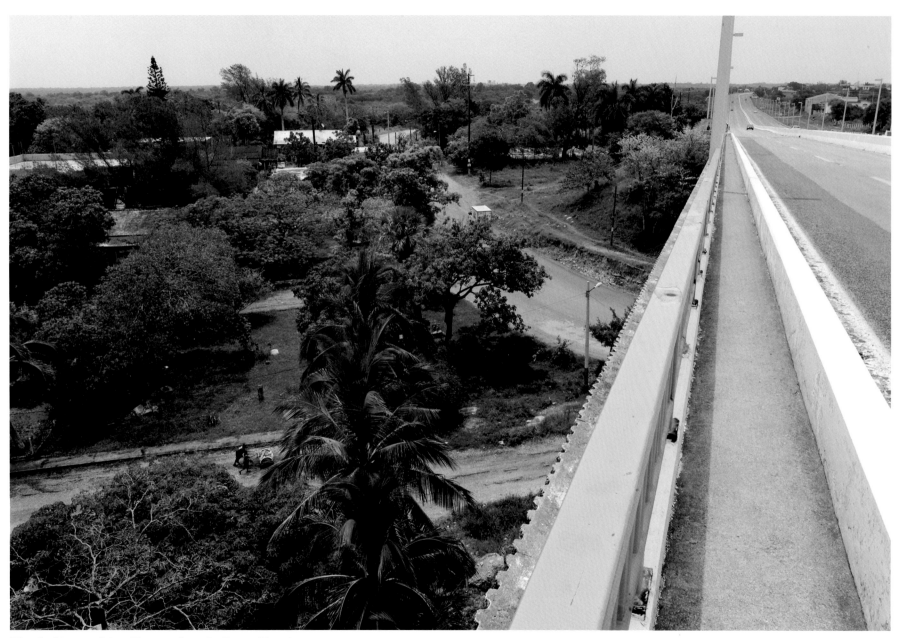

View looking south into Veracruz from the Puente Tampico

Now the little girl's head tilts slightly to one side, and she looks at me from the backseat with curiosity. I believe I can read her thoughts: Who is this person that comes down the highway with his own climate? The girl says something to her mother, and then I hear paper rustling. In the mirror I see that they are opening one of their packages, and then the truck is filled with the smell of freshly baked bread. The girl hands me a crisp, fragrant *bolillo,* the Mexican equivalent of a French baguette.

"Por favor, señor, pan de horno?" the girl asks in her soft voice, as she passes me a piece of freshly baked bread. Touched by her generosity, I thank the girl and bite into the warm, crusty bread. The man asks if I am on vacation. I answer that I am. It's a simple, easy answer and approximately true. I tell them where I'm from, and, yes, I have children, five in all. I ask the man what kind of work he does. He tells me that he is a schoolteacher, and he has a little goat cheese business on the side.

We have driven along in silence for a few minutes, and then the man tells me that this is where they will get out. Each of them thanks me as they exit the truck. The man reaches up to shake my hand, and I have my first good look at him. Light-skinned for a Mexican, with jet-black hair. Round faced. Warm, intelligent eyes. *"Vaya con dios, señor,"* he says, and the child and her mother repeat his words, as they wave goodbye, *"Vaya con dios, señor."*

My ride with the family lasted fifteen minutes or less, but I was deeply impressed. The kindness, the goodness of one family—a schoolteacher, his wife, and his daughter—would stay with me. They gave me a piece of bread, and what did I give them? Nothing, I regret to say. Nothing except a short ride down the road to their home, plus a brief impression of a stranger from the Other Side, an impression that I suspected would linger, particularly with the girl, for some time to come.

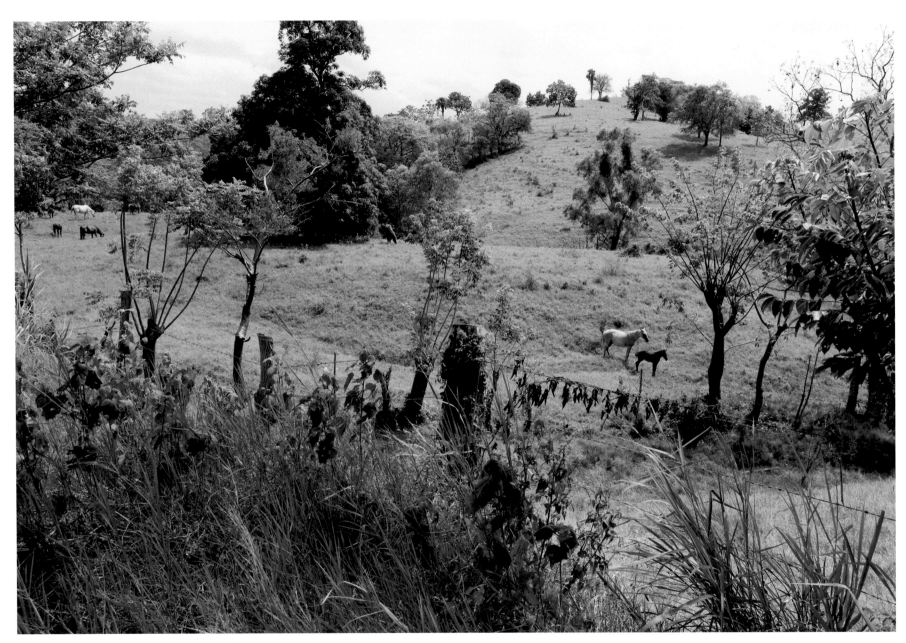

Along Mexico Highway 180 near Naranjos, Veracruz

Alamo, Veracruz

On the road to Tamiahua, I pass a pickup truck pulling an old cabin cruiser. This cruiser was once a symbol of wealth, somebody's personal yacht, but the motor has been stripped off, leaving a gaping hole in the stern, and the trim around the cabin is hanging loose, flapping in the wind. The trailer under the cruiser has Texas plates, and the name "Sugar Land" can still be read, though it's a bit faded, on the old yacht. The cruiser, I'm sure, is headed for reincarnation in the waters of Laguna Tamiahua.

Tamiahua turns out to be strikingly similar in appearance to the towns along the coast north of Tampico. The fine ranches and thriving farms I saw along highway 180 south of Tampico have vanished, and once again, as I approach the coast, signs of poverty are all around me. The road to Tamiahua runs along the southern shore of the Laguna Tamiahua, a huge, shallow lake situated between the mainland and the barrier island of Cabo Rojo. Hundreds of fishermen work the lake out of Tamiahua, along with others from Cabo Robo. From the road coming into Tamiahua, I can discern the barrier island across the lake. I have read about mangrove swamps on the lake side of the island, miles of open beach on the Gulf side, and immense dunes of fine quartz sand on the northern end of the island. But that's another trip. Today, I want to reach the city of Tuxpan before dark.

South of Tamiahua, I encounter the first reminders of Mexico's roots to the Amerindian cultures of prehispanic times. Towns appear with strange and curious names like Xoyotitla, Zacamixtle, and Tihuatlan, towns that trace their origin to the Nahual culture that once thrived here. Nahuatl, along with Mayan, is one of the two most widely spoken Native American languages in Mexico today. One and half million people still speak Nahuatl today, and a good number of them live right here on the coast of Veracruz.

At Alamo, a sign over the road announces that I am entering the "Valle Dorado del Naranjo," the Golden Valley of the Orange, and the highway is lined with orchards. A bridge crosses the shallow water and grassy banks of the Río Tuxpan, where several hundred people have come on this hot Sunday afternoon. Families sit together on the banks of the river, eating fresh mangoes and drinking Cokes. Inside the town, an impressive concrete monument depicts a single worker from the orange fields, shirtless, with trousers rolled to his knees. He is leaning forward, and his muscular body forms one-half of a giant arch. The other half of the arch, starting at a

Tuxpan, Veracruz

dark-haired Latin *hombre joven* at the throttle with a Mexican doll snuggled up behind him. They smile and shout to me—"*hola, hola*"—clowning for my camera as they buzz past. People seem happy here in Tuxpan, and why not? Life on the river looks very good, indeed. From the main square, across the street from the esplanade, I watch, along with a dozen other bystanders, as a tall man in a bright red cap throws a fishing line into the river.

As dusk arrives, the tables on the plaza are cleared, and the streets grow quiet. The river lends an air of timelessness to the city. By the last light of the evening, I can still make out the fisherman in the red cap down by the river. He has a light at his feet now, pointed out toward the water, and he's still casting for fish. On the ground behind him lies a big catfish flopping about. With each toss of the line, the man's hand rises toward the sky and hangs there for a few seconds, a gesture of reverence.

I could stay in Tuxpan for a long time. I could put aside my camera and take up fishing on the river. But this is not where I want to end this journey. I long to see more of the Mexican coast, especially Veracruz city, so I will have to return to Tuxpan another time. Tomorrow morning, I'll be up and on the road early.

• • •

South of Tuxpan, sixteen kilometers down a badly potholed road off Highway 180, in the little town of Castillo del Teayo, the northernmost archaeological monument of ancient coastal Mexico goes largely unnoticed. It's little wonder that the site is seldom visited. The only road to Castillo is so difficult to travel that I am averaging no more than ten miles per hour. The road travels through a curious landscape of pointy little hills and tiny valleys, citrus orchards, and steep cornfields. This, too, was once a tropical

basket on his shoulder, is shaped by a cascade of oranges that fall, in one continuous stream, to the ground.

The city of Tuxpan lies approximately halfway between Tampico and Veracruz city, in a small valley shaped by its namesake river. By the time I arrive, it's almost seven o'clock in the evening, and the esplanade along the river is buzzing with people. In many ways, Tuxpan looks more like a port on the coast of Spain, or a town along the Duoro River in northern Portugal, than anything I have seen in Mexico. Narrow streets rise from the river walk, winding through plazas and tiny courtyards filled with fountains and palm trees. Motor scooters buzz around the street corners. Many have a

Castillo del Teayo, Veracruz

forest, but there is virtually nothing left of it today. An occasional grove of tropical trees crops up along the way, with bromeliads growing among the thick vines and branches, but the rest is farm and pastureland. The pyramid in the center of the tiny town is a strange one. Small by comparison to the great ruins farther south at Tajin or Cempoala, the pyramid at Castillo is seventy feet tall, and it sits in the central plaza like a huge, blackened meteor that fell from the sky. Constructed of dark volcanic stone, with steep steps to a little temple at the top, Mayan style, this site is a major mystery to archaeologists. The structural and decorative features of the pyramid are Toltec, which makes sense, since this was Toltec territory. Yet certain elements of the construction are distinctly Mayan, and that's where the mystery comes in. What were the Mayans, people from the Yucatán Peninsula and Guatemala, doing here? And if there were no Mayans here, how did these distinctly Mayan building techniques get here?

Judging from the scene on the square this morning, no one in Castillo del Teayo is worrying themselves with this archaeological mystery. A few teenagers in rolled-up blue jeans, spiked hair, and hip jackets are hanging around a taco stand and pacing the streets, way too groovy for this place. Three young women sit in front of a unisex *peluquería*. Color photos of the latest hairdos, shown on bleached-blond *gringas* and fair-skinned men with blue eyes, hang in the window. I had hoped to climb to the top of the dark pyramid and look out across the town, but INAH, the Mexican archaeological agency, has posted signs forbidding anyone to climb the steps. The only thing I can find to do in Teayo is to stand on the corner by the taco stand and watch the thousand-year-old pyramid continue to age. One of the groovy kids strolls past, spinning a plastic Coke bottle on his index finger. He tosses a disinterested glance in my direction, then at the pyramid. I'm ready for him. Click. Got it. Maybe there was a picture in Teayo after all.

Southeast of Castillo del Teayo, on the way to the coast, I have to drive through the city of Poza Rica, an encounter that I truly dread. I have been forced to drive through this city before. Poza Rica is simply the ugliest city in Mexico. It is littered with trash, congested with traffic, and has, as far as I can see, no redeeming qualities. If there is any good to come of a passage through Poza Rica, it might be that this city can provide a clear and instructive vision of where an unrestrained petroleum industry would take us. Poza Rica—the literal translation is Rich Hole—has been a major center of oil production and refining since it was founded in the 1920s. A sprawling complex of Pemex facilities—the national oil company of Mexico—sits at the center of Poza Rica today. There must have been a huge amount of money generated in and flowing through Poza Rica for decades now. But the city looks as though it's ready to collapse into chaos. The place is falling apart, its air is foul with the smell of gas, and the traffic seems to be in gridlock every hour of the day.

I try, as always, to get through Poza Rica as quickly as possible, but it's never easy. All traffic is forced to pass right through the center of the city. I follow the signs for Veracruz, inching my way through the hot, congested streets in bumper-to-bumper traffic. At a traffic circle on Boulevard Ruiz Cortines, a bunch of dusty cactus and a few wilting ficus trees surround a pedestal with a public clock that's running four hours late. Farther down the divided boulevard, in front of the main gates to the Pemex complex, a monument has been erected to mark the fiftieth anniversary of the government's expropriation of the petroleum industry. It's a goofy-looking, gold-plated bust of Lázaro Cárdenas on a granite base. A few blocks later, a bridge carries traffic over an open drainage canal, thirty feet wide at least. The stink of open sewage rises from the filthy canal. On top of that, the smell of gas is everywhere.

How do you photograph ugliness? Where should I start in an effort to make compelling pictures of Poza Rica? I have no answers to those questions, but I find myself challenged by the task. I park my truck and set out on a walk through the city. On a major street, with morning traffic jammed up to a red light and pedestrians swarming the sidewalk, several large pots have been propped together on two old concrete planters. The pots are made of cheap plastic and show evidence of three or four sloppy paint jobs.

The pots hold a sad collection of plants: a scraggly little palm, a wilting pine of some kind, and a thin, struggling ficus. Any place other than Poza Rica, this might be assumed to be trash left on the curb for pickup. But here, it is someone's effort to beautify the city street and to attract business to the sandwich shop behind it. This may be the best Poza Rica has to offer.

I am tempted to drive out to El Tajin, the major archaeological site and ancient Totonac religious center, but on previous visits I have been disappointed by the commercialization of the site. Besides, a trip to El Tajin would take me twenty kilometers or more inland, and I am longing to see the ocean again. The Costa Esmeralda, Mexico's Emerald Coast, is only an hour away, so I return to my old friend, Highway 180, and head east toward the sea.

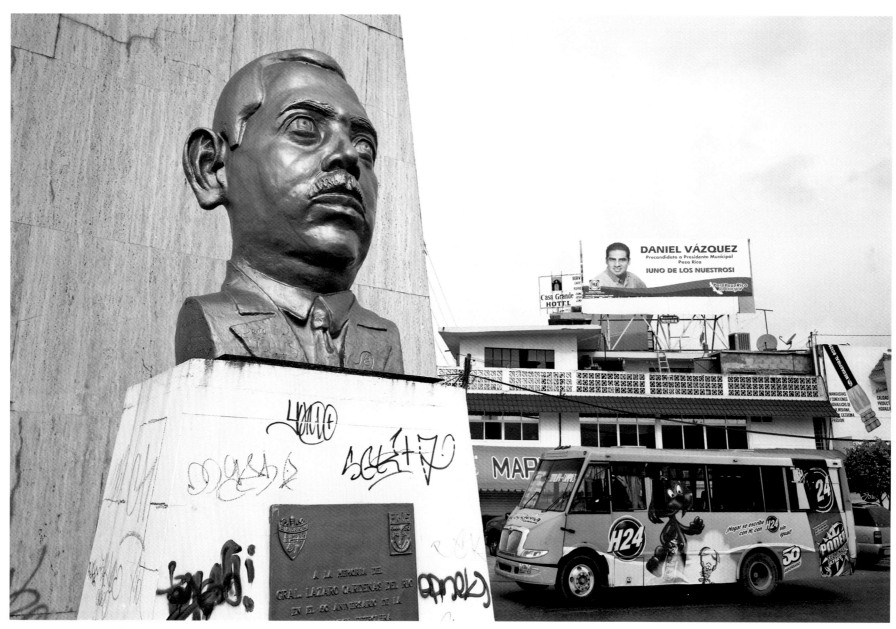

Monument to General Lázaro Cárdenas del Río, Poza Rica, Veracruz

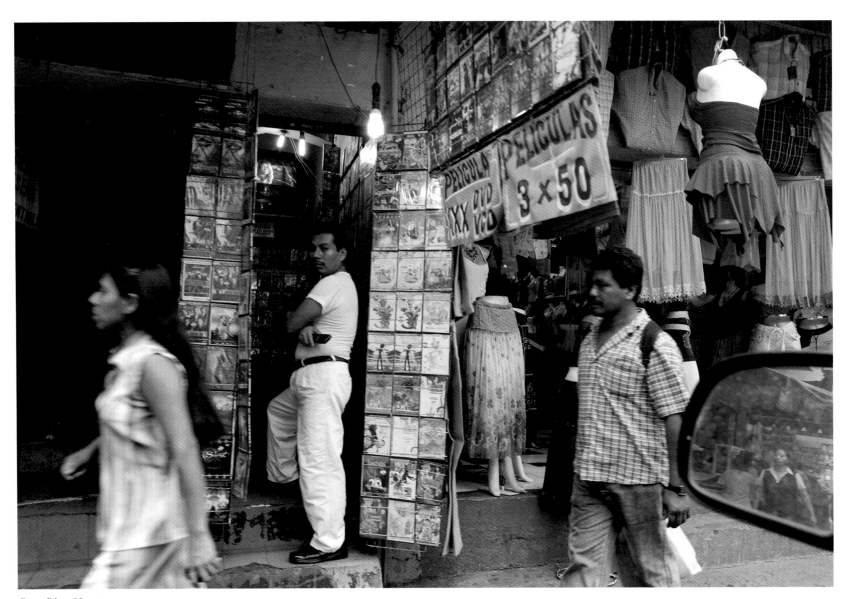

Poza Rica, Veracruz

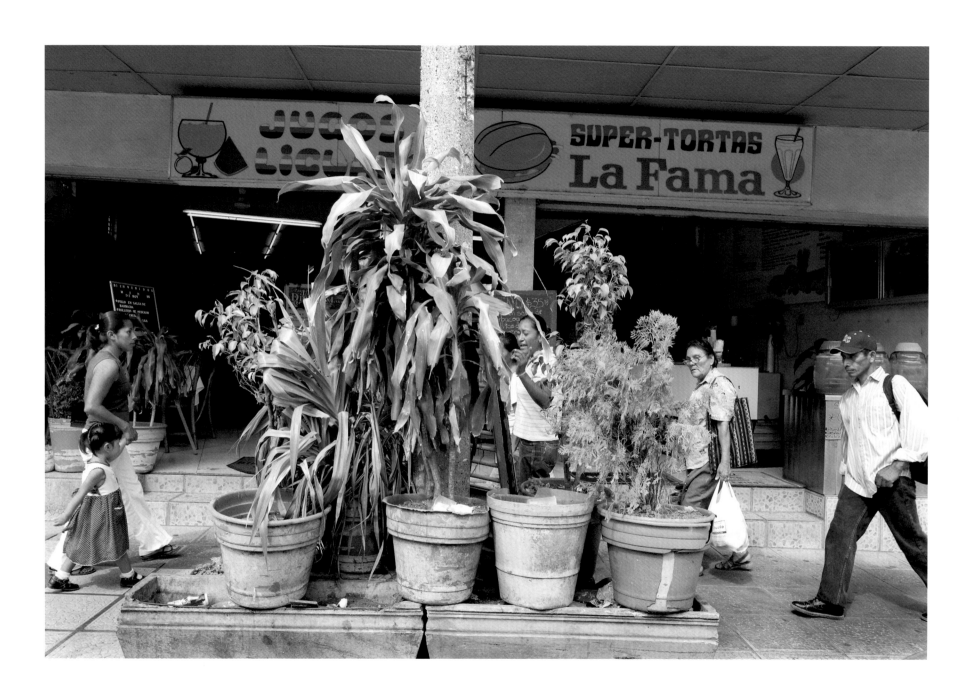

• • •

To date, I have covered almost eight hundred miles of Gulf coastline. Approximately half of that distance has taken me along the mostly brownish, silty waters of the Texas coast. Along the Mexican coastline, up to now, the majority of my views of the water have been across one pale, shallow *laguna* or another. Now, as I round the final curve on the road descending from the town of Gutierrez Zamora, the Gulf appears once again, but this time it bears no resemblance to the body of water I have seen up to now. The water, a shimmering ribbon of light and color, spread across the horizon in the afternoon sunlight, is emerald green. White-capped waves are crashing on dark, volcanic sand beaches. I have arrived on the Costa Esmeralda.

At the tiny community of La Guadalupe, Highway 180 passes through the town and continues along the coastal plain, never more than a mile from the beach, at times as close as a hundred yards. Small hotels and private homes dot the coastal side of the highway. Approaching the little town of Casitas, I cross the bridge over the Río Casitas, and cruise into town. Little shacks and makeshift stores along the road display swimsuits, beach toys, and homemade candies. A pickup truck loaded with eight kids stops at a roadside stand, where they purchase bags of *dulce de leche* in flavors of *coco, vainilla,* and *piña.* Then they roar off for the beach.

A few miles down the road, I pass over another powerful river, then another. I cross five rivers in less than twenty miles. Between the rivers, rangeland alternates with sugar cane fields, banana groves, and mangrove swamps. To the west, a range of mountains angles toward the sea. At Barra de Palmas, the road bears southeast, angling away from the coastline and toward the mountains. For the first time in fifty miles or so, I lose sight of the sea. Crossing yet another river, I look to my right and spot an enormous banyan tree growing on the riverbanks. I park my truck on the side of the road and start walking back to have a good look at the old tree.

A short, bearded man in ragged clothes, all alone, is walking down the highway toward me. It would be easy to miss the fellow entirely. His old gray jacket and trousers are almost the same color as the highway. Dirt stains on his woolen sweater suggest many nights of sleeping along the highway. He carries half a dozen ragged old bags and bundles, hung by ropes from his shoulders and around his neck. He stares straight ahead as he walks, expressionless, unblinking. A truck roars past us at highway speed, and the tall grass along the road swirls in the wind, but the man doesn't seem to notice. His stride is brisk and determined, unflinching. But where is he going? And where has he come from? The nearest town is thirty miles back.

When the man is about fifteen feet away, still walking at the same brisk pace and showing no sign of noticing me, I call out to him: *"Hola, señor."*

He continues walking, with no indication that he heard me, so I call out again, louder this time, *"HOLA, señor."* This time he stops, his face a few feet from mine, but he's still looking past me, staring straight ahead down the road. His clothes are disheveled, torn here and there, and covered in dirt. His shoes are the ragged remains of a pair of old sneakers. His black hair, stringy and tangled, protrudes from under a gray cap with a white Nike symbol. He shows no sign of distress that I can detect, yet I cannot coax him to speak or to respond in any way.

The man looks as though he might have been walking for months. Could he be catatonic? Could he be fleeing some sort of horrible disaster? For all his ragged and dirty clothes, for all the signs that he has been on the road for a very long time, I detect no odor, and that causes me to wonder if I am looking at a man or at a spirit of some kind. Could he be the lost soul of one of Pineda's Spanish soldiers, a forgotten survivor of the Huasteca massacre of 1522? Or could he be the anguished spirit of one of the Padre Island shipwreck victims, destined to walk the coastal road forever in search of solace?

We stand there on the side of the highway for a few more seconds as I look directly into the glazed eyes of this mystery of a man. His gaze remains fixed beyond me, down the highway. I reach into my pocket, pull out a hundred peso bill, and squeeze it into his hand, under several coils of rope. Then I bid the fellow *"Vaya bien,"* step aside, and he's off again, striding down the highway.

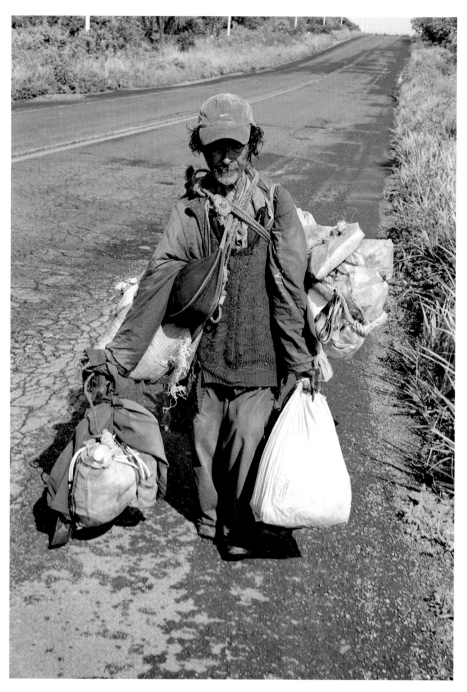

*On Mexico Highway 180, south of
Casitas, Veracruz*

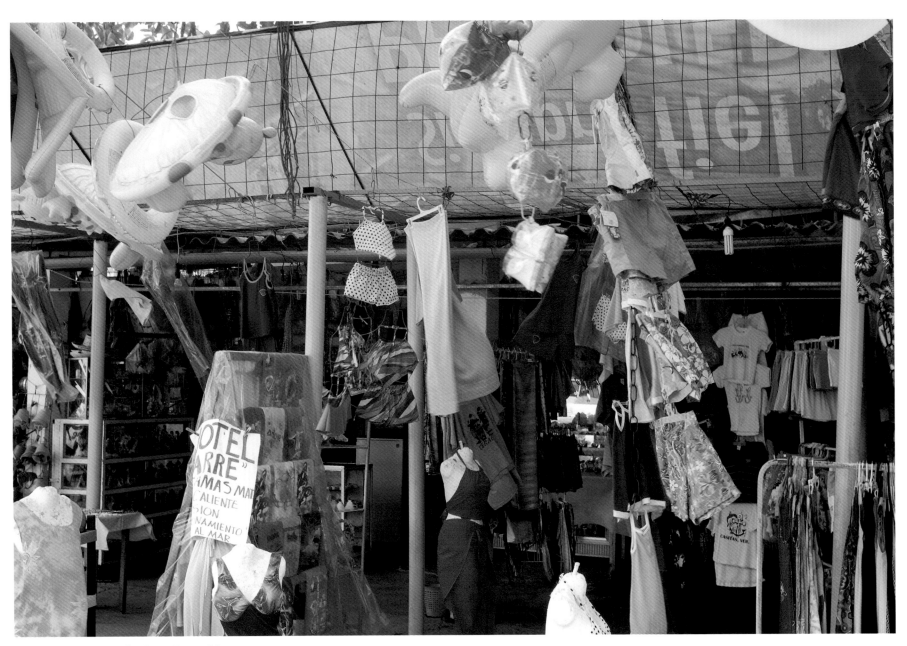

Casitas, Veracruz, on the Costa Esmeralda

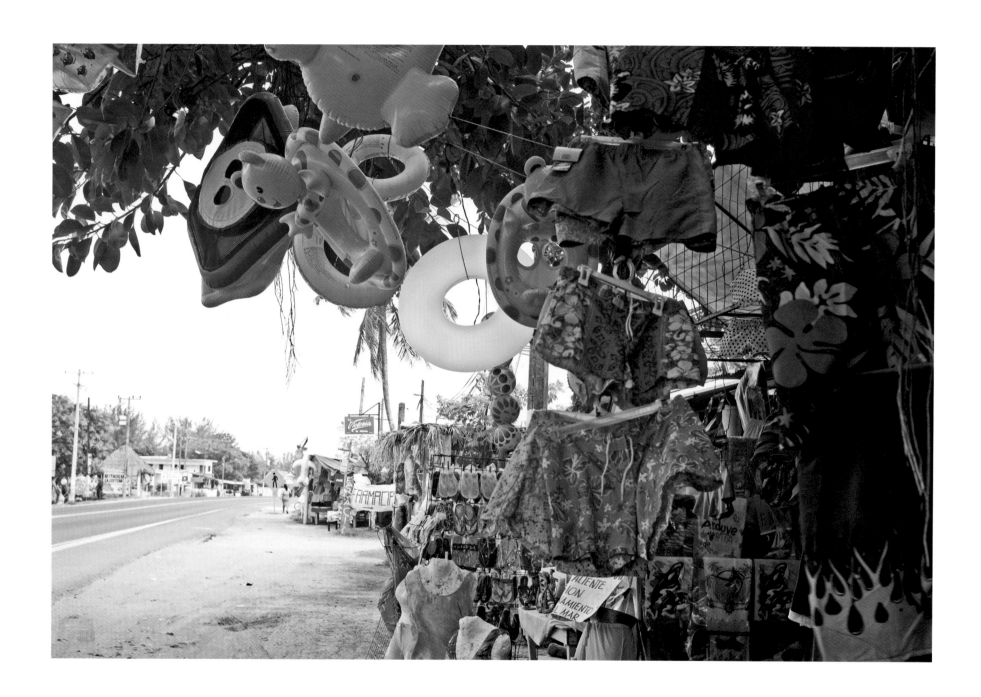

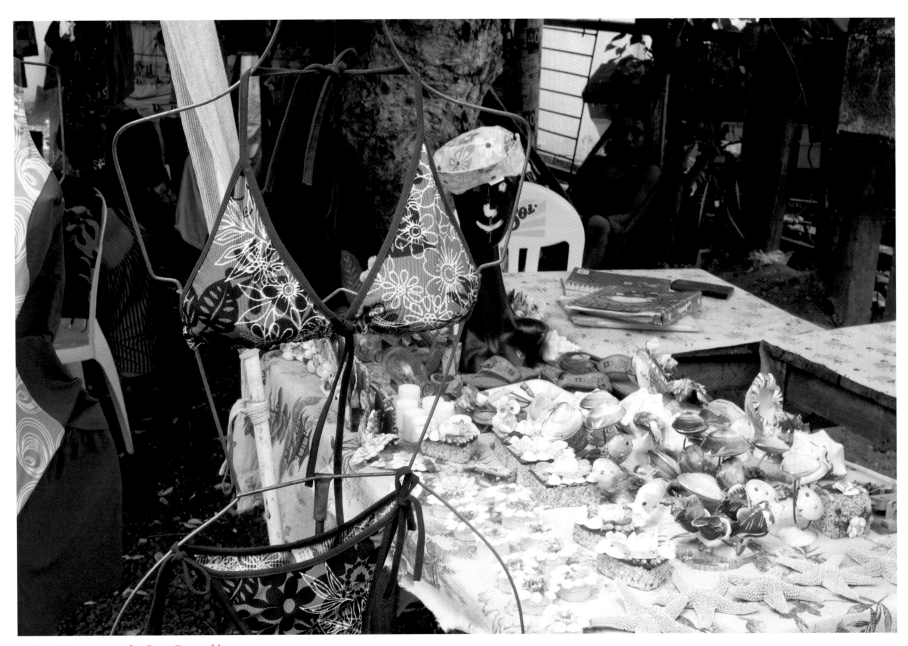

Casitas, Veracruz, on the Costa Esmeralda

• • •

As it travels south, Highway 180 passes through a series of small towns. I have driven this route in the past, on my way from Texas to southern Mexico. The coastal route, a two-lane highway all the way from Veracruz to the border, was always slower than taking the *autopista* through Mexico City, but there was so much to see and photograph along the way. The little towns always looked more or less the same—from Casitas to Nautla, then Vega de Alatorre and Emilio Carranza—little Mexican beach towns, each of them set alongside a river, with a couple of cheap hotels, a service station, a string of shops selling swim suits and beach gear, and of course at least one *vulcanizadora,* or tire repair shop. The towns seemed virtually interchangeable; so much so that I could never recall in which town any particular photograph was taken. But now I see that things are indeed changing.

In Vega de Alatorre, past the old Pemex station, a stunning new development has arisen, a harbinger, I suspect, of the future of the Mexican coast. Like a child's bright new toy, only life-sized, the Richard Express has opened for business. The little hexagon-shaped building, in sparkling red and yellow, houses a more-or-less American style convenience store. With a red deckled awning, two little potted palms on each corner of its tiled terrace, and a pair of neat, clean plastic tables out front, the Richard Express looks so out of place it could be from another planet. A plump teenage girl in a t-shirt and jeans sweeps the terrace with a broom and a dustpan. I believe that's the first dustpan I've ever seen in Mexico. The time-honored tradition in the small towns of Mexico, as I have observed for almost thirty years, is for women to sweep the dust from the front of their home or store toward their neighbor, or across the street. Then the neighbors sweeps the dust back, thus extending a never-ending cycle.

The next town on Highway 180 is Emilio Carranza, where I pass a string of muffler repair and oil change shops, a few dusty hotels, and the requisite *vulcanizadoras.* It's a good time, I decide, to wash the accumulated layers of dirt and dust from my truck, so I pull into the Lava Auto Cyndi, where two young men are at work vacuuming the carpets of a VW sedan. Texas license plates and pale complexions identify the first Americans I have seen since I

crossed the border—a couple in their thirties and their young son—sitting off to the side on a low stone wall, waiting for their car to be washed. After a few minutes, their car is finished, they pay, and then drive away. The woman taking the money and managing the operation is Cyndi, a plump, energetic, talkative woman in a flower-print dress. She's probably thirty years old, and I assume that the young men doing the car washing are her sons. Lava Auto Cyndi strikes me as a typical small-town Mexican business in every respect. It's family owned and operated, it's distinctly low tech (a small power washer and an old canister vacuum cleaner are the only equipment), and men supply the labor while the woman takes charge.

The car wash is done entirely by hand, with great attention to detail. Cyndi's two boys start by pressure cleaning under my truck, removing great chunks of mud from the frame and the inside of the fenders. Then they lift the hood and clean the engine compartment. They move fast and efficiently, working as a team. They have closed the hood and started on the top of my truck when the VW sedan returns, screeching to a stop right beside me.

The man and woman jump out of the VW and run over to Cyndi. They are speaking a mixture of Spanish and English, and they're both talking at once, so there's a lot of confusion, but this much is clear: they are telling Cyndi that something is missing from their car. They are pointing at the two boys and talking about the woman's *bolsa,* her purse, which had *mucho dinero* in it. The boys stop spraying my truck. They look frightened. Their eyes move back and forth from the woman, who's screaming at them about the money that's been stolen, to Cyndi, and to each other. Cyndi wants to know the details. Where was the purse? Under the front seat. Where is it now? Right here. The woman holds out a brown leather bag with a strap. Only the money is gone now.

Now Cyndi looks upset. She pleads to the woman in Spanish. Her boys are honest. They would never steal anything from anyone. Perhaps you misplaced your money.

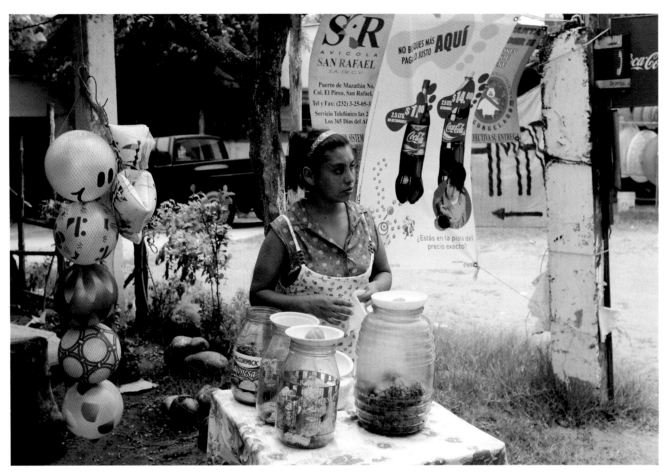

Casitas, Veracruz, on the Costa Esmeralda

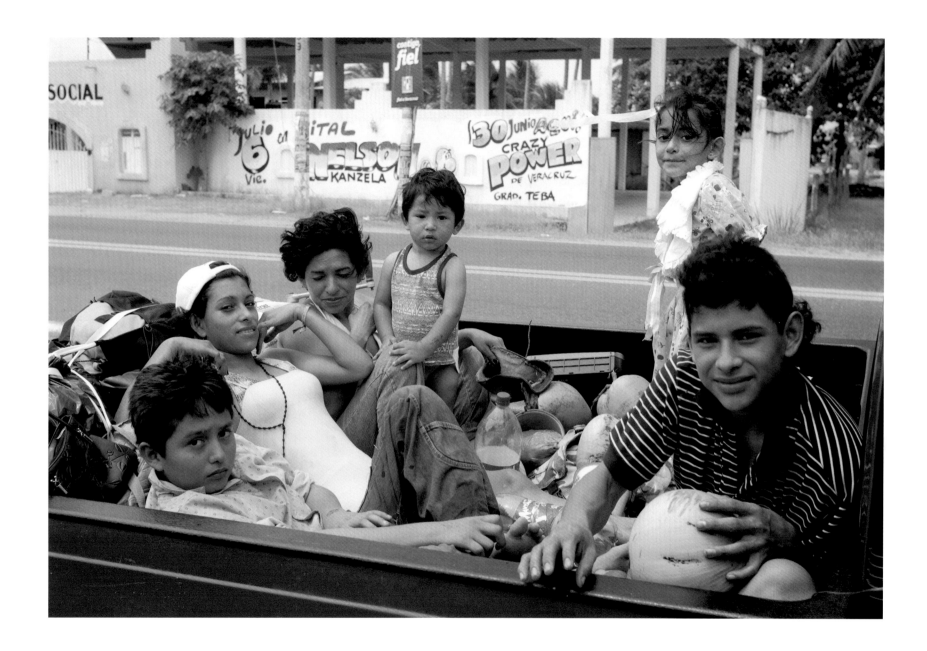

Vega de Alatorre, Veracruz

The woman insists, and her husband backs her up. "The purse was under the seat with the money in it. Your kids were the only ones around the car. They took the money. Call the police. *"La policia. Ahora."*

The intensity of the confrontation is ramping up by the minute. Cyndi is crying now. She is an honest woman, she insists. And her children are honest. *"Somos pobres, pero honesto. Por Jesus Cristo, somos honestos."* We are poor, but we are honest. By Jesus Christ, we are honest.

The woman still won't back down. There must have been a lot of money in that purse, and I'm wondering where this confrontation will lead. The couple wants the police, but I have read that a foreigner can go to jail in Mexico for accusing a Mexican citizen of a crime without proof. I'm tempted to warn the couple, but I want to stay out of the confrontation altogether.

Cyndi is weeping openly now, the couple is conferring between themselves, and the boys are pointing across the street. They remind Cyndi that while they were washing the car, the couple brought a man from the *vulcanizadora* on the other side of the highway to repair a leak in their tire. He was around the car, too, they remind her. All eyes turn to the shop across the street. Go get the man, Cyndi orders the boys. Bring him here now.

The two boys run out and return in a minute or two. Walking deliberately behind them is a short, fat, dirty-looking man in his fifties. He's a tire repairman, but he looks like an escapee from the local jail. His eyes dart about furtively, as though he's sizing up the situation he is about to encounter. He stands back from Cyndi and the American couple and asks why he has been brought here. Cyndi, still crying, tells the man that something was stolen from this car—the car he worked on—and they want it back. She expects him to give it back right now, so that no one will suspect her or her sons. Either that, or she will call the police.

At first, the man says nothing. He's still sizing up the situation. Then, looking directly at the American couple, he speaks. *"Robo nada."* I stole nothing. If something was stolen, then call the priest, not the police. If you call the police, you have to satisfy them. But if you want to know who did the stealing, call the priest. He will come and bring the holy oil. He will put a drop of the holy oil on the hand of each of us. When the holy oil touches the hand of the thief, smoke will rise, and we will know for sure who is the thief. He turns toward Cyndi, points at her, and orders her to call the priest now.

Silence.

The boys look at each other. Cyndi looks at the couple, and the couple is speechless. The man orders Cyndi again, *"Llame el padre."* Call the priest. The couple's little boy, about seven years old, has been in the back seat of the car throughout the confrontation. Now he puts his head out the back window and pleads with his mother to go. She looks at her husband, they nod to each other and return to the car. Without another word, they drive away.

• • •

South of Emilio Carranza, the landscape begins to rise and fall in increasingly steeper hills, and the mountains close in on the highway from the west. Dark sand beaches and white surf pop in and out of view to the east, then I lose sight of the coast entirely as I drive south along the curving highway. I pass a sign pointing the way to the Laguna Verde Nuclear Plant. Two sleepy, teenage Mexican soldiers with machine guns stand guard at the gate. That's a scary thought, no matter how you approach it: a Mexican nuclear plant. The highway takes a wide, sweeping curve and a gravel road on the left leads to the village of Villa Rica.

The state of Veracruz, someone once observed, is one huge, outdoor museum of history. The problem is that there are no signs to guide or inform the curious traveler. Places of great historical importance are totally unmarked, and nowhere is that more true than at Villa Rica, arguably the most important historical site in all of North America. For it was here, almost five hundred years ago, that Hernán Cortés brought his fleet to anchor, came ashore, and founded the first European settlement on the mainland of North America. He built a small fort here, and it was from this base camp that the greatest conquistador started his bold march inland, toward the Aztec capital of Tenochtitlán.

On the road to Villa Rica, Veracruz, with the Cerro del Metate in the background

Ruins of Cortes's original fort above Villa Rica, Veracruz

Astoundingly, there is no sign anywhere in or around Villa Rica—neither on the highway nor in the little town—that acknowledges the importance of this historic place. The only fact or feature that might cause a traveler to take notice is the striking mountain that rises on the west side of the highway, opposite the town. The east side of the mountain, known as the Cerro del Metate, is a sheer rock wall that rises about a thousand feet above the highway, facing the ocean. A gravel road leads off the highway and up to the ruins of Quiahuitzlán, the sacred burial grounds of the Totonac people.

I resolve to take the road to Quiahuitzlán a little later. Right now, I want to check out Villa Rica, so I turn east, toward the shoreline. A potholed, blacktop road crosses through rich, green pastureland. About a mile down the road, three Mexican women stand together, talking and laughing. As I approach, the ladies turn to me, and I ask if there might be someone in the town who can show me what remains of the history of Villa Rica. They look at each other and giggle.

In the course of a short conversation, it becomes clear that they have no awareness of any particular history in Villa Rica, except the Totonac cemetery on the side of the mountain. They urge me not to miss the view over the ocean from *los dos quebradas,* the two rugged promontories beyond the town. As I am about to walk back to my truck, one of the women recalls something else. There are ruins, she says, of an old fort, a Spanish fort, she thinks. You can follow that dirt road to the left, she tells me, follow it up the hill, then take the second road on the right. Down that road, near the top of the hill, on the left hand side, out in the tall grass, you will see the foundation of the old fort.

I have read about the fort that Cortés and his men built in 1519, and ten minutes later, following the woman's directions, I have found it. Again, there is no sign or marker, but the ancient stone foundation is there, in excellent condition. The afternoon light is bright and clear, and tall grass is waving in a stiff breeze from the sea. The stone foundation stands over two feet high, and the structure must have been much larger, at least fifty yards from one end to the other. There's no mystery why Cortés picked this site for his fort. From this hilltop, he would have had a clear view for miles up and down the coast, but today, with the trees that have grown up on three sides, I can't see a single house in the town. All I can see, beyond the tall grass and trees around the foundation, is the Cerro del Metate to the west and the Gulf to the east. I have with me, among thirty or so books, a copy of Bernal Díaz del Castillo's *The Discovery and Conquest of Mexico.* I take the book out and sit down on the foundation. Soon I have located the passage that I recall reading several years ago:

> Cortés himself was the first to start carrying earth and stones and to dig the foundations; and all of us, captains and soldiers alike, followed his example.

After I ponder for a while the fact that Hernán Cortés might have placed the very stones on which I am sitting, I begin to wonder what else I might be able to find around Villa Rica. I know that Díaz wrote of a protected cove where Cortés anchored the twelve ships of his fleet. And across the field, toward the ocean, I see a shallow lake on the south side of the little town. I follow the dirt road back to the asphalt pavement and take a right turn. This dirt road ends at the edge of the lake. To my left are the beach and the surf. A huge rock rises from the blue waters of the Gulf, about a mile offshore. That would be Punta Rica. Bernal Díaz mentioned that rock in his account of finding the landing site that Cortés would call Villa Rica.

Today, there's an expanse of sand—three hundred yards at least—between the shallow lake and the sea. But the lake, if it were deeper, as it might have been five hundred years ago, would have formed exactly the kind of cove Díaz described. This, I figure, must be where Cortés anchored his fleet in the spring of 1519.

The sandy road into the center of Villa Rica takes me past groves of palm trees and several huge flamboyan trees. The little village is set in a lush, tropical landscape by the sea, but it looks like most every other village along this part of the Mexican coast. There are no signs of the desperate poverty of the northern coast, but there is also no evidence of economic progress or even the bustle of everyday business. The quiet, sleepy look of Villa Rica is a reminder that the Mexican Gulf Coast, between Veracruz city and Tampico, has been almost entirely overlooked in terms of development. That will certainly change one day, likely soon, but it hasn't happened yet.

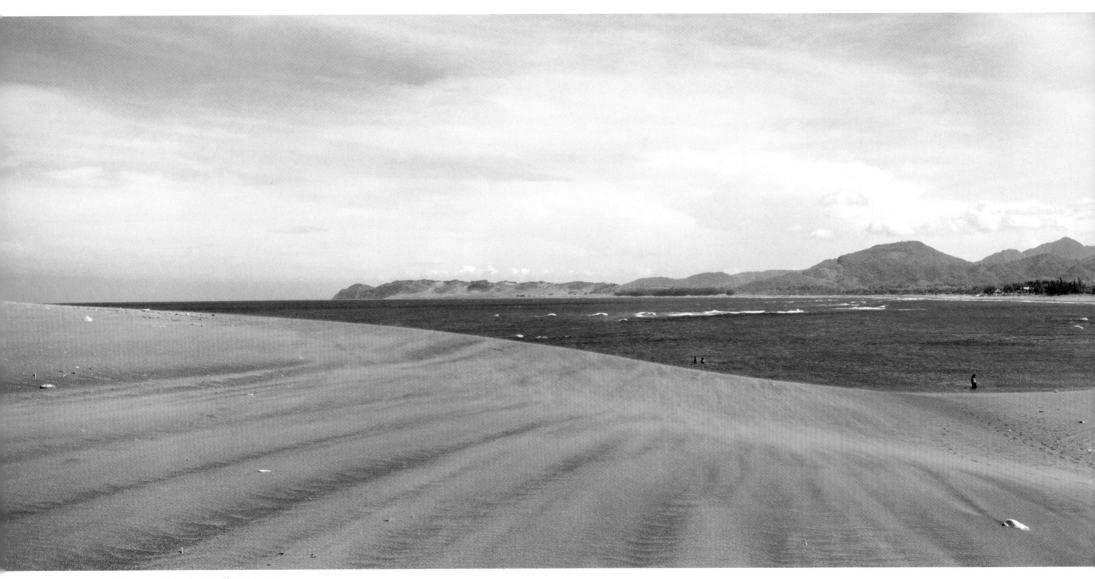

Cove and beach at Villa Rica, Veracruz

Despite the pristine, beautiful beach and the clear blue waters of the Gulf at Villa Rica, there's not a single hotel in the town.

In the center of Villa Rica, opposite the beach, one tiny store is open for business. Two men sit side by side in plastic chairs on the porch, in the shade of a palm tree, drinking beer. They nod and eye me with curiosity as I approach. The two hours I have spent photographing in the sun have dehydrated me, so I buy two two-liter bottles of water and sit down to rest and drink, all the while trying to imagine how Cortés and his army could have dealt with this heat and humidity. Carrying a view camera in this weather is one thing; wearing a suit of armor and fighting for your life in these conditions is something I cannot imagine.

A wide, sandy road leads north from the center of Villa Rica, past a few homes and up toward a broad promontory jutting out into the Gulf. Along the way, someone has tacked a hand-painted sign onto the trunk of a palm tree, "Los Quebradas," with an arrow pointing up a footpath. I can see that I am facing a long, hot walk across the sand and up to the top of the promontory, but it's late afternoon now, and the heat has begun to let up a bit. I grab my view camera and start up the path, which leads directly onto a large sand dune. Several hundred yards away, across the sand, I can see the promontory rising out over the water. My feet sink into the coarse, volcanic sand as I walk. I have the big camera and tripod slung over one shoulder, and a bag with film holders on the other. I'm huffing, puffing, and sweating mightily as I trudge through the deep sand. At the base of the promontory, the dunes end and dense vegetation begins. Another footpath leads through heavy brush toward the summit. As I climb, I have to stop every five minutes to get my breath. The thick vegetation is cutting off every trace of a breeze. After about twenty minutes, the trail ends, and I emerge from the brush. The view over the sea from the top of the promontory is breathtaking.

I have arrived at this beautiful place at the perfect time on a perfect day. A few white clouds drift overhead in a crystal blue sky. The sun has dropped behind me, over my right shoulder as I look out to sea, so that the sunlight sparkles across the surface of the ocean. Two deep ravines, *quebradas,* cut through the promontory and drop, in a series of descending rocky ledges, to the surf below. I have to brace myself against the wind gusting from the sea. Gigantic chunks of volcanic rock stand in the earth, amid cactus, maguey, and tall grass. As the sun alternately slips behind the clouds, then emerges again, the landscape, the rocks, and the sea fall into shade, then come alive again with light. The wind continues to blow in my face. It whips my cap from my head and threatens to take my tripod and camera. I lean into the wind and make my way cautiously to the edge of the promontory. The vast, sparkling expanse of sea lies below me.

Surely this is the most beautiful site on the entire Gulf Coast, and yet there's not another person in sight, not a trace of another human being. The magnificent vista out across the sea takes my mind back five centuries, to what has been called the greatest event in all of history: the Discovery of the New World. At this moment, standing on the edge of the New World and looking over the sea toward the land from which the conquerors came, I recall the words of one of the conquistadors:

It was a miracle that these wonderful lands remained unknown to the rest of the world through all of history, and were saved by God to be discovered in our time . . .

• • •

The discovery of the New World was not so much a moment in history as gradual revelation that occurred over several decades. Despite the great scientific and intellectual advances of the Renaissance, European knowledge of geography in the late fifteenth century was still primitive, and Christian understanding of creation was derived entirely from the Bible. Still, Europe was haunted by stories of strange, undiscovered civilizations to the west. European geographers already believed the world was round, but there was not so much as a hint of knowledge of the large land masses to the west of Europe that would eventually be known as North and South America.

All the oceans and seas of the world were thought of as one—*el Mar Océano,* the Spaniards called it—the Ocean Sea. After Columbus's first voyage and arrival on San Salvador, that part of the world now known as the Americas was shown on maps as a cluster of islands, known to be inhabited by exotic and primitive peoples. But these people were considered to be not "like us," not even descended from the same creation as that of the Bible. Europeans debated whether these newly found people had souls, whether they were the human remnants of time before the Fall, living in blissful ignorance, or whether were they barbarous, corrupted creatures, debased by the touch of the Devil himself.

Christian nobles, in carrying out their prolonged wars against Mohammedanism, had acquired a taste for exotic goods from the east. As the wealth and power of the Christian nations increased, there was increasing speculation as to the possible existence of a direct trade route to Asia. On four successive voyages, Columbus continued his determined search for a passage to Asia. He explored the Caribbean, including the northern shore of Cuba, which he believed to be a peninsula of Asia, but he never found the mainland of America. Nor did he find the hidden sea that we now call the Gulf of Mexico, though he came close. On his second voyage, sailing north of Cuba, Columbus saw what he described in his journal as "seas rushing westward like torrents from the mountains." Doubtless, he was looking west into the Straits of Florida, which would have led him into the Gulf of Mexico and, almost certainly, to the discovery of the mainland of North America. But Columbus, the Admiral of the Ocean Sea, turned away from the rushing waters and afterward demanded that his each of his crew, under threat of having their tongues cut out, attest that the coastline that they had been sailing—the northern shore of Cuba—was that of a peninsula, not an island. As a result, Columbus died clinging to the belief that Cuba was a peninsula of Asia and without seeing the Gulf of Mexico.

By 1509, five years after Columbus's last voyage, Spanish sailors had circumnavigated Cuba, crossed to the Yucatán, and looked across the vast waters of the Gulf. Their voyages marked the beginning of the age of discovery and exploration of the Gulf of Mexico and its three thousand miles of

Gulf of Mexico looking east from the promontory at Villa Rica, Veracruz

Gulf of Mexico looking northeast from the promontory at Villa Rica, Veracruz

The Spanish fleet disembarks in Mexico; from a sixteenth century history of the conquest of Mexico

coastline. Long before any significant activity by the English on the Atlantic coast, this Spanish Sea and its coastline became the great avenue for the discovery, exploration, and settlement of the New World.

By 1510, Spanish explorers touched the shore of Florida, and Ponce de Leon's voyage of 1513 left little doubt that a huge landmass lay north of Cuba and west of the Bahamas. Then, the action shifted back to the other end of the Gulf Coast, back to what we now call the Yucatán Peninsula, where events began to unfold at a rapid pace. In 1517, the Spanish explorer

Francisco Hernández de Córdoba crossed from the southern tip of Cuba to Cabo Catoche on the tip of the Yucatán, where he saw evidence of Mayan civilization for the first time. He was received by a Mayan chief at a town he called "El Gran Cairo" then was attacked by Mayan warriors near today's Campeche. Half his men had died by the time Córdoba returned to Cuba, but he brought back pieces of gold, which he understood had been traded from people to the north of the Maya. That was enough to start a chain reaction that would shape the history of the world.

Within a year, a second Spanish expedition, under the command of Juan de Grijalva, sailed from Cuba. When they became desperate to replenish their water supply, Grijalva and his men went ashore near where Córdoba had stopped the year before. Another fierce attack ensued, in which Grijalva was seriously wounded by an arrow to the mouth. The Spaniards retreated and sailed farther along the coast, eventually entering the gushing waters of the Río Tabasco. Indians lined the shores of the river, waving their turtle shell shields and marveling at the "floating castles" of the Spaniards. Grijalva received a native chief aboard his ship. They exchanged gifts, and from the chief Grijalva learned of great mountains to the north, rivers abounding in gold, and—at a distance of sixty days' journey across the land—another ocean. One by one, the clues were coming in, and the Spaniards were beginning to see the big picture: perhaps they had discovered not just a series of islands, but a vast continent.

Leaving the Río Tabasco, Grijalva sailed north along what is now the coast of the state of Veracruz and landed on a little island inside a reef. There, an Indian guide led him and his men up a stone staircase to a temple where they found a bloody altar and a plumed idol. Severed human heads and rotting bodies with their chests cut open lay at the base of the temple. Grijalva named the place Isla de los Sacrificios, the Island of Sacrifices, then crossed to the mainland coast, where he was welcomed by the local people, Totonac Indians. From them he learned of a great city to the west, beyond the mountains, the center of a vast empire that ruled the Totonacs and other people of the land. The empire, according to the Totonacs, had laws, ordinances, and courts of justice. From this, and from the size of the rivers, the height of the snow-capped mountains, and from the diversity of the cultures and languages they had found, the Spaniards understood, perhaps

for the first time, that they were indeed on a continent and that it was populated by diverse peoples, some of relatively advanced civilizations.

When the news of Grijalva's discoveries reached Cuba, the effect was electrifying. Governor Velásquez moved immediately to fund and assemble another expedition. In doing so, he turned to a man who, in only few years time, had made a fortune in Cuba, Hernán Cortés. Cortés had abandoned his plans to enter the legal profession and left Spain at the age of twenty-two. He had come to the Indies to seek his fortune, settling first in Hispaniola, where he earned a reputation as a gambler and a womanizer. Then he moved on to Cuba, where he established a hacienda on the eastern end of the island. By 1518, when the Grijalva expedition sailed for the Yucatán, Cortés was a wealthy man. His ambitions, however, went far beyond mere wealth. A frequently told story of Cortes during this period related how he had sworn that he would either die to the sound of trumpets or on the scaffold. Hernán Cortés was waiting for his chance to make history, when the call came from Velásquez to help fund and to lead the next expedition.

The objectives of the expedition were stated in Velásquez's order to Cortés: he was to advance the discovery and exploration of the newly discovered land, establish the basis of trade with its peoples, and—in a phrase that suggested some of the great mystery and romance that the venture held—he was to make every effort "to know the secret of the said island and lands" he would explore. The customs and manners of the people were to be recorded. The kinds of flora and fauna were to be described in detail. The reports of people with gigantic ears, of giants and dwarfs, of Amazon women and men with the faces of dogs, all this was to be determined and noted. Unstated, but perhaps abundantly clear to all concerned, was the objective of determining how much gold there was in the new land.

Less than six months after receiving the appointment from Velásquez, Cortés had assembled a fleet of eleven ships. He had recruited an army of 530 Europeans, including thirty crossbowmen and twelve skilled harquebusmen. He had purchased fourteen pieces of heavy artillery and had found two hundred Cuban natives, as well as a number of Africans, to serve as servants and porters. Cortés was also bringing what would prove to be his secret weapons: sixteen horses and a pack of wolfhounds, trained for warfare.

Aztec spies watching a Spanish ship in the Gulf, from the sixteenth century Códice Durán

On November 18, 1519, Cortés's fleet departed Cuba, sailing along the south coast of island, then crossing to the Yucatán. There they coasted down to the island we now call Cozumel, where they, like Grijalva, saw pyramids and other signs of Mayan culture. Then Cortés had his first stroke of luck. A native canoe from the mainland came out to meet the Spanish fleet, filled with men who looked like natives. One of the men turned out to be a Spaniard, Jerónimo de Aguilar, who shipwrecked on the Yucatán in 1511 and had been held captive by the Maya. Aguilar had learned the Mayan language, and now he came to join Cortes's expedition. Aguilar became the first of two interpreters who would eventually prove crucial to Cortés as he plotted and maneuvered to conquer Mexico.

Next, the fleet rounded the tip of the Yucatán, sailed west along its northern coast, then turned north, following the route that Grijalva had traveled a year earlier. Cortés finally disembarked at Potonchan, at the mouth of the Río Tabasco. The natives had turned hostile there since Grijalva's stop, and they sent word to Cortés: "We have no more gold . . .

you will be killed if you do not leave . . ." Cortés put the cavalry ashore to face tens of thousands of frenzied, attacking Indians, and the Spaniards defeated the enemy hordes with hardly a casualty of their own. The vanquished Indians brought gifts, including women. One of the women, said to be the disinherited daughter of a local lord, was known as Malinali, or Malinche. When Cortés noticed that she spoke both Mayan and Nahuatl, the Aztec language, he knew that he had stumbled upon the key to his ambitions; he had found a way to speak to the Indians. Through Aguilar he could speak to Malinche in Mayan, and then through her he could speak to the Indians in Nahuatl. From that point forward, Malinche and Cortés became inseparable. She became his mistress as well as his translator, and she became known in Mexico as La Malinche, the traitor, the betrayer of her own nation, the one who delivered Mexico to foreigners.

The Cortés fleet sailed on, reaching the Isle of Sacrifices in mid-April of 1519. From the crow's nest of the fleet's flagship, Cortés could have seen inland all the way to the 20,000-foot, snow-capped peaks of the Orizaba range. If he did, and if Malinche had begun to tell him what she knew of the mighty Aztec Empire, then Cortes's bold plans must have begun to take shape at that point. Totonacs paddled out from the mainland in canoes to meet the fleet, bringing gifts of lavish foods, feathered cloaks, and gold ornaments. In return, Cortés gave them cloth shirts and doublets. On Easter Sunday, a regal Aztec steward came in person to greet the Spaniards. The steward's name was Teudile, and he arrived to great fanfare, dressed in a parrot-feathered cloak, in the name of his majesty, Montezuma II, ruler of Mexico. Teudile had been ordered by Montezuma to welcome the Spaniards, to supply and feed them, and to offer them gifts. He began by putting a damp finger to the earth and then raising it to his lips, for to "eat dirt" was a gesture of great respect in the Aztec world. Then he lit incense and bled himself, offering the Spaniards food sprinkled with his blood. It was the beginning of Spanish exposure to the complex and exotic rituals of the Aztecs. Teudile and his entourage then watched as the Spanish soldiers knelt and offered their Easter prayers to a simple wooden cross set in the sand.

When the prayers were done, Cortés ordered the cavalry to charge up and down the beach, swords drawn and flashing, in mock combat. Then he fired his cannons at close range, causing the earth to shake. The Aztecs fell to the ground in fear. The artillery blasts scorched the earth and obliterated entire trees. The intended audience for the demonstration of Spanish killing power was not just the Aztec contingent, but Montezuma himself, who would hear all the details in due time.

The Spaniards had already glimpsed the grisly evidence of human sacrifices, but they had no idea of the complex religious beliefs of the Amerindian people, including the Aztecs. At the core of their religion was an absolute belief in magic, in dreams and auguries, and in the recurrence of time. When the Spaniards finally did get a sense of Aztec belief in magic, they dismissed it as a naive network of superstitions, but it was far more than that: it was a coherent system of thought, a true philosophy. They believed in a cyclical universe, in which the world ended, only to begin again. The Western idea of linear time—born in the past, flowing toward the future, then ending—was totally foreign to Amerindian culture. Nor did they accept the idea of an omnipotent, all-controlling god. Although both the Aztecs and the Maya had developed remarkably accurate calendars, their goal was not to master the laws of the universe, but to perceive their destiny.

Amerindian cultures also shared a belief in the sacred nature of the earth. The great earth mother took different forms in various cultures, but always the earth was the source and the sustainer of all life. The natural world that surrounded Amerindian people was seen as far more than decoration. It was a physical expression of divinity, and as such it was to be respected, even worshipped. They would pray to their gods to ask permission to cut down a tree, and the idea of anyone "owning" a piece of the land was incomprehensible. Tilling the soil, cultivating crops, digging mines, and even taking clay to make pottery were all profound acts that required the blessing of the gods. The Amerindian relationship with the mother earth was also expressed in their festivals, their holy days, when men danced, striking the ground with their bare feet, as they offered homage to their deity.

When Cortés and his army arrived on the coast of Veracruz, encountered the Totonacs, and defeated them in the first battle, reports were immediately taken to Montezuma. For more than ten years, a series of strange and ominous events had been observed, which the Aztec people saw as terrible omens. First, a great pyramid-shaped light had risen at midnight, glowing above the cones of the volcanoes, "bleeding fire like a wound in the

eastern sky." Each time the light appeared, the end of the world was forecast. Then, a mysterious fire erupted at the top of the pyramid of Huitzilopochli, the Aztec god of the underworld. Soon after that, the temple of the god of fire was struck by lightning. These events were ominous and threatening, and they continued.

A bright, three-headed comet flashed across the eastern sky, obscuring the sun and causing crowds of people to fall to their knees, weeping and moaning at midday. The waters of a major lake boiled up and destroyed many homes, and a female voice was heard crying in the night. The omens went on and on. Human monsters with two heads were spotted near Tenochtitlán, the Aztec capital, then suddenly vanished. The Aztec wise men interpreted these omens as harbingers of the end of the world, or at least the end of their race.

In the midst of all these frightening omens, came a peasant man from the Gulf Coast, begging for an audience with Montezuma. When granted that audience, the frightened man fell to his knees before the ruler and reported:

> Our lord, forgive my boldness. But on the shores of the Great Sea I have seen a small mountain, floating on the water. It moved about, never touching the shore. Our lord, no man has ever seen the likes of this.

That report was soon bolstered by Totonac messengers, who came reporting "floating castles" on the sea, inhabited by bearded, fair-skinned men. To Montezuma, there was only one way to account for these strange men: Quetzalcoatl, the "white god," the "bearded one," who had departed years ago into the Great Sea, promising to return, had come back to reclaim his kingdom and his throne. The only hope Montezuma had of saving his empire was to bribe the returning god, so that perhaps he might leave again. Gifts of gold, emeralds, and precious metals were collected and sent by Montezuma to the coast with Teudile. It was a strange and ambivalent greeting that the ruler was sending: he was welcoming the Spaniards with gifts, while giving explicit orders that, under no circumstances, should they be allowed to come travel inland to the Aztec capital.

Cortés sinking his own ships in the bay at Villa Rica, an anonymous sixteenth century Spanish painting

After Teudile and his delegation met with the Spaniards, runners were dispatched to Tenochtitlán, where Montezuma awaited word of the results of the meeting. According to Aztec scribes, when Montezuma heard the reports, "it was as if his heart fainted . . . as if he were conquered by despair."

> Their arms and their clothing are all made of the white metal, iron; they dress in white metal and wear it on their heads. Their swords are of iron, their bows are of iron, their shields and spears are of iron. They have deer which carry them wherever they wish to go. Our lord, these deer are as tall as the roof of a house!
>
> They cover their bodies, except for their face. Their skin is white, like lime. They have yellow hair, though some have black. Their beards are long and yellow, and their mustaches are yellow. Our lord, their hair is curly, with fine strands.

Emissaries of Montezuma meet Cortes on the road, then return to tell the distraught ruler, from the sixteenth century Códice Florentino

Their food is like human food, but strange. It is like straw, with the taste of a cornstalk, but tasting also as if of honey . . .

Their dogs are enormous, with yellow eyes that flash fire. The dogs bellies are hollow, and they have long and narrow flanks, and they leap about, with tongues hanging . . .

Were they gods or were they strange men from another place? Montezuma could not possibly know for sure, but all the omens suggested they were gods, most likely Quetzalcoatl himself, along with a supporting cast of other divinities, returning to claim his empire.

At this point, Cortés must have realized that he had, in fact, found not only a new land, but also a kingdom to conquer, and he must have begun to plot that conquest. He had no way of knowing if Montezuma or others might attack him or from what direction, but it was clear that his initial camp, located on the mainland close to the site of today's Veracruz city, left his forces vulnerable. So he dispatched two ships north along the coast, with instructions to look for a better place to settle. The ships sailed as far north as Cabo Rojo, then returned and reported that they had found a protected cove forty miles north, near the Totonac village and sacred burial ground called Quiahuitzlán. Cortés immediately dispatched his fleet of ships there, with orders to anchor and await his arrival. Then, he began an overland march toward the same site. Along the way, Cortes and his army passed through Cempoala, by far the largest town the Spaniards had seen in the New World. It was a glistening city of whitewashed buildings and luxuriant gardens. The chief of Cempoala came out and embraced Cortés, presenting him with lavish gifts, and complaining to the Captain-General about Montezuma and the Aztecs, who demanded tributes of the Totonacs, including their sons and daughters for sacrifice. In the Totonacs, Cortés had found the first of many Native American allies that would join him in his effort to conquer the Aztecs.

Arriving at Quiahuitzlán, Cortés immediately set about building a fort and establishing a small settlement. That was the same fort whose foundation I had seen earlier in the afternoon, up on the hillside in Villa Rica. When the fort was done and the settlement was underway, Cortés named the place Villa Rica de la Vera Cruz, the Rich Village of the True Cross. For Cortés, founding a Spanish town, making himself and his men its first citizens, and having himself elected the captain-general, was more than a formality. By Spanish law, the citizens of a town have certain rights, one of which is to be governed directly by the Crown. In founding Villa Rica de la Vera Cruz, Cortés was making himself responsible only to the Spanish king and legally freeing himself of any responsibility to Velásquez, the governor of Cuba who had sponsored the expedition and selected Cortés to lead it. As soon as he had founded Villa Rica and had himself elected captain-general, Cortés dispatched a ship directly to Spain. On board was a treasure trove of exotic gifts "from the new land of gold" meant for King Charles.

There were elaborate mosaics, a giant gold disc representing the sun and a silver disc representing the moon, sculpted jade animals, gold-crusted ornamental spear throwers, and fantastic feathered cloaks. With these gifts and with his first letter to the king, which conveyed the news of the settlement of Villa Rica, Cortés was solidifying a brilliant legal construct that gave him what he wanted: the right to march inland, "to know the secrets of the place," to explore, and to conquer whatever kingdom he found.

To some of Cortés's men, the prospect of a march on the Aztec empire seemed outrageous, even lunatic, and so a rebellion formed among the Spaniards. The plan was to seize one of the ships from the fleet and sail back to Cuba. Cortés got wind of the rebellion and had the two leaders brought to him. One was hung, and the other had his feet cut off. Then, in a daring act of resolute confidence—or sheer foolhardiness, depending on your perspective—Cortés scuttled all his ships.

It happened right there, nearly five centuries ago, in the cove below the promontory where I am standing now. Cortés had all his ships stripped of their sails, their metal fittings, oars, and other gear. Then the ships were all sunk. It was a roll of the dice, a gambler's throw, and it guaranteed that there would be no looking back. The way ahead was two hundred miles inland, over the towering mountains and down into the Valley of Mexico. In the Aztec capital of Tenochtitlán, Montezuma awaited them, haunted by magic and ancient prophecies, but with hundreds of thousands of Aztec warriors at his call.

Cortés's army of roughly five hundred soldiers marched across the coastal plain, climbed to over 11,000 feet as they crossed the mountains, then descended into the valley of Zautla, home of the Tlaxcalans, old enemies of the Aztecs. Cortés's attempt to conquer Mexico very nearly ended there. The Spaniards faced a Tlaxcalan army estimated at 150,000 warriors, in a desperate battle in which the Indians suffered terrible losses. Still, by nightfall the Spaniards were on the brink of defeat. They retreated to a small hill, where they took refuge, holding out for two weeks as they continued to kill Tlaxcalans by the thousands. In the end, the Tlaxcalans conceded and asked for peace. They wanted an alliance with the Spaniards in order to take on their real enemy, the Aztecs.

Even more than the superiority of his technology—his iron swords, crossbows, and artillery—it would be his alliances with Native American peoples that would bring victory to Cortés.

Marching now with thousands of Tlaxcalan allies, Cortés continued toward Tenochtitlán. Passing through Cholula, the great pilgrimage city of the Aztecs, the Spaniards feared an attack. Cortés, warned by Malinche of an assault, took the initiative and brutally massacred at least 3,000 Cholulans, destroying their temples and throwing down their idols. Word of the massacre spread to Tenochtitlán. More than ever, Montezuma was paralyzed with fear. No mortals would dare destroy the temple and the idols.

A few days later, the Spanish army and their Tlaxcalan allies came within sight of the Valley of Mexico. They saw vast, shining lakes and deep pine forests. Towns, scattered across the valley, glittered below them. They saw temples rising from the center of the towns, shining like silver in the high, clear air and sunlight. They told each other that they must be in a dream, for nothing so beautiful had been seen before on earth. Their enchantment was mixed with fear of the unknown, and some wanted to turn back, but Cortés would have no part of it. On the night before reaching Tenochtitlán, the army camped on the high plains between the volcanoes.

In a last, desperate effort to keep the intruders from coming to the city, Montezuma sent more gifts. He had learned that the Spaniards, most of all, wanted gold. Cortés had even told Aztec emissaries on the coast that he and his men "suffered from a disease of the heart which is only cured by gold," so Montezuma sent necklaces, streamers, and other objects of gold. His ambassadors watched the Spaniards reaction and reported to the ruler that

> the Spaniards appeared to be much delighted . . . they seized upon the gold like monkeys, their faces flushed. For clearly their thirst for gold was insatiable; they starved for it; they lusted for it; they wanted to stuff themselves with it as though they were pigs. They went about fingering the streamers of gold, passing them back and forth, grabbing them one to the other, babbling, talking gibberish . . .

In the valley the Indians called Anahuac, on the shore of a great lake, the conquistadors stopped and looked at what they had found. Of that moment, Bernal Díaz wrote:

The Conquest of Mexico by Cortés, an anonymous sixteenth-century Spanish painting

And when we saw all those towns and villages built in the water, and other great towns on dry land, and that straight and level causeway leading to Mexico, we were astounded. These great towns and temples had buildings rising from the water, all made of stone, [and it] seemed like an enchanted vision. . . . It was all so wonderful that I do not know how to describe this first glimpse of things never heard of, seen, or dreamed of before.

At dawn on the morning of November 8, 1519, Cortés and his army of four hundred Spaniards entered the causeway toward Tenochtitlán. Montezuma, accompanied by his officers and noblemen, was brought out to greet him. The ruler was carried down the causeway on a litter. Thousands of Aztec people jammed the causeway, and the lake was covered with canoes. It was, certainly, one of the most dramatic meetings of two cultures in the history of the world. The wondrous firsthand descriptions by the conquistador Bernal Díaz del Castillo are matched for drama and beauty by those of the

Aztec chroniclers. Years later, the Spanish Friar Bernardo de Sahagún interviewed the few survivors of Tenochtitlán who had witnessed the coming of the Spaniards. Scribes had recorded their recollections, given in their native Nahuatl tongue, and translated to Spanish. One survivor told how

they came in battle array, the conquerors, with dust rising in whirlpools from their feet. Their iron spears shone in the sun; their pennons fluttered in the wind like bats. Their armor and swords clashed and clanged as they marched; they came on with a loud clamor, and some of them were dressed entirely in iron . . .

Their great hounds came with them, running with them; they raised their massive muzzles into the wind. The dogs raced onward, before the column; they dripped saliva from their jaws.

There are both Spanish and Aztec accounts of what was said between Cortés and Montezuma when they met on the causeway, and, surprisingly, there are only minor differences in the two accounts. The English translation of the Nahuatl account of Montezuma's greeting to Cortés, preserving the characteristic alliteration and repetition of the Indian speech, may be one of the most stirring documents in history:

Our lord, thou hast suffered fatigue, thou hast suffered weariness. Thou hast come to arrive on earth. Thou hast come to govern the city of Mexico; thou hast come to descend on thy mat, upon thy seat, which for a moment I have guarded for thee. . . . I by no means merely dream, I do not merely dream that I see thee, that I look into thy face. I have been afflicted for some time. I have gazed at the unknown place whence thou hast come—from among the clouds, from among the mists. And so this . . . now it has been fulfilled; thou hast come. Thou hast endured fatigue, thou hast endured weariness. Peace be with thee. Rest thyself. Visit thy palace. Rest thy body. My peace be with our lords . . .

Cortés's response, also recorded by Indian chroniclers, was to embrace Montezuma, but that was not allowed. Then

he spoke to them in a barbarous tongue; he said in his barbarous tongue, "Let Montezuma put his heart at ease; let him not be frightened. We love him much. Now our hearts are indeed satisfied, for we know him, we hear him. For a long time we have wished to see him, to look upon his face. And this we have seen. Already we have come to his home in Mexico. At his leisure he will hear our words."

With that, the two worlds had met. Two civilizations, totally unknown to each other a few months earlier, had come face to face. What followed over the next two years was nothing less than a war of worlds, a war in which European technology, mental flexibility, and faith in divine destiny prevailed over Bronze Age weaponry and mystical fatalism. In short order, Cortés would take Montezuma captive in his own quarters; in Cortes's absence, Spanish soldiers would senselessly slaughter hundreds of Aztecs and set off an uprising, ultimately driving all the Spaniards from Tenochtitlán. By all rights, that should have been the beginning of the end of Cortés's attempted conquest of Mexico. But Cortés's greatness as a military leader was yet to be proven. He was forced to pull together his depleted, exhausted, and retreating army in the valley of Otuma and face a massive army of Indian warriors. Outnumbered perhaps a thousand to one, and without their firearms or artillery, the Spaniards fought brilliantly. Cortés, employing military tactics worthy of Alexander the Great, drew his Spanish soldiers into a single line of steel, and they were able to repel one Aztec battalion after another. Finally, Cortés charged around the Aztec flank on horseback and cut down the enemy commander, a tactic never before seen in Amerindian warfare. Seeing their commander killed, the Aztec army lost heart and fled in defeat.

Cortés not only survived that day at Otumba, he ultimately conquered the Aztecs, after an eighty-day siege of Tenochtitlán that left the city in utter ruins. The victory began as a surprise naval attack. Cortes had the fittings of the Spanish ships at Villa Rica brought to Tlaxcala where they were used to fabricate thirteen brigantines—smaller boats, yet big enough to carry cannon—that were launched on the lake. The Aztecs fought to the very end.

Totonac ruins at Cempoala, south of Villa Rica, Veracruz

• • •

The city of Veracruz was relocated three times by Cortés. The first site was in the sand dunes opposite the Isle of Sacrifices, roughly where the modern city stands today. That was nothing but a rough campsite, where the conquistador met the Totonac chief and the Aztec emissaries from Tenochtitlán, and where he struck fear into the Indians by demonstrating his cannons and horses. Then he moved about fifty kilometers north and set up a more elaborate base camp with a small fort at the site he called Villa

Casa de Cortés, La Antigua, Veracruz

Rica de la Vera Cruz, strategically located under the Totonac city and burial ground at Quiahuitzlán. The Villa Rica site is recognized by historians as the first European settlement on the American mainland. But the situation is confused by the fact that yet another location, the town of Antigua, about thirty kilometers south of Villa Rica, is often referred to as the "original site of Veracruz." Antigua was, in fact, the first municipality founded in the New World.

By the middle of the sixteenth century, the Spaniards had begun to mine massive amounts of gold and silver in that part of the New World that we now call Mexico. The riches were channeled down the Camino Real from points as far north and west as San Francisco, California, and Santa Fe, New Mexico. Antigua, located about five kilometers inland from the sea, along the banks of a quiet river, was ideally situated to be the southern terminus of the royal road, and thus became the departure point for what would prove to be perhaps the largest transfer of wealth in the history of mankind.

Today, La Antigua appears to be just another coastal Mexican village. In the center of town, tall palm trees rise above a tiny plaza, where white concrete benches and a red and white concrete gazebo sit under clusters of mango and almond trees. I have to slow down to let a litter of pigs dart across the road in front of my truck. The first church established in the Americas, a simple, whitewashed structure with red trim, faces the east side of the little plaza. A few blocks from the plaza, down a shady cobblestone street, the Casa de Cortés looks like the setting for a horror film. Built by the Spaniards shortly after the conquest, the structure was never actually a residence for Cortés, as some are led to believe, but the center of administration for the handling of goods coming down the Camino Real. From 1525 until about 1600, La Antigua was the heart of Veracruz. Riches from throughout the New World were funneled and collected here on the banks of the Río Antigua, then shipped directly to Spain. Today the Casa de Cortés is the primary tourist attraction of La Antigua. It's ancient walls, built of stone and brain coral from nearby reefs, are covered in parasite vines, giving the roofless building a grotesque and mysterious appearance.

Around the corner from the Casa de Cortés, in the center of another little plaza, a small crowd of tourists wanders among the low-hanging branches of an old tree. I park my truck and walk over to see why so many people are interested in the tree. A young boy approaches and offers, for a hundred pesos, to guide me around the town. I decline the offer but ask him about the tree and all the people standing with one hand on it. He explains to me that this has been positively identified as the tree where Cortes originally tied his ship. I ask him how Cortés got his ship here, since I don't see any water anywhere. Over the centuries, the river has moved, he explains. It used to come right up to the tree. How else, he asks me, would Cortés have been able to tie his ship to the tree? For ten pesos, he offers to tell me all about the magic tree and to demonstrate its powers. I watch as a succession of people walk up to the tree, put a hand on it, and fall into what looks like a state of prayer. My curiosity is getting the best of me, so I agree. Why, I ask him, are all of these people standing in silence with their left hand on the tree?

"*Vibraciones de la historia,*" the boy tells me, with authority. History vibrates in the tree. It has magical powers. Some people can feel the history in the tree, others cannot. Try it for yourself, he offers, leading me to one of the huge limbs, "*Con mano izquierdo.*" He demonstrates, placing his left hand on the limb.

I ask the boy why I have to use the left hand, and he explains that only the left hand can feel the history. I should have known. I place my left hand on the rough bark of the limb. Then, adopting the gesture of others around me, I drop my head, close my eyes, and wait to feel the vibrations of the tree. After about thirty seconds, I inform my young guide that the vibrations aren't happening for me. What about him?

"*Sí. Hay vibraciones muy fuertes. Muchas veces los gringos no puede sentirlos,*" he says matter-of-factly. The vibrations are strong. But many times gringos, like me, can't feel them. Then he asks me for ten pesos for his services.

Because I'm a gringo?

"*Sí.*"

I give him ten pesos and watch as he runs toward the nearest store.

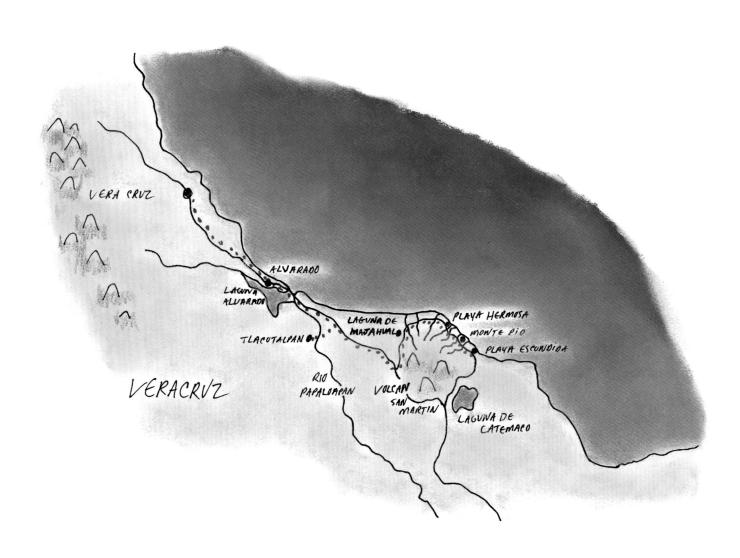

THE SUN IS RISING over the sand dunes that line the new *autopista* from La Antigua into Veracruz city, or Puerto Veracruz, as the locals call it. The dunes along the roadside are mostly covered in grass, providing fenced pastureland for a succession of ranches. Cattle graze among billboards that tempt the traveler with images of city pleasures that lie ahead. My mouth waters at the sight of a juicy, full-color, twenty-foot cheeseburger planted in the sand.

The entry into the city from the north is surprisingly quick and easy. The *autopista,* passing through a zone of commercial warehouses and truck dealerships, is reduced to a four-lane boulevard. The entry road to the Port of Veracruz bears off to the left, and most of the traffic heads in that direction. A quarter of a mile later, the road is reduced to two lanes and crosses over an old, arched bridge. The skyline of Veracruz, the oldest city in the New World, lies ahead. There are no gleaming towers or modern structures in the panoramic vista of the old city from the top of the bridge. It's not the dramatic skyline I had expected, nor is it an especially pretty one. No modern buildings are in view. Instead, there are lots of old, fancy, filigreed rooftops, palm trees, and commercial buildings in faded pastel colors. There is a sense of *age,* of things having been weathered by time and the elements, and of that uniquely Mexican way of letting things go. I recall my entry into Tampico a couple of weeks ago, and I am struck by the contrast. There is nothing California about *this* place. Havana, perhaps, but definitely not San Diego.

Railroad tracks pass under the bridge, crisscrossing the shipyards of the port. Tankers and cargo ships sit at berth, waiting to be loaded. As I drive over the bridge and enter the city, I notice the Hotel Buenos Aires on my right. Three women are standing in front of the two-story hotel, the door is open, and the sound of music drifts out of the hotel bar. Judging from their short skirts, boots, and posture, I assume the women are looking for business from the shipyards.

I have arrived at the Plaza de la Independencia, one of many plazas in the old part of the city. An elegant old post office building sits on the east side of the plaza. A flock of pigeons, along with a year or more of their droppings, cover its Corinthian columns. A cast iron statue of Benito Juárez anchors the north end of the plaza, but its marble base has been shattered, and chunks of marble lie all about.

I park my truck just off the plaza and stroll toward the *zócalo,* trying to get my bearings and reacquaint myself with the city. I have passed through Veracruz many times, usually on my way back to Texas from Oaxaca, and occasionally I stopped for dinner or spent the night. I would listen to the marimba bands and drink coffee in one of the old cafes on the square, but I never took time to explore the city. I knew Veracruz's reputation as the liveliest of Mexican cities, and then, as now, it reminded me most of what I imagined Havana must be like. With its balmy tropical atmosphere, its decaying old buildings with their elegant balconies, and its vibrant, sensual music, Veracruz always seemed to belong at least as much to the Caribbean as to the Gulf Coast.

From my parking spot on Calle Eparan, I walk south, across the *zócalo.* There, under long rows of almond trees, a dozen shoeshine stands have opened. Old, black cast iron benches form a perimeter around the central fountain, and they are beginning to fill with people. It's barely nine o'clock in the morning, but the *zócalo* is already alive with activity. On the corners of the square, vendors sell balloons, candy, and magazines. The big arched doors to the cathedral, on the south side of the square, are open, and I follow the crowd inside.

The space inside is dark, immense, and fragrant with incense. A vaulted ceiling rises perhaps fifty feet above the altar, but my eye is drawn to the series of alcoves along the side of the main vestibule, where carved figures of saints sit inside glass cases. Below each saint, on the ancient wooden floor, hundreds of tiny candles burn, each representing a prayer to the saint. Some of the glass cases have ribbons and tiny photo portraits hanging from them, and cross-shaped smudges on the glass itself. Those who have prayed have left images and made marks on the glass to remind the saint of their prayers.

Directly across Calle Independencia from the cathedral, the Gran Café del Portal awaits those who seek the perfect cup of coffee. Emperor Maximilian is said to have brought Carlota here in 1864. Alexander von Humboldt came to Veracruz not only to study its plant life but also to check out the famous café for himself. Through history, the list of Mexican heroes

who have had coffee at the Gran Cafe del Portal is truly impressive, including Benito Juárez, Venustiano Carranza, and Porfirio Díaz. Even Harry Truman, if the café's promotional literature is to be believed, came to sample the famous coffee and milk concoction they call the *lechero*. The first thing that strikes me, as I enter the café from the portico on Independencia, is its warm and comfortable ambiance. From the original French-tiled floor, to the old wooden beams overhead, and the floor-to-ceiling brass columns, the place exudes age, comfort, and well-being. Waiters in starched white jackets, their black hair slicked back, glide among the tables with an amiable professionalism. A soft hum, the sonorous blend of all the voices in the room, hangs pleasantly in the air. Every few seconds, from somewhere around me, there comes the soft ting-a-ling of a spoon tapping on a glass. I watch as one waiter, carrying two silver pitchers, answers the ting-a-ling. He is the man who brings the authentic ingredients and pours the *lechero* in the time-honored way—with drama and flourish—to the specific requirements of each patron.

On a marble counter in the back of the café, two gigantic coffee makers sit side by side. Each one is six feet in diameter and eight feet tall, made of polished silver topped with a set of brass wings. A busy crew of Mexican baristas rush around them, as they sit puffing steam, like two mighty rockets ready for blastoff. The aroma of the rich, jet-black coffee drifts through the old café amid the tinkling of spoons.

No sooner have I found a seat than a waiter appears, takes my order—*un lechera grande y pan dulce*—then steps away and returns to place a tall glass on my table. In a matter of seconds, the waiter with two kettles appears in front of me. He holds both kettles up for my inspection and awaits my instructions. I have picked up the routine by watching others place their orders, so I point to my glass, indicating the amount of coffee I want. From the smaller kettle, the waiter pours the coffee to that level, about half full. Then, with a flourish—and with perfect aim—he pours the steaming milk from the big kettle in one continuous stream, lifting as he pours, until the stream of milk is a yard high. Not one drop goes astray. The *lechero*, of course, is technically just a caffe latte—coffee, espresso, with hot milk—but what a caffe latte it is! The blend of fresh, whole milk and the rich, aromatic Mexican coffee puts a Starbucks latte to shame.

At the Gran Café del Portal, Veracruz

View to the north from the Veracruz waterfront

By the time I have finished two *lecheros* and studied my map of the city, it's ten o'clock in the morning, and I decide to explore the city streets. A few blocks to the east, on the *malecón,* I find a crowd gathered on the promenade next to the water. In the center of the crowd, several young men in swimsuits stand atop a concrete balustrade, their lean, brown bodies glistening in the morning sunlight. The crowd has gathered to throw coins into the water and watch the boys dive for them. Judging from the time it takes the boys to retrieve the coins, the water couldn't be more than fifteen or twenty feet deep, maybe less, but it's impossible to tell because the water is so murky. Several dozen people, all Mexican tourists, line the concrete wall of the *malecón* as the boys climb to the top of the balustrade, about eight feet above the sidewalk. Most often, three or four boys will dive for the same coin, and one of them will surface after a few seconds, holding up the coin for the crowd to see. The competition among the divers for the tossed coins is spirited, but the rewards are small. Most people seem to be tossing one- or two-peso coins When a big, ten-peso coin flies through the air, half a dozen divers go after it. I have maneuvered myself into the front of the crowd, in a good spot to catch pictures of the divers going over my head, when the boys begin to urge the crowd to move farther down the *malecón.* At first, the crowd doesn't want to move, and the coins continue to fly, but then the boys stop diving. One of the divers points down toward the water, right next to where they have been diving. *"Aqua negra,"* he yells to everyone. Black water?

Looking down into the water, a few feet to the left of the crowd, I spot some sort of dense, black liquid flowing into the water from a pipe under the concrete seawall. In a few seconds, the "black water" has billowed into a huge, dark cloud, barely under the surface. Then the smell hits me, the rank odor of raw sewage. As everyone in the crowd strains to see what's happening, I hear one woman say to her children, *"Son aguas residuales."* Residual water? That strikes me as a fairly benign term for the foulest, most repulsive discharge of sewage that I have ever seen. The divers and the crowd move down the *malecón* about a hundred feet, then the coins start flying and the boys start diving again, oblivious of the dark cloud that continues to move toward them in the water. But the divers and crowd appear to be unconcerned. I can hardly watch, as the boys continue to dive into the polluted water, so I decide to move on. The next thing on my schedule is the city museum.

Walking back toward the Plaza de las Armas, I notice that many of the small, colorful restaurants and bars are beginning to open now. El Tiburón Rojo is advertising a special today, a cocktail of fresh seafood for only thirty pesos, and La Playa Tamiahua offers live *son jarocho* all day, the lively blend of Mexican folk and Cuban *son* music that originated in the southern part of the state. The people of Veracruz, as well as their music and other distinctive traditions, are known throughout Mexico as *jarocho.* The term, I've been told, has its origins in the fact that the ranch hands of Veracruz were known for carrying switches, or *jarras,* to herd their cattle.

The Museo de la Cuidad occupies a two-story, nineteenth-century building on Avenida Zaragosa, in the heart of the *centro histórico* of Veracruz. The receptionist offers a cordial greeting as I enter, but there are no guards, no other staff, and not one other visitor in the museum. The only sound is a feeble stream of water trickling from a massive stone fountain in the central courtyard. My first reaction to the place is that the trickling fountain ought to be a roaring waterfall. That little dribble of water strikes me as a rather puny centerpiece for a museum dedicated to a place with enough history for ten major cities. Still, the little fountain does nothing to dim my excitement or my expectations. A series of rooms surrounding the central courtyard of the museum trace the history of Veracruz in chronological fashion. The first of the rooms contains a set of displays on the pre-Hispanic cultures of the area. Each display is interesting, though a bit worn and dog-eared, distinctly second-rate compared to similar presentations I have seen in the great anthropology museum in Mexico City. So I move along to the second room, where a large map on the wall catches my eye. The map shows the exact routes of the earliest sixteenth-century Spanish explorers who came to the Gulf Coast of Mexico: first, the voyage of Córdoba, then Grijalva, and finally Cortés. I'm reminded of the succession of U.S. space flights from the 1960s and '70s, voyages that probed successively farther into space: the Mercury flights, the earth orbits, then the Apollo voyages.

But what really excite me are two reproductions from the Códice Durán. The codices were compilations of pictograms, collections of simple

Diving for coins on the embarcadero, Veracruz

Railyards in the Port of Veracruz

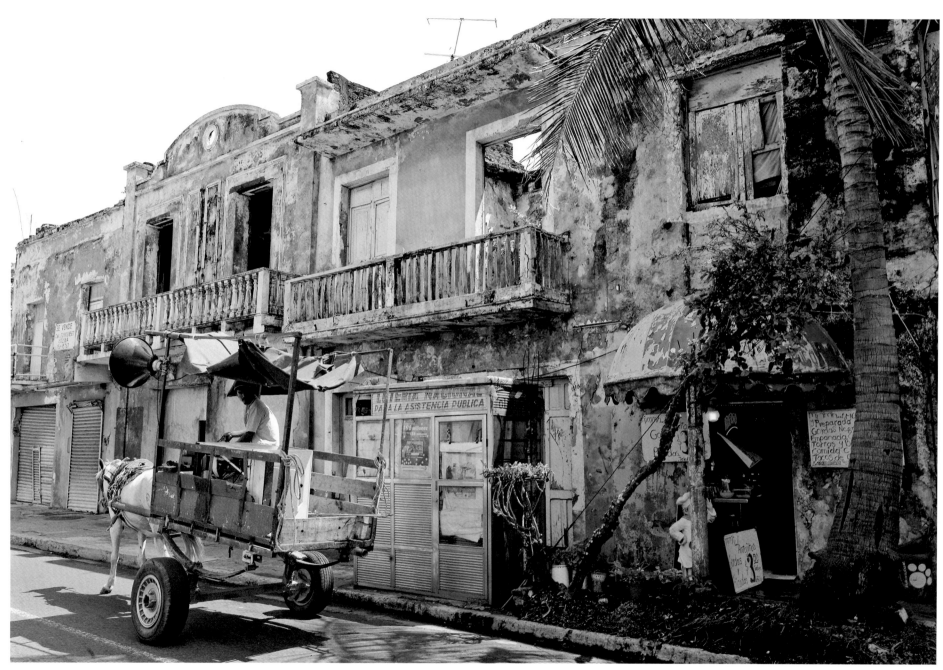

Calle Independencia, Veracruz Centro

pictures representing daily or historical events, put together as books. The codices were done in the decades after the conquest by Spanish friars who employed scribes and artists to record every aspect of indigenous Indian life and culture before the arrival of the Spaniards, as well as the conquest itself. I have seen pictograms from the most famous of all the codices—the Códice Florentino, and a few others—but those from the Códice Durán are new to me, and the enlarged color reproductions stop me in my tracks. Both images are rendered in a style not unlike a child's crayon drawing. The first pictogram shows an Aztec noble watching from his home as a meteor flashes across the sky overhead. A simple gesture by the man, the extending of his right hand out to his side, palm up, suggests the wonder and foreboding the comet must have brought to the Aztecs in the time just before the conquest. The next pictogram depicts a Spanish ship floating on the sea off the Mexican coast. Three sailors peek over the deck, simple figures with dots for eyes, each gazing toward the coastline in apparent wonder. One sailor points toward the land, where a single Indian is perched in the top of a tree. The Indian points back at the ship. Another Indian fishes from a canoe in the water below the tree. The childlike color rendering—blue sea, brown ship, green tree—and the urgent, primal message of the picture—I see you and you see me, but who *are* you?—suggest the wonder and mystery of the first encounters of the two cultures.

In the next room, a large display case houses what appears, at first glance, to be a doll show. Upon closer examination, the miniature figures of people have been arranged under glass to represent a historical event, and even closer examination suggests the horror of the occasion. Most of the dolls represent women and children in their nightgowns, running from sword-wielding pirates. A nearby label identifies the event as the notorious sacking of Veracruz by the Dutch pirate Laurens de Graaf in 1683. The two-day rape and plunder of the city by the infamous pirate led to the building of a wall around the entire city, in order to give protection from future pirate raids.

The history of Veracruz continues on the second floor of the museum, where it moves into the nineteenth and twentieth centuries. Veracruzanos often boast that the city has been "Four Times Heroic," and that is the unstated theme of the narrative and photographs on the second floor. First, there is the expulsion of the Spanish in 1815, then the 1838 occupation of the French Navy during the conflict that came to be known as the Pastry War, and finally, the Mexican resistance to occupations by the United States, in 1847 and again in 1914.

On the way out, passing through the museum's central courtyard, I stop to study several large stone figures from the Olmec culture. Dating as far back as 1800 BC, these massive carvings of Olmec deities are impressive, suggesting a history and a culture that remains shrouded in mystery; no one knows for sure where the Olmecs originated. But the object that provides the best historical perspective is a gigantic fossil of a sea turtle, measuring over six feet wide and estimated to be 100 million years old.

From its center at the intersection of Hernán Cortés and Nicolas Bravo streets, the Mercado Hidalgo sprawls for twelve blocks or more in every direction. The range of goods and services offered along those streets is astounding and—for a photographer with an eye for the confluence of unlikely things and people—exhilarating. There are entire blocks with vendors selling nothing but corn. There are fruit stands filled with mangoes, a dozen varieties of bananas, mandarin oranges, and other fruit that I have never seen before. There is one city block of nothing but chiles: chiles habanero, guajilla, chipotle, ancho, pasila de arbol, serrano, morita, cascabel, and mulato. CDs and DVDs are hawked alongside live chickens and other

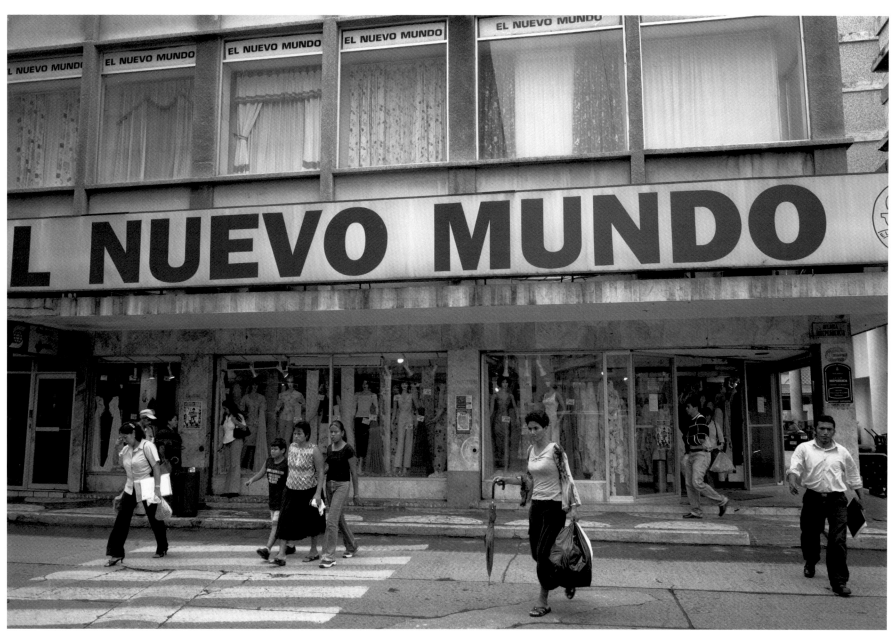

Calle Altamira, Veracruz Centro

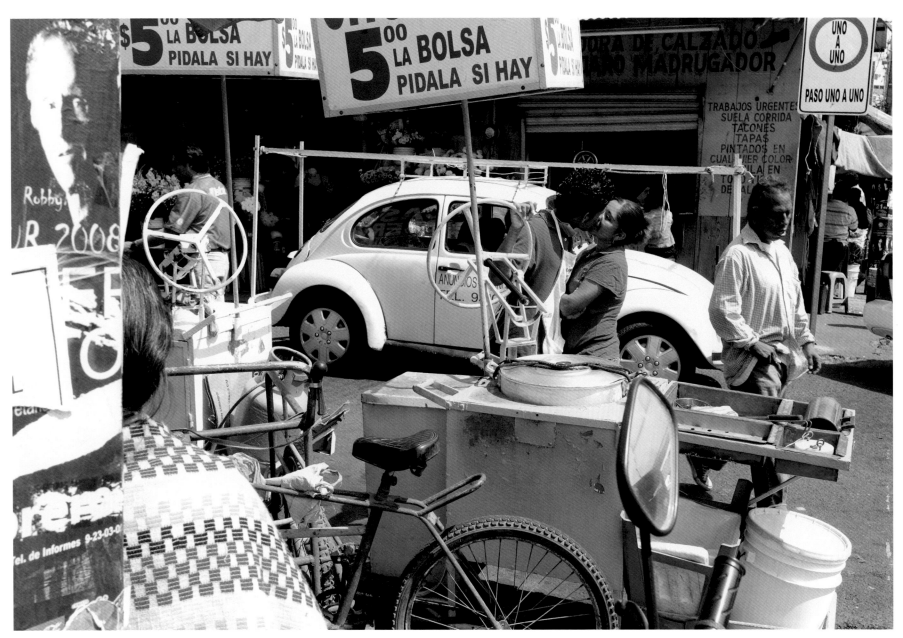

Mercado Hidalgo, Veracruz Centro

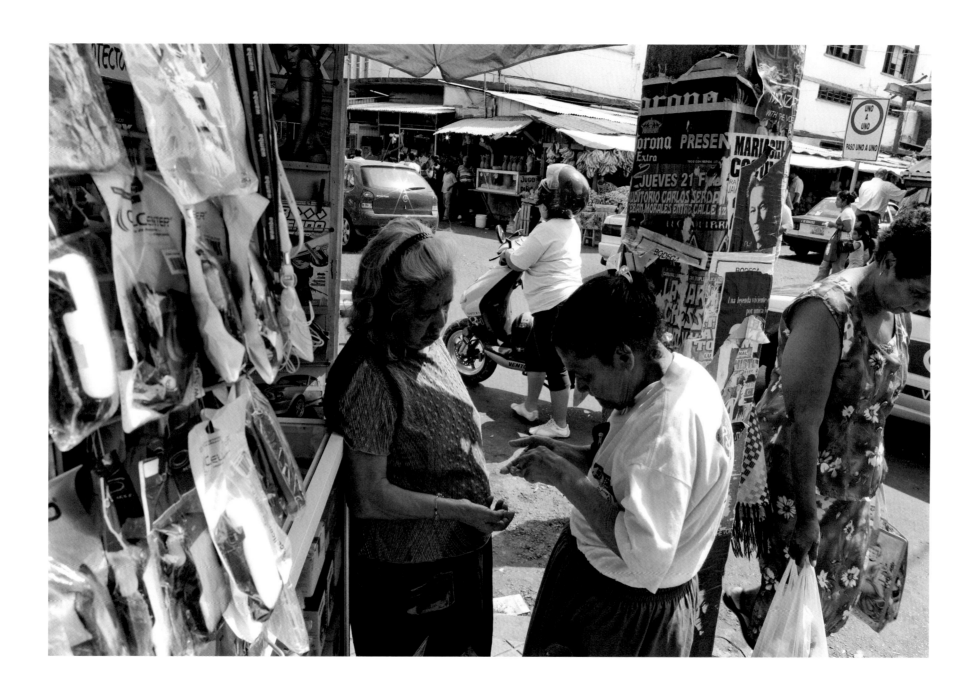

Statue of San Judas Tadeo in the Mercado Hidalgo

and even snake oil—yes, *snake oil*—is sold in a frenzied pitch by a man with a live, ten-foot constrictor around his neck.

Somewhere near the center of the market, in a little green spot where several mango trees cast their shade over a cluster of benches, I sit to change my film. As I work, I notice a large glass case that encloses a robed figure of man. The figure carries a staff in his right hand, so my first thought is that this is a representation of Jesus. On closer inspection, the face does not appear to be that of Christ. And there's the oddest thing about this carved figure: a red bump rises from the top of the head. I'm wondering if this could be something like Pinocchio's nose, a physical aberration caused by some human failing. There is no identification on the figure or the glass case, so I decide to ask.

An old lady, looking bored and annoyed that anyone had to ask, tells me the figure is Judas. I suppose that big red knot on his head is what he got for betraying Christ. But why is he enshrined in the center of the Hidalgo market? What's that about? I notice a man standing at a bicycle repair booth directly in front of my bench. He's speaking fluent Spanish, but he looks like an American.

He introduces himself as Alfred Espinosa, and it turns out that he's a graduate—both an MBA and a law degree—from the University of Texas. He has lived in Veracruz for five years now, and mostly he likes it here. "I hate the pollution," he tells me. "The big hotels dump sewage into the Gulf every night, and no one is even talking about stopping them. And I hate the double parking in the streets. I know that sounds petty, but it gets annoying as hell when you live here. It's the day-to-day example of the Mexican attitude toward the law. You know, the law says you can't double park, but everybody does it anyway, and if a cop comes up and gives you trouble, which they seldom do, you give him twenty pesos and that's it. Problem taken care of. Only then, you're left with a bigger problem: with cars double parked on both sides of the street, the traffic gets totally jammed right here in the center of the market."

I ask Alfred what kind of work he does.

"I move sugar. It's a very lucrative business here. I can do things here that I can't do in the States. I can buy sugar in Israel and sell it to Iran. I can buy it for a hundred dollars a ton and sell it for seven hundred and eighty-five dollars a ton."

fowl. Brassieres, underpants, and girdles are arranged in displays that might have been designed by a visiting artist of surrealist temperament. Right on the street, in tiny booths placed side by side, watches are repaired, gold is bought and sold, shoes are shined, fresh fish is scaled and weighed, bread is baked, keys duplicated and locks rekeyed, *gorditas* and *tacos dorados* cooked and gobbled down, eyeglasses fitted, hair cut and styled, Xerox copies made,

Mercado Hidalgo, Veracruz Centro

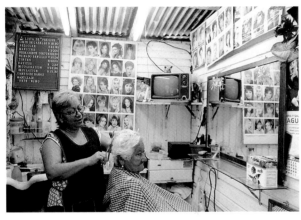

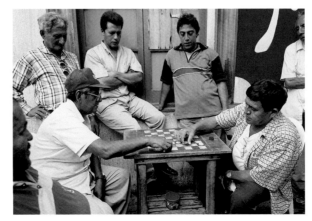
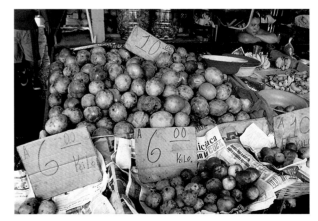

Mercado Hidalgo, Veracruz Centro

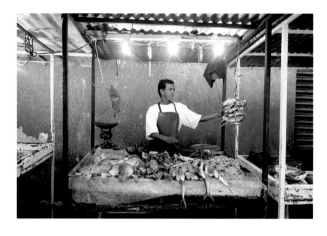 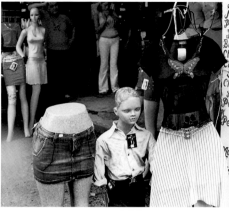 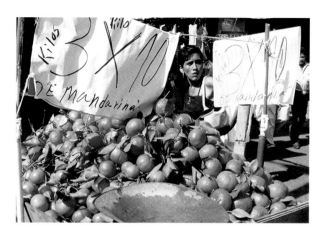

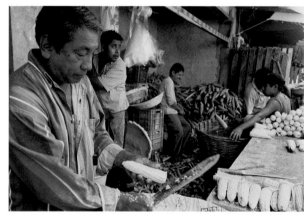 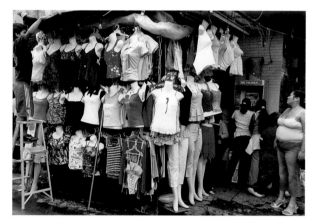

Alfred also tells me that he finds the tourism perspective here to be maddening. Not only does the government allow the hotels to pollute the water the tourists are swimming in, they also don't take care of the historical buildings, not even the forts. When they talk about what to do with the tourists, their big idea is "Take 'em to the mall." So the water keeps getting nastier, the streets are jammed, the important old buildings are crumbling, and all the government officials want to do is enlarge the mall.

I ask Alfred, the sugar mover, if he can tell me about the saint in the glass case.

"Of course," he replies. "That's Saint Jude. You don't know about Saint Jude? If it weren't for the Virgin of Guadalupe, he'd probably be the patron saint of Mexico."

"Are we talking about Judas, the betrayer of Christ?"

"No, no, no. This is *Saint* Jude. Not Judas. Saint Jude was one of the minor apostles, a sort of second-string apostle. He was also known as Thaddeus. The Mexicans calls him San Judas Tadeo. Here, he's the saint of lost causes and desperate situations, the perfect saint for Mexico. One way to explain the Mexican outlook on life is that they decided long ago that life is a lost cause, or at least a desperate situation. So they just accept that as a given, and then they move on, taking whatever life brings them. Come to think of it, that's not a bad philosophy for anyone, wouldn't you agree?"

What about the big bump on the head of Saint Jude?

"Oh, that's not a bump on his head, even though it looks like it. That's supposed to be a flame, the flame of hope that stays alive in Saint Jude. Saint Jude is always shown with the shepherd's staff in his right hand and the flame of hope rising from his head. By the way, I've always thought it's kind of funny, but in Mexico San Judas is the patron saint of both cops and robbers, as well as the saint of prostitutes. Basically, he's the patron saint of all people of ill repute."

"Well, what's he doing enshrined in the center of the market?"

"Beats me. But, really, don't you think he ought to be *everywhere?*"

• • •

I must see the mall. No matter how much I love the traditional Mexican market, and no matter how much I detest the idea of Mexico becoming a country of shopping malls, I must see what has been described to me as the biggest and best mall in the country, the Plaza Las Américas. To reach the mall, I must follow the coastal drive south for almost five miles from the *centro histórico.* At some point along the way, I realize that I have crossed an ill-defined line that separates Old Veracruz from the New. Gradually, the crumbling old buildings with their elegant balconies disappear, and in their place arise spiffy, new apartment buildings, storefronts, and restaurants. Like cities all over Mexico, there seems to be little or no sense of the importance of maintaining the older, historical parts of the city. The old buildings are left to slowly decay, while newer, bigger, more modern structures are built on the periphery of the city.

As the coastal road reaches a traffic circle on the south side of the city, I find myself surrounded by big, new hotels. The Camino Real, the Fiesta Americana, the Crowne Plaza, and other luxury franchises line both sides of the road. The Plaza Las Américas sits on the opposite side of the traffic circle. I have to pay a ten-peso fee to enter the massive parking lot, and there must be at least two thousand cars in the lot on this Monday afternoon.

Three stories high, with a man-made river and a waterfall as the centerpiece, with massive skylights overhead and escalators at every turn, the Plaza Las Américas is an impressive place. As I stroll and explore the various wings and floors of the mall, I am struck, again and again, at how many similarities I find here to a large American mall. Middle-class couples in blue jeans and polo shirts push their babies along in strollers. Clusters of teenagers, wearing baggy jeans, fancy sneakers, and backward baseball caps, hang out in the coffee shops. All of the movies in the eighteen-theater complex are American-made, even if the titles are in Spanish. Lines have already formed for the three o'clock features of *Shrek Tercero* and *Los 4 Fantasticos.* The mall appears to be a business and social concept that has transplanted perfectly to Mexico, and the Plaza Las Américas strikes me as a model for what is likely to happen, whether I like it or not, in cities all across Mexico.

Plaza Las Américas mall, Veracruz

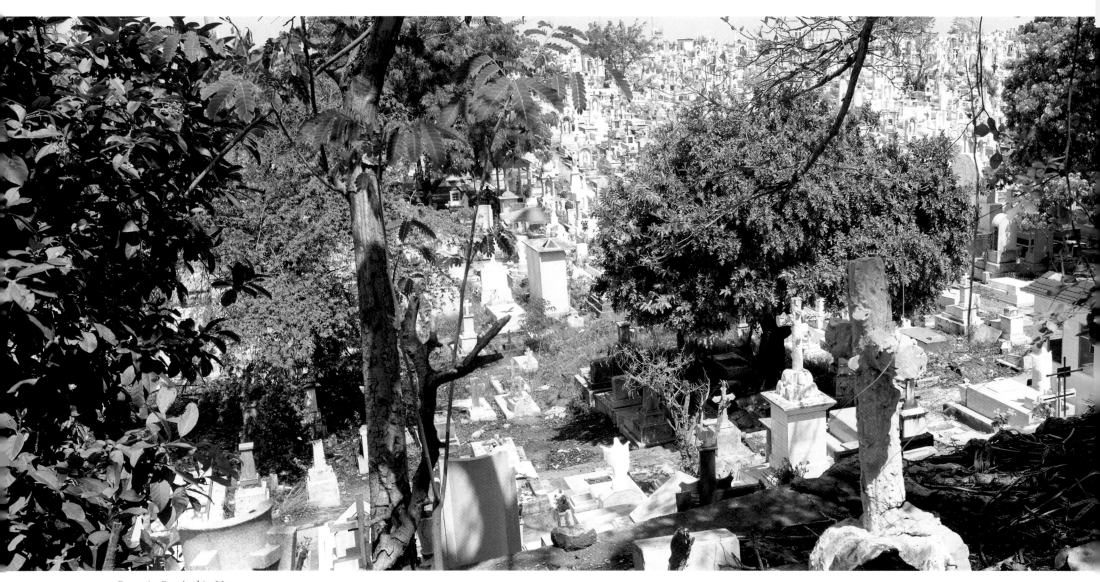

Panteón Particulár, Veracruz

In the south wing on the second floor, I find the super luxury section of the mall. There's a Bulgari store, a Prada franchise, and several shops offering expensive women's lingerie. I'm framing a picture through one of the display windows, when a feel a tap on my shoulder. I turn around to see a uniformed security guard wagging his finger and admonishing me, *"No se permite fotos, señor."* No photos permitted, the same policy as the malls in the United States. Rather than protest the policy, I concede, thank the guard, and walk toward the exit. He follows me at a discrete distance to be sure that I don't snap any more pictures on my way out.

Back on the streets of the south side of Veracruz, along Avenida Díaz Mirón, I pass a row of vendors selling flowers, and I notice the entrance to an old cemetery, the Panteón Particulár. I can also see some tall, old trees behind the cemetery wall—pines, sycamores, and maybe oaks—outlined against the sky.

The tall, iron gates of the Panteón Particulár open into a tropical park of flowering plants and ancient trees. A central walkway descends from the main gate for three or four hundred yards, past thousands upon thousands of white gravestones. Along the descending walk, smaller footpaths ascend on both sides, rising through the gravestones and leading onto hillsides covered in groves of mango and olive trees. The heat and humidity of the summer afternoon seem to be amplified here in the white glare of all the tombstones, and I'm sweating profusely, but I have never seen such a beautiful cemetery. The grounds and the individual gravesites are mostly well cared for, but there's just enough of the inevitable Mexican neglect and dilapidation to make the place really interesting. Here and there, a stone tablet or grave marker has fallen over and lies in pieces on the ground; a flowering bush has grown out of control and taken over a plot, covering the tombstone in a glorious display of color.

At the bottom of the hill, I pick a narrow path that leads up to a hilltop, and following that path I find three elderly women with brooms. They have taken a break from their job sweeping and are sitting on gravestones, talking quietly, deep in the shade. Behind them, a man with a shovel has fallen asleep on top of a white marble grave cover. His feet are bare. His shoes and cap are tucked neatly at his side. The women look over their shoulders at him, then at me, and laugh.

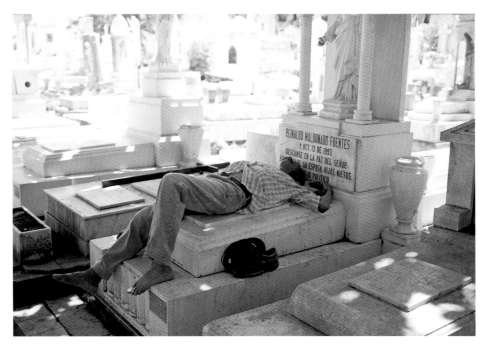

In the Panteón Particulár, Veracruz

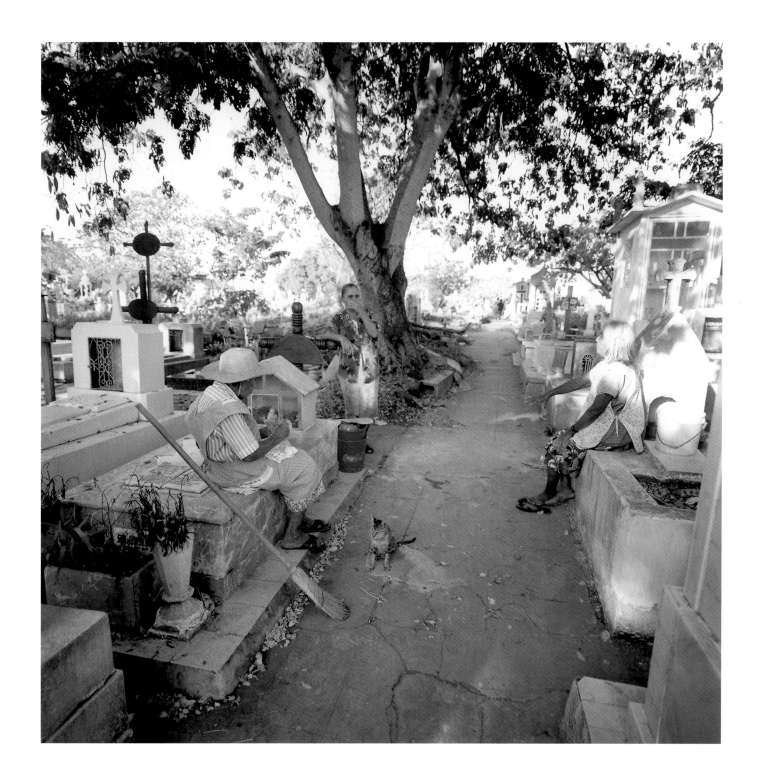

I hear the sound of a hammer tapping on metal coming from some-place ahead. I pass along the walkway between the three women and bid them *"buenos tardes."* They reply the same, softly, smiling politely. They eye my camera as I pass, and I sense their curiosity about my presence here. Why would a gringo be wandering through this old Mexican cemetery? I'm not sure I can answer that question myself, except that this cemetery, this garden, with its wonderful combination of nature and history, strikes me as a unique and beautiful piece of Gulf Coast landscape.

A few yards past the women, under a huge mango tree, I find four men huddled in the deep shade just off the pathway. Three of the men are watch-ing, as the fourth man chisels lettering onto a piece of white stone. By ges-ture, I ask if I may photograph, and they all nod their consent. The man who is chiseling, the oldest of the four, sits on a wooden stool, bent over as he works. A red bandana, soaked with sweat, is tied around his head. As I move closer for a good look at his work, I notice that he is using a tiny steel ruler and a pencil to write the letters that he will chisel onto the stone sur-face. Then, with his hammer and a small steel chisel, he cuts each letter.

I walk up the hillside on the south side of the cemetery. I labor as I climb in the afternoon heat. Still, I find the cemetery comforting, and I want to stay a while longer. I pause at an inviting spot where two trees—a large mango and a smaller mesquite—cast a pool of shade over a grassy spot. I put my camera bag down and sit beside it. The soft grass feels invit-ing, so I lay back and close my eyes. Exhausted, and perhaps dehydrated from an hour of walking in the heat, I draw a deep breath and lay for sev-eral minutes, resting and recovering. The peaceful silence is broken only by the soft rustling of leaves and the gentle tap-tap-taping of the stone carver's hammer, back down the hill.

The ground underneath my body feels surprisingly comfortable. I could lie here forever. When I finally open my eyes, the overhanging limbs of the mango tree filter my view of the bright sky overhead. I brush away a few leaves that have fallen on my chest, then I sleep for few minutes. I open my eyes again, and in the periphery of my vision, over my head, I notice some-thing else. I tip my eyes back to see what it is. A soft, white tableau emerges from the trees behind me. An image of a woman, dressed in a flowing gown, kneels in prayer.

I jump to my feet and stand back, startled by the figure that seems to have come to me like a dream. I see now that it's a gravestone, a carving in relief on a smooth, pearl gray slab of marble, beautiful, luminous, and a bit spooky. The woman seems to glow from the marble surface. She is seated, bent forward, with her forehead resting on her left hand. In her right hand, she holds a bouquet of flowers. Now that I can see the full figure, it's

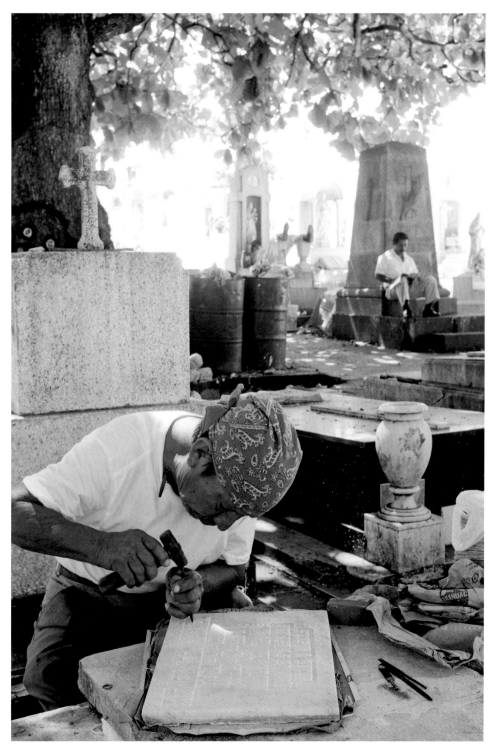

Stone carver,
Panteón
Particulár,
Veracruz

clear that she is grieving. But I'm not sure if those are flowers she's holding. Could they be stalks of corn? The large marble slab, about five by six feet, has fallen off its base at the head of the grave and now rests at an angle against the hillside behind it. Leaves, mesquite pods, and twigs have fallen across the white marble and settled into the carving. Her stone bouquet is sprinkled with decaying leaves and dried flower petals. Life and art mingle on the fallen monument to someone's life. I look to see whose grave I have found and find these words carved on the base stone:

Maria Borrell de Echevarria
24 de enero 1912
su esposo e hijos

That's who is buried here, but who is the alluring figure carved on the stone? My first thought is that she is a muse. The flowing gown and the classical features of her face suggest that. But the muse of *what?* That's not a musical instrument she holds, but a bouquet. And the more I look at the bouquet, the more it appears to be corn, not flowers. In a rush of memory from my high school mythology course, it comes to me: the figure carved on the tombstone is Demeter. Not a muse, but the earth goddess. And now I recall her story: her beloved daughter, Persephone, was lured by Hades into the underworld, and Demeter wandered the earth in search of her lost child. Such was Demeter's grief for her abducted daughter that the earth became barren, and there was no harvest. Eventually, Zeus was forced to intervene, ordering Hades to return Persephone to her grieving mother. Hades released Persephone, but not before persuading her to eat a magical pomegranate, which doomed her to return to Hades once a year. This, as I recall, is the classical account of the origin of the seasons. As Persephone returns to Hades, and Demeter falls into grief, fall turns into winter. The cycle of

the seasons is inexorably tied to Persephone's repeated return and then release from the underworld.

Now I recognize the wreath of braided corn on the woman's head and the bouquet, not of flowers, but of corn. I stand for a while, soaking in the beauty of the tombstone, a monument to one woman's life, here by her husband and children nearly a century ago, in their grief and in their love for her. For some reason that I cannot begin to understand, I feel that this monument has been waiting for me. So I sit again on the grassy spot in the shade and consider the leaning tombstone with the luminous goddess and the dried leaves and blossoms scattered over it. What is the message it has for me?

Several years ago I decided to make this trip. My initial plan was to begin on the Texas coast, on the magnificent flat prairie of White Ranch, then travel south along the entire Texas coast. I would cross the border into Mexico and continue south, completing my journey somewhere on the cliffs overlooking the Gulf, probably on the Costa Esmeralda in central Veracruz. These two landscapes—vastly different, but equally beautiful— would form the northern and southern boundaries of my study of the Gulf Coast landscape.

Then I decided to start a little farther east, at Sabine Pass, at the Texas-Louisiana border. That led me to Port Arthur, a city I saw as struggling to survive, and so my journey started with a cautionary tale I had not anticipated. In the beginning, I assumed I would photograph a coastal landscape of great beauty and immense diversity. Experiencing Port Arthur introduced something that I hadn't anticipated but could not overlook: a nagging concern for the well-being of the landscape. I have never been an "environmentalist," nor an activist for any cause, and professionally, I have always photographed things because I enjoy them, believing that pleasure is at the root of all great art.

Now, as I look at the grieving figure in stone, I am aware for the first time how much I have seen on this trip that speaks of loss. Some of the loss is due to natural and inevitable causes, especially the hurricanes that have swept across the coast and taken lives, property, and even the land. But most of the loss and environmental abuse I have seen has been due to either the side effects of commercial development or senseless pollution of the land

Gravestone, Panteón Particulár, Veracruz

and water. I have seen coastal wetlands that are disappearing, replaced by vast real estate developments. Bays that once teemed with fish, now nearly depleted. Magnificent tropical forests have been wiped out to make space for more cultivated farmland. Erosion is rampant in places where people struggle to survive the day. Once clean gulf waters are being polluted with massive discharges of untreated sewage.

The last thing I set out to do was to make photographs with a message. Polemics and art don't mix. I photograph things I love to look at, and—in the immortal words of Garry Winogrand—I photograph things to see what they will look like as a photograph. That's what real photography is about. It's as simple as that.

Or is it? I love to photograph the natural landscape. But what if the landscape is disappearing before my eyes. How can I *not* be concerned?

Now it's getting late, and the cemetery is falling into darkness. The sun has dropped below the hill on the opposite side, and it's time for me to leave. I take one long, last look at the glowing image of Demeter, and head for the gate. I want to get a good night's sleep because tomorrow morning, I'm driving south again. There will be a place to end this journey on the right note, but I haven't found it yet.

• • •

On the south side of Veracruz city, just beyond the Mexican resort community of Boca del Rio, I find my old friend Highway 180. The road is a two-lane blacktop, and the traffic is heavy on this Tuesday morning, mostly trucks going into and out of a string of subdivisions under construction on both sides of the highway. Clearly, the city is growing to the south at a rapid pace, and I suspect that all the small farms and ranches I see today will soon be transformed into gated communities and new homes for the growing middle class of Veracruz.

At Paso del Toro there seems to be nothing but a railroad track crossing the highway, a bus stop with lots of people standing around, and a few vendors offering *tamales de elote*. Just looking at the scene gives me a rush of pleasure. I have traveled fifteen minutes from the disheartening conformity

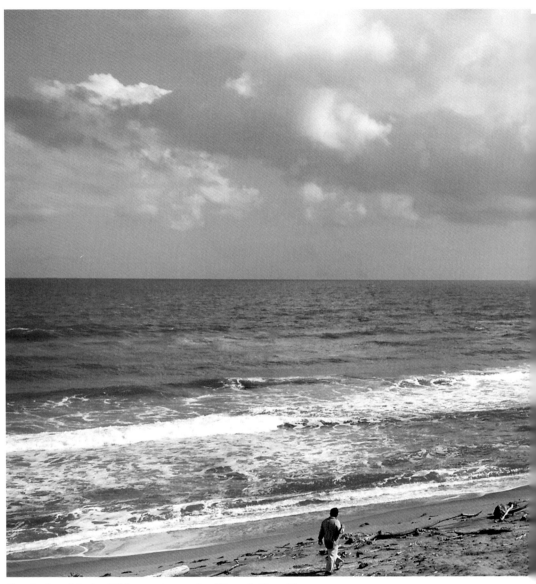

Beach along Mexico Highway 180, south of Paso de Toro, Veracruz

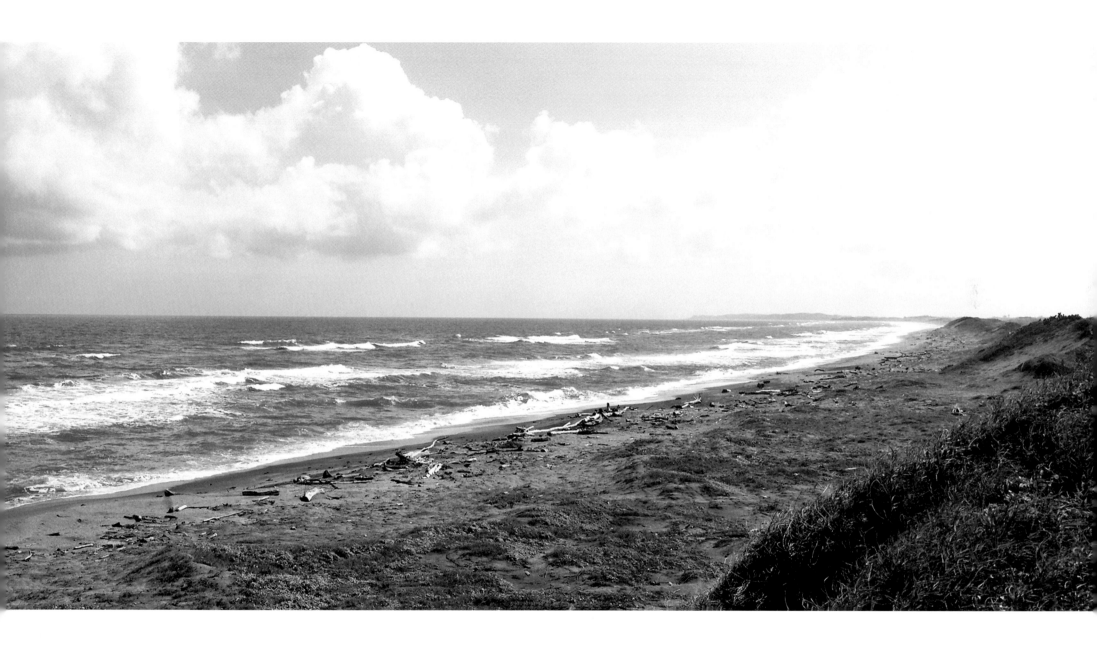

of the Plaza Las Américas mall, and already I find myself back in The Real Mexico.

The highway follows a route due south now, which is why I can no longer see the Gulf. From my map, I can see that the coastline is starting to take a slight bend to the east. The landscape is a sort of arid savannah, in which rolling green hills alternate with cactus-covered sand dunes. I feel reinvigorated being out of the city, but the haunting image of Demeter, kneeling and holding the bouquet of corn, is very much on my mind. Like her, perhaps, I'm longing for something that's lost.

Then, after a curve in the road, the glistening waters of the Gulf appear in the distance. Billowy white clouds hang in the sky over the deep blue water. The dark brown volcanic sand extends along the water as far as I can see, finally disappearing into a haze of clouds and mountains, far to the south. Soon, the highway is running parallel to the beach, with the shoreline less than a hundred feet from the road. Long lines of cactus have been planted off the side of the highway, in an effort, I would guess, to keep the dunes and even the highway from eroding away. I decide to stop for a walk along the deserted beach. A stiff wind is blowing in from the sea and frigate birds glide overhead in circles. I see a single figure—one man, all alone— walking the beach.

Back on the highway, in the little town of La Union, traffic must slow to a creeping pace every hundred meters in order to cross the *topes.* Vendors' stands, with plastic bags full of fresh shrimp, oysters, and crab on display, are placed strategically at the speed bumps. One vendor catches my eye. His portable stall is built on a bicycle, with a bright blue tarp shading his goods. Red and black lettering on an orange background advertises shrimp, crab, octopus, and *toritos de cacahuate.* That's a new one. What in the world is a *torito de cacahuate?* Literally, of course, it's a little bull of peanut, but that doesn't tell me anything, so I decide to stop and investigate. As I walk up to the covered cart, I spot a young man sitting in the shadows, and I notice that his homemade advertisement is signed "su amigo Che Lelo." Maybe that's Che himself in the shadows, so I walk around and ask about the *torito de cacahuate.*

Che is wearing dark sunglasses and a Los Angeles Lakers t-shirt. In response to my question, he pours me a shot of a thick, creamy white liquid from an unlabeled, quart bottle.

"*Shoot it,* man," Che urges me, with a thumbs up sign and a chuckle.

I down the shot in one gulp, and it's delicious. It's peanut liqueur. "What's in it?" I ask.

"Peanuts, cream, and alcohol. And some secret stuff. Can't tell you what it is. That's my secret. It's good, huh."

"That's what a *torito* is?"

"Hell yeah, man. Different flavors. Wanna try a strawberry one?"

Before I can answer, a pickup truck slows for the speed bump in front of Che's stand. A man lowers his window and yells for Che to bring him a bag of shrimp. After he has serviced his drive-by customer, Che returns and we continue talking. He tells me he was born here in La Union and went to "the other side" when he was fifteen years old, following several local friends who had traveled to Los Angeles in the 1980s. He lived in California for twelve years, before he returned here. I ask him what brought him back.

"I made all the money I need, man. I bought a pickup truck, and I still got it. I brought back enough money to buy a house of my own. And I like it better living here. Nobody bothers me. I can do my thing. I got customers from all over Mexico. They know I got the best *toritos* in Veracruz. I got a good little business here. You want to buy a bottle of the *cacahuate?* A hundred pesos. You can't get it in Texas, that's for sure."

I pay Che for the bottle of peanut liqueur, and the conversation turns to where I'm headed. I tell him that I'm looking for a place with unspoiled, natural beauty. "I tell you where you gotta go, man. Take the road around San Martín, the volcano. That road goes around the mountain and out to the ocean. There some nice little villages out there on the ocean. Man, it's like Tahiti, only with Mexicans. Nobody much goes there, but maybe a few hippies and some German tourists. It's really beautiful."

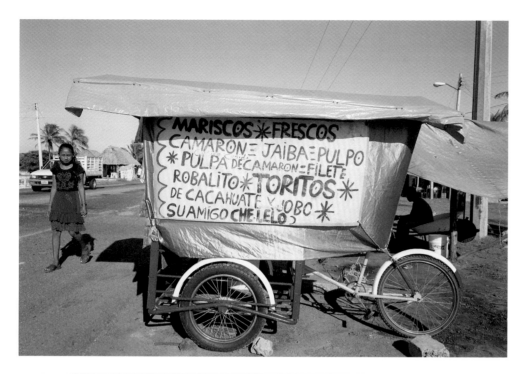

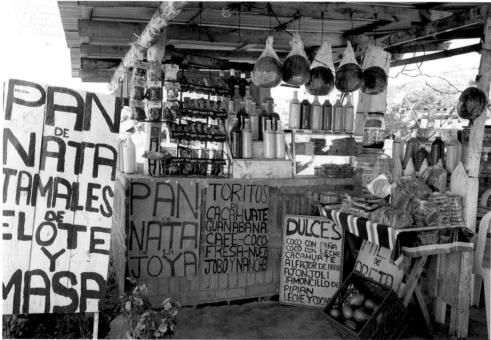

Roadside vendors on Mexico Highway 180, La Union, Veracruz

Alvarado, Veracruz

Back on the highway, out across the rolling hills to the west of the road, a vast lake comes into view. Checking my map, I see that I'm looking at the Laguna de Alvarado. The lake is least forty kilometers in length, situated at the mouth of a big river, the Río Papaloapan. After a few more kilometers, I cross a high bridge over a bay formed by the river and the lake as they enter the sea. The view from the bridge looks down toward the little port of Alvarado. The old port, all rusty and ragged looking, sits on the edge of the *laguna,* like a place that had its heyday a century ago and now languishes in the tropical air. Old shrimp boats are docked along its wharves, but they're so decrepit looking I can't imagine they have moved in the last ten years. Still, I see people stirring around on the docks. The old port is not dead, it just looks like some ancient, near-forgotten place in a García Márquez novel. It's lunchtime, so I decide to turn around, go back down into Alvarado, and see what's cooking.

Alvarado is one of those wonderful Mexican towns that is completely charming without even trying. The streets are quiet and devoid of almost any human activity, until you get down close to the wharves. Then the place comes alive in a swarm of activity. I park and walk along the riverfront, where seafood restaurants line the little *malecón,* tucked in between the warehouse operations of major commercial fisheries. Those old fishing boats I saw from the bridge are apparently still working just fine. Trucks are ferrying tons of red snapper, flounder, and crab straight from the fishing boats into one side of the warehouses, while other trucks are departing from the opposite side, loaded with seafood headed out for Mexico City, Guadalajara, and other Mexican cities.

Nearby, a narrow passage leads through a succession of smaller fish operations. The jaunty, lively notes of *son jarocho* spill out from a bar, so I step inside for a look. The place has a low ceiling and folding tables set around on a concrete floor. Even the walls, ceiling, and booths are made of concrete. You could power wash the whole place down with a hose and water, which I suspect is exactly what they do every morning, because the bar has a damp feeling. It's dark in the corner where I enter, but the opposite side of the room opens directly onto the river, and light pours in, along with a salty aroma from the sea. A couple of boats with outboard motors are tied to the dock outside, but I see only one person in the bar. He's a short, wiry fellow, with intense eyes, and he's sitting by himself, wearing a green Boston Celtics cap.

As I return to the highway and head south again, the only destinations I have in mind are Tlacotalpan, an old river town, slightly upstream from Alvarado on the Río Panaloapan, and the road circling the San Martín volcano, the route that Che, the *torito* man, recommended. The turnoff to Tlacotalpan comes quickly. I cross a long, low bridge over the river and arrive at a tollbooth. I pay the eighteen-peso toll, and enter a narrow, two-lane highway running right beside the river.

For decades, Tlacotalpan's chief claim to fame was that it is the birthplace of Agustín Lara, Mexico's widely celebrated and deeply loved composer of popular music. Now the little town has another distinction, proudly proclaimed on a monument along the main road through town. In 1998, Tlacotalpan was put on the UNESCO Historic Register, thus making it part of the Patrimonio de Humanidad, the Heritage of Mankind. The town was cited for its original urban layout and architecture, both of which remain virtually unchanged since the eighteenth century. About the only thing that has really been altered in modern times are the wide streets, which were once covered entirely in grass, back when the town could only be reached by boat. Now the streets are paved, but the town layout is the same as ever, with two interlocking plazas in the center. Each street is lined with one- and two-story houses of neoclassical design, all painted in a delightful rainbow of colors.

Tlacotalpan, Veracruz

Tlacotalpan is like no other place in Mexico. The town is clean, neat, and prosperous looking, but it's the colors that are most distinctive. Each house, without exception, seems to sparkle with a fresh coat of paint, and the color combinations look like Josef Albers was in charge. There are houses of emerald and lime green with melon-colored columns. Lavender, purple, violet, and pale blue come together on another house, and next door: yellow, peach, and orange. In the first plaza, I stand for a few minutes to soak up the beauty of this wonderful town.

The town square, elegantly paved in tiles of gray and white marble, is so quiet it seems suspended in a tropical slumber. A white kiosk with a curved dome, a delicate wedding cake of a structure, sits in the center, shaded by tall palms with whitewashed trunks. Each corner is anchored by a monument—a gold bust on a stone base—to a prominent citizen of the town's past. The main church is an elegant white structure with accents painted a vibrant *rosa mexicana* color. Once every five minutes or so a person passes, walking or bicycling slowly through the square. If they pass in front of the church, they tip their hat and cross themselves.

If the main square is drowsy on this summer afternoon, the riverfront is sound asleep. But things seem to come alive a bit as I walk onto the scene. Several men call to me, offering to take me for a boat ride up the river. A woman offers to sell me homemade empanadas from a covered basket. She has cheese, ham, and *congrejo*, or crab. I sample one of each of the delicacies, then decide to wander over to Avenida Carranza, where a handmade sign in bright colors hangs in front of an old house: "Aquí es el Mini-Zoológico Museo de Don Pio. Cocodrilos enormes. Aves exóticos. Tortugas. Y mucho mas." Who could think of missing such a place? The very idea of a mini-zoological museum with enormous crocodiles, exotic birds, turtles,

and much more . . . well, I'm certainly going to have a look. A large birdcage on wheels serves as a door, and an elderly gentleman in a straw hat rolls the cage aside to welcomes me.

There are times when you know immediately, within seconds, that you've found something truly wonderful, when pleasure and surprise come out of nowhere and sweep over you. That's the feeling I have as I scan the first room of Don Pio's remarkable museum. First, my eye is drawn to the wall directly opposite the entrance, where a collection of black and white glamour photos of Mexican movie stars hangs in three delightfully irregular rows. The old man, whom I assume might be Don Pio himself, senses my pleasure in the pictures, leans close to me, and whispers, *"Artistas de la Epoca de Oro."* Ah, yes, of course. Actresses from the Golden Age of Mexican Cinema. But what is that thing on the shelf right there under the photos, that odd-looking object the size of a volleyball? That's a petrified vertebra of a mastodon, the old gentleman informs me, and it comes from Argentina. And beside *that?* That guillotine-looking thing? Why that's an eighteenth-

Jardin and church, Tlacotalpan, Veracruz

century bull castrator, can't you see? I've begun to wonder which department of the museum we are perusing, when I notice that the diversity of the objects continues to grow: the jawbone of a crocodile, a musket from Puebla (from the Battle of Cinco de Mayo, I am told), a ceramic beer bottle from Belfast, a foot-operated dentist drill, and an elegant set of woven cane lobster traps from Alvarado. No sooner have I expressed my delight in these fine vintage objects and introduced myself to the old gentleman—who is, indeed, Don Pio—than a young man appears. He introduces himself as Victor, the nephew of Don Pio, and he commences to take up where his uncle left off, guiding me on a personal tour of the museum. Don Pio returns to his chair beside the birdcage door.

I follow Victor toward a room filled with cages in dappled sunlight. The first holds a pair of large gray hawks that stare back at me, unflinching, as I point my camera at them. Then there are parrots, a gorgeous mature toucan, and a cage full of picture-perfect white pigeons. But what catches me by surprise are the two snow-white pelicans, easily three feet tall, that waddle past Victor and find Don Pio, resting in his chair.

"*Sube, Tito. Sube,*" Don Pio man calls to the first pelican, and Tito, with a noisy flapping of his wings, hops right into Don Pio's lap and settles there, his long beak resting on the old man's forearm. Victor then introduces me to the four crocodiles. Each croc is in a cage of his own, stretched out on the tile floor behind a screen of wire mesh, hardly enough of a barrier to restrain a small dog, much less a half-ton reptile. Victor reaches for a long stick and pokes one of the beasts. A deep, low, throaty growl causes me to step back, and Victor laughs. "*No es peligroso. Pero tiene hambre. No ha desayunado.*" That's exactly what I'm afraid of. He's thinking of breakfast. I've seen enough of the crocodiles. Where are the turtles?

Victor rolls up his sleeves and straddles a muddy spot in the yard. Then he shoves both hands down into the mud, all the way to his elbows. With a grunt and a groan, and with a great smacking sound from the mud hole, he lifts what appears at first to be a flat, muddy rock. Then he turns the object toward me, and a beaklike mouth opens, revealing a fat, pink tongue.

"*No pone el dedo en la boca,*" Victor warns me. Not a chance. I know nothing about snapping turtles, but inside that beak is the last place I'm going to put my finger. Next, Victor guides me to the garden at the back of the

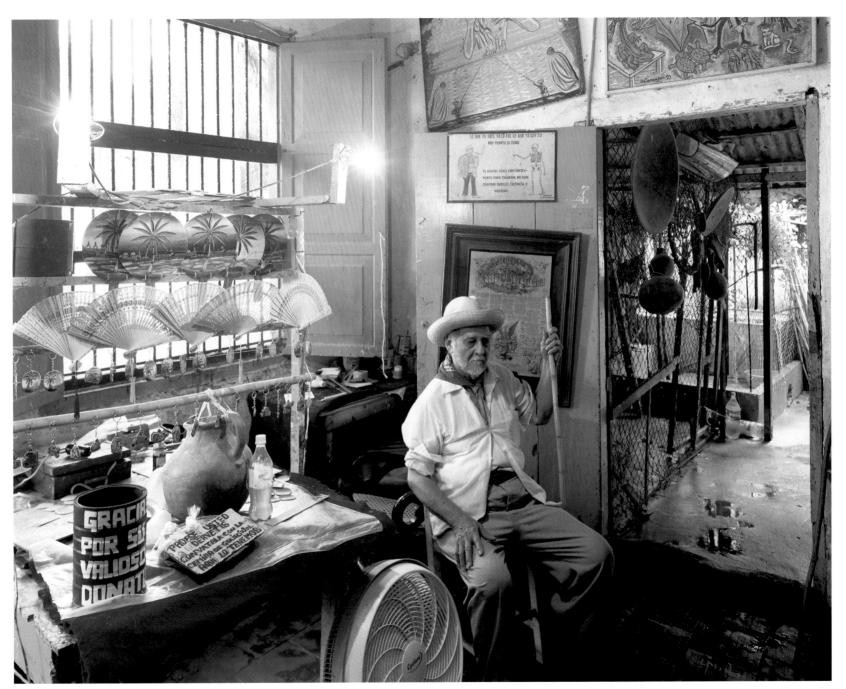

El Mini-Zoologío Museo de Don Pio, Tlacotalpan, Veracruz (and following two pages)

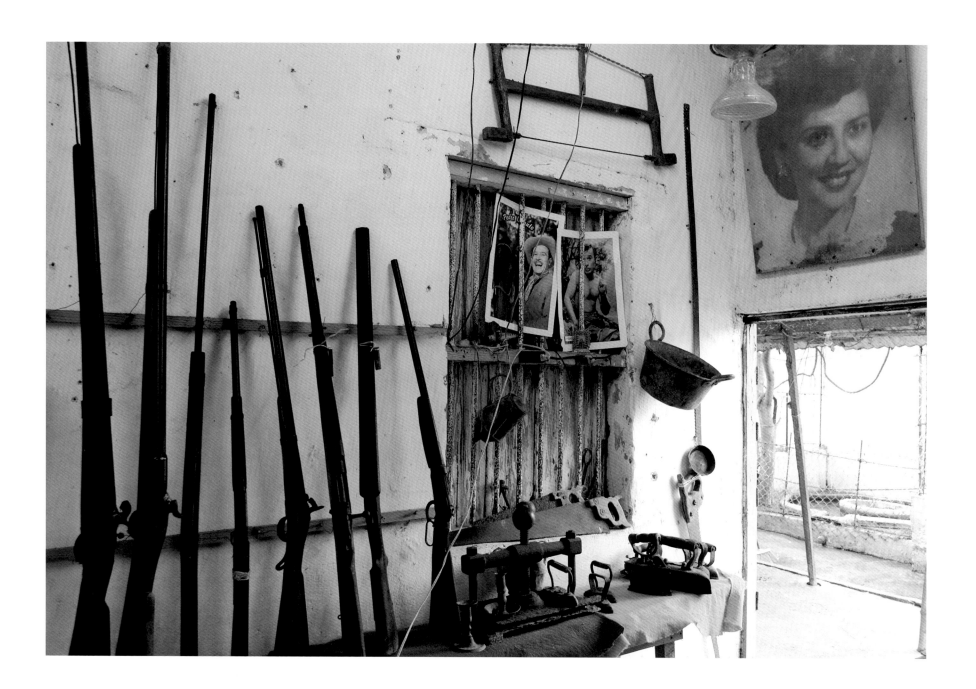

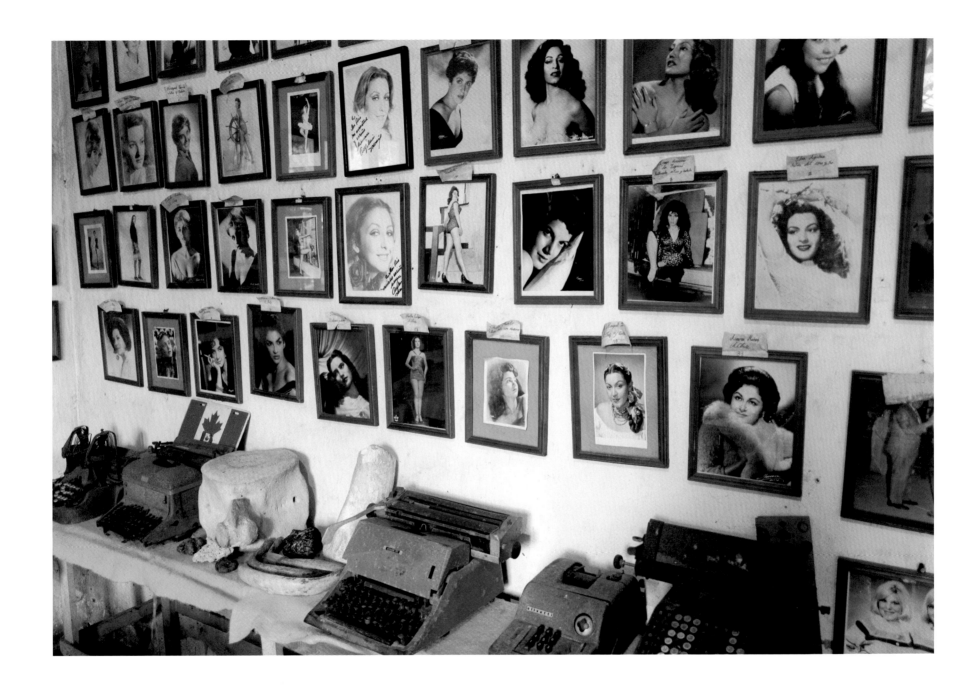

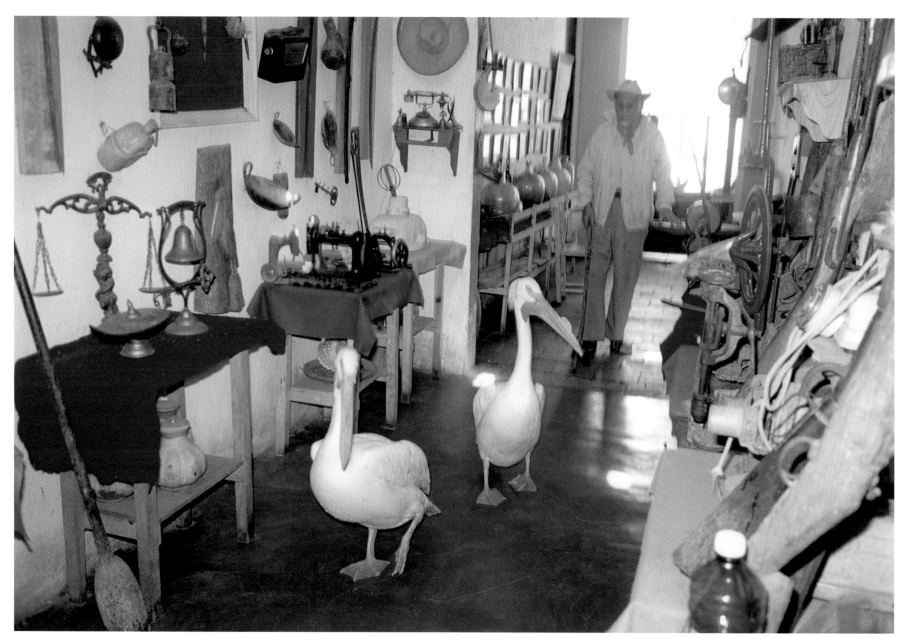

El Mini-Zoologío Museo de Don Pio, Tlacotalpan, Veracruz

museum. There, inside an arched wall painted vibrant blue and gold, under zapote, almond, and papaya trees, sits one of the most prized pieces in Don Pio's collection: an Austrian carriage from 1895. So far, I have put aside questions of provenance, but now I have to ask: how did you acquire this carriage? From a very important family in Tlacotalpan, Victor tells me, a family with much confidence in Don Pio.

There are more rooms, each with a theme, more or less, and each with its own unique style of installation. There's the Agustín Lara room, with photographs and memorabilia of the famous musician. Victor gets really revved up, talking about Lara's eleven wives, the thirty-six countries where he performed, the vast wealth he accumulated, and the fact that he never forgot his hometown of Tlacotalpan. Finally, I'm exhausted, just trying to look at all of Don Pio's marvelous collection. There's too much to see. I have to stop Victor in the middle of his informative talk about Don Pio's lamp collection—the lamps from Saudi Arabia, Africa, Afghanistan—I have to stop him and tell him that I will be back again soon, which I hope I will.

On Calle Ignacio Allende, a narrow street off the main road through town, several men are sitting on the sidewalk in front of a shop. The shop, it turns out, is for shoe repairs, but the work going on in the street appears to be a little down-home physical therapy. I watch as a young man massages the arm of another fellow, who is seated on a wooden bench, grimacing in pain. Two other men are sitting and watching with great interest. The man seated on the bench, I learn, was painting a house earlier that day, when he took a fall from his ladder. He landed on his left elbow, which began to swell and tighten, so he came to his friend Jaime for help. Jaime's main work is repairing shoes, but he is also known for his skill in treating injuries.

After Jaime finishes his treatment, the injured man stands, flexes his arm, and declares the elbow much better. He pays Jaime ten pesos, less than one dollar, and leaves, promising to come back the next morning. He's going back to work now because he promised to finish the job today. Jaime settles into his little shop and sets to work stretching out a pair of boots. He tells me that if I like to take pictures I should come for the big festival around *candelaria,* the second of February. It starts in late January, he tells me, and it goes for two weeks. All the hotel rooms are already taken, but people rent rooms in their homes to tourists. In the week leading up to the big festival days, there are *bailes tropicales* (salsa dances), *una feria y un tianguis* (a fair and a big outdoor market), then a *cabalgata* (an equestrian parade), *jareneros* (traditional musicians of Veracruz), and *decimistas.* I have never heard of a decimista, so I have to ask Jaime for an explanation. He tells me that these are men who come to present their *décimas,* poems of ten stanzas, reading them dramatically to the accompaniment of *son jarocho* music. Many of the *décimas* tell of their love and devotion to Veracruz, the beauty of its women, and the pleasures of life here, but others are picaresque tales of adventure and comedy. I have already begun to make plans to be here next year on the second of February, as Jaime continues.

Best of all, like nothing else in the world, is *el corrida de toros,* the running of the bulls, here in Tlacotalpan on the day of *candelaria.* The *vaqueros,* the cowboys, herd the bulls into the river on the opposite banks, and the bulls swim across, where they are driven out of the water and into the streets of the town. There, they encounter hundreds of people—mostly young men from all over Mexico—who have come to run with them in an event that makes Pamplona's running of the bulls look like child's play. The bulls, dozens of them at the peak of the event, run absolutely amok. They shoot down the streets of the town without any control whatsoever, they jump onto the sidewalks, clearing pedestrians by the score, and even, according to Jaime, have been known to enter houses. I'm trying to decide why anyone would leave the front door to their house open on that day, or if the bulls simply break the doors down. I resolve to be in Tlacotalpan next year for the running of the bulls.

There are dances tonight in the plaza, Jaime tells me as I leave. That's enough reason to spend the night in Tlacotalpan, so I head back toward the center of town to look for a room. A single room at the Hotel Doña Lala costs four hundred fifty pesos. By small town Mexican standards it's a fine hotel, a former private hacienda that has been converted to a hotel and restaurant. I book a room for the night and the desk clerk gives me a key with a curious attachment, a plastic card, about the size of a credit card, with a metallic strip on one end of it. The card is permanently attached to the key by means of a loop of steel cable. When I ask what the card is for, the clerk tells me it's for *la clima,* the air conditioning. I figure that the operation of the device will be obvious when I get to the room, so I grab my suitcase and start up the stairs. The Doña Lala falls into what Mexicans refer to as *clase turística* hotels, as opposed to *hoteles regulares.* Tourist class hotels are supposed to have the kind of amenities tourists would expect: things like secure parking, a table or desk in the room, a television, and even a towel and toilet paper in the bathroom. When you check into a *hotel regular,* you should expect none of these things. The desk clerk might (or might not) give you a towel as you check into the room—which you are expected to return when you check out—along with a few sheets of toilet paper.

At the Doña Lala, I find two towels and a full roll of toilet paper in the room, along with a curious electrical apparatus fitted to the air conditioner. There's a slot, like that on an ATM machine, for a card. But unlike an ATM, the wiring behind the slot, leading to the air conditioner, is completely exposed. When I check the card that's attached to my key, it has an arrow painted on it right beside the metallic strip, which matches an arrow painted onto the slot. I get it. This is how you turn the air conditioner on. Simply put the card in the slot. So I slide the card into the slot. The result is a sharp crackling sound and an electrical spark that flashes an inch from my fingers. I jump back from the wall, just as the air conditioner hums into action. Startled, but also fascinated by this piece of makeshift Mexican engineering, I cannot resist pulling the card out, which shuts off the air conditioner, then reinserting it. Again, with a scary crackling sound, the sparks shoot across the contacts and the air conditioner kicks on. Upon consideration, the device strikes me as a practical offshoot of the electric chair, albeit with a more mundane purpose, but with equally deadly potential.

As I contemplate this remarkable device, I decide that it belongs in the same general category as the bulls that run through the streets of Talcotalpan for the annual *candelaria* festival. Both are potentially deadly, but only if approached without a reasonable measure of common sense, and both are fully, perhaps even uniquely, Mexican. Either one of them alone would surely be sufficient grounds for the U.S. State Department to issue warnings against travel in Mexico. And finally, each of them represents an aspect of Mexico that I love . . . and fear.

• • •

Later that evening, at dusk, I sit alone at a table in the Café Rokola, on the corner of Tlacotalpan's main square. The streetlights have come on, casting soft pools of light onto the gray marble tiles of the promenade. Bicyclists glide slowly through the plaza, and couples sit on white, wrought iron benches around the square, amid highly scented pink oleanders. Two young women are circling the square on a tiny motor scooter. They wave at me and giggle as they pass, then they stop at a hot dog stand. I order a *lechero* and sit back, savoring the scene.

Surely, in Tlacotalpan I have found not only the prettiest town in Mexico but also the most civilized. A peaceful air of comfort and well-being permeates Tlacotalpan. The present and the past seem to be alive together in the rhythm of everyday life, while the serene presence of the river hangs over the town. My *lechero* arrives, and I savor that as well. At the table next to me, a woman and a girl in her late teens are speaking French. Then, in Spanish, they introduce themselves—Marie and her daughter Liliana from Paris—and soon we have a conversation going, comparing our favorite places in Mexico. They tell me they have come from Monte Pio, a little town farther down the coast, off the main highway. They describe the area around Monte Pio as a natural paradise. After asking directions about exactly how to get there, I realize that they are describing the same area that Che, the *torito* vendor, told me about two days ago.

Tlacotalpan is beautiful, but I have a feeling now that an even more beautiful place lies ahead. I am looking forward to tomorrow. I want to see that road to Monte Pio.

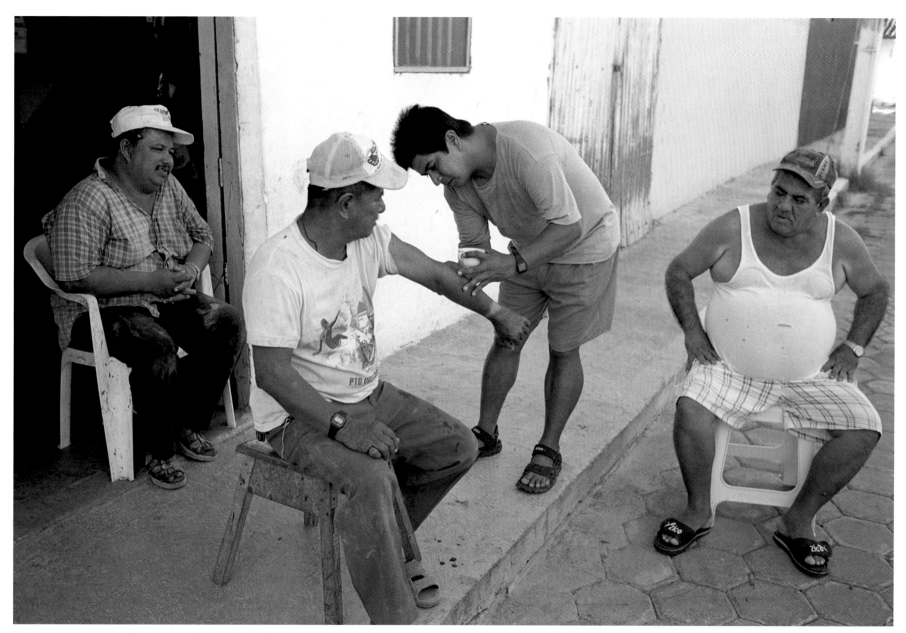

Physical therapy on Calle Ignacio Allende, Tlacotalpan, Veracruz

On the road to Monte Pio

• • •

Early the next morning I leave Tlacotalpan, following the narrow highway back along the river. I pass through the tollbooth and turn south onto Highway 180. A glance at my map explains why I can no longer see the waters of the Gulf. The highway takes a southwesterly course here, while the coast turns due west. For the next hundred miles or so, as it approaches and then enters the mountains of the Sierra de las Tuxtlas, Highway 180 will move progressively farther from the coastline. Traveling about ten miles, I pass through a fair-sized town, Lerdo de Tejado. After Lerdo, the highway cuts a straight path through a landscape of tall, dense sugar cane. The fields of green cane remind me of the first time I passed along this highway, about ten years ago. I was returning from a trip to Chiapas, and as I drove along this highway, a man emerged from the cane fields holding a small, primitive stone figure. He held up the figure up for me to see, then quickly jumped back behind the cane.

I knew I was passing through territory that had once been at the center of the Olmec empire, the great mother culture of all Amerindian civiliza-

tions, and I have read that it is still possible to stumble upon buried Olmec sculpture and other objects. I hit the brakes and turned around. The man in the cane field had succeeded in getting my attention. What I found, thirty feet or so back in the cane, were four men standing over a deep, fresh hole in the red soil. Two other men were down in the hole, digging and passing stone figures up to the men above them. They were talking and shrieking with great excitement as, one after another, the stone figures were lifted out of the dirt. It looked as though I had stumbled upon a major discovery of Olmec figures in someone's cornfield. But as soon as I took a close look at one of the figures, I began to have my doubts about what was actually happening. The figure I held in my hands, a primitive representation of a woman, actually looked less like stone and more like concrete. The asking price, it turned out, was one hundred pesos per figure. I decided that someone must have made a set of forms, was pouring concrete and putting out "original stone figures" by the hundreds. Then, I figured, they would bury the little concrete replicas in the bottom of the hole and unearth them for suckers like me. When the price came down to twenty-five pesos apiece, I bought two of them, mostly out of respect for the sheer novelty of the scheme. As I got back in my truck, the man who had lured me into the cane field was back in position, holding another figure, ready to entice the next passing motorist.

So here I am again, traveling the same highway ten years later, and who should appear on the side of the road? Three young men holding Olmec-style stone figures. I have to stop, just to compare the goods being offered today with the two concrete bookends I still have at home. The three boys, in baseball caps and t-shirts, rush to my window. The price is three hundred pesos for a large Olmec head. I ask them how to find the road to Monte Pio. Ten kilometers ahead, they tell me, look for the sign to the *balnearios,* the swimming pools.

A few miles down the highway, I spot two small, hand-painted signs pointing the way to the Balneario Paraiso and the Balneario Cinco Chorros. The gravel road could easily be mistaken for a private road into someone's cane field, but I decide to trust the boys' directions. I turn left off the highway, checking the compass on my dashboard. I'm headed due north, and I estimate from my map that I must be about twenty-five miles from the coastline.

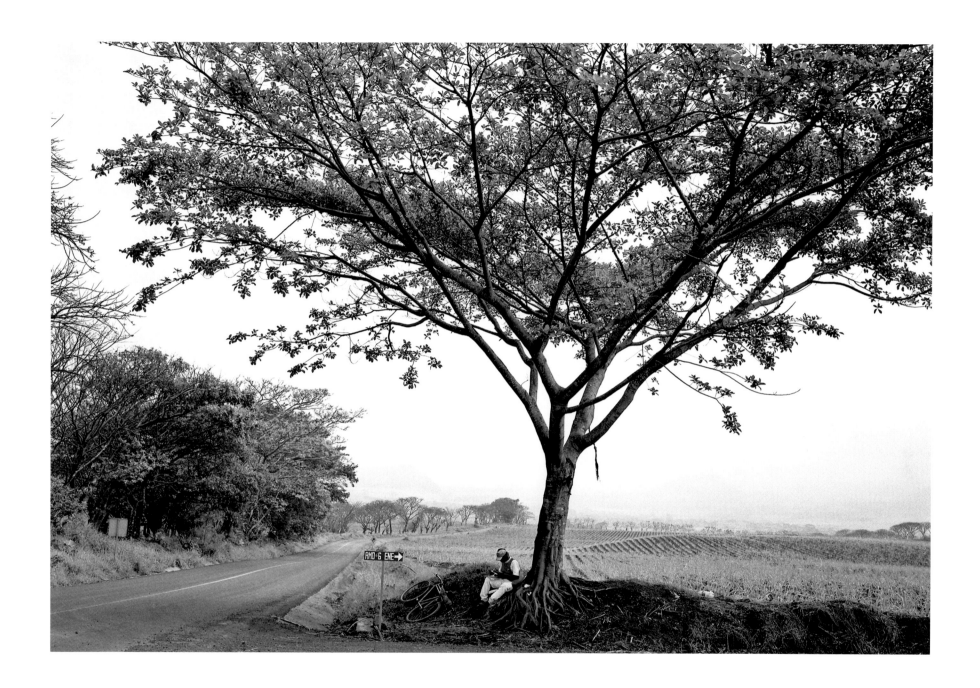

There's no traffic on the road, except for an occasional truck hauling a load of sugar cane, but the going is slow. Potholes big enough to swallow a tire and destroy my suspension are scattered along the gravel road, so I am averaging less than fifteen miles per hour. About forty-five minutes down the road, I notice that the landscape and foliage is changing. Flowering plants and trees line both sides of the road. Vast fields of sugar cane, lined with growing fence posts of gumbo limbo branches, extend to the horizon. On my right, the distant shape of the San Martín volcano can be seen, blue and hazy, far beyond the misty contours of smaller mountains. As I pass, dark-skinned people stare back at me from the steps of their wooden shacks. Their features look distinctly oriental. Replace the burros with a yak here and there, and I could be in the foothills of the Himalayas. There's even a monkey perched in a mango tree in front of a small store in the town of La Florida. I resist the temptation to stop. I have a growing feeling that the best still lies ahead of me.

About ten miles beyond La Florida, the road begins to rise and fall steeply, curving through a mountainous landscape of sugar cane, ceiba trees and flowering jacarandas. The fence posts—branches from the gumbo limbo trees, *mulatos,* they call them here—are sprouting new, green growths. The farther I drive, I can see the landscape to the south of the road climbing up toward the hidden peak of San Martín. Volcanic stones, some as big as houses, lie along the slopes. Dirt roads lead into the cane fields on both sides of the road, and each one tempts me. Passing any road in a new place is difficult for me, for who knows where it might lead? Finally, as the highway takes a turn into the community of Laguna de Majahual, I yield to the growing temptation and turn off the highway onto a dirt road. The road rises sharply for a hundred feet, before dropping into a sugar-cane field. From a wooden shack on the edge of the cane field, a pack of dogs rushes toward my truck, snarling and barking. Chickens, squawking and flapping, scatter in every direction. A man steps onto his porch, watching me suspiciously as I pass.

I'm not sure where to go from here. The dogs are making quite a racket around my truck, and all I can see is mile after mile of mountainous countryside, covered in sugar cane. I follow the dirt road as it bears to the left. I pass a few more houses, the dogs finally give up, and the road ends at a

barbed wire fence overlooking a valley. The beauty of the landscape beyond the fence is breathtaking. The ground falls off in a steep grade, dropping several hundred feet to a little creek. Cattle are grazing on the steep hillsides in grass dotted with black rocks. A huge ceiba tree sits at the base of the little valley, the centerpiece of a radiant landscape, glowing in a thousand shades of green. As I unpack my view camera and begin to study the scene in front of me, a short, dark-haired man steps out of a nearby house and waves to me. I am more anxious to get a good picture of the landscape while the light is right than I am to get into a conversation, so I pull my dark cloth over my camera, then over my head, and begin studying the image on my ground glass. I'm hoping the fellow will go back inside and let me work.

When I peek out from under the dark cloth, the man is standing beside me, smiling broadly. I smile back at him, nod politely, and duck back under the dark cloth. I fiddle with the camera, pretending to be working, when in fact I'm stalling, hoping the fellow will leave me alone. When I look again, the man has been joined by a woman, along with a young girl with a burro on a rope. I nod to all of them, smile, say something about the beautiful light on the landscape, and go back under the dark cloth again.

A minute later, when I reach for my camera bag, I find that a small crowd has gathered behind me. A young man in a Planet Hollywood t-shirt has joined the girl with the burro, and he has a parrot on his shoulder. Three younger boys are sitting on the grass beside him, along with two dogs. Six or eight chickens have wandered over, and the whole bunch, including the menagerie, seems to be watching me with great curiosity. The man steps forward and introduces himself as Alberto Nieto. The woman is his wife, Margarita. The girl with the burro is Liliana, the daughter of a neighbor. Two of the boys are Alberto and Margarita's sons, Fabian and Osiris. The other two are neighborhood kids.

Alberto explains to me that the land I am photographing is not *ejido,* or communal farmland, as I expected, but private property. He works for the owner, who lives in a farmhouse down by the river. They run cattle on the land, and they grow corn, sugar cane, and melons. I can't stop raving about the beauty of the landscape, and Alberto asks me if I'd like to go out and explore it with them. There's a beautiful pasture over the first hill, and a waterfall on the river. Would I like to see it all?

Exploring the landscape with Alberto Nieto and his family, Laguna de Majahual, Veracruz (and following two pages)

Soon, we are running across the grass, down the steep hill toward the river, eight of us in all, plus Edgar, the parrot, perched on Fabian's wrist, and the two dogs. Alberto is at the front of the pack, leading the way. The kids are shouting, the dogs are barking, and I feel as though I have stepped into a dream. A few moments ago, I was driving a potholed highway, daring myself to take off down one of those dirt roads. Now I'm off on a glorious adventure, across one of the most beautiful landscapes I have ever seen, along with seven new friends and their animal companions.

At the bottom of the hill, we take off our shoes, roll up our pants, and cross the stream, locking our arms together to wade as one through the powerful currents of the rushing water. On the other side of the river, we climb a steep hill to the top of another ridge. Alberto leads us, single file, along the edge of a cornfield. It's early afternoon, and the sun is hot, but a cool breeze is blowing from the ocean, a mile or two in front of us, still out of sight. A vast, green pasture opens before us. I ask everyone to stop for a photograph, and I set up on the edge of the cornfield, framing a panoramic picture back across the valley we just covered. Everyone gathers for the group portrait. This is *not* a dream. This is real. A beautiful day, in a magical place, with some very good people.

As we start out again, hiking downhill toward another part of the river, I notice that Alberto has become ebullient. He dashes ahead of the rest of us, climbs a tree, and drops grapefruits to us. He calls me *"Papacito"* now, and his voice rings with pleasure as we arrive at the waterfall: *"Que leeeeen-do, Pa-pa-SEE-to. Mira, mira, MIRA, Pa-pa-seeee to."* Following his example, everyone strips to their underwear and dives into the pool around the falls. Alberto shows me how to swim around the powerful downspout, and we climb together onto the wet banks behind the falls. We smear gobs of brown clay over our faces and necks—*"Que sa-brooooo-sa, Papasito,"* Alberto exclaims—then we dive back into the cold, exhilarating water.

"Cómo está, Papasito? Le gusta?" Fabian asks. I'm Papacito to everyone now. On the walk back to his house, Alberto again runs ahead, bringing me, one by one, a collection of wondrous things from his land. He brings black bean pods as big as an ear of corn, *vainas,* he calls them, from a tropical tree; he brings me half a dozen spindly, delicate white flowers that he calls *lecheros;* then juicy, ripe grapefruit and several different varieties of

Alberto Nieto (second from right) and family, Laguna de Majahual, Veracruz

On the road to Monte Pio, north of Toro Prieto

On the road to Monte Pio, north of Toro Prieto

bananas. This land, in all its beauty, with all its bountiful surprises, is a natural treasure. And today this treasure is Alberto's gift to me.

When we arrive at his house, Margarita has prepared food for us. We sit together at a table in front of their house and share a lunch of black beans, rice, and tortillas, along with pitchers of melon-flavored *agua fresca*. Afterward, in a painful farewell, we exchange hugs. Alberto puts his arms around me in a gentle embrace, and softly places a kiss on my heart. *"Regrese pronto, Papasito. Te esperamos."* Return soon, Papasito. We will be waiting for you. It's not easy to leave these kind, gracious people, but I am eager to be on my way. Still, I have a feeling the best is yet to come.

From Laguna de Majahual, the highway continues on a northeasterly course, passing through a fair-sized town, Nueva Victoria, then another smaller community, La Gloria. In the first ten miles from Alberto's house, the road crosses three large rivers. Coming out of the community of Salinas, the pavement gives way to gravel, and I wait my turn to cross a primitive, one-lane bridge over yet another river. The road begins to turn due east now, and I can see from my roadmap that I am about to enter Los Tuxtlas Biosphere Reserve. To my right, on the south side of the road, row after row of terraced fields rise up the slopes of a range of mountains. The San Martín volcano marks the southern tip of the Sierra de los Tuxtlas. The summit, at 1,650 meters (5,413 feet), is a kilometer-wide cinder cone. Given that altitude, it is no surprise that San Martín was visible to the early Spanish explorers as they sailed this part of the coast. From the crow's nest of their ships, they might even have been able to make out the dense, tropical rainforest that covered, as it still does today, the upper flanks of the volcano. The lower slopes—as I can see from the road now—have largely been converted to pastureland. Huge, black volcanic stones lie in the fields, the remains, I'm guessing, of one of the violent eruptions of San Martín, in 1664 and 1793.

At the village of Toro Prieto, a beautiful vista of the sea appears to the north, the first view I've had of the Gulf since I left Veracruz. The deep blue waters sparkle in the afternoon sun, watched over by the lighthouse at Punta Roca Partida, which sits above the sea on the crest of a wooded headland. The bright green pastures, the blue sea, and the luminous sky present an eye-catching panoramic landscape in three broad, parallel stripes. I stop

Playa Hermosa,
Veracruz

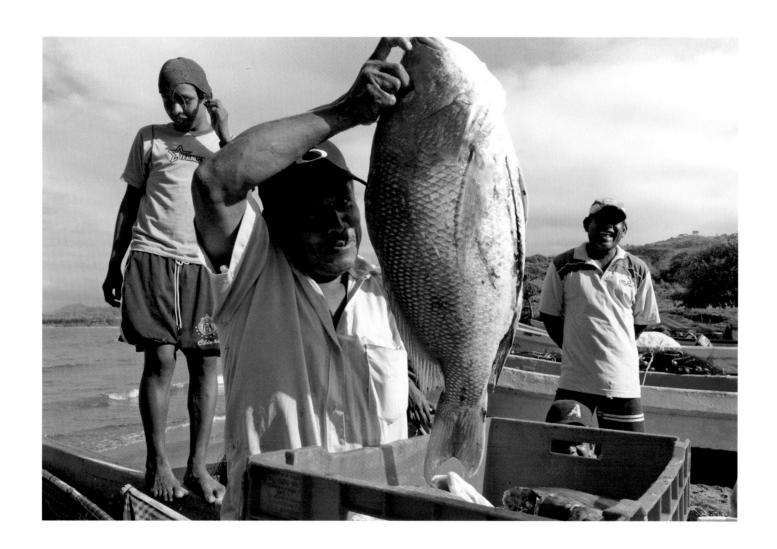

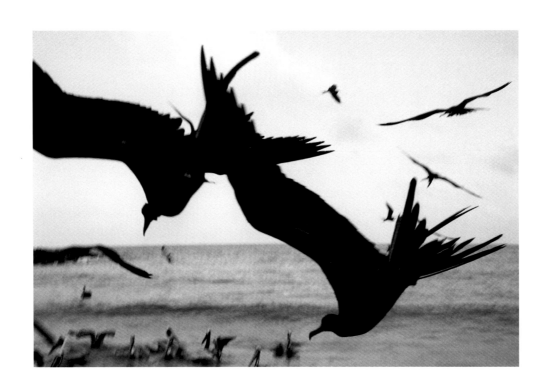

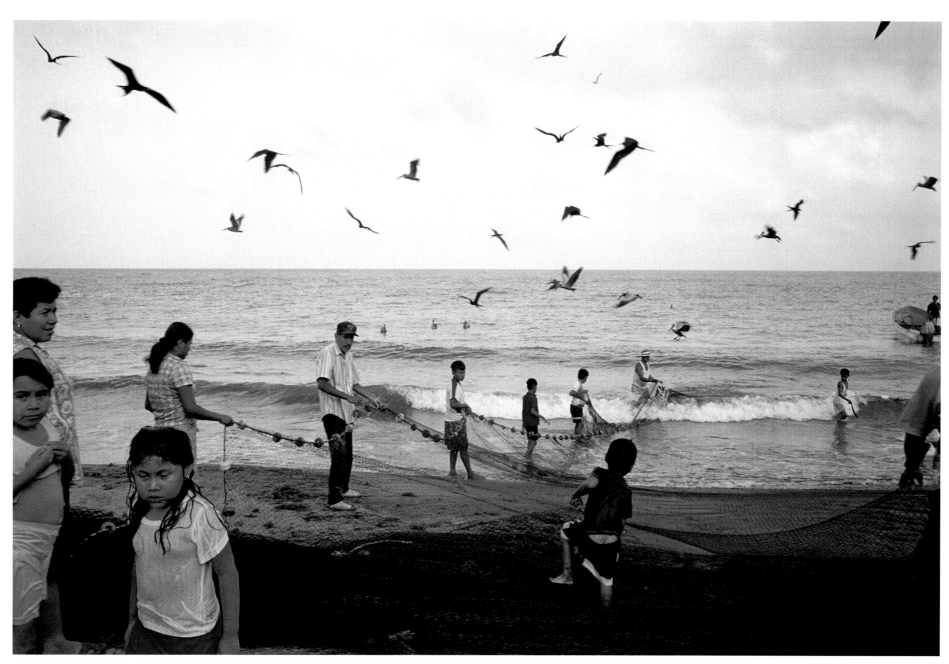

Playa Hermosa, Veracruz

briefly for a photograph, and then continue. My map shows the town of Monte Pio approximately ten miles ahead. From my vantage point on the road, I can see for several miles down the coast. A series of promontories jut out into the sea, and I think I can see Monte Pio in the distance. At the end of the first promontory ahead of me, I can see a small crowd of people on the beach. The road leads into the tiny village of Playa Hermosa and takes me directly to the beach.

Twenty or thirty people, in two lines, are pulling a very large seine net from the sea. Judging from the amount of net that has already been pulled, they have been working this net for a long time. Hundreds of frigate birds glide in the sky overhead. Two dozen gray pelicans hover as well, at a lower altitude. Children are playing all around the beach, but they are beginning to gather in the surf, as the big net gets close to the beach. The pulling of the net seems to be both a practical event—the gathering of food for the entire village, I would guess—and a social scene. The men and women pulling each side of the net are talking and laughing as they pull.

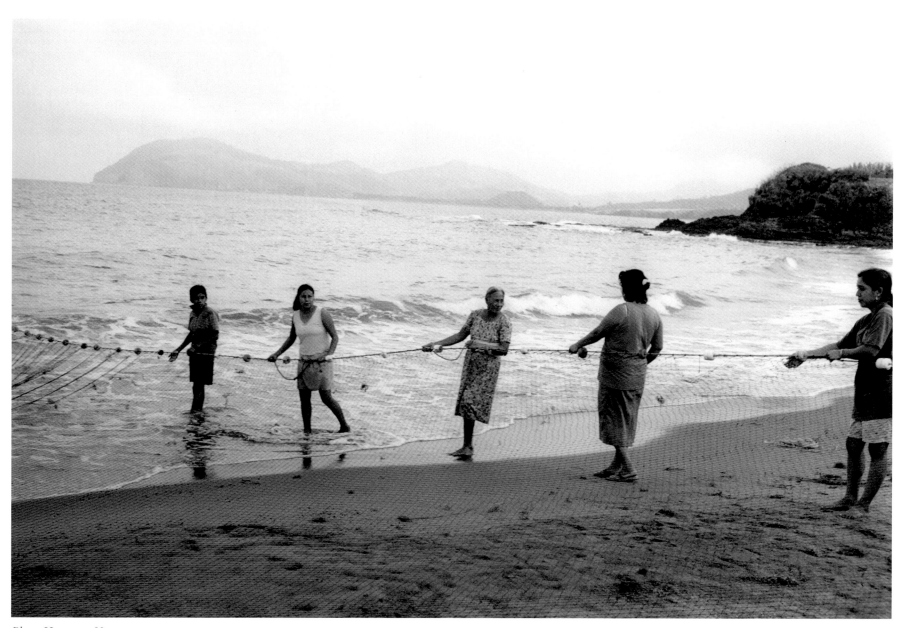

Playa Hermosa, Veracruz

There is a flurry of activity as the end of the net gets close to the shore. Fish jump from the net, and the frigate birds swoop down in a frenzy of feeding. As soon as the net is on the beach, everyone rushes in. The catch is mostly *huachinango,* bright orange-red snapper, some as large as two feet long. There are hundreds of blue crabs clinging to the net, a few eels, jellyfish, and one three-foot shark. In a matter of minutes, everyone scoops what they want from the net, and the birds take care of the rest. A dozen men linger on the beach in the late afternoon light, completing the task of folding the huge seine net and winding up the ropes that were used to pull it. The frigate birds are still gliding overhead, and to the south, at the tip of a wooded promontory, the little town of Monte Pio is visible through the misty air. By the time I arrive there, half an hour later, darkness has fallen. I check into the modest Hotel Paraiso, have good night's sleep, and then awake the next morning, looking for breakfast.

Monte Pio is a disappointment. I had expected a charming, idyllic, unspoiled beach town, as I found the afternoon before at Playa Hermosa. Monte Pio, in contrast, is a funky sort of place, with lots of stray dogs, lost chickens, and the dumpy ruins of an old fort. I decide to get back in my truck and keep following the road around the volcano.

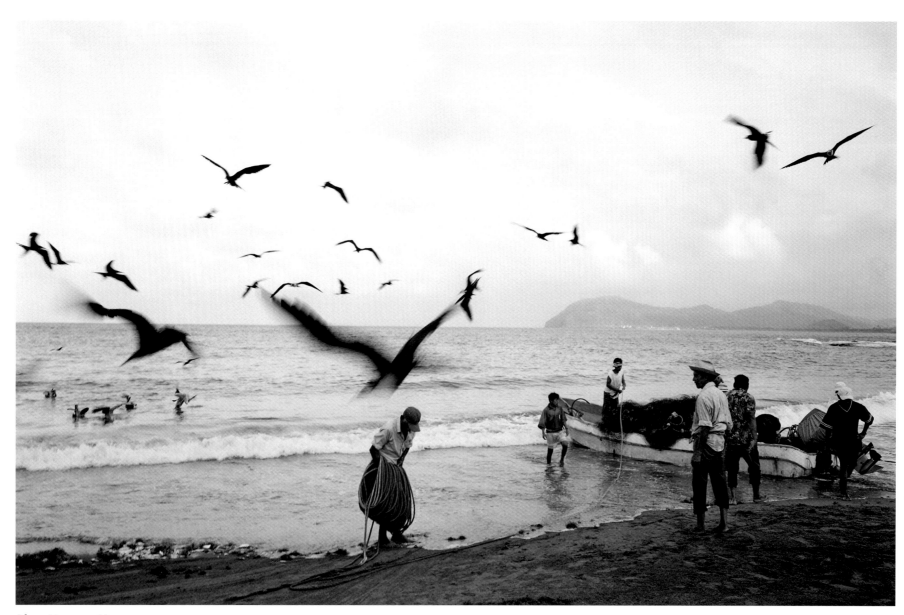

Playa Hermosa, Veracruz

. . .

The road out of Monte Pio is little more than a wide pathway through the dense tropical forest. Narrow dirt roads lead off the cinder pavement every quarter mile or so, up onto the slopes of the volcano or down to the sea. A few kilometers out of Monte Pio, I pass the headquarters and research station of the Las Tuxtlas Biosphere. Signs along the road warn travelers not to disturb the plants or to remove anything from the federally protected natural environment. As I wind my way slowly along the road, from time to time through the trees I can see the succession of wooded headlands that extend from the mainland toward the sea.

Less than a kilometer past the biosphere headquarters, on a steep, curving downhill grade, one little road catches my attention. There are no signs or markers, and a mesh of vines dangling from overhanging limbs partially obscures the entry. I pull to the side of the roadway and look closely. Judging from the broken pavement of rocks and cracked concrete, the road is very old. The entry is dark, except for the vines that hang all about, aglow in the morning sunlight. Tiny white butterflies flutter through the air around the vines. I assume this is a private road, perhaps to some rancher's property, but there is no warning against entry or trespassing. Still, I hesitate. The road drops steeply past the entry, and if the pavement turns to dirt, or mud, I could get stuck in there. Judging from all the vines hanging at the entry, it doesn't look like there's been any traffic for some time.

There is something alluring about this road. The glow of the light on the vines. The dappled sunlight and darting butterflies. The darkness leading to light . . . and to who knows what else. I turn in, easing my truck carefully through the vines, then moving slowly through the patches of sunlight and shadow.

Around the first turn, I find sunlight. The morning sky appears through the trees overhead, and the landscape to the right of the road opens onto a pasture of rolling hills and high grass. Fence posts of planted *mulato* branches make a string of lively shapes against the bright green grass. One old tree, a hundred feet tall, has fallen. It lies flat, almost totally covered by the grass, its rotting trunk pointing downhill.

The road takes a sharp left-hand turn and descends. Looking up and to my right, through the trees I see a headland, far in front of me. Perhaps the road leads there.

To my right, in the lush field below the road, two boys are running through the high grass, toward a little river that lies ahead of them, at the base of the hill. The road levels out, and I cross an old stone bridge over the same river. The rushing water is dark green, with splashes of silver sunlight dancing across its surface.

On the far side of the bridge, two simple homes stand, one on each side of the road. Laundry hangs on a clothesline in one of the yards, but there is no one in sight. Two chickens, a red rooster and a white hen, cross the road in front of my truck. Tall, thick *mulato* trees grow on each side of the road-way. A pretty gray mare and her foal graze in a pasture beyond the trees.

The road bears to the right, then right again, winding through fields lush with huge ferns and bright red bromeliads. The jagged contour of the headland appears closer now. I cross another creek, and the road moves through deep shadows, while the fields on both sides are ablaze in sunlight. I suppose I have traveled a mile now on this road, but it is impossible to say for sure. The road, the changing landscape around it, and the mystery of what lies ahead feel timeless and eternal. I urge myself to go slowly—as slowly as I possibly can—as I follow this beautiful road.

Ahead, the road bears left and begins to rise through a bright canopy of leaves and vines. The light of the morning sun, filtering through the leaves, forms a bright green halo over the road. As I begin the ascent, swarms of white butterflies dance in the air in front of my truck. For the first time this morning, I hear the sound of the ocean. Then, at the crest of the hill, I see the surf. Beyond a green pasture of rounded hills, the brown sand of the beach and the crashing waves form an elegant, curving coastline.

A border of tangled, flowering vines and trees line the road at this point. Beyond that, the land dips slightly, then rises sharply toward the crest of a hill. Volcanic rocks lie scattered on the hillside, with a dozen horses grazing among them. A banyan tree grows at the very top of the hill, and its crest of foliage casts a pool of shade over the stones and horses. I want to climb that hill, if only for the view of the sea from the top, so I pull my truck to the side of the road and start up the grassy slope.

At the base of the tree, I find the biggest stones of all, boulders as big as a small house. They must have landed here hundreds of years ago, when the Volcán de Tuxtla erupted. Vines have grown into the ebony-like surface of the rock. One of the biggest stones wears a crown of bright green, heart-shaped leaves. The horses eye me as I explore around and photograph. Some stones appear to have faces etched in them, faces that look back at me as I record their jagged contours with my camera.

Back in my truck, I continue to follow the road. I descend for a hundred yards, take a turn to the left, and find myself facing a very steep ascent, again through a canopy of leaves and vines. At this point, however, the road has deteriorated. Parts of the old rock surface have cracked and broken apart, and I'm not sure, even with four-wheel drive and high clearance, that

I can make it across the piles of broken rock that were once a road. I could end up with a flat tire or two, sitting on a thirty-degree slope, enmeshed in vines, with no help in sight. Still, I've gotten this far along the road, and I'm not about to stop before I find out where it leads. I shift into four-wheel drive and inch forward, over the crumbled rocks, up the steep hill, pushing through branches and vines as I go.

The rough stretch of the road extends for about a hundred yards, then the rocky pavement improves, and I move smoothly up the hill. I hear the distinctive *kreeee* of a hawk and out of nowhere it swoops down from behind my truck and sails up the road ahead of me, an escort to whatever lies ahead. Tropical birds are calling and monkeys are howling in the trees above the road.

The road ascends for another few hundred yards, then ends on a flat, grassy knoll surrounded by trees, and—lo and behold—a cluster of abandoned buildings. There are three structures, simply constructed of concrete blocks. They were once painted white with blue trim, but are now faded and moss stained in the shadows of the tropical trees. They appear to have been abandoned for some time. Most of the doors are missing, the windows are broken, and the jungle has begun to grow over the buildings. I park my truck and get out to have a look. I hear the sound of the sea, from far below, like a soft breeze blowing up and over the tip of the headland.

Two of the old buildings, each three stories high, hold about twenty bedrooms each. The furniture is still in place, damp and rotting. The beds have collapsed, and the chairs and tables are covered in cobwebs. It's clear that this was once a hotel, but no one has occupied it for years. Vines have grown through the windows and now cling to the musty ceilings. Moss and lichen cover the interior walls. In one dark hallway, bats hang from the ceiling.

A smaller, one-story structure houses the remains of a kitchen and a small dining room; an attached concrete stairway leads to a rooftop terrace. Cautiously, avoiding limbs that have fallen over the stairs, I climb to the terrace. A white balustrade around the perimeter has collapsed and fallen onto the concrete floor of the terrace. Over the years, tree limbs have fallen onto the terrace and turned to compost; now plants have taken root on the roof-top. In another decade, the jungle will have completely overgrown the abandoned hotel.

The view of the sea from the rooftop is spectacular. I can see for fifty miles or more down the curving coastline, and the Gulf itself is a deep, brilliant blue-green color. Far below, white-capped waves are skimming the surface of the sea and falling onto a dark beach of volcanic sand.

I look out at the sea, then at the jungle that's reclaiming the old hotel, and I recall that fleeting vision I had at the start of this journey. I remember when I was leaving Houston and, for an instant, I imagined the city in ruins. Suddenly, that vision comes alive again in my mind, and I see, in vivid detail, the still and empty remains of the once shining city. Its skyscrapers, now deserted for a millennium at least, lie half hidden in vines. What had once been city streets are now dense forests of pines and live oaks, dripping with Spanish moss. Still, the old brown bayou flows through the heart of the abandoned city, and a maze of crumbling freeways encircles it all.

Then, the vision of the city in ruins passes, and I return to the reality of this place and this moment. The view of the sea before me, the presence of the volcano somewhere behind and above me, the magical road that brought me here . . . all of this is real, and at this moment it is mine.

To the side of the terraced building, I notice a stone pathway leading through the jungle, down toward the sea. I climb down from the terrace and follow the path. It drops, gently at first, and then steeply. As the sea comes into view below me, the path becomes a concrete staircase. The steps twist and turn, descending through a hillside of flowers and dense foliage. Below me, several hundred yards down, lies a small, perfect beach, rimmed with black volcanic rocks, hidden at the tip of the headland I have traveled. I have never seen a more perfect or a more beautiful beach. It's no wonder that someone built a hotel above it and made this winding staircase to reach it. A hand-painted sign tacked to a tree trunk, faded red letters on a rusted sheet of corrugated metal, points the way down to "Playa Escondida."

I count four hundred and eighty steps from the old hotel to the sea, then I walk onto the beach and into the surf. The waves wrap around my feet and wash onto the sand. Some surge over the black rocks. The white tips of the waves, rising and falling across the brown sand and the dark rocks, make a series of rhythmic drawings for my camera to capture.

How could it be, I wonder, how could it *possibly* be that this perfect place has been saved for all these years for me, and for me alone, to find.

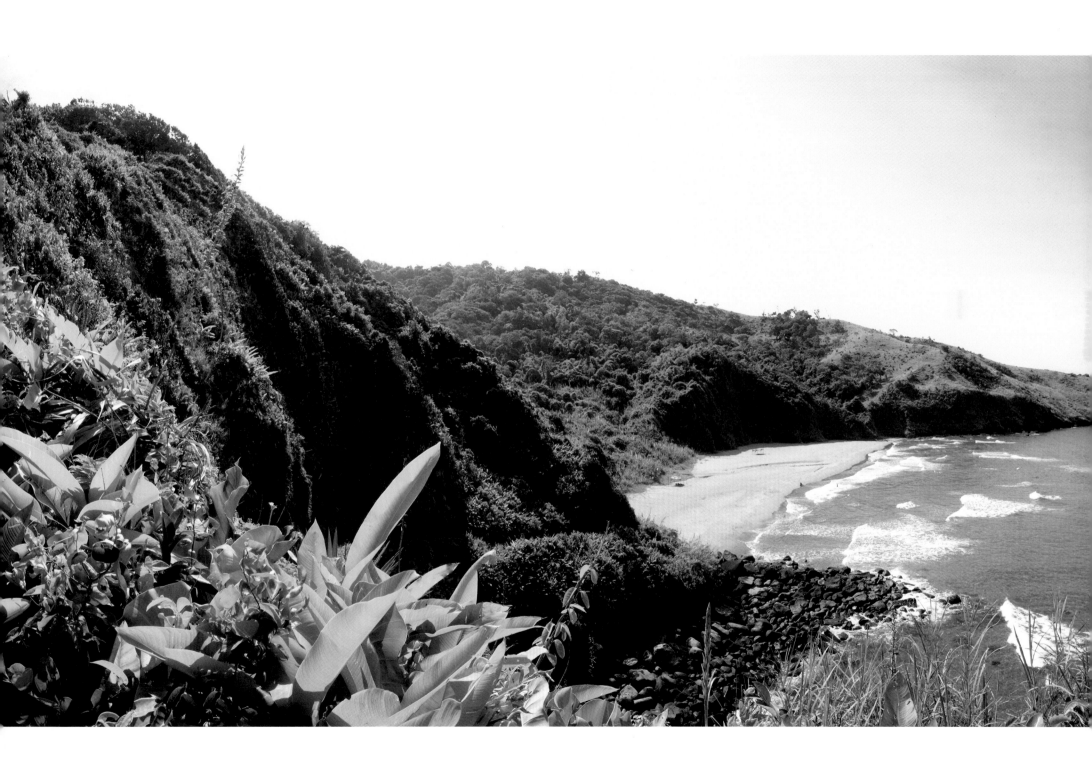

Acknowledgments

FIRST AND FOREMOST, I want to express my deepest appreciation to Jim Jard and to Patrick Oxford of Bracewell & Giuliani, LLP whose early support and encouragement made it possible for me to undertake the project that culminated in this book.

As the project progressed, I also received critical support from the Energy and Environmental Systems Institute at Rice University and from the Summerlee Foundation. I thank them, as well as the School of Humanities and the Department of Visual and Dramatic Arts at Rice, who also provided assistance.

The grand adventure of traveling the Gulf Coast was most memorable for the people I met, the help they gave me, and the glimpses they offered me into their lives. No one was more generous with his time and energy than Bill White—gentleman, rancher, and seventh generation owner of the White Ranch—who graciously allowed me unfettered access to photograph his magnificent ranch and his cattle operations. I also wish to thank Jerdy Fontenot of Port Arthur; Kevin Ladd of the Wallisville Heritage Park; Casey Edward Greene, Head of Special Collections at the Rosenberg Library in Galveston; Sis and Hasty Johnson, who allowed me to photograph their property on Schicke Point; Tony Amos of the University of Texas Marine Science Institute in Port Aransas; Dr. George Flood and Jeanne Adams of Corpus Christi; Frank Perrone and Joey Clements of the King Ranch; and John Todd Jr. of Veracruz.

There is no way for me to express my full appreciation and sincere affection for Alberto and Margarita Nieto. The kindness and hospitality they offered me, a surprise visitor, on one unforgettable day in Laguna de Majahual, Veracruz provide perhaps the sweetest memory of my entire Gulf Coast journey.

I must thank Robert S. Weddle. As I read and researched the history of the Gulf of Mexico, one source more than any other—his brilliant, authoritative book, *Spanish Sea: The Gulf of Mexico in North American Discovery, 1500–1685*—sparked my imagination and ultimately provided inspiration throughout the project.

I offer my deepest appreciation to my friend and colleague from Rice University, Professor Terrence Doody. Terry came to my side when I undertook the writing of the text for this book. He coaxed and inspired me, read my drafts, offered advice, and—in the wondrous way that great teachers do—helped me find the confidence and energy I needed to complete the task.

I also want to thank Professor Jimmie Killingsworth of Texas A&M University, who read final drafts of the text and offered crucial advice, as well as Dawn Hall, my copyeditor, whose careful reading and corrections brought the text to its final form.

I thank my wife, Janice Freeman, first for the good eye and sound judgment she offered on matters ranging from picture editing to layout, but most of all for the maps that she generously created for the book.

Finally, I wish to thank the editorial and production staff of the Texas A&M University Press for the care and attention they gave to this book, especially managing editor Thom Lemmons, designer Mary Ann Jacob, prepress manager Kevin Grossman, and most of all Shannon Davies, Louise Lindsey Merrick Editor for the Natural Environment, for her enthusiasm and her countless valuable contributions to the project.

Bibliography

Barnstone, Howard. *The Galveston That Was.* College Station: Texas A&M University Press, 2001.

Blackburn, Jim. *The Book of Texas Bays.* College Station: Texas A&M University Press, 2004.

Bruseth, James E., and Toni S. Turner. *From a Watery Grave: The Discovery and Excavation of LaSalle's Shipwreck, La Belle.* College Station: Texas A&M University Press, 2005.

Burkhart, Louise M. *The Slippery Earth: Nahua-Christian Moral Dialogue in Sixteenth-Century Mexico.* Tucson: University of Arizona Press, 1989.

Calderon de la Barca, Frances. *Life in Mexico.* London: Chapman and Hall, 1843.

Cieza de León, Pedro de. *The Discovery and Conquest of Peru: Chronicles of the New World Encounter.* Edited and translated by Alexandra Parma Cook and Noble David Cook. Durham, N.C.: Duke University Press, 1998.

Daniels, A. Pat. *Bolivar! Gulf Coast Peninsula.* Crystal Beach: Peninsula Press of Texas, 1985.

Díaz del Castillo, Bernal. *The True History of the Conquest of New Spain.* New York: Da Capo Press, 1996.

Farley, Barney. *Fishing Yesterday's Gulf Coast.* College Station: Texas A&M University Press, 2002.

Fehrenbach, T. R. *Fire and Blood: A History of Mexico.* New York: Da Capo Press, 1995.

Foster, William C. *Spanish Expeditions to Texas, 1689–1768.* Austin: University of Texas Press, 1995.

———. *The La Salle Expedition to Texas: The Journal of Henri Joutel, 1684–1687.* Austin: Texas State Historical Association, 1998.

Graham, Don. *Kings of Texas: The 150-Year Saga of an American Ranching Empire.* Hoboken, N.J.: John Wiley and Sons, 2003.

Guthrie, Keith. *Texas Forgotten Ports.* Austin, Tex.: Eakin Press, 1988.

Harrigan, Stephen. *A Natural State: Essays on Texas.* Austin: University of Texas Press, 1988.

Hollon, W. Eugene, and Ruth Lapham Butler. *William Bollaert's Texas.* Norman: University of Oklahoma Press, 1956.

Jackson, Jim Bob. *They Pointed Them East First.* Self published, 2004.

Landry, Wanda A., and Laura C. O'Toole. *Betting, Booze, and Brothels: Vice, Corruption, and Justice in Jefferson County, Texas.* Austin, Tex.: Eakin Press, 2006.

Le Clézio, J. M. G. *The Mexican Dream; or, The Interrupted Thought of Amerindian Civilizations.* Chicago: University of Chicago Press, 1988.

León-Portilla, Miguel, ed. *The Broken Spears: The Aztec Account of the Conquest of Mexico.* Boston: Beacon Press, 1992.

Olmsted, Frederick Law. *A Journey through Texas; or, A Saddle-Trip on the Southwestern Frontier.* Lincoln: University of Nebraska Press, 2004.

Pagden, Anthony, ed. *Hernán Cortés: Letters from México.* New Haven, Conn.: Yale University Press, 1986.

Parkes, Henry Bamford. *A History of Mexico.* Boston: Houghton Mifflin, 1969.

Schueler, Donald G. *Adventuring along the Gulf of Mexico.* San Francisco: Sierra Club Books, 1986.

Sibley, Marilyn McAdams. *Travelers in Texas, 1761–1860.* Austin: University of Texas Press, 1967.

Thompson, Jerry. *A Wild and Vivid Land: An Illustrated History of the South Texas Border.* Austin: Texas State Historical Association, 1997.

Tijerina, Andrés. *Tejano Empire: Life on the South Texas Ranchos.* College Station: Texas A&M University Press, 1998.

Tinsley, Russell. *Fishing Texas: An Angler's Guide.* Fredericksburg, Tex.: Shearer Publishing, 1998.

Tyler, Ron, ed. *The New Handbook of Texas,* Austin: Texas State Historical Association, 1992.

Wauer, Ronald H. *Naturally . . . South Texas: Nature Notes from the Coastal Bend.* Austin: University of Texas Press, 2001.

Weddle, Robert S. *Spanish Sea: The Gulf of Mexico in North American Discovery, 1500–1685.* College Station: Texas A&M University Press, 1985.

———. *The French Thorn: Rival Explorers in the Spanish Sea, 1682–1762.* College Station: Texas A&M University Press, 1991.

———. *Changing Tides: Twilight and Dawn in the Spanish Sea, 1682–1762.* College Station: Texas A&M University Press, 1995.

———. *The Wreck of the* Belle, *The Ruin of La Salle.* College Station: Texas A&M University Press, 2001.

Weise, Bonnie R., and William A. White. *Padre Island National Seashore: A Guide to the Geology, Natural Environments, and History of a Texas Barrier Island.* Austin: Bureau of Economic Geology, University of Texas at Austin, 1980.

Weniger, Del. *The Explorer's Texas: The Lands and Waters.* Austin, Tex.: Eakin Press, 1984.

Wood, Michael. *Conquistadors.* Berkeley: University of California Press, 2000.

Index

Page numbers in **bold type** refer to illustrations.

Adams, Jeanne (Corpus, Christi), 114–16, **115**

Aguilar, Jerónimo de (interpreter for Cortés), 237–38

Alamo, Veracruz, 206, **206, 207**

Alvarado, Veracruz, 278, 279

Álvarez de Pineda, Alonso, 116, 182–84

Alligator Head Ranch (Port O'Connor, Texas), 96, 98

Amichel (province of), 184

Antigua, Veracruz. *See* Las Antigua, Veracruz

Aransas National Wildlife Reserve, 100–103, **101, 102, 103**

armadillo (observed by Spanish explorers), 188

Atakapan Indians, 3

Aubry, William P. (Corpus Christi, Texas), 107

Audubon Village development (Gilchrist, Texas), 33

Aury, Louis (French pirate), 44

Ballí, José Nicolás (Padre Island), 118

Barra de Palmas, Veracruz, 216

Bay City, Texas, 76–86

Baywater Villas (Galveston Island), 58

Bellisle, François Simars de, 3–4

Boca Chica Beach, 135, 142–47, **140, 145, 146–47**

Bollaert, William, 44, 47

Bolivar ferry, 40, **41,** 44, **45**

Bolivar Peninsula, **31,** 33–40, **32, 34, 35,**

Brazoria County, Texas, 71, 73, 74, **76, 77, 78, 79**

Brazos River, 70–71

 origin of name, 70

Brazosport, Texas, 67

Broussard, B. J. (Port Arthur, Texas), 12

BUC-EES bait and convenience store, 67–68, **62**

Cabeza de Vaca, Álvar Nuñez, 58–64, 86

 arrival in Culiacan, Mexico, 64

 first encounter with native Americans, 60

 healing the sick, 63

 landfall at "Malhado," 60

 map of route, **61**

 "region of the prickly pears," 63–64

 Relación of 60–64

Cabo Rojo, 58, 104, 206, 240

Cade, C. T. (High Island, Texas) 30

Calderón de la Barca, Francis (19th-century chronicler of Mexico), 200, 201

Camargo, Diego (expedition of), 184

Campeche (headquarters of Jean Lafitte), 44

Caney Creek, 76, **77, 78, 79**

Carbonera, Tamaulipas, 168

Cardenas del Río, Lazaro, 212, **213**

Cartier-Bresson, Henri (photographs of Galveston), 46

Caracol development (Port O'Connor, Texas), 96

Cárdenas del Río, Gen. Lázaro (monument to), 212, **213**

Carvajal, Tamaulipas, **viii,** 168, 168–71, **169, 170**

Casitas, Veracruz, 216, **218, 219, 220, 222, 223**

Castillo del Teayo, Veracruz, 208–11, **210**

Cempoala, Veracruz, 240, **243**

Cerro del Metate, 227, **228,** 229

Chapa, Alfred (Indianola, Texas), 94

Chapman Ranch, Texas, 128, **129**

Chinquapin, Texas, **80, 81**

Clayton, Nicolas J. (Galveston architecture), 45

Clements, Joey (King Ranch), 136

Columbia Bottomlands, 74–76

Columbia Historical Museum (West Columbia, Texas), 72–74

Columbia, Texas, 72 (last load of slaves to arrive in North America). *See also* West

Columbia, Texas

Columbus, Christopher, 232

Códice Durán, **237, 239,** 252–56

Códice Florentino, **240**

conquest of Mexico, 238–43, **236, 237, 239, 240, 242**

Córdoba, Francisco Hernández de. *See* Hernández de Córdoba, Francisco

Corpus Christi, Texas, 107–16, **109, 111, 112**

 Adams, Jeanne, 114–16

 deepwater port, 108

 history of, 107–108

 hurricane of 1919, 108

 Old Bayview Cemetery, **112,** 113–14

 Quintana-Perez, Selena, 110, **111**

Cortés, Hernándo, 58, 182–84, 188, 226, 237–43

 Casa de Cortés (La Antigua, Veracruz), 245, **244**

 ruins of fort at Villa Rica, **228,** 229

Costa Esmeralda, 212, 216, **218, 219, 220, 222, 223, 224, 225**

Crystal Beach, Texas, **32, 34**

Cuellar, Serefino and Margarita (Port Lavaca, Texas), 90, **91**

Cuellar, Jose Reyes and Domingo (gravestone of), 89, **90**

Díaz del Castillo, Bernal. *See Discovery and Conquest of Mexico, The.*

Discovery and Conquest of Mexico, The (Díaz del Castillo), 229 (building the fort at Villa Rica), 242 (first view of the Valley of Mexico)

Dow Chemical Company (Freeport, Texas), 67

Dowling, Lt. Richard. *See* Dowling Park (Sabine Pass, Texas)

Dowling Park (Sabine Pass, Texas), **2,** 18

Dunn, Patrick ("Duke of Padre"), 119

Echevarria, Maria Borrell de (gravestone of), 270–72, **273**, **344**

Edington Courts (Port Arthur, Texas), **11**

El Barrancón del Tío Blas, 163–67, **165**, **166**

El Mesquitál, Tamaulipas, 151–61, **154**, **156–57**, **159**, **160**, **161**

Emilio Carranza, Veracruz, 221

Escondón, José de, 107

Espinosa, Alfred (Veracruz), 260–64

Evia, Don José de, 44 (Spanish mapping expedition of 1785)

ex-voto painting (from Veracruz, Mexico) 114–16, **115**

Firehouse Restaurant and Bar (Gilchrist, Texas), 33–38

Follett's Island, 58, 64

Fontenot, Jerdy (Port Arthur, Texas) 13–18, **15**. *See also under* Jerdy's Barber Shop

Freeport, Texas, 64, 65, 66–67, 69

fruit stands (near Rancho Viejo, Texas), **136**, **137**

Galveston Bay, 44, **46–47**

Galveston, Texas, 46–58, **49**, **50**, **51**, **59**
 East End Historical District, 46, **54**, **336**
 Laffite's Cove, 48
 Mardi Gras in, **52**, **53**
 oak trees near Stewart Road, 55, **56**, **57**
 origin of name, 44–45
 Rosenberg Library, 47–48
 "three trees," 44, 47, 48, 55 *See also* Lafitte's Grove

Galveston That Was, The (Barnstone), 46

Garay, Francisco (Governor of Jamaica), 182, 187–88

Gates, John W. (Port Arthur, Texas), 10

Gilchrist, Texas, **31**, 33–38, **35**

Graaf, Laurens de, 256 (sacking of Veracruz)

gravestones
 in the Old Bayview Cemetery (Corpus Christi, Texas), **112**, 113–14
 in the Port Lavaca Historical Cemetery, 89, **90**
 in the Panteón Particulár (Veracruz), 270–74, **271**, **273**, **344**

Gray, Col. W. F., 44 (early description of Galveston Island)

Greene, Casey (Galveston, Texas), 47–48

Grijalva, Juan de, 187, 188, 236–37

Gulf Intracoastal Waterway, 4, 18, 30, 96

Gulfgate Bridge (Port Arthur, Texas), 4–7, **6**

Gutierrez, Ambrosio "Bocho," 68–70, **69**

Hanselka, Don and Kerry (Indianola, Texas), 94

Hardee, David Carlton, 27(early description of the coastal prairie)

Hathcock, Pat (Seadrift, Texas), 96

Hernandez de Córduba, Francisco, 236

Higgin, Sarah (Matagorda County Museum), 86

High Island, Texas, 30–33

Holland, James K. (1848 description of south Texas prairie), 130

Houston, Texas, 2, 326

Houston Ship Channel, **39**, 45, **46–47**

Huasteca Indians, 184, 188

Hurricane Carla (1961), 94 (Indianola, Texas), Padre Island (116)

Hurricane Emily (2005), 164 (El Barrancón del Tío Blas, Tamaulipas)

Hurricane Katrina (2005), 213 (Port Arthur, Texas)

Hurricane Rita (2005), 22 (Sabine Pass, Texas), **20**, **21**

hurricane of 1875, 70 (Velasco and Quintana, Texas), 94 (Indianola, Texas)

hurricane of 1886, 18 (Sabine Pass, Texas), 94 (Indianola, Texas)

hurricane of 1900, 18 (Sabine Pass, Texas), 30–33 (High Island, Texas), 45 (Galveston, Texas), 70 (Velasco and Quintana, Texas)

hurricane of 1915, 18 (Sabine Pass, Texas)

hurricane of 1919, 96 (Seadrift, Texas), 107 (Corpus Christi, Texas)

Iglesia la Luz del Mundo, 171

Indianola, Texas, 45, 94, **95**,

Indian Point, Texas, 94

Island of Misfortune (Malhado), 60, 61

Isle of Sacrifices, 236, 238

James Commission (investigation of Port Arthur, Texas), 14

Jerdy's Barber Shop (Port Arthur, Texas), **15**, **16**, **17**

Jesus Juarez, Maria de (gravestone of), **112**, 113, 114

Johnstone, Dean (Port Lavaca, Texas), **88**, **89**

Joplin, Janis (Port Arthur, Texas), 12, 14

Journey through Texas, A. (Olmsted), 100 (early observation of whooping cranes)

Karankawa Indians, 44, 55, 60, 86, 116, 118

Kaufman, Dorothy (Chapman Ranch, Texas), 128, **129**

Kenedy, Mifflin, 130

Kennedy, William (1839 description of Wild Horse Desert), 130

King Charles IV, 118 240

King Ranch, 130–35, **131**, **132–33**, **134**
 history of, 130–35

King, Richard,130

Kinney, Henry Lawrence (Corpus Christi, Texas), 107

La Antigua, Veracruz, 245, **244**

La Crema, Veracruz. 200

La Belle (LaSalle's ship), 86

Lafitte, Jean, 30, 33, 44

Lafitte's Grove (Galveston Island), 48, 55. *See also* Galveston, Texas; "three trees"

La Guadalupe, Veracruz, 216

Laguna de Majahual, Veracruz, 294–303, **295**, **296**, **297**, **298–99**

Laguna Madre, 116, 158, 163
 at Carvajal, Tamaulipas, **viii**
 at El Barrancón del Tío Blas, Tamaulipas, 163–64, **165**
 at El Mesquitál, Tamaulipas, 158
 at the King Ranch, **131**
 at Port Mansfield, **138**

La Pesca, Tamaulipas, 172–76, **173**, **174**, **177**

Lara, Agustín (Tlacotalpan, Veracruz), 279

LaSalle Addition (Port O'Connor, Texas), 96

La Union, Veracruz, 276, **277**

Lava Auto Cyndi (Emilio Carranza, Veracruz), 221–26

León, Alonso de (expedition of 1689), 107

Lewis, Gideon (Corpus Christi, Texas), 130

Luttrell, R. W. (Galveston Resurvey of 1901), 47

Malhado. *See* Island of Misfortune

Malinche (mistress of Cortéz), 238

Matagorda County Museum (Bay City, Texas), 86

Matamoros, Tamaulipas, 150–51, **151**, **152**, **153**

McClintock, William (1846 description of the Wild Horse Desert), 130

Mena, Fray Marcos de (Spanish shipwreck survivor), 126

Menard, Michael (founder of Galveston, Texas), 45

Mercer, Robert Ainsworth (Mustang Island), 103

Mexico Highway 180, 151, 161, **162**, 163, 167, **178**, **179**, 181, **204**, **205**, 217, 221, 274, **274–75**, **277**, 292

Mini-Zoologío Museo de Don Pio, El (Tlacotalpan, Veracruz), 282–89, **284**, **285**, **286**, **287**, **288**, **291**

Monte Pio, on the road to 292, 310, **292**, **293**, **300**, **301**, **302–303**, 306

Montezuma II (Aztec ruler), 182, 238–39

Moreno, Enrique (Tampico, Tamaulipas), 187

Morgan, Charles (Indianola, Texas), 94

Museo de la Ciudad (Veracruz), 252–56

museums and archives

 Columbia Historical Museum (West Columbia, Texas), 72–74

 Matagorda County Museum (Bay City, Texas), 86

 Mini-Zoologío Museo de Don Pio, El (Tlacotalpan, Veracruz), 282–89, **284**, **285**, **286**, **287**, **288**, **291**

 Museo de la Ciudad (Veracruz), 252–56

 Museum of the Gulf Coast (Port Arthur, Texas), 10–12

 Rosenberg Library (Galveston, Texas), 47

Mustang Island, 103, **106**

Nahual culture, 206

Naranjos, Veracruz, 201

Narvaez, Pánfilo de (voyage of 1527), 58

New World, discovery of, 232–43

Nieto, Alberto and Margarita (Laguna de Majahual, Veracruz) 294–303, **295**, **296**, **297**, **298–99**

Newport News, Virginia, 192–97

O'Connor, Thomas O. (Port O'Connor, Texas), 96

Olmec culture, 292

Olmsted, Frederick Law, 100 (early observation of whooping cranes)

Opelousas Trail, 27

Orobio y Basterra, Juaquín de (expedition of 1747), 107

Ortiz Murillo, Arturo (El Barrancón del Tío Blas, Tamaulipas), 164

Padre Island, 114, **117**, **118**, 119, **120–21**, **123**, **124**, **125**, **126–27**, 338

 history of, 116–19

 Little Shell, 122

 Mansfield Channel, 119, 122–25

 Spanish shipwrecks of 1554, 118, 125–26

Paso del Toro, Veracruz, 274

Pierce, Mary (Port Arthur, Texas), 13, **13**,

Pineda, Alonzo Álvarez de. *See* Álvarez de Pineda, Alonso

Pineda map, 184

Playa Escondida, Veracruz, **i**, **xii-xiii**, **322–23**, 328, **330–31**, **332**, **333**, **334**

Playa Hermosa, Veracruz, **vii**, **304**, **305**, 306, **306** **307**, **308**, **309**, **311**

Ponce de León, Juan, 236

Port Aransas, Texas,

 history of, 103

 South Jetty, 103–107, **104–105**

Port Arthur, Texas, 4–18, **6**, **8**, **9**, **11**, **13**, **15**, **16**, **17**,

 history of, 10–12

Port Bolivar, Texas, 40. *See also* Bolivar ferry

Port Comfort, Texas, 86, **87**

Port Lavaca, Texas, 86–90

Port O'Connor, Texas 96, **97**, **99**

Potonchan, México, 237

Poza Rica, Veracruz, 212, **213**, **214**, **215**

Punta Rica, 229

Punta Mancha, Veracruz (lighthouse), **iv**

Puente Tampico, 200, **201**, **202**

Puerto Veracruz. *See* Veracruz, México (city of)

Quetzalquatl (ancient Mexican deity), 182, 239, 240

Quiahuitzlán (Totonac cemetery), 229, 240

Quintana beach, 68, 72, **71**, **72**

Quintana-Perez, Selena, 110, **111**. *See also* Selena.

Quintana, Texas, 70

Ramos, Joe (Port O'Connor, Texas), 96–98, **99**

Rancho Péricos, Tamaulipas, **180–81**

Rauschenberg, Robert (Port Arthur, Texas), 12

Restaurante Las Palmas (San Fernando, Tamaulipas), 167

Río Antigua, 245

Río Casitas, 216

Río de las Palmas, 58, 64, 126, 188

Rio Grande, 118, 142–47, **145**, **146–47**, 150

Río Pánuco, 182–84, **190**, 191, **193**, 201

Río Papaloapan, 279, **281**

Río Soto la Marina, 172

Río Tabasco, 236, 237

Rollover Pass (Bolivar Peninsula), 38

Ropes, Elihu H. (Corpus Christi, Texas), 108

Ropesville, Texas (Mustang Island) 103

Roseate Spoonbill Gallery (Port Lavaca, Texas), 89

Rosenberg Library (Galveston, Texas), 47

Sabine-Neches Waterway, 7, 18

Sabine Pass, Texas, 2, **4–5**, 18, **19**, **20**, 21

Sabine River, 4

Sahagún, Fray Bernardo de, 242

San Bernard River, 76

Sanchez, Homer (Sanchez Tip, Texas), 139–42, **143**

Sanchez Tip, Texas, 139–42, **143**

Sand Point, Texas (Mustang Island), 103

San Fernando, Tamaulipas, 167

San Judas Tadeo, 260–64, **260**

San Luis Pass (Texas), 58

San Martín, Volcán de, 294, 303

Santa Gertrudis Creek, 130

Santisteban del Puerto, 58, 187

Schicke Point, 82, 83, 84, **85**

Seadrift, Texas, 94–96

Selena (Selena Quintana-Perez), 110, **111**

Sea View Hotel (High Island, Texas), 30–33

Selkirk, James (early map of Matagorda County, Texas), 86

shipwrecks (of 1554 on Padre Island), 118, 125–26

Singer, John (Padre Island), 119

Snake Island (early name for Galveston Island), 44

Soto la Marina, Tamaulipas, 172, 187

Spanish Sea: The Gulf of Mexico in North American Discovery, 1500–1685 (Weddle), xiii, 181,187

Spindletop field (Beaumont, Texas), 10, 45

SS Selma (Galveston Bay), 44

St. Louis, Brownsville, and Mexico Railway, 96

Stilwell, Arthur (Port Arthur, Texas), 10

Tamiahua, Veracruz, 206

Tampico, Tamaulipas, 181, 184, **190**, **193**, 200, **201**, **202**

 Colonia Centro Histórico, **183**, **194**, **195**

 Colonia Elita Perez, 184–87, **185**, **186**

 malecón, 191

Playa Miramar, 188, **189**

Plaza de las Armas, **196**, 197

Puente Tampico, 200, **201**, **202**

Tarpon, Texas (Mustang Island), 103

Taylor, Gen. Zachary, 118

Taylor's Bayou (west of Port Arthur, Texas), 3

Tenochtitlán (Aztec capital), 182, 226, 239, 241, 243

Teudile (Aztec steward), 238–39

Texas City Dike, **36**, **37**

Texas Highway 4, 135–39, **140** (near Boca Chica), **141** (sand flats and south Padre Island)

Texas Highway 35, 86 (Brazoria County), 100

Texas Highway 77, 130 (south of Corpus Christi, Texas)

Texas Highway 87, 18, **23** (southwest of Sabine Pass,)

Texas Highway 332, 67, **66–67** (view toward Freeport)

Texas Highway 521, **76** (near Brazoria, Texas)

Thompson, Ned (ex-slave , West Columbia, Texas), 72

Tlaxcala (alliance with Cortés), 241

Tlacotalpan, Veracruz, 279–90

 Hotel Doña Lala, 290

 Mini-Zoológío Museo de Don Pio, El, 282–89, **284**, **285**, **286**, **287**, **288**, **291**

Toro Prieto, Veracruz, 303, **300**, **301**, **302–303**

Totonac Indians, 182, 238, 239

Treaty of Guadalupe Hidalgo, 118

Tropic of Cancer (monument on Mexico Highway 180), **179**

Tuxpan, Veracruz, 208, **208**, **209**

Vasquez, Steve (Port Arthur, Texas), 12–13

Vega de Alatorre, Veracruz, 221, **224**, **225**

Velasco, Texas, 70

Velásquez de Cuellar, Gov. Diego, 237

Veracruz, Mexico (city of), 243–45, 248–72, **249**, **250–51**, 253, 254, **255**, **257**

 Gran Café del Portal, 248–49, **249**

 malecón, 252

 Mercado Hidalgo, 256–64, **258**, **259**, **260**, **261**, **262**, **263**

 Museo de la Ciudad, 252–56

 Panteón Particulár, **266–67**, 267–74, **268**, **269**, **271**, **273**, **344**

 Plaza Las Américas, 264–67, **265**

Victoriana Garayana, 187, 188

Vietnamese fishermen (Seadrift, Texas), 95

Villa Rica, Veracruz, **iii**, 182, 184, 226, **227**, **228**, 229–32, **230–31**, **233**, **234–35**, **239**, 240, 243–45

Weddle, Robert S., xiii, 181

West Columbia, Texas, 72–74, **75** (San Jacinto Festival Parade)

White, Bill (Stowall, Texas), 27–30

White, James Taylor, 27

White Ranch, **xii-xiii**, xiii, 22, **24–25**, 26, **28–29**

 history of, 27–30

whooping cranes, 100

Wild Horse Desert, 130

Womack, Emma (Columbia Historical Museum), 72–74

Yoakum, H., 44 (early history of Galveston Island)